Heresies of Modern Art

Heresies of Modern Art

COLUMBIA UNIVERSITY PRESS

Xavier Rubert de Ventós

J. S. Bernstein, Translator

New York · 1980

Library of Congress Cataloging in Publication Data

Rubert de Ventós, Xavier.
 Heresies of Modern Art

 Translation of La estética y sus herejías.
 Includes bibliographical references and index.
 1. Aesthetics, Modern. I. Title.
BH151.R813 700'.1 79-19613
ISBN 0-231-04458-5

Spanish edition © 1974 Editorial Anagrama

Columbia University Press
New York Guildford, Surrey

Copyright © 1980 Columbia University Press
All rights reserved
Printed in the United States of America

La estética y sus herejías, from which this book is a translation, was awarded the Anagrama Essay Prize in October of 1973. The jury was comprised of Juan Benet, Salvador Clotas, Hans Magnus Enzensberger, Luis Goytisolo, Mario Vargas Llosa, and (without vote) Jorge Herralde.

CONTENTS

Foreword

Richard Sennett

WHEN Xavier Rubert de Ventós' *Heresies of Modern Art* appeared in 1973, it caused something of a sensation. The book combines philosophy, literary and artistic analysis, and social criticism. To say it is an "ambitious" book is both to understate and to demean it; as one French critic wrote, "this is criticism conceived as a heroic act." Rubert de Ventós refuses to leave anything relevant to his theme out, and his theme is endless: what is modern about modern art?

And yet this massive enquiry into systems theory, the development of the novel, Wittgenstein's later philosophical works, city planning, Surrealism, the sociology of small groups, the theater, all is unified by a clear and astonishingly simple thread. Rubert de Ventós believes that once the arts were freed of their Church and palace patrons, and became instead independent activities, they took on a new meaning in society. He calls this meaning "puritanism"; it stands for the artist's task of representing reality, telling the truth about it, as no other form of expression can. Free of pleasing a patron, the artist entered into a new bondage: revealing society to itself. Rubert de Ventós' term "puritanism" is an apt one: the artist might reject the conditions of society, but he was not free to be indifferent to them. Nor could he indulge in fantasy and play-acting for their own sake.

The story told in *Heresies of Modern Art* is how the modern artist came, in a variety of ways, to rebel against this puritan task of representing society to itself; heresy was born in our century when the artist would no longer, through rejection, defiance, or celebration, serve as a conscience. This theme takes up where Erich Auerbach's *Mimesis* left off, and there are many similarities between the two

books. Both are preoccupied with the artist's representation of reality not so much in terms of specific images or at the level of information as in terms of ways of seeing, writing, and speaking. Both *Heresies of Modern Art* and *Mimesis* are ambivalent about their subject. Representation does impose a sort of slavery upon the artist; he or she is forced always to tell about rather than just to tell. On the other hand, without that burden the act of aesthetic composition has no purpose.

Rubert de Ventós' book makes immense demands on the reader. In addition to the author's daunting erudition, the paths of his reasoning are indirect; he believes in paradox. His writing is "modern" in a way which echoes his subject; he refuses to be a straightforward guide. And the elegance of the original text is better appreciated by readers of Spanish. But despite these difficulties, the English publication of this book is an important event, and the very demands the author makes upon his readers are ways to learn from him.

Heresies of Modern Art

ONE

A MODEL

1. THE PRINCIPLE OF CONSERVATION OF THEORIES

SYSTEMS OF THOUGHT—scientific, artistic, metaphysical, or whatever—are always and fundamentally conservative. That is, they tend to project and impose their modes of understanding even when they have ceased to be effective. As Kuhn pointed out, *paradigms* or all-inclusive models of experience tend to make invisible, or to label as irrelevant, the new discoveries that undermine their basic commitments or expectations. Thus the need to go beyond the range of expectations opened up by science and art does not arise out of any "internal necessity."[1]

This "principle of conservation" or inertia in theoretical systems is paralleled by a similar principle in human behavior. Life styles do not contain in themselves the factors that generate their change. Only a discomfort stemming from a change in the environment forces individuals to stop doing things today the way they were doing them yesterday. Only when a new milieu or a new time transforms the norms into systematically dysfunctional ones do individuals begin to change their behavior.

Inertia seems to be the common denominator of scientific theories, economic models, or behavioral norms, and though we may think that possible tranformations are already written in their "deep structure," we come to see that, on the contrary, changes occur only as a result of an irritation from outside.

2. THE PRINCIPLE OF CONSERVATION OF ESTHETIC THEORIES

The above observations are relevant to an explanation of the evolution of present-day art. To begin with, the concept of *puritanism* [2] will help us to understand what has happened in art since it came out of the Church or the Palace and internalized as a puritan superego the demands which, in those spheres, had restricted it. The responsibility of representing, symbolizing, or revealing the reality that lay beyond the interplay of superficial forms fell to art itself the moment it became "free."

And, contrary to what might seem to be the case, avant-garde formalism was but one of the more sublimated theories and practices of this puritanism: whether the formalism which stressed the "syntactic" value of form (as opposed to its instrumental-play value, among others), the "structural" formalism which pointed to its heuristic value, or the "realist" formalism which attempted to describe the intimate nature of the universe (the "Intrinsic Reality" Mondrian talks about, or the "internal, original law" that Klee discovers by means of his "nonoptical vision of cosmic participation").

I will follow the strategies of this puritanism, from Neoclassicism down to today. And I will try to explain a good deal of modern sensibility as an attempt to free itself of this. I will also indicate what will be explained specifically in the last part: that an art free of puritan connotations is an idea which is fun to play with, but sterile when it becomes a precise program or "ideology." [3] Today we see indications of a "nonrepressive" art but not, on that account, of a sublime art. On the one hand, we have been witness to the repetitiveness and cheapness of the counterculture's by-products: "handcrafted" beads, psychedelic painting, candles in the best tradition of Bavarian kitsch, *Hair*-style performances. But we have also witnesed, and this is what matters here, other products, not specifically "artistic" and much more worthwhile, of this crisis of repression: those derived from the infiltration of the inventive or imaginative capacity into practical life, into social, sexual, culinary usages, etc.

Theoretical and practical institutions are condensations of a prior situation, and they tend to perpetuate themselves and to incorporate new events. Generals, it has been observed, are always perfectly

prepared to win the previous war. Extant language is always suitable for naming that which was. Our modes of vision often keep us from seeing what is before our eyes, but they are perfect, as McLuhan would say, for seeing by means of the rearview mirror.

Although in his often-quoted thesis on Feuerbach (until now philosophers interpreted the world, now we must transform it) the reverse might seem to be true, Marx basically shares Hegel's view that theoretical frameworks lag behind the reality which, at one and the same time, they depend on and explain. Marx, much more Hegelian here than Hegel, includes theoretical activity among real phenomena. The philosopher thus ceases to be a "reasoning spectator" of historical reality, and becomes its protagonist. Marx rejects the "division of labor" established by Hegel between those who, more or less instinctively, *make* history (Napoleon, the people taking the Bastille, etc.) and those who *understand* or interpret it (the philosophers of the ensuing generation who write the record of past deeds). Thus, Marx redefined theoretical practice's dependence on the transformation of reality: direct engagement of the individual in this transformation is now that which gives "body" to his theory. "Knowledge," writes Marx, "becomes false once it specializes and isolates itself, and it only keeps being true if it keeps itself in constant tension toward the goals which still elude it . . . but whose connection with them is assured by the individual through praxis."

Whether in Hegel's causal conception (a change in reality → a change in the theory) or in Marx's more mediated and frankly dialectical one (transformation of reality → theoretical practice → tranformation of reality), changes in theoretical systems are not independent of real changes. When reality does not change, or only changes slightly, theories tend to survive, comfortably ensconced in their own principles. If we're driving in a car slowly, continuing to look through the rearview mirror involves no grave danger; if we are in an age when every day resembles the next, we can safely face the coming day with the wisdom we took to bed the night before. Seeing the last highway post fifty yards behind me, I can guess that I am about to reach the next one; remembering that yesterday the sun rose at 6:30 I know that there are three more hours of darkness, etc. The little changes which occur I can, in any case, integrate into my "wisdom" by adding a few "ancillary hypotheses."

In summary, theories do *not* tend by themselves to change their

explanatory models, and now we see that they *can afford* not to when the external changes are few or slow, and they therefore continue to be fairly functional. So long as American social structure was relatively stable, the "General Theory" could survive as academic scholasticism. So long as art consisted of variations on the theme of the avant-garde which Malevich and Surrealism inaugurated, esthetics could continue with variations on the "modern" themes of formal balance and violation of conventional codes. While the revolution in Western Europe or in America continued to be a theoretical possibility, the theory of revolution could consist of glossing and "humanizing" the models of Marx, Lenin, or Gramsci.

In any case, we could believe that we knew very well *what* social structure, art, or revolution were: their meaning and function, the relative place they occupied in the totality of theoretical and productive practice. The only question we raised was the "internal" problem of *how* to analyze this structure, of *how* to make art or make the revolution. Theory consisted then only of solving the problems of local puzzles which arose within each one of these spheres—each one of these "disciplines."

3. OBJECTIVE CHANGE AND A SHIFT IN PUNCTUATION

When a series of rapid and unexpected changes occurs, theoretical systems undergo a real identity crisis. The question now arises not of *how* to make art or the revolution, but rather of *what* art and revolution *are*. We discover that the society, art, or revolution that we had been talking about were not a *fact* but a *construction*—a hypothesis which we recognize as such when it begins not to function. To understand what is happening, then, it is no longer enough to generalize our frameworks, or add onto them some ancillary hypothesis.

Let us take some conventional examples of changes that have occurred since the mid-sixties: *May 1968, in France,* the uprising led by those who, according to revolutionary theory, "weren't supposed to"; *the introduction of commercial and advertising iconography into art,* the art in opposition to which avant-garde art had defined itself practically and theoretically; *qualitative social demands,* awareness of the intentional exploitation and manipulation of women, of the sick,

the old, the insane, children, etc., as such (as against the mere awareness of economic or colonial exploitations); the *political relevance of sexual and religious issues,* etc.

The changes which these facts exemplify in their most accepted version have been the ones which have brought on an "identity crisis" in the theories. This shake-up of the facts was required so that what had been so long taken for granted would be thought through again; it was necessary for things to get outside of their "definitions," so that theorists of art or society would be forced to get rid of their ideological "gadgets." The theoretical frameworks which, it was assumed, were to have explained the facts, turned out to be as contingent as the facts themselves.

Finally, current theories not only consider themselves capable of interpreting certain phenomena, but also of pointing out how and where new events will occur. New events are awaited which will be, of course, integrable and integrated into the framework of the theory.

Now, the most significant thing about the recent changes is that new questions have arisen, and new answers have come, from the most unexpected quarters. And this will not surprise us if we keep in mind that it is a property of real changes not to occur *how* or *where* we expected them to, just as it is also a property of genuinely *new* answers to arise from *outside the field staked out by the inquiring reason of the moment.* A change that occurs when and where it is expected to has a diminished informational and innovative value; but it is only and precisely that *weak* type of "expectable" or "anticipated" change which theories can digest without getting out of kilter.

The real "increments" in knowledge or experience, on the other hand, come from spheres which had not been marked out as likely to bring them about. It is from outside of what our esthetic or social theory has outlined as the spheres of "art" or "politics" that significant changes occur, forcing along with them a redefinition of the meaning of these terms. And it is for this reason, as we shall see, that the answers which arise seldom have any relationship to the questions that are asked.

In artistic spheres people were asking how to compensate for the rising tide of bastard forms of pop culture and advertising—and the answer was that it was necessary to retrieve these forms. Political par-

ties were asking themselves why the proletariat was becoming depolit-
icized—without noticing the complementary proletarianization of
professionals. The most terribly intimate and subjective questions
about human behavior raised by late existentialism were answered by
structuralist philosophy, which did not try to understand this behav-
ior but rather to classify and search out its impersonal origins. Just at
the point when superstructures—of culture, art, literature, religion—
are undergoing their most refined "immanent" analysis, they are
beginning a process of desublimation, of contamination, and are dis-
solving into worldly practices. When in 1968, Pierre Boulez took up
again Ortega's argument that what must be overcome is the hedon-
ism of popular and easy forms of art,[4] there arose a spontaneous
demand for the most syrupy manifestations of kitsch, popular symbol-
ism, and esthetic practices which sought the well-springs of the most
elemental hedonism.[5] At the point when it seemed as if a consensus
had been reached about the absolute and autonomous nature of the
esthetic *object*, the new "conceptual" trends in art decreed objectivity
to be commercially induced and artistically irrelevant. While archi-
tecture was searching for a definition of architectural space, the new
architectural rhetoric sought inspiration in the world of street signs or
Illuminist standards. While Adorno was passing judgment on the
homogenizing character of American mass culture and music, to
which he opposed the European critical tradition, it turned out that
Europe was beginning its "homogenization," and the most critical
forms of art or behavior were arising precisely on that side of the
ocean. While leftists in the developed countries kept calling for mass
consumption as opposed to the conservatives' rhetoric of formal free-
doms, the spread of consumption, its use by the right as an in-
strument of social integration and the politically totalitarian tendency
inherent in the development of monopoly capitalism, forced the left
to denounce consumerism and to demand formal liberties—a de-
mand which previously was part and parcel of the rightist's repertoire.
 Philosophy had already had this surprising experience a long time
before: the answers to the questions which had been posed by aca-
demic philosophers in German universities did not come from acade-
mia, but precisely from outside: from Kierkegaard, Nietzsche, Marx,
and Freud. So we know now that a characteristic of the radical an-
swers, the answers which transform the questions themselves, is not

only the originality of their content but also the unpredictability of the point from which they will come. This fact, which was encountered until recently only by scientists, philosophers, or artists, has today become widespread. Things began to "get out of whack"; that is, out of our control and out of the places where we had laboriously and scholastically put them. And it is for that reason that we have to begin today by shuffling the papers in the files if we hope to understand a situation in which functions, positions, and along with them, obviously, identities themselves, have begun to be shuffled or permuted.

A basic hypothesis of my *Teoría de la sensibilitat* was that, as Proust, Bergson, and Sklovski had already foreseen, the function of art and literature in our day is to manifest singular realities not yet categorized by the multiple languages—commercial, political, academic—which tend to present us with their supposed "essence"; to free perception of its cultural "lenses"; "to provide a sensation of the object as vision and not as recognition."

"Primitive" peoples who live mostly amid purely natural and contingent phenomena show an obsessive tendency toward ordering and classification. The need to make sense of their environment leads them to categorize all phenomena according to formal frameworks—tame vs. wild, etc.—and to see as evil or dangerous what is not perfectly classifiable: the armadillo, cold-blooded animals, the "intermediary" areas between the settlement and the forest, etc. Aristotle's insistence on the fact that art must represent the general or the characteristic tells us that even in Athens the needs of general understanding were not socially satisfied. Today, nonetheless, the hard part is no longer reaching principles or generalizations—we live literally in an "eidosphere" of slogans, clichés, and images—but rather having the experience of a singular reality not marked out yet by any general principle. And in the same way that art and culture had to provide *recurrence and redundancy* in Chiapas, or *typicalness* in Greece, today it has to help us to approach *singular phenomena*, that is, phenomena which have not yet been categorized. Art must be able, at one and the same time, to *bring these phenomena to our perception* and to *keep them away from all categorization:* to "make them evident and let them underlie," as Heidegger would say.

If art is to avoid the categorizing function according to which the course of events is socially interpreted and served up to us, it must certainly begin by avoiding the rigorous segmentation which the different arts and genres—painting, lyric poetry, the novel—have introduced into this continuum. Hence my criticism in *Teoría de la sensibilitat* (1968) of the classical avant-garde aspiration to define—and actualize—the "properly" pictorial, the "specifically" musical, cinematographic, etc.

Since 1968, we have witnessed an increasing tendency in all the arts to register singular phenomena through a confusion of limits and domains, by means of the play of extensions and displacements, of dissolves and flashback effects, of ambiguities and levels of interpretation. In that book only one example was developed of the blurring of boundaries between what had been conventionally labelled as "artistic" and not "artistic": between what we have come to consider as *art, artifact, tool, spectacle, practical life,* etc. Here I shall show that the fall of the boundary between art and utensil is the counterpart of another breakdown which in the earlier book was only noted in passing.

1. We shall see that on the level of "subjects" or "themes," the *cold* breakdown that blurred the distinction between art and artifact is paralleled and counterbalanced by a *hot* breakdown which in its turn blurred the distinction between artistic behavior and everyday behavior. The milieu where the exercise of the artistic imagination is considered appropriate has thus been blurred on both sides. The theme, problem, or object of application of formal fantasy is no longer confined to the world of artistic representation or creation, but rather extends to the design of objects of everyday use and, at the other extreme, to the design of these very usages. Thus, to some extent we also have to invent and be "creative" in our social and sexual behavior, in our political and religious rituals, in the way we carry our bodies and organize our space. And the occasions and institutions—Church, Party, Fashion, etc.—which provided the norms for these forms of behavior have been the first ones to be overrun by this imagination which is emerging from its gilded cage.

2. On the level of "treatment" or "stylization" this double breakdown is no less apparent. Faced with an art which until now was inspired by intuition and formal imagination, the new artistic products

seem to be seeking their inspiration in the much colder sphere of analytical Reason and in the hotter one of a genuinely *fauve* Imagination that is not professionally "punctuated."

Schematically:

Change in subject
{
 Cold: artifacts, habitat, etc.
 Hot: norms of behavior, rules for the
 use of objects
}

Change in treatment
{
 Cold: formal or technological research,
 use of already established languages
 Hot: extrapolation, displacement, and
 hybridization of formal languages
}

This double split is described on pages 27 ff and 45. Its development and exemplification are the subject of chapters 4 and 5. I illustrate the *change in treatment* by reference to the practice and ideology of architectural rationalism and the two senses in which its limits have been overrun. I analyze the *change in subject* by focusing on the practice and ideology of classical avant-garde art, and indicating the two extremes where its punctuation of the "subject matter" of art was to turn out to be too restrictive.

My first hope for this theoretical model is that it help us to understand the coherence of the seemingly two-headed evolution of present-day art and sensibility. We are dealing with two fronts of a single tendency confronting the puritan tradition of art, which insisted on:

1. The "esthetic" dignity of the subjects that art may deal with.
2. The "humanist" nature of the faculties exercised in, or stimulated by, art.[6]
3. The "transcendent" (e.g., subjective, ontological, practical) value of the formal experiments which gave them both their meaning and their justification.

The tendency to unify, to show that everything is fundamentally the same, is always suspect. Linear and puritan forms of thinking want to make things as "clear and distinct" as their own frameworks, and they reject overlapping, extrapolation, and boomerang effects.

They need to think that every trend is marked with an indelible and unmistakable sign. My hypothesis about the profound unity of present-day artistic trends, on the contrary, assumes its paradoxical duality and, what is more, the ambiguous nature of each particular trend. It aims to show, moreover, that the consequences and implications of the most scientific or rational formulations are not necessarily technocratic or utilitarian, just as those of imaginative formulations are not necessarily speculative or creative: that there still exists the possibility of an unholy alliance between reason and imagination which can confront a world of increasing bureaucratic and technocratic control.[7]

4. THREE POSSIBLE INTERPRETATIONS

What happens to art when formal esthetic practice seems to get out of touch with the domain of intuition and good taste, and to ally itself with technical processes of production or with changes in manners? Is that art dead? Has it exploded? Perhaps imploded? Personally, I think it is simply a matter of a change in the cultural segmentation of social reality. But let's begin by considering the previous hypotheses.

1. The easiest and most progressive interpretation seems to be that there is no longer any difference between art and non-art: "sculpture is any object," "theater is in the street," etc. This answer, nevertheless, shares all the limitations of the very question "What is art?" Because the question, as we have seen, is no longer "What is art?" but "*When* is art?": in what context and under what conditions is the combination of certain themes in a text, the manipulation of an object, or travelling around the world, art? In other words: in what situation does a gesture, an object, or a discourse acquire a signifying value that transcends its mere functional and conventional existence?

Those who never distinguished the function from the institution (art from the museum, say) may feel bewildered by an art that neither has a specific place nor seems to appeal to a specific esthetic sensibility. And they may certainly believe that the specific task of art has become dissolved in the routines of secular activity and daily production. But if art today is to enter into industry, into fashion, or into revolution, it is precisely so as to counterbalance their institutional

routines and to point out—beyond what is given and perceivable—what is possible and imaginable. Art today tends to be much less "pure" than it was in classical bourgeois society, but this is because usages and creeds, the ways of dressing and mating, tend to be much less conventional. Both creation and convention seem to be escaping from their former reserve.

2. Or we can adopt a still more dramatic tone and speak about the Death of Art. To decree the death of art is certainly a useful, if not a new, rhetorical device. From Fray Gerundio de Campazas down to Altizer and the theologians of the death of God, we have seen that declaring the Death of God is a subtle way of enhancing public interest in Him. But to speak of the death of Art—like the death of God, the death of the Family, the death of Marx, or the death of Man[8]—is simply this: an affirmation on the level of what Barthes has called "writing," which signifies nothing but "the choice of a tone, an ethos." And I fear that our age is less and less sensitive to this tone.[9]

What the "death of art" talk, rhetoric aside, is in fact alluding to is the change in the position and function of art within the system of social and institutional relations. Those who thought that the position occupied by art within the system of cultural institutions (sports, politics, leisure, consumption, display, social convention, etc.) was its "natural place," have logically misunderstood its displacement to be its death. Haven't grandparents always said that "nowadays" there is no longer any education, seriousness, discipline, or whatever?

Thus, neither the content nor the emphasis of the proposition "art is dead" seem appropriate. Rather than speak about death, therefore, I will speak about a shift to a new system in which art occupies a different position, where esthetic messages are differently translated, channeled, and assimilated.

3. One might think, finally, that the new displacements and alliances of art presuppose a betrayal of its critical function. The issue then becomes not the explosion or death of art, but its cooptation.

But committed art does not mean coopted art, just as art for art's sake does not mean subversive art. Purely artistic products can be perfectly integrated into the market system, while the imaginative exercise of supposedly an-esthetic, secular practices—construction, subversion, etc.—can disturb the conventional usage of objects and spaces, or escape the established forms of repression. But there is still

an additional confusion in this argument. The classical forms of art which are taken as models of "pure" art (symphony, easel painting, Gothic cathedral, Greek theater) were products as much linked to the social needs and mores of their time as our industrial arts or social conventions are. Only the passing of time and placement in the museum, which separates the works from their contexts, permits us to appreciate them as strictly formal.

Now then, I don't think that this formal consumption of the works of the past ought to be criticized. On the contrary: in a period when everything is "designed," preplanned, useful, explained, and reasoned-out, it is often only in the works of the past (and thanks precisely to our not knowing, or knowing imperfectly, the context to which they were responding) that it is possible for us to have the voluptuous experience of a nonmotivated object, of a nonfunctional form.

But it is one thing to delight in the works of the past, and another to attribute to them the freedom and gratuitousness which a modern reading appreciates in them. It is one thing for us to savor as a pure interplay of signifiers what was in fact an arduous labor of signifieds, and another to think that the art of the past really *did* consist of the free and critical play of the imagination. The marvelous autonomy of the easel painting is not something which we discover but rather something we project; it is not so much a characteristic of the painting as a product of the use we make of it today. Who has not noticed that a stylistic device which was common in another era comes to interest us as art when it has fallen into disuse?

This is an obvious example of culturalist hypermetropia as described by McLuhan. The prior milieu or means of communication comes to be considered artistic only in opposition to the secular or an-esthetic nature of the modern means and channels: it is the printed word that turns the oral tradition into a "poetic" tradition; it is the Industrial Revolution that invents the Romanticism of "nature"; it is the movies that transformed the theater into a more cultured spectacle, and television that allowed for "artistic" films. Bricks made building with stone "classical," and the invention of plastic gave a new sophistication to objects made of wood or even of tin. And what, if not *design*, has invented *painting* as a "vehicle of eternal values"?

But surely it was Nietzsche who, in his analysis of Greek art in *The Gay Science*, best criticized the prejudice which is at the root of these

conceptions: i.e. that "it was precisely the desire to get away from utility for once that elevated man and furnished the inspiration for morality and art." Against this humanist idealism, Nietzsche argued that to refer to the origin of poetry he was obliged "in this case . . . to side with the utilitarians." It is not necessary to appeal to periods when art was in the service of Popes or Emperors to discover its profound functional nature. It was in *mousike* itself—the poetry-music-dance of classical Greece—that Nietzsche saw that "rhythm was meant to impress the gods more deeply with a human petition, for it was noticed that men remember a verse much better than ordinary speech." They understood, furthermore, that "rhythm is a compulsion; it engenders an unconquerable urge to yield and join in; not only our feet follow the beat but the soul does, too—probably, one surmised, the soul of the gods as well! Thus one tried to *compel* the gods by using rhythm and to force their hand: poetry was thrown at them like a magical snare." In the second place, "music was credited with the power of discharging the emotions, of purifying the soul, of easing the *ferocia animi* . . . all orgiastic cults aim at discharging the *ferocia* of some deity all at once, turning it into an orgy, in order that the deity should feel freer and calmer afterward and leave man in peace." *Melos* (melody) means, etymologically, "sedative." Finally, rhythm seemed to be associated with the effectiveness of actions, mechanical ones (sowing, drawing water from a well) as well as dialectical ones. Even in modern days, Nietzsche observes, "the most serious philosophers, however strict they may be in questions of certainty, still call on what poets have said in order to lend their ideas force and credibility."[10]

Hence, the idea that art's intermingling with social practices is a modern technocratic or degenerative phenomenon that can and should be overcome by taking as a model classical art forms seems untenable. Taking it the other way around: a twenty-third-century social anthropologist studying our times will probably classify what we call our "arts" as forms of religious or social liturgy, while the way we build houses, wear clothes, and use media will be called "art."

5. THEORY OF ESTHETIC TYPES

We have just seen the paradoxes and contradictions to which we are led by theories which try one-dimensionally to understand the

function and meaning of art in a period such as ours when art seems to mix with what we used to understand as nonesthetic realities: beliefs and behaviors, tools and politics.

Now then, to understand an artistic activity which escapes from the frame to which it is accustomed, we need a theory not only of art but also of these very frames: a theory of a higher level of abstraction than that of artistic activity itself. Every culture organizes experience in a series of categories: sacred / profane, natural / artificial, one's own / another s; and, also, craft / art, work of art / tool, artistic / practical, etc. Now in a relatively stable cultural period, the function, place, range, and limits of artistic activity are very precisely defined by this social punctuation. Changes will one day occur, nevertheless, which will escape and break this punctuation, thus forcing a reorganization of the cultural frame itself. And this reorganization will work in either of two ways:

> 1. by separating what was, in the preceding punctuation, connected (e.g., in Greece, the progressive dissociation of concepts which were undifferentiated before: practical wisdom / theoretical wisdom; natural law / conventional political norms);
> 2. or by joining what was, in the preceding punctuation, separated (e.g., since Galileo, gravity / stars' trajectories; since Marx, productive process / cultural production; since Einstein, matter / energy; since Freud, culture / repression; since Reich, genitality / productivity).

Wittgenstein's *Philosophical Investigations* seems to offer a theoretical framework for dealing with these problems. For Wittgenstein, an *expression* ("Your name is Queen Mary," "I swear it," etc.), only takes on meaning in the context of a *linguistic game* (christening ships, giving my word) whose sense, in turn, depends on a *way of life* within which these practices (christening a ship, taking on a responsibility through the ritualized utterance of the expression "I swear") are meaningful. It is easy to see that any word or activity that we may choose is already defined by a first $context_1$ or linguistic game which in its turn is contained within a broader $context_2$ or way of life: "*to stamp,*" for example, is a term and an activity which acquires meaning within the linguistic-administrative game of the post office ($Context_1$), which in its turn has meaning within the organization of the

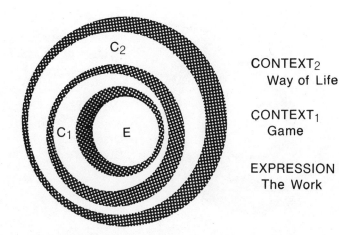

CONTEXT$_2$
Way of Life

CONTEXT$_1$
Game

EXPRESSION
The Work

modern state, which assumes the responsibility for the transportation and distribution of mail (Context$_2$).

Wittgenstein's analysis is far from conclusive and definitive, but what interests me here is less his philosophical criticism than its use by way of analogy in our field.

The meaning of artistic works is also defined by the context within which they occur, i.e., by the segmentation which segregates them as more or less stabilized social practices: writing, making up poems, singing hymns, painting pictures, etc. Now then:

1. The illusion that artistic practice is independent of its context is only possible at times when the contextual change is so small that we can do without it.

2. But when the process of transformation accelerates, we have to take into account a more general context in relation to which singular works are defined: this context or Wittgensteinian "game" would, in art, be that of *Styles*. The artisan of a Gothic cathedral could carry out his work simply and routinely, but the Parisian artist of the 1930s and '40s could not keep from defining himself in relation—positive or negative—to various general tendencies or "artistic games"—Cubism, Dadaism, Informalism, Surrealism—which punctuated the artistic debate of the times. Picasso is the paradigmatic example of the artist who took on this situation fully, and made of his painting a question and a questioning of styles.

3. But the limits of the artistic debate within which our avant-garde

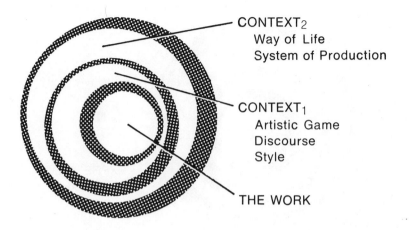

CONTEXT$_2$
Way of Life
System of Production

CONTEXT$_1$
Artistic Game
Discourse
Style

THE WORK

artists remained depended, in turn, on the more general context in which their "style" or "artistic game" acquired its meaning, i.e., within a given *way of life*. And this fact, which because of the pace of artistic change was irrelevant to the artists of the thirties, appears to us as the primary problem since we can no longer take for granted the role or place occupied by artistic practice in relation to other theoretical, imaginative, productive, political, or ludic practices of our time. The problem (which only the Marxists raised, and certainly did not solve) of the relativity of Art and Revolution is now raised on the level of a General Theory of Relativity of Art.

The range of the problematical has thus been getting larger: from *how* ("in what style") one should write or paint, to *what* writing or painting is, to *where* and *when*—in what social or life situation—a written testimony becomes "literature" or a set of forms becomes "painting".

But the development of this more general problem of the place and function of artistic activity in the context of social practice has involved, in its turn, a new emphasis on the internal analysis of the structure of the works of art. The *sociological* approach of context$_2$ has fostered an internal or *rhetorical* analysis on the level of the works themselves: an analysis which had not been felt to be necessary so long as a general *poetics* of times and styles took responsibility for explaining everything.

6. ART AS FORMALIZATION

The esthetic analysis at work in context₁ tried to explain styles and works of art with more or less normative concepts like *Formalism* or *Realism*. But we have seen that in order to raise the much more general question of the position and function of artistic activity in the context of other practices, we had to start with a much more concrete and immanent understanding of its specific nature.

Thus, we have to describe artistic activity with a term which can cover the *variable* nature of its positions and functions but which at the same time will take account of the *specific* nature of its task. What term can we use to describe the specific activity of such diverse professionals as the builders of Polynesian canoes, tatoo artists of New Zealand, cathedral builders, romantic composers and jazz musicians, Renaissance investigators of linear perspective and modern experimental painters, epic poets and nineteenth-century novelists? The only term I think withstands the test of describing all these activities is *Formalization.* Let's see what it means.

The activity of the artist as *formalization* will perhaps be better understood if we compare it to the activity of the intellectual as *formulation.*

Formulating

Intellectual activity consists basically of formulating. And to formulate means:

> 1. On the one hand, to give theoretical "consistency" to the interests of the dominant class—with intellectuals as "experts in legitimization," according to Marx; to make explicit what everyone "already" knows and to elaborate as universal codes the boundaries between legitimate and illegitimate knowledge which the state of science promotes.
> 2. But, on the other hand, it can also mean a *critique* of this implicit or explicit conventional knowledge: an ambition to transcend the framework of the dominant ideology, unmasking its origin and functioning.

In its legitimizing aspect, it tends to validate the reason or good sense of the given: to show *the necessary nature of what is contingent.*

As a critique, on the contrary, it points out *the contingent nature of that which tends to appear as necessary and natural:* of "eternal" institutions and "imperishable" principles. Intellectual activity, at the same time producer and demythifier of conventional wisdom, is thus fundamentally ambiguous: it can either legitimate or criticize what it seems merely to describe. And it is ambiguous, above all, since its influence is not necessarily related to the legitimizing or subversive intention of the author, so that it often serves *to stabilize what it denounces,* or conversely, *to denounce what it describes.* In fact, in the last analysis, *every criticism can be used by the establishment* (who can doubt that it learned a great deal from Marx, Mao, May '68?) and inversely, *every formulation which tends to legitimize or reinforce the existing state of affairs can be turned against that state of affairs.* Hegel's theory of the Prussian State as Ideal State lays the groundwork for the first radical critique of the State; his explanation that every social phenomenon is a manifestation of the Idea was developed, in the hands of his materialist disciples, into the most perfect demonstration that the "idea" was nothing more than a gratuitous extrapolation of these social phenomena.

Formalizing

Whether we like it or not, the intellectual's responsibility turns out to be somewhat more complex than "telling the truth," and the artist's responsibility is less simple than that of "creating beauty." To formalize or endow with form is a weapon with as many blades as "to formulate": it is, on the one hand, *to confirm and disguise* the real-life situations to which form is given, but it can also be the unmasking of these situations and the invention of alternative models. The codes or materials out of which one formalizes are not only artistic or linguistic: they are also social, ideological, etc., and the operation of the artist, as Eco has pointed out, "only acquires meaning through these codes which at one and the same time are mocked and recalled, criticized and reconfirmed."

Hence the two functions, seldom clearly delimited, which artistic creation takes on. On the one hand, it looks for a new language (symbolism, naturalism, functionalism, etc.) which will correspond to the new world and experience that until now had to be expressed

in a language born out of, and suited to, a different reality, i.e., an old language which no longer has the necessary flexibility for transmitting the new messages and thus tends to blur the innovative nature of what is said with it. But, on the other hand, art does not look for a language which will be a better vehicle of expression for existent reality, but rather a language which will permit us to perceive anew, to describe critically and to suggest alternatives to this old reality and to its superstructural formations. Hence, the ambiguity of the great works of art—Michelangelo's Capitoline Chapel, for example—which carry out a complex synthesis of both functions and always surpass the unilateral interpretations that most art historians provide.[11]

But before pursuing its possible functions, it is useful to define somewhat more precisely the very sense of the term artistic *formalization*. We began by distinguishing it from theoretical "formulation" and we must now do the same with regard to the other meanings of the term "formalize."

To a scientist, formalizing consists of transforming the maximum amount of quality into quantity, and for a logician, the maximum of ordinary language into signs in a precise language: into a system of notations that will facilitate a calculus (algorithms). Logical formalization of language thus tries to set up a *consistent language (which will make the paradoxes of ordinary language impossible)*, and a *decidable* one (that is, one which will contain the rules for deciding if a formula is valid within the discourse).

In contrast to scientific or logical language, artistic formalization does not try to describe the deep formal skeleton of language or reality but rather *to bring to the surface* and find the "formal" manifestations of reality's possible "contents." It tries to make all the profundities, meanings, or intentions come up to the surface where our senses can take them in.

The artist "formalizes," thus transforming the maximum amount of *function* into *form*, the maximum of *exigency* into *gratuitousness*, the maximum of *ideals* into *images*. In a word, *the maximum of Essence into Appearance*.

As Lowenthal saw, the specific creative treatment which an artist gives to nature or love, the weight he gives to reflections, descrip-

tions, or conversations, are primary sources for the study and penetration of the most intimate areas of private life and of the social climate of the age. This artistic formalization, moreover, usually precedes theoretical formulations. The desacralization and homogenization of space in Renaissance painting occurs prior to its Cartesian definition as *res extensa*. The "subjective" and "effectist" composition of space in Baroque artists precedes the Kantian formulation of space as "an a priori category of sensibility." Goethe is almost a century ahead of his contemporaries and philosophical friends (Kant, Fichte, Schelling, and Schiller) when he abandons the hope of responding to the problems of the soul and the world from the domain of theology and philosophy. The social *dilettantism* of Proust anticipates modern work in Social Psychology.

But to speak of art as formalization also suggests that the work of art has always been a footnote to the job it was implicitly or explicitly meant to do. Art has always been asked to "give form" to a series of nonesthetic exigencies. The client's commission has very rarely been formal: its formalization, is, precisely, the function of the artist. The artist is thus the translator to the world of the senses of the more or less symbolic commodities which the dominant class asks him for—: middle-class display, ecclesiastical exhortation, commercial publicity. *No one or almost no one asks for art; one asks of art.* The bourgeois will ask the artist for symbols of intimacy, respectability, and opulence: marble in the entryway, paintings in the living room. Nor does the dealer ask the artist for creativity, but rather that he be the faithful imitator of himself; that he keep repeating the forms for which he has already found a market (in this sense, the role of dealers in the formation of orthodoxy in modern art needs further study).

But great artists have always been able to introduce a certain subversive power or esthetic surplus into the commission itself. In the Capitoline square referred to above, for example, Michelangelo was able, as Giedion has shown, to transform the Counter-Reformation "job" into a symbol of the communal life and bourgeois freedoms which had been lost. Artistic formalization draws upon and at the same time violates the stylistic system from which it begins; so it can demythify, and make manifest the limitations of, the task in the very act of giving form to it.

But what is the advantage of understanding artistic activity as "formalization" instead of speaking of "structure," "mirroring," or some other well-established term in art theory? I believe the concept of formalization permits us to explain that the relation of artistic practice to other social activities (consumption, luxury, display, exploitation, etc.):

1. is what defines and gives meaning to that formal activity;
2. is not, nonetheless, a relation from which it is proper automatically and mechanically to deduce the "formal strategies" of a given period; on the other hand,
3. is neither a constant nor an essential relation, as is presupposed by classical models: Art as "Secularized Magic," Art "between Religion and Science," etc.

"Formalization," in fact, offers us a theroetical model which, at the same time (1) accounts for the external or contextual definition of art but (2) leaves both extremes of the artistic operation—the attitude *out of* which one formalizes and the *place* or *realm* to which this attitude is applied—open and capable of being filled by different "styles," "manners," or "genres." Until now, the internal evolution of art has only been described from idealist postulates, and its external connection has only been explained from mechanistic ones. Here, we want a model which allows us to understand the transformation of the very system of relations which defines art in each period.

And in art, as in marriage, these external relations which define it are in no way accidental. Simmel observed that in all known cultures, marriage is defined precisely in opposition to that which should be understood as its nucleus: the sexual relationship.[12] That is why no attempt at a theory of marriage can succeed without dealing, beyond the strict sexual relation, with the social and conventional context; and it is for the same reason that a theory of art cannot be attempted without turning away from purely esthetic matters and entering the nonesthetic context: the context which makes artistic practice, at one and the same time, difficult and possible.

In any of their variants, and despite being opposites, *Formalism* and *Realism*—the theory of art as pure field of expression of formal

competence, and the theory of art as a reflection of social structure and conflict, etc.—coincide in assuming this context to be something fixed in regard to which the art of all ages maintains a preestablished relationship. Moreover, with the realism of Semper or Lukács, as also with modern formalism which did not learn Riegl's only important lesson, one tends toward an interpretation and evaluation of the artistic past as a function of its fidelity to prior theoretical postulates. The history of art is then seen as a series of tendencies or attitudes that are more or less "progressive" or "decadent," creative or conventional, according to whether they approach or distance themselves from the "real" function of art. These esthetic positions then adopt the normative and strict tenor in which Lukács warned us against symbolist "dangers," or reactionary "assaults on reason"; the same tone with which formalism's stragglers warned us of the intrinsic superiority of the easel painting over design, the cinema, or propitiatory rituals.

TWO

APPLICATION OF THE MODEL

1. THE RELATIVE NATURE OF THE DISTINCTION BETWEEN STYLES AND OBJECTS

BY UNDERSTANDING ART as formalization we avoid the substantive nature which dogmatic esthetics must attribute to its object of study: *Beauty* for metaphysical esthetics, *Infrastructure* for sociological esthetics, or *Internal Structure* for formalist esthetics. But still one must show that formalization is a flexible concept; i.e., that it can explain the qualitative changes that occur on the level of the *means of formalization* (Styles, Rhetorics) as well as on the level of the *formalized objects* (Themes, Subject matter). It remains to be seen whether this concept helps us to understand (1) the changes in the ways of reworking objects which the artistic practice of a period considers pertinent, as well as (2) the changes in the very system of punctuation from which certain objects, themes, subjects, or places are labelled as suitable for esthetic formalization.

But before studying both dimensions separately, it is well to recall their interdependence. *How* one formalizes and *what* one formalizes are not independent questions, but rather two aspects by which transformations of the cultural and artistic task manifest themselves to us, according to the time frames we apply in our study.[1] In fact:

1. In a very *hot* or *descriptive* history which follows the evolution of art along year by year or even month by month (the shape in which the "history" of our own time is presented), change manifests itself as a progressive *internal transformation in style*. To scholars of the Gothic, change thus appears as a progressive transformation of the "how": *primitive gothic* (depth and assymmetry predominate over centralization); *classical gothic* (autonomy of the supporting and covering ele-

ments but still the effect of the whole predominates); *late gothic* (transformation of the classical continuity into absolute isotropy dissolving the duality between supportive and covering elements; disappearance of the prominence of the tracery which now appears as a homogeneous weaving, etc.).

2. If we open the net of our chronology somewhat, we pass from the internal history of a style to an *external history of different styles* (*"hows"*): Byzantine, Roman, Romanesque, Gothic, Renaissance, Baroque. Further, the quantity of these "hows" will vary according to the relative density of this chronology. The Late Roman or Mannerist styles will emerge as independent structures if the history of art is approached in periods of, say, ten years, instead of periods of fifty in which no style "appears" between the Roman and the Romanesque, or between the Renaissance and the Baroque.

3. If we open our chronological net even more, some changes appear which are no longer merely stylistic or rhetorical: not only does the *how* of making art change but also *what* art is in each period. Thus, for example, the Hegelian history of art: *symbolic* art (Egyptian-architechtonic-theocratic), *classical* (Greek-sculptural-humanist), and *romantic* (European-Christian-pictorial-intimist).

4. With an even more elongated history, with even broader periodization of the cultural tradition (of, let's say, every 400 years), the changes in *what* is being done are even more obvious: magic-art, artisanship-art, luxury-art, expression-art, etc. The different "arts" which we perceive through this net (history) do not only imply variations in the ways of doing it, but rather different tasks whose function and social position have little or nothing to do with each other.

Thus, according to the spacing of the cuts which we apply to a period, change appears on the internal level of art styles or on the wider level of the functions which art fulfills and the spheres in which it operates. And my attempt is none other than to *apply both perspectives to our own period* so that they can reveal to us the two levels of their evolution. The difficulty, obviously, will be greater when we try to study the qualitative changes which are occurring in our period: when we try to understand its development, which we inevitably follow day by day, out of a logic of "long periods," that is, the only logic which can reveal to us not only the changes that have occurred in modern art but the recent transformation of the very concept of art.

When we apply both perspectives—one more intensive, the other

more extensive—to the art of the sixties, I hope that not only these two levels of transformation, but also their interdependence, their hybridizations, will become apparent. We will then see that phenomena usually understood from a perspective of "styles" take on a new aspect when they are seen from the viewpoint of "thematic" changes. But now let us look at both transformations separately.

2. THE CHANGE IN STYLE: ITS TWO DIRECTIONS

The style or way of formalizing of the sixties seemed to break with the tradition of artistic puritanism which, with its important subjects, noble materials, and unequivocal messages, governed the development of art since the Renaissance, fully dominating it since the triumph of the bourgeois revolution. In order to see this transformation, it will suffice to notice the change that has begun to occur in "prestige" materials, periods, or terms since the beginning of the sixties.

1. The *terms* with which a work was evaluated were the classical ones of humanism: authenticity, commitment, naturalness, the breaking of codes and conventions. From then on, on the contrary, terms opposite to those acquired prestige—terms marked during the preceding period with an unmistakably pejorative connotation: ambiguity, artificialty, historicism, eclecticism, camp, "recovery."

2. People admired *primitive styles* above all ("The Romanesque is a truly authentic style"), and the works of the artists which ushered in the classical periods—Aeschylus, Cimabue, or Haydn—but which yet were not marked by their perfection nor, above all, by their later stylishness. Since then, more decadent, popular or academic periods or works took on interest for us: mannerism, modern-style neoclassicism, art *pompier*, etc.

3. Natural, honest *materials* which inspired the superior rhetoric of Tapiés or Mies van der Rohe were appreciated: hopsacking and stone, sand and brick, wood, granite, and glass. Henceforth, more artificial and conventional, expensive and technically sophisticated materials began to interest people.

As mentioned above, it was a bidirectional reaction—rational and imaginative—which at both its extremes broke with a tradition of

bourgeois art (note that here and subsequently I use the term "bourgeois" as a description, not as positive or negative evaluation) which had been able to keep both dimensions within a reasonable and familiar universe.

The only clear precedent of an analogous shift is Mannerism. On one side, Mannerism tended to codify and effectively carry out what Renaissance artists had often limited themselves to presenting as projects (in architecture, for example, such was the function of the "Vitruvian Academies" of the sixteenth century). But together with this *cold* or *technical* reaction which tried to carry out what the previous ones had only promised, Mannerism also brought about a *hot* and *imaginative* shift away from the rationalism of the Renaissance: it tended to recover all the imbalance, violence, or eroticism which the Renaissance had rejected or repressed by means of its linear perspectives, its strict stereometry, and its centralized geometries.

The art and literature of our day is not backed by the rationalist idealism of the Florentines, but by a humanistic and moralistic formalism which makes the honest citizen in modern cities—his victories and frustrations, his science and prudery—the measure of all things. And confronting him, our arts have had the same ambiguous reaction as Mannerism: on the one hand, they have tried to find a language with which to recover these formalist ideals as a "cultural phenomenon," along with a technique to implement them; and, on the other hand, they have tried to break with the grandiloquent, grave, and sublimated nature of avant-garde formalism.

The classical avant-garde of the forties and fifties (I mean Informalism, Abstract Expressionism, etc.) had been in a sense the culmination of humanist projects and ideals: formal discipline, autonomy of art, rejection of the gratuitous, search for essence, etc. With atonal music, architectural functionalism, abstract painting, Chanel's *couture*, the theater of the absurd, etc., art seemed to have freed itself by dropping the norms of representation, plausibility, tonality, etc., that had shaped its evolution until then. But it had freed itself only the better to fulfill, in modern times, the very thing for which those norms were used in their day: to serve the demands of autonomy, good taste, formal rigor, etc., which made of art a symbol of the bourgeois synthesis between nature and culture, between life and intellect, reason and imagination.

It is hard to spell out the factors which, on different levels, have forced artists to suspend the illusion of a synthesis and to venture boldly in one or another of the two directions noted; that is, it is hard to explain the concurrent emergence of phenomena such as: the disinhibition of signs (signs which need not "justify themselves" any longer by their function or meaning, as dress which today need not camouflage its seductiveness as an *als ob* of utility); the blurring of distinctions between genres in art; the disinterest in "essential" or specific languages (pictorial, cinematographic, etc.), and the delight in hybrid ones; the eruption in art of the most shamelessly private fantasies and of the most unequivocally artificial techniques.

It is probably a question of the synergy of distinct but otherwise interdependent factors, among which are:

1. The growing pace of change, which has nullified the symbolic efficacy of short-range cultural syntheses: psychological deconditioning, humane city planning, etc. The contradictions which architectural rationalisms and pictorial neoplasticisms *theoretically* resolved only got worse; the gap between artistic experience and everyday life only got wider, giving the lie to the ideology that made of art an anticipatory "model" of new forms of experience and existence.

2. The greater "reasonableness" and stability of the socioeconomic system, which art can only counter with radical proposals. The Establishment already produces the "well-made work," items of standardized quality which, spiced by advertising imagery, are offered up for passive consumption. And by a logical strategy of supply, since the only thing that conventional production can no longer provide is the real intervention of individuals in its processes, participation and action-art become the leit-motiv of art. Only the *imagination*, dreaming different situations, or the *reason*, carrying the conventional system to its extreme or to the breaking point, seem capable of offering alternatives.

3. The personal schizophrenia of the artists who retain the memory of a time when their profession was still a "liberal profession"; that is, the time when the relations between capital and profession were actualized in the form of a commission, since capital only used the results of the work without directly ruling the entire productive process. But since capital *does* rule the productive process, either outright collaboration or radical protest seem to be the only "ways out" for the liberal profession.

4. The unmasking of the repressive nature of realities that, like "in-

formation" or "organization," had been considered rather aseptic (by the right wing) or mere superstructures (by the left). In his *Anti-Oedipus*, Deleuze tells us that there is only desire and repression. The intermediate structures which seemed to synthesize desire and order, passion and institution, love and family, were now seen as purely repressive ones. Only a systematic analysis of the conditioning nature of such structures and/or the search for alternative ones seemed to respond adequately to this discovery.

5. The new scale of cities and communication nets. Either the growth of social institutions was controlled by keeping them within limits where intuition, good sense, or good taste were adequate, or one had to develop reason and imagination (beyond the point sanctioned by the classic synthesis) for the purpose of maintaining communication on this new scale. The city has evolved more in the last fifty years than in the previous five thousand (Weimar in the nineteenth century is "somewhat" more like Ur in the third century B.C. than like the new metropolis) and the conventional artistic channels of urban communication have suffered the effects of this transformation.[2]

As Weber and Simmel had already announced,[3] we are seeing the breakdown in civic culture which ensues upon the development of the city itself—the transition from the modern city to the contemporary metropolis. In the concentration of tertiary industry, of business and communications which compose the present-day metropolis, the citizen experiences a permanent sensual and neural stimulation (changing and discontinuous images, unexpected stimuli) for which he tries to compensate by developing his *intellectum agens*, an intellect that enables him to digest the multiplicity and diversity of the sensations he finds himself assaulted by. Only by intellectualizing himself and making himself *blasé*, understanding or classifying everything, does he manage to keep his own psychic balance, "not being surprised by anything any more."

But there is yet another factor, likewise pointed out by Simmel, which helps us to understand the cacophony of modern culture. The modern city provokes a frightening increase in the available *objective* culture: objects which the individual does not regard as natural phenomena but rather as products of human culture—definitely his pro-

ducts—but which, nonetheless, he neither understands nor manages to "keep up with."

Here in buildings and educational institutions, in the wonders and comforts of space-conquering technology, in the formations of community life, and in the visible institutions of the state, is offered such an overwhelming fullness of crystallized and impersonalized spirit that the personality, so to speak, cannot maintain itself under its impact. On the one hand, life is made infinitely easy for the personality in that stimulation, interests, uses of time and consciousness are offered to it from all sides. They carry the person as if in a stream, and one needs hardly to swim for oneself. On the other hand, however, life is composed more and more of these impersonal contents and offerings which tend to displace the genuine personal colorations and incomparabilities. This results in the individual's summoning the utmost in uniqueness and particularization, in order to preserve his most personal core. He has to exaggerate this personal element in order to remain audible even to himself. The atrophy of individual culture through the hypertrophy of objective culture is one reason for the bitter hatred which the preachers of the most extreme individualism, above all Nietzsche, harbor against the metropolis. But it is, indeed, also a reason why these preachers are so passionately loved in the metropolis.[4]

The increase of institutionalized culture provokes an individualist and irrationalist reaction: technology, general education, and "progress" on one side—demand for the irrational, anomalous, and individual on the other. The possibilities of an urban cultural synthesis have been negated by the radical nature of these extremes, which the city itself fostered.

In this situation, the arts can no longer aspire to a humanist reconciliation of life and intellect, and are instead caught up in the process of radicalizing and sublimating the extremes. The ideal of a reasonable synthesis—Apollonian, Goethian—is overwhelmed in a society where the needs of Systematic Calculus and of "Lateral Thinking," the demands for Reason and for Imagination, have both increased exponentially.

The avant-garde's intuition and good taste are insufficient in the current artistic context, for the same reason that good sense will no longer suffice in business, which has to replace the old boss's "eagle eye" with market research, his "vision" of the future with sales projections, and his "fine instinct" for making decisions with techniques of decision-making. Likewise in science, imagination and the precise calculations that modern science requires have gone beyond the intuition or the "mind's eye" of Ptolemaic cosmology. Parliamentary pol-

itics in Western countries has also been split into processes of technocratic decision-making which transcend it, and "wild" protests which, at the other extreme, overrun it as well.

In all the arts and cultural activities of our age, we can see this bidirectional split on the cold / hot model: rational / wild, technocratic / romantic, etc. Below, I will refer to some significant aspects of this split in the Theater, Cinema, Architecture, Plastic Arts, Fashion, Philosophy, and Contemporary Marxism.

The *Theater* of "distancing" and the "absurd," which tried to denounce a social situation within the coordinates laid down by the bourgeois performance, was overrun:

> 1. by expressive or kinesic experimentation which makes of it a genuine laboratory, and by documentary works such as P. Brook's *The Deputy*, Kipphard's *Oppenheimer File*, or P. Weiss's *Investigation* and *The Vietnam Discourse*; and
> 2. by the works of the new theater which no longer move comfortably within those coordinates of the spectacle and are trying to introduce elements from popular and pagan festivals: magic, propitiation, participation, adoration, copulation, etc.

The cultural and humanistic character of the theatrical performance is thus threatened by a *cold* tendency which wants to make of it a documentary or experimental laboratory, and by a *hot* one, much more elaborate and exuberant, which aims at recovering melodrama or at transforming it into a clearly provocative spectacle of gestures, emotions, and situations. The one extreme tends to close it off perfectly and the other to open it up totally.

In the *Cinema*, the neorealism and "nouvelle vague" of the early sixties were followed by two equally polarized tendencies:

> 1. At one extreme, filmmaking tended toward the diverse forms of *cinéma-verité* or documentary: the early works of Rouch and Morin; the pointed reporting of Rossi in *Hands Over the City*; the international episodes of Costa-Gavras and Semprún (*State of Siege*, *Z*, etc.); the hyperrealism of Godard in *Masculine Feminine* or in *Two or Three Things I Know About Her*, where (as with the 768-page narration of sixteen hours in the life of Mr. Bloom in *Ulysses*) the minute account-

ing of the things that happen to a person in an hour (going to class, trying to remember where he left his key, preparing the strategy of his new affair, etc.), finally manage to create an "unreal" atmosphere; the deliberately non-"filmlike" planes, colors, and editing of Andy Warhol's *Heat*, which manage to convey a good deal of the anguish and enervation produced by actually dealing with a reality that has no "framework" or "continuity"; the Canadian experimental cinema that makes the very technique of its manufacture into a theme; the collective films of Marin Kamitz, which try to be an actualization—and not an a posteriori description—of the very collective process out of which the action arises; the counter-information films starred in by Gian Maria Volonte (*The Mattei Affair, Investigation of a Citizen Above Suspicion, Confession of a Police Chief to the Public Prosecutor*), where the aim is to relate the bare fact itself before any stylization at all—even before this very special stylization that transforms a "fact" into "news."

2. At the other extreme, there evolved a much more unrealistic, exuberant, complex, and Baroque cinema, such as *Yellow Submarine;* Bertolucci's *Partner;* or Russell's *The Devils*, which scandalized people not for moral reasons but rather because of its attack on "good taste" and its failure to respect the "genres" (*The Devils*, in fact, as so many works of Shakespeare or Lope de Vega, was at once tragedy, melodrama, vaudeville, etc.).

The *Novel*, which from Balzac on consisted of a well-thought-out mixture of chronicle and creation, narration and experimentation, has led, after the pathfinding works of Joyce, Proust, and Kafka, to:

1. A "cold" or analytical reaction which, in the tradition of the *nouveau roman*, describes objective or subjective landscapes millimeter by millimeter, and a "structural" writing ("metafiction"), which deals with the writing itself and with the conditions that make it possible, in a discourse which no longer tries to be the "description of an aspect of nature as seen by one temperament" but rather acknowledges that the subject of the observation, as well as the language used, are part of the game.

2. A "hot," much more artificial, romantic, and sensual writing, which uses the most private imagery, and even uses as raw material the clichés of popular culture, or, as in *Pantaleón and the Visitors*, the language of military reports and dispatches, radio announcements, and the Sunday supplements of provincial newspapers.

The moderate classical discourse of the novel—equidistant between description and experimentation, chronicle and creation—is thus overrun both by (1) *a play of signifiers* colder than itself, and by (2) *an overflowing of the signifieds* that conventionally were considered pertinent. And if we still do not see that both splits are but the two sides of the same coin, we have two representatives of the "hot" direction (Lezama Lima and Vargas Llosa) whose works are also a contribution to the "cold" split (i.e., the experimentation with the structure of the language and making problematical the very activity of writing). Someone has said that Joyce was "modern" not in looking for *a* new style, but rather in using and abusing a different style in each of the eighteen chapters of *Ulysses*. And on a more general level such as the present one, where the problem of Context$_2$ arises (see above, p. 21), no longer are *styles* accumulated but *discourses* (Vargas Llosa) or *techniques* (William Burroughs taping the narration and rearranging it by "cutting and splicing.") Finally, perhaps the renewal of literature must be sought in such marginal discourses as "prison literature" (Miguel García, George Jackson)—in the discourses, at once very cold and very hot, of those for whom writing is an urgent need of expression and survival.

The two directions of the split in *Architecture* are analyzed in chapter 4. For now, it will suffice to observe that the supposed *Rationalist* synthesis between function and form also has its limitations. In reality, its proposals were not *rational* enough, nor was its projection of needs to be fulfilled sufficiently *functional*.

1. The modern *cold* tendency, from Ulm to Rittel and the early Alexander, stressed the fact that a rational solution would demand a systematization and sophistication in both the analysis of function and the synthesis of form, which the merely "ideological" rationalism of the Bauhaus lacked.

2. And the other trend—from Italian neohistoricism and the new evaluation of the ambiguous and complex—stressed in its turn that functionalist proposals were not functional enough, that their conception of human needs was a rationalist's caricature and a simplification of the real human needs which go beyond problems of clarity, accessibility, order, and simplicity.

In architecture as well as in literature or painting, the avant-garde ambition to find an "original" language—a specifically literary or ar-

chitectural language which would break with the old codes—has been increasingly given up. In literature we saw Joyce and Vargas Llosa using established languages, stylemes, or discourses. Modern architecture also seems to assume that, after the catharsis of the rationalist movement, architecture has no modern language all its own, and that that naturally leads to speaking a metalanguage which will now use established repertories. Portoghesi takes his inspiration from the Baroque, Smithson from the common style of nineteenth-century mass housing, and Bofill, now, from the Gothic. Bohigas sought inspiration in our modern-style tradition and is now trying to discover the possibilities of neoclassicism; Venturi is trying to rework the language of shopping centers in architecture; Morris Smith works with *ad hoc* elements; and A. Rossi or the Five Architects work in the rationalist "style." In each case, the concern for modernity and the elaboration of a new language seems to dissappear from the horizon of contemporary architecture.

In the *Plastic Arts*, the Informalism and Abstract Expressionism of the fifties were followed by new realist attitudes which attempted to carry to its conclusion the avant-garde dictum that "a work of art ought to be a thing added to the world of things rather than a reflection of things which already exist."[5] And, as in the preceding instances, this realist attitude took two extreme directions which overran the synthesis of the classical avant-garde:

1. On the one hand, the "hot" direction of an art like *Pop, Funk,* etc., much more visceral and common than the abstract tradition, whose reaction had been precisely against the vulgarity of the business and advertising environment. *Body Art, Land Art, Environmental Art,* or *Conceptual Art* try to dissolve the autonomy of the art object, whether in the *use* which is made of it (post cards), or in the *idea* or action which it stems from (a cast of the artist's wrist). Conceptualism does not aim to absorb the spectator into the work, but to refer him to the concept or process which lies behind it. With their balloons and bubbles, Hacker and Ponsati wanted to make visible the "environment" which moved them, and Hans Haacke tried to make visible the very act of attending his exhibition at the John Weber Gallery in New York: a show consisting only of a questionaire and survey of its own visitors (see figure). The replies about where those attending lived, what their income was, or what they thought of Nixon were posted on a bulletin board. Thus, those attending were

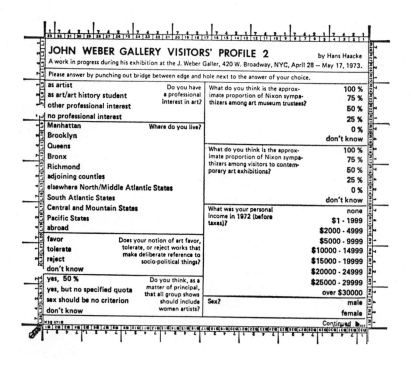

effectively the message and the whole show was an immense tautology in which the gallery goers "saw themselves"—attested to and reinforced their own peculiarities.

Nauman asks the visitors to his "rooms" to place themselves in the spot where the two axes of the room coincide with the axes of their own bodies, or to imagine the only thing which is not perceivable in his "Metallic cube with the word 'dark' written beneath." Baldessari wants to capture the movements of a palm tree in the wind on graph paper, or organize an endless process of selecting pieces of candy. The environments of Navarro try to elicit and make conscious the levels of experience which correspond to the different degrees of structural complexity in the same phenomenon, and his *necklaces*, sensitive to light and to the location of other people, try to create in their wearers an awareness of interpersonal distances and movements—to repopulate space with guideposts or bench marks that will permit the detection of always elusive experiences. In all these instances, we see that behavior and time, movement and situation, are to be directly stylized, instead of represented or symbolized.

2. But this very conceptual, body, or environmental art which ends up in the process which gave birth to it, in the reaction it provokes, or in the difference which it introduces into an environment, this realism which is no longer formal but corporal, kinetic, and vital, has a *"cold"* dimension or aspect which brings it face to face with the classical avant-garde, not on account of its denial of sublimation, but rather precisely because of its excessive sublimation. Here we find:

—Certain forms of *Minimalism* and *Hyperrealism,* "impersonal description of depersonalized industrial objects," as H. Ferber describes it.

—The new alliance of art with technological devices (motors, video, sensors, photoelectric cells, selsyns, servomechanisms, circuits, tape recorders, etc.) which leads artists such as J. Seawright to claim that the aim of art today is none other than that of understanding technological processes themselves.

—Yturralde's "serial structures" (see figure), which work out the

possibilities of a bidimensional plastic language with the help of information theory and the psychology of perception.

—The *involvement* of art in the objects or spaces of everyday use, with a view to inducing certain behaviors or upsetting certain habits, given the subliminal effect upon us of the objects we handle, the spaces we move about in, and the images that bombard us—what Walter Benjamin labelled the sphere of "distracted reading."

A few years ago painters began to realize that the worlds of photography, the academic tradition, and advertising iconography were not something in opposition to which they had to define themselves, but rather that they were potential points of departure for new realisms, new distortions or recoveries, new Dadaisms. And today artists recognize the need to get rid of the last echoes of professional defensiveness, and to see technology and design not as opposing forces, but rather as media relatively open to whatever use may be made of them. Technology can be used as a means of extending personal attitudes into the behavior of certain devices whose informational content is directly transformed into an event; patterning and design—counterdesign, if you will, just as people speak of counterculture or counterpsychiatry—can be used to introduce the products of these laboratory experiments into the sphere of everyday life.

Thus, from *pop* to *happenings,* or from *conceptual art* to *design,* is drawn the spectre of the cold / hot, rational / imaginative reactions that overrun the cultivated intuition, good taste, and the wise manual activity of the classical avant-garde.

Even *Style* in clothing, until recently in the hands of stylists, *couturiers,* and fashion commentators who kept the game within certain well-defined limits (raise the waist-line, shorten the skirt, stylize the lapel) and who had a purely visual sense of the female form, have been overrun, practically and theoretically:

1. practically, by a clothing style which is much freer, picturesque, and artificial, which comes closer to the family of the costume and the tattoo than to that of classical "smart-looking" clothes.

2. theoretically, by an analysis and description of fashion which, ever since Roland Barthes' *The System of Fashion,* has ceased to be a game of suggestive terms and has become a systematic analysis of the paradigmatic and syntagmatic relations existing among articles of

clothing (Rubert de Ventós) or the terms which describe them (Barthes).[6]

Also, the traditional journalistic styles of Alsop or Lippman seem to have undergone a split, pulled in two opposite directions:

1. On the one hand, by a more objective, analytic journalism look-ing for the facts behind the events—behind Watergate, or behind the Rosenberg or Sacco and Vanzetti trials.

2. On the other hand, by a more "invented" and personal, nearly confessional, account of the event (Tom Wolfe, Terry Southern, Rex Reed, Barbara L. Goldsmith, Umbral, Vázquez-Montalbán, etc.) for which it was possible and proper "to write accurate nonfiction with techniques usually associated with novels and short stories . . . from the traditional dialogisms of the essay to stream-of-consciousness . . . to excite the reader both intellectually and emotionally . . . [to feign] the tones of an Ingle Hollow moonshiner, in order to create the illusion of seeing the action through the eyes of someone who was ac-tually on the scene and involved in it, rather than a beige narrator."[7]

But this phenomenon of polarization of the extremes is not unique to artistic or generically formal activities.

In *European Philosophy*, for example, the existentialist-phenomenological tradition which, ever since Husserl and Merleau-Ponty, tried to lay the groundwork for an objective analysis, a theory of knowledge, and a program for action, has also been overrun at its two extremes:

1. By a much colder or impersonal "structural" philosophy which in order to understand man dispenses with all subjective consider-ations and reduces itself to the consideration of the objective condi-tions—ethnological, economic, ecological—from which man has sprung, and, on the other hand,

2. By a hotter philosophy of individuality—no longer of the Person—in its most radically irrational aspect, which continues (in the spirit of Nietzsche) to express everything the Objective Culture of the city had repressed.

In the specific area of *Marxist Philosophy* the split was even more dramatic, if such is possible. The commentators and popularizers of

Marxism in the sixties—from Garaudy to Schaff, the early Lefebvre to the ever-present Fromm—devoted themselves to a humanist exegesis of Marx. After their adaptations and interpretations, Marxist thought appeared as the most balanced and reasonable mixture of pragmatism, positivism, and humanism: an ideological product perfect for the progressive bourgeoisie which, quite accurately, associated it with the thinking of Teilhard du Chardin. But at the point of greatest influence of "Teilhardian Marxism," two sets of works appeared that destroyed this idyll:

> 1. The *cold* Marxism of Althusser, rejecting the still "humanistic" Marx of the period before *The German Ideology*, and proposing a detailed reading of *Das Kapital*. For Althusser, one had to find the sociology, theory of ideologies, etc., that still had to be worked out from the perspective of this second Marx. The laborious and erudite nature of the project did not fail to provoke a reaction among the old guard which, in the words of Garaudy, warned of the danger that this new "scientific Marxism" might no longer serve to guide the souls of partisans.
>
> 2. But plausible, humanistic Marxism also broke down at the other extreme: with the early Sartrian critique of the communist dogma about the scientific and necessary nature of Revolution; and with the advent of a Marxism which, appealing to a more literal reading of Freud himself as against his "humanistic" interpretation,[8] and recovering the works of Reich and Benjamin, demanded an immediate and universal liberation—sensual, political, familial, etc.—without accepting the Marxian promises of a "later" liberation of superstructures. The disappointing example of a bureaucratic and imperialist Russia seemed to call for this change in orientation: hence, the "Cultural Revolution" in China, salvation and revolution *now*, the growth of communes and alternate educational institutions, the attempt to *begin* by an esthetic-erotic revolution.[9]

No doubt many of these examples have been ephemeral, and we ought not confuse the evolution of modern culture with an incident in the history of fashion. It is also clear that cold / hot is a conventional distinction, and in many cases the characterization of a work or trend in one or the other of these pigeonholes is more than debatable, since they are only two aspects of a single phenomenon, two sides of the same coin. Nevertheless, in the main, the examples given

above are enough, I think, to show the double and polar nature of the split occurring in recent years: *enlightened* reaction and *romantic* reaction; *technocratic* utopia as against a *"let it be"* utopia; cinéma-verité versus sensual and Mannerist cinema; scientific design versus complex and historicist design; conceptual or engagé art versus pop art or body art; structural philosophy versus irrationalist philosophy; Althusserian Marxism versus Marcusian Marxism, etc.

Reason and imagination, which the cosmopolitan bourgeoisie of the nineteenth and twentieth centuries were able to keep together in their "culture" have developed such a polarization that the old synthesis now seems impossible. We have also seen that this polarization of "styles" (or, in my terms, "modes of formalization"), also meant a displacement of the objects of art away from its traditional precincts and toward the environment, one's own body, the creative idea, the function or destiny of the object, etc.[10] But this is the subject of the change we will explore next.

3. THE CHANGE IN SUBJECT: ITS TWO DIRECTIONS

In modern art, writes Lévi-Strauss, the academicism of language has replaced the traditional academicism of themes.[11] But this academicism of language also had a clear influence on defining the places or objects where such a language could be spoken. As Proust showed, and Deleuze emphasized, all languages "are specific and make up the material of this or that world." In fact, the diversity of (domestic, courtly, snobbish, sentimental, and other) "worlds" arises out of the fact that, in each one of these worlds, "the signs are not of the same type, do not have the same shape, do not permit us to decipher them in the same way, and are not identical to their meanings."[12]

The double split on a "stylistic" level which we have seen in the above chapter implies also a break at the "thematic" level. The environment and even the body become "places" for art; the concept and the fate—not just the material existence—of the work become of aesthetic relevance. The change in *"how"* one formalizes thus keeps forcing a change in our understanding of the *objects* or *places* fit for doing it: a change in "what" one formalizes. New forms or styles may

for a time continue to arise in old formats (naturalistic scenes, for example, in tryptychs or retables, as in the early Renaissance), but in the long run the new style gives off a new format: new messages end up creating new media.

Today, imagination and formal elaboration are applied less and less to objects specifically designed for that purpose (today, dress and cars, decoration and social rituals, political and social protest, stand as objects fit for stylization), and the result is less and less a specific *message*. The norms which confined the exercise of the artistic imagination to certain vehicles—sculpture, symphony, the stage, or painting—are becoming increasingly fluid and flexible; the borders which delimited these spheres have become ambiguous and poorly defined. Every day the overly clear traditional distinctions between art and use, art and life, actor and spectator, medium and message, become less precise: how do we assign a place to the theater of Mexican farm workers in California, environmental art, the happening, or the rock festival? And if classical avant-garde art is today an "anxious" object, no doubt it is due to the fact that, as Rosenberg acknowledges, " 'art' survives today at the intersection of the mass media, craftsmanship, and the applied sciences."

This situation is not necessarily better or worse than others—it is different. We might even think that this intimate demand to "formalize" our life and relationships creatively is responsible for the anxiety and anguish of modern society—an anxiety which did not exist in more "formal" societies where the role, attitudes, gestures, and expressions of each individual in each situation were clearly preassigned.

From another point of view, one can still deplore this loss of "distance" between art and life. It was precisely thanks to its distance and nobility that art was able to play the role of model and counterpart to the extant ways of life. Faced with the products of a nonrepressed imagination, we can also feel the nostalgia for those products of pure repression which were also pure message. Tired of good designs and discotheques, of "participatory" festivals and informal fashions, we often feel the need for a small dose of repressed culture in the classical mold: paintings instead of "environments," concerts instead of pop music festivals, good "supper clubs" instead of psychedelic settings.

In the next section I am not going to do any futurology but just the reverse: look back to see how this split in the traditional modes (hows) and channels (whats) of formalization took place—a slow process in the erosion of puritan morality, which invented first the neoclassical disguise and later on, with more sophistication, the romantic one, and then in our own century took on the aspect of functionalism, formalism, and even—who would have guessed!—of symbolism or irrationalism.

THREE

PURITANISM IN MODERN CULTURE

1. GENERAL THEORY OF FORMAL PURITANISM: BEAUTY AS SEQUESTRATION

I WANT TO LOOK for the puritan origin of a good many of the strategies used by artistic creation and criticism—from Neoclassicism and Romanticism to Formalism and Structuralism—and then explain the present bankruptcy of these strategies.

No one will dare to deny that a goodly dose of puritan repression goes into the formation of the prevalent concept of "good taste," "elegance," or "distinction." Philip Slater writes:

"Good taste" means tasteless in the literal sense. Any act or product which contains too much stimulus value is considered to be "in bad taste" by the old culture. Since gratification is a scarce commodity, arousal is dangerous. Clothes must be drab and inconspicuous, colors of low intensity. . . . The preferred colors for old-culture homes are dull and listless. . . . Stimulation in any form leaves old-culture Americans with a "bad taste" in their mouths. This taste is the taste of desire—a reminder that life in the here-and-now contains many pleasures to distract them from the carrot dangling beyond their reach. Too much stimulation makes the carrot hard to see. Good taste is a taste for carrots.[1]

The bourgeois universe, first bent on *exclusion* and then on *sequestration* (Foucault) of everything that was anomalous, intense, or overly emotional found in its definition of Beauty and Art an ideal place to kidnap—mark out, *lock up*—these phenomena.

Beauty

Ever since Locke, there has been a tendency to consider as objective or *primary* the most serious and austere qualities of the body—its

dimensions, movement, etc.—and to consider as *secondary* those qualities that are the result of our perception, the more sensual or "attractive" qualities—color, taste, smell, etc. The quality called *beauty* was the residual term under which this society locked up the whole mass of emotional or sensual qualities which earlier had been understood to be inherent in things. But even this residual objectivity granted to those emotions locked up under the rubric of "beauty" was soon considered to be an "illusory" creation of the subject: beauty was not objective, but rather an objectification, a projection, etc. It was "the sensation separated from the object that produced it, and itself transformed into object" (Pradines); "pleasure seen as a quality of things" (Santayana); "the desirable when it ceases being desired, in order to be contemplated from a certain distance" (Baudouin).

These theories managed to decontaminate the world of demoniacal and sensual elements, locking up the qualities that were not merely mechanical under the rubric of "beauty." Once collected together, they were viewed as no more than a projection or objectification of emotions. In doing this, bourgeois puritanism had a double and complementary aim: to disinfect the world of spirits, and to give an "objective" character to subjective sensations or emotions. In regard to the first point, Santayana had already pointed out how intolerable a world populated by "esthetic" qualities was for this sensibility.

One may well believe that a primitive and inexperienced consciousness would rather people the world with ghosts of its own terrors and passions than with projections of those luminous and mathematical concepts which as yet it could hardly have formed. . . . But in all the intermediate realm of vulgar day, where mechanical science has made progress, the inclusion of emotional or passionate elements in the concept of reality would be now an extravagance.[2]

Art

If the "definition" of Beauty could eliminate the "exaggerations and extravagances" of mythic *conceptions* of reality, the practice of bourgeois art in turn eliminated the exaggeration and extravagance of the emotional *reactions* to reality. Art transformed into virtual objects of "contemplation" the very objects it described. That's why Lenin refused to listen to the *Appassionata* of Beethoven; he was convinced that art could dissipate revolutionary fervor and soften people's indig-

nation. "From a revolutionary point of view," observes Harrington, "a specialist in Agitprop who incites the emotions without satisfying them, leaving his audience hungry and excited, could turn out to be considerably more effective."

As Marcuse has shown, the puritan virtue of form consisted in its power to "temper" the reaction to that very thing it pointed to.

The artist accuses, but accusations anesthetize terror. Thus, all the brutality, stupidity, and horror of war are in the work of Goya, but as paintings they are absorbed by the dynamics of esthetic transfiguration: they can be admired alongside the glorious portraits of the king who presided over this terror. Form contradicts and triumphs over Content—at the cost of anesthetizing it. The immediate response, not psychologically or physiologically sublimated (vomiting, weeping, fury, etc.) is transformed into an esthetic experience. . . . Only in this purification of everyday experience and experience's objects, only in this transfiguration of reality, do the object and the esthetic universe emerge as pleasant, beautiful, and sublime. In other, somewhat more brutal, words: the prior condition of Art is a radical look at reality and a renunciation of this look—a repression of its immediacy, and of the immediate response to it. It is the *oeuvre* itself which *is*, and carries out, this repression; and as esthetic repression it is "satisfactory," agreeable. In this sense, Art is in itself a happy ending: desperation becomes sublime and pain beautiful.[3]

2. FROM THE PROSE OF EFFORT TO THE POETICS OF THE GIFT: THE ESTHETIC OF THE EDELWEISS

In a sufficiently developed and diversified society in which formal practices are no longer mixed with magic or with craftsmanship, art occupies a fixed position and fulfills a precise, although ambiguous, function. As we have already seen, it may be—at the same time, although on different levels—a *reflection* of a situation, a *denunciation* of it, and even a *reconciliation* of what it reflects and denounces.

But in psychoanalysis we are told that the repression and authority of the father endure, internalized as the superego, after the individual is "free." In an analogous way, once the external control of the Church or the Court disappeared, the "free" art of the bourgeois period developed an "internal" need for *serving*, for being *useful*. This internalized need of artists legitimizing themselves with something that transcends the mere play of forms is what I am here calling puritanism.

Max Weber was the first to describe bourgeois puritanism. Under

puritanism, work ceased being a punishment, a means, or a need, and changed into the very God-given objective of life (*Selbstzweck des Lebens*). Everything easy, given, free, or gratuitous was now eyed suspiciously by the prophets of the religion of work—Kant, Erasmus, Carlyle. Only that which costs was seen as Good or Beautiful: *per aspera ad astra*. The medieval *intellectus*, which was a vision or contemplation of reality, was now displaced by reason and observation, which "process" facts and "arrive at" reality.[4] Truth was only achieved by the extreme of intellectual *labor*; it was not something we could glide up to, but a summit which we must scale. And Beauty was also something to be conquered. Like the flower of the edelweiss, beauty blooms only on the steepest slopes, to reward our skill and stick-to-it-iveness. This was the bourgeois esthetic—*the esthetic of the edelweiss*.

This does not only mean the triumph of rationality, as Sombart thought,[5] but the emergence of a new myth, of a frankly irrational cult of work, effort, profit, which Calvinism sanctions as "sign" of predestination. Thus arises the classical "type" or model of the capitalist entrepreneur: bold, sober, thrifty, honest, jealous guardian of his reputation (whose measure is credit), rejecting all the luxuries and pleasures, and content with the sense of having been faithful to his secular and economic vocation. An entire conception of the world and of man which is perfectly synthesized in Benjamin Franklin's "advice" and "hints:"

—time is money
—credit is money
—money can beget money
—prompt payment increases access to credit ("The good paymaster is lord of another man's purse")
—the appearance of honesty increases credit
—credit should be applied to productive investment
—you should be vigilant and frugal in what you consume, etc.[6]

The objective economic yield of this poetics of effort has not been negligible in the least. In fact, it was the basis on which the new capitalism established itself, subverting those axioms in the long run and generating the more glamorous ones of the affluent society. The synthesis of the principles of "acquisition" and of "restriction in consumption" could not but result in the great accumulation and re-

serves of fixed capital which have occurred in Europe since the mid-nineteenth century. This accumulation was the product of work which did not wish (in the case of the entrepreneur) or was not free (in the case of workers or the colonies) to consume for immediate gratification all the fruits of its labors. As Keynes vividly pointed out in 1918, repression and the puritan *ethos*, respectively, prevented the proletariat and the middle class from consuming the cake they were making.[7]

And, as we shall see in the next section, this very poetics of effort and productivity, with its chronic horror of the gratuitous, superfluous, or unproductive, has characterized the practice of art and the products of art since the triumph of the bourgeois revolution. This poetics and artistic practice have lost ground together with the old capitalist system which they were a response to.

In fact, following Keynes's diagnosis and therapy, capitalist economics itself became less "puritan." Keynes warned that, with the change in objective conditions, the puritan ethics and poetics of the old capitalism had also ceased to be functional. Since then, the poetics of effort and savings have been changing towards a new poetics of expenditure and waste, dynamism and consumption.

Compared to the seriousness and honesty characteristic of early capitalism, today's economic practice takes apparently more frivolous and playful forms: everything seems to be waste, extravagance, endowment, gift. From long-term investment in intangible products such as the "image" of the company, to sales treated as "discount," "clearance," or mere pretext for gifts, options, or points; from apparently unproductive expenditures on packaging or styling, the purchase of know-how and the expenditure for procuring information about consumers' preferences, to the "paradox" that the more expensive a product the cheaper[8]—everything seems to point to a return to the primitive economy Mauss had described as an interchange of gifts; everything seems to confirm the picturesque image which Bataille drew of the economy of the postwar period to support his thesis that life—and now the economy as well—was governed by the law of unproductive expenditure, excess, and waste.[9]

Nothing is more normal, in this period of partial recovery of abundance and apparent rebirth of the gift, than art abandoning its puritan reflexes and finding again a taste for the complicated, rich, and ex-

uberant—a taste forbidden in the bourgeois period. Thus, it is again the poetics of quality and gratuitousness—as before it was a poetics of quantity and effort—which touches all cultural products.

And it touches everyone because the boundary line between works which reinforce or legitimate the system and works which denounce it or propose an alternate model is much less clear and definite than it seems to be. Often this distinction only comes from our "interpretation" of the works, which eliminates its constitutive ambiguity and lends them a definite and decided goal, a clear will, a specific place in the evolution of forms or of ideas. The *Annunciation* by Fra Angelico: is it a medieval work (because of its theme, because of the symbolic elements used in it) or is it a modern work (because of the "daring" of painting the sky its own color instead of accepting the conventional gold color)? Michelangelo's *Capitoline Square:* is it in the service of the Counter Reformation, or is it a subtle nostalgic hymn to the bourgeois freedoms of the city-state? And if it's the second one, is this a reactionary or progressive "message"? Was pop art the exaltation or the denunciation of the rhetoric of consumption? A chronicle of commercial iconography or a criticism of it? It is evident that works of art seldom are one *or* the other, and that their effectiveness certainly does not depend upon an unequivocal message. But I will pursue this further below.

3. THE STRUCTURE OF PURITAN DISCOURSE

Esthetic play with forms and appearances produces pleasant sensations, independent of any other value or meaning that can be assigned to it; its experiential value is prior to other values or meanings which it may carry, though it may not be independent of them. And this value is not "objective," nor merely "subjective," but rather *instrumental, stimulating, relative to the sensations which it incites, to the practices it provokes.*

But the history of the definitions of art or of beauty places less stress on this stimulating character than on the deep content or the supreme usefulness of art. In the ontological tradition, art is the "viaticum of truth" (*Symposium*), "perceivable Manifestation of the Idea" (*Phaedrus* and Hegel's *Aesthetics*), "reflection of the ideas of harmony, proportion, and symmetry" (*Philebus*), etc.[10]

In the tradition of the modern bourgeoisie, the emphasis changed dramatically, and Art was understood as a pure creation of the Subject—"subject of esthetic judgments" for the rationalists, "subject of sensations" for the empiricists. But once the limitless confidence of the revolutionary bourgeoisie in the Individual as the foundation of all values was lost, romanticism looked to restore the Ideal Objectivity of classicism.[11]

Whether it was the expression of a Subject or of an ideal Object, the play of appearances had to be legitimated from outside of the forms themselves and the impression which they produced. What I call *puritanism of content* tried to legitimize the play of beautiful appearances by: the transcendent *Object* which it denoted, the *Effort* implied in its realization, the *Genius* which manifested itself in it, the practical *Utility* it assumed, the *Tradition* it embodied, etc. And alongside this *puritanism of content* which "justifies" the form on account of its historic origins or by its semantic effectiveness, we will still discover a *puritanism of form* which similarly avoids the consideration of the relative and ludic nature of form by refusing to go beyond a strict formal or syntactic description of it.

I am interested here in showing how the different expressions of this puritan sensibility form a coherent system, how the diverse cultural manifestations and styles of the bourgeois tradition all pay tribute to their common puritan origin.

What characterizes all puritanisms of content is their rejection of art as an agreeable play of signifiers. The work must not be a frivolous symphony of signifiers but an efficient messenger (*viaticus*) of meaning; it must not serve amusement or pleasure but rather knowledge and instruction. I am thus calling puritan all styles that manifest an intimate obligation to justify forms from *outside* of themselves. But I still must make clear which "outside" I am referring to.

Courtly and church art *used forms* to give emphasis to their festivals or ceremonies, and *played with the senses* to create suitable illusions, sensations, or atmospheres. Bourgeois art rejects both expedients. The forms of art are not to be used, but appreciated, contemplated, savored. Nor should the senses be toyed with: seeing or hearing are the means by which we can arrive at authentic knowledge of reality through the strict treatment of the facts they offer us (induction, etc.). Henceforward, the value of art was to be sought *beyond*

(Romanticism, Naturalism, etc.) or *before* (Formalism) its daily use, or even *within* this very use or operative value, now understood in a pragmatic and restrictive way (Functionalism). Beyond, before, or within, never in its simple relation with life and practices: as a manifestation of the exuberance of the everyday relation with the tools of work (what I call a *cold conception*) or with the extraordinary experiences of the festival, eroticism, death, or pleasure (*hot conception*). Since the Baroque—the last style which to some extent is still the unprudish expression of a dominant class—art ceases to appear as an occasion, a party game, enrichment or "formalization" of the experiences which are really lived. After a certain Flemish or Florentine juncture, the new bourgeois *ethos* was unable any longer to accept art as an instrument and exaltation of *civil society*, of its new usages, objects, rituals, ways of life. On the contrary, art—and hence its puritanism—was in service of the sublimation, camouflage, or subterfuge of its most elemental appetites and aspirations. The greatest revolutionary class in history also brought with it the *mauvaise conscience* that soon prevented it from putting up with its own reflection and exaltation in art. That is why, as Charles Lalo said, the bourgeois Revolution at first developed "among poetic and musical pastorales," and that later on "the basically peaceful France of the Restoration of Louis Phillipe would throw all its fervor into the Romantic whirlwind."

Probably it is not inaccurate to consider that this bad conscience, and the subterfuges used by it, have been, at one and the same time, a symptom of and a stimulus for the magnificent flexibility and capacity for adaptation of said class. The versatility shown in the search for subterfuges which would keep art from reflecting and plainly exalting the bourgeois world from which they arose is certainly impressive. Art could not be simply a reflection of their banal, humdrum life, but neither could it be a play of forms more proper to leisure classes or castes than to the new, hard-working, urban, and progressive class. It ought, on the other hand, to be "useful"; to legitimize itself by the objective contents it carried, the skills it developed, the "worlds" it helped people to discover. From this stems the series of puritan strategies which we will presently see: from Neoclassicism to Formalism and Structuralism, passing through Romanticism and Socialist Realism.

But before going over these historical fluctuations in formal puri-
tanism, let us look momentarily at a character who embodies and
symbolizes the unstable and precarious nature of this repression as
well as the modern impossibility of avoiding it. One can be either
submissive or rebellious to repression, orthodox like Carlyle and
David, or heterodox like Nietzsche or Rimbaud—but in either case
one defines oneself in relation to this repression which still manifests
its power (perhaps above all) in the outbursts of the Norman Mailers
or Norman Browns of the moment.

The character I am referring to is Professor Aschenbach in Thomas
Mann's *Death in Venice*, who reveals all the contradictions of the es-
tablished intellectual writer in bourgeois society. On the one hand,
Aschenbach aspired "to deny knowledge, to reject it, to pass it with
raised head. . . . His style in later life fought shy of any abruptness
and boldness, any subtle and unexpected contrasts; he inclined to-
wards the fixed and standardized, the conventionally elegant, the
conservative, the formal, the formalized, nearly. . . . The educa-
tional authorities included selected pages by him in their prescribed
school readers." [12] On the other hand, nonetheless, Aschenbach's life
culminates in delirium, in the love of an adolescent's bodily charms,
in death in the abyss so long repressed. By breaking with the prudent
and hardworking nature of bourgeois classicism, he releases almost
endless surrealisms, symbolisms, or irrationalisms that had been
heretofore repressed. Similarly, we have seen surrealisms, symbol-
isms, and irrationalisms breaking with the measured effects and se-
lected themes of bourgeois classicism.

But do they really break with it? The split in Aschenbach himself is
in some sense symbolic of the extent and limits of all deviations from
the puritan norm. Until his trip to Venice, Aschenbach is the proto-
type of the bourgeois creator for whom art is, above all, discipline,
composition, effort, authenticity, well-made work. In Venice,
Aschenbach suddenly discovers the "other" beauty—the gratuitous,
sensual, given, sinful beauty—and he dies tragically pursuing it,
making up his face, sacrificing all the balance and dignity of his soul,
his life, his work.

The Greek or Elizabethan could perhaps at certain moments be
pagan, but after the advent of the poetics of authenticity, effort, and
dignity, and of the modern "guilty conscience," simple praise of im-

mediate, given, sensual beauty becomes a drama in which repression triumphs and reigns even though transgressed against. Once having passed through puritanism, the recovery of immediacy becomes grandiloquent and melodramatic, when not too "professional": a "wild" grandiloquence which is the tribute that even those who devote their lives to avoiding it—from Nietzsche to Mailer, all things considered—pay finally to this puritanism; or an excessive "professionalism" like Cortazar's when he tells us about his marginal experiences, about his familiarity with the unusual, of his marginality or out-of-placeness—themselves so cultivated! [13] Thus, one can affirm or deny modern repression and sublimation but not behave as if it didn't exist. In bourgeois art there is hardly any *affirmation* which does not imply a rejection: no *naturalness* but rather *naturalism*; there is no *freedom* but rather *rebellion* or *heterodoxy*—a heterodoxy which is seldom more than:

$$\frac{1}{\text{orthodoxy}}.$$

There has been no hymn to the given or the natural ever since the natural became marked by the sign of either the *Sublime,* or the *Accursed.* Thus we witness the complete bankruptcy of the *idealism* which linked the conceptual and spiritual with the seen, touched, or felt. [14] Henceforth, the world of immediate experience can no longer be the object of plain description or happy exaltation, but only of the nauseated Sartrean experience or of Burroughs' twitching claim for it.

Let us now look at some of the strategies of this ubiquitous and inescapable puritanism which, in one way or another, marks all works of art in the modern age.

4. PURITANISM'S TRICKERY: FROM CONTENT TO FORM

Puritanism of Content

Neoclassicism is surely the first and most coherent bourgeois reaction against art as ostentation, luxury, adornment, or ritual that was typical of the courtly or ecclesiastical classes. "The Mass," as Schöffer points out, "is the first and best audio-visual spectacle of the

West,"[15] in whose structure are synthesized the basic elements of a total work: sound, light, space, dance, mime, symbolic interplay. But the new class distrusted this exuberance of formal and sensual symbols. Ethically as well as esthetically only the effort of the rational subject could create values. Art ought to be and appear to be a warrant of seriousness—not, "in any way, something light, divine, closely akin to dance, to petulance."[16]

The bourgeois Guillotine, in fact, took charge of cutting down every given, embodied value, and only absolutely subjective or absolutely universal values could be spared from this carnage: Duty, Intention, Effort, Good Will. On the esthetic level, the aristocratically *pleasing* and the ecclesiastically *pious*—the civic beauties—were equally put to the guillotine until only the *Ideal Beauty* that Winckelmann speaks of was left.

The so-called Neoclassical style thus tries to overcome "the irresponsibility, extravagance, and impertinence of the Baroque" (David) with a new emphasis on structure, restoration of the frontal plane, and the classical austerity of Rome. It opposes the strict beauty of classical order to Baroque pomposity; to the frivolous themes of the Rococo it opposes grave and important subject matter (Horatio's oath, etc.); it opposes clarity of draftsmanship and compositional order to soft pastels and sensual tints. Everything must be ordered according to Reason: Le Nôtre takes charge of the gardens, Vaugelas of language, Boileau of theatre, and the Academies created by Mazzarino take charge of art.

Forms, in any case, have to be justified by their historical or pragmatic "content." Not even classical ornament can be accepted without more ado—without finding its final human and functional truth. That is why the Jesuit Laugier—who will inspire Soufflot's design of the Pantheon—searches for the deep constructive need on which the Doric and the Ionic are based: the "primitive cave" from which these orders are derived by stylization (see figure).

The "reason" for forms is always outside of the forms themselves: in the truth they respond to, in the function they fulfill, in the rationality or universality they reflect. As Broch has said, bourgeois art had to be "a more serious, more elevated, more cosmic art than the art of its predecessors."[17]

Laugier's "Primitive Cave"

But, isn't *Romanticism* a break with this austere and grave style, its very antithesis? Aren't its forms and effects appreciated for themselves? Doesn't Schiller even go so far as to say that "man is civilized to the precise degree to which he is capable of valuing appearances above essences"?

On closer inspection, nevertheless, it becomes apparent that the Romantic "style" is only another subterfuge of puritanism. Certainly, the denial of all autonomy to the signifiers, the rejection of what is simply pleasant or ornamental, is no longer made in the name of Reason, History, and Social Utility; but it is maintained, still, in the name of Genius, the Spirit, the Cosmos or, in the last analysis, of the "stimulation of the productive imagination," in whose service the artist, like the tourist, "must renounce domestic pleasures when he visits strange places in search of instruction and enjoyment."[18] Following a process of progressive sublimation, Neoclassical efficiency and order end up being turned into Romantic genius and sublimity. The confidence of that early enlightened bourgeoisie in its own good sense, sobriety, responsibility, and historical legitimacy is displaced by the worries of the Romantic bourgeoisie, which has lost that individualist optimism and tries to dress up as or identify itself with a Cosmos, Reason, Nature, or Universal History. Art is no longer the practice or perception of a new order, but rather a manifestation of a profound reality, which appears in certain typical or characteristic aspects or guises: folklore, exotic landscapes, convents, cemeteries.

In any case (whether in its subjective version, Novalis' *schöpferische Krafft*; its social version, Schlegel's *Volkgeist*; or its objective version, Schelling's *poetische Geist der Natur*) it is clear that art takes on a gravity, grandeur, and cosmic dignity which is opposed, even more radically than Neoclassical rhetoric, to medieval chronicles and images, to the princely entertainments or the formal acrobatics of the Baroque.

The entire world view of a new puritan class lies between the volatile sounds of Vivaldi and the "grandeur" of Beethoven or the "sublimity" of Schumann. In perfect harmony with Romantic music, which doesn't "distract the ear" but "moves the soul," which is *grossartig*, the Romantic philosophers remind us that "the conjunctions, changes, oppositions, and modulations falling within the purely musical sphere of sounds . . . remain empty and meaningless . . .

[because] spiritual content and expression, is missing from it . . . and is not yet strictly to be called art. Only if music becomes a spiritually adequate expression in the sensuous medium of sounds and their varied counterpoint does music rise to being a genuine art." [19]

Without content, message, or meaning—without thought or passion "turned into sounds"—music would dissolve into the creator's pure *virtuosity* or into mere *sensuous enjoyment* on the part of the listener: a virtuosity or courtly enjoyment which the bourgeois *Studierstube* wants no part of.

In architecture and decoration, *Historicism* and *Organicism* are the poles between which puritanism oscillates in nineteenth-century formal discourse. The bourgeoisie, who "although it had despised feudal-courtly decorativeness so as to keep the faith in its own ascetic tradition, secretly liked it," [20] had to find another subterfuge to legitimize and give "content" to its needs for ornamentation. So, in its buildings it uses the structural possibilities of cathedrals and the picturesque and functional ones of the medieval city plans (Neogothic), or it seeks legitimization in natural and organic forms (Modern-style). Not only did these styles validate architecture retrospectively—toward nature or toward history—but prospectively as well: as accomplices of pragmatism, of the taste for authenticity, and the need for making materials and techniques adequate to construction. As Benevolo points out, by means of eclecticism, organicism or historicism they managed "to keep separate the technical problems and those of formal classification so that, leaving aside the latter under the pretext of historical styles, they could attack piecemeal the problems posed by the new circumstances and make the art of building progress in all spheres according to the analytical methods of modern science and culture." [21] The new public buildings (schools, hospitals, railway stations) could be *camouflaged* with rigid classical orders, but they could not express themselves through them. It was Neomedievalism which, eliminating symmetry and the strict axes of classicism, managed to produce the first modern, "functional" house, Webb's Red House (see figure)—the first building which takes its name from the very color of the brick used to build it.

The literature of this century is also permeated with the puritan and positivist ethos; with the *nous sommes tellement en progrès!* ethos

Webb's Red House

which Nietzsche ridiculed in some of his finest pages. For Taine, literature is useful and legitimate to the extent that it adds to knowledge. Botany helps us to understand the plant world—literature the social world. And if the "deep" meaning of things appeared to the Romantics in the soul's rapture, the new "scientific" meaning will show itself in any object to which we apply the cold eye of the scientist. Writers then have the option[22] of considering things and men "the way we consider mastodons and crocodiles: to display them, turn them into oddities, put them in jars of alcohol" (*les oreilles s'écartaient des têtes, on était tondu à neuf*: thus does Flaubert describe the townspeople who attend Madame Bovary's wedding.)

The scientific, redeeming, and pragmatic aspirations of this Naturalist preference for the aseptic description can be seen better in the work of Zola than anywhere else. Literature, like science, has to serve progress. How does literature serve? Discovering and describing evils, thus fostering their resolution. And the cyclical nature of Zola's work (workers, soldiers, prostitutes, entrepreneurs) shows clearly his

desire to make an authentic *Treatise* of the Human Condition. The novel—Zola writes in his theoretical work, *Le Roman expérimental*—must take the responsibility for pointing out the operation of the phenomena scientific analysis has not yet analyzed. Thus, his novels are psychology or sociology *avant la lettre*; the still mythological and figurative St. John announcing the advent of the New Science. The novelist is a researcher and not a poet or bard: he should not express the states of his soul but rather analyze and objectively describe the operation of human passions and institutions.

In this same tradition, Compte will tell us that social phenomena ought to be studied as *things*, and today, in a similar situation, reacting to the modern Romanticism which called itself Existentialism, Lévi-Strauss and Lacan will insist that they should be studied as words or messages—as realizations of a code within which we move but which we are unaware of. Puritanism then turns into an authentic asceticism, as we will see.

The modern *puritanisms of content*—from *Functionalism* in architecture to *Existentialism* in philosophy (Sartre), literature (Camus) or plastic arts (Giacometti)—have basically followed the same course. The gratuitous, the uncommitted, the arbitrary is still a sin. Functionalism thus tries to create an architecture "all beautified with omissions," and existentialism proposes radical "commitment," the search for an "authentic" life and the imperative of assuming one's own freedom in an always open existence. In either case, to do art is to construct a small habitat of (or for) the truth—*ins Werk Setzen der Wahrheit*, to use the proper Heideggerian phrase.

Puritanism of Form

As we have seen, there was always an avoidance of the gratuitous play of ornament. But puritanism of form has used a totally different strategy for this. While *puritanism of content* was trying to avoid the superficiality of forms by appealing to the deep reality of which they are an expression, searching for the meanings which anchor and give weight to the signifiers, *puritanism of form* aspires to the same thing, claiming that these signifiers are neutral and autonomous. Either forms with profound messages or aseptic forms: in neither case just capricious forms.

As Herzen rightly observed, while the victory over medieval dual-

ism was clear in the sphere of art with Raphael, Titian, and Coreggio "in science, the Catholic idealism called scholastic was only overcome by a Protestant scholasticism, called idealism."[23] And the lack of confidence of this Protestant scholasticism (Kant) with regard to any sensual effect or image not subsumed in rational categories is greater by far than that of Catholic scholasticism.

For Kant, esthetic judgment "must not be mixed with any merely empirical pleasure; with stimuli or emotions which might adulterate the authentic judgment of the beautiful object."[24] The beautiful as a rational judgment thus must be clearly distinguished from merely pleasing, sensual affection. Only drawing and composition—the most abstract and intellectual elements—can properly be considered beautiful, and thus constitutive of pure judgments of taste. The other effects—color, etc.—are impure sensations which instead damage "solid, uncontaminated, and authentic taste."[25]

Avant-garde concern for ridding esthetic judgment of all *representation* corresponds to Kant's theoretical concern for freeing it from *sensation*. Instead of amusing us with representations of objects, the work of art is to interest us as a present object. We are to arrive at the essence of forms by clearing all extrinsic reference out of them. The avant-garde's apology for Form was not a claim for "the forms," but rather for deep content, deeper than that of simple appearances.[26] In Nietzsche's words, the avant-garde of modern art "didn't like a form for what it was but rather for what it expressed. They were children of an erudite, tortured, and thoughtful generation, very distant from those ancient masters who read or thought only to give pleasure to their senses." Nordic Neoplasticism, Constructivism, or Suprematism tried to reach the essence by overcoming anecdote—by "demythifying" art as Protestantism had demythified Christianity: dispensing with Saints, Virgins, and other too-human Symbols. And not the least of Picasso's virtues is that he was the great—perhaps the only—"Catholic" painter (or pagan, which is the same thing here) of this period, the only one who didn't work by eliminating elements or analyzing, but by adding, integrating, accumulating.

Structuralism

On a theoretical and methodological level, this puritanism of form has taken on a new impetus with what is called *Structuralism*. To

this aspect of structuralism I have devoted a chapter entitled, "The Chaste Study of Signifiers," in an earlier work to which I refer the reader for the completion of what will be said here.[27]

According to the structuralist "principle of immanence," any phenomenon is to be considered from the standpoint of its own formal organization: menus are to be studied from the vantage point of the nutritional system, or marriage from the kinship system, instead of appealing to economic, meteorological, or ecological hypotheses. Structuralists speak about this principle of immanence with the same puritan, heated, and chaste excitement as the neopositivists had shown when speaking about the principle of verifiability or about the need to reduce every expression to a series of protocol propositions. This structuralist restraint reaches its high point when they warn us, in contrast to the "frivolity" of the neopositivists, that we should put our own logical schemes on the sidelines and generate in their place models which will reflect the organization and internal logic of the phenomenon under study. The only acceptable outcome is, then, the one that goes in search of the code or scheme these phenomena spring from: language *from* which we speak, nutritional system from which we eat, literature from which we write, the "episteme" from which we think, the system of exchange from which we do business, etc.

"Logical analysis" derived from axioms or principles foreign to the object studied; the "formalist" theories of art attended to the form itself, but the term "form" suggested that this was just an aspect of reality—opposed to another aspect: the "content." Only if that "logic" and this "form" are understood as *structure* can we succeed in seeing that it is its own content. The structuralist method thus presents itself as a synthesis of logicism and formalism: the paroxysm of modesty, closure carried to extreme voluptuousness.

It is hardly debatable that structuralism has opened up new perspectives on artistic and literary phenomena—even on the "system" in which these phenomena are included and which formalism never understood—e.g., on painting in Lévi-Strauss's *The Savage Mind* and *The Raw and the Cooked*, on music in Lévi-Strauss's *L'Homme nu*,[28] the literary criticism by Barthes, etc.

In *L'Homme nu*, for example, Lévi-Strauss places music within a system of orientations that frame structural analysis. *Mathematics* is

the formal pole where structures are free of all semantic implication. At the opposite pole is *Natural Language*, the result of the intersection of sound and sense. To the left and right of this axis are situated *Music* and *Myth*, autonomous areas but derived from Natural Language: music as a language free of sense and myth as a language free of sound.

In literary criticism, this concentration on the level of signifiers has allowed Barthes to show how in works as disparate as those of Fourier, St. Ignatius of Loyola, and the Marquis de Sade the same "writing" (*écriture*) is at work.[29] Whether the theme is social reform, holiness, or eroticism, it is one and the same writing which appears in the three works—a writing characterized by a *classifying voluptuousness* (of "techniques," whether of pleasure or holiness it matters little), a *numerical obsession*, and a *suffocating meticulousness*.

The inherent study of "superstructures"—attending to them in

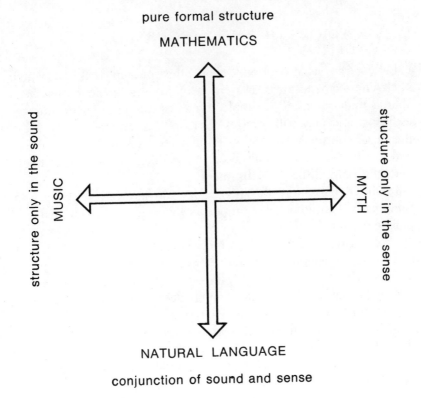

pure formal structure

MATHEMATICS

structure only in the sound

MUSIC

structure only in the sense

MYTH

NATURAL LANGUAGE

conjunction of sound and sense

themselves and to the systems they make up, instead of seeking their "causes" on another level—has thus had an undeniable heuristic and experimental value. It has even been effective in inciting the "fauve" reactions which opened new spheres of reality to study or to action. In fact, it is no accident that out of the most rigorous thinker (Kant) the least puritanical of the Romantics (Schiller) should arise; that from the purest idealist (Hegel) should spring the historical materialism of Marx, and that out of structuralist puritanism, the Derridas, Deleuzes, or Lyotards should emerge, bent on discovering a madman, a surface, an event, an exception, an anomaly for God's sake.

But do these "fauve" reactions really succeed in breaking the logic of puritan discourse? Aren't they, in some sense, a sublime expression of it? This is what we are going to see now, following the pattern of some of the discourses which today people have taken to calling subversive or "accursed": Nietzsche, Proust, and Breton.

5. THE TRICKS OF THE "ACCURSED" TRADITION

Let's recap what we said about this puritan tradition which Nietzsche seems to break away from. No bourgeois period has been able to understand art as simple reverence for appearances, homage to forms, and play with images. Certainly, as opposed to the art of theocratic and symbolic eras, its solutions seem spontaneous, natural, and low-key; but there is always a transcendent framework that supports this naturalistic embellishment.

In the Renaissance, this framework was *idealism*. The ideas of Simplicity, Harmony, Proportion, or Symmetry are admired and praised as much or more than the actual Forms themselves: the "sacred harmony of the parts" which Michelangelo discovers in man and which Copernicus, Kepler, or Galileo acknowledge in the spheres. The "Physical Reality" Bacon speaks of, or the "Necessity." Leonardo praises,[30] point to a much deeper and more substantive substratum than the one of mere appearances.

In Romanticism, this framework is *pathos*. At first glance it seems that after Neoclassical academicism, with its cult of Ideal Beauty and Good Taste, people are returning to natural forms and appearances; but soon enough *l'esprit du serieux* swallows all this up. It seems that

this art wants to praise life, but soon it will show itself to be an efficient instrument for a new (deeper and more profuse, more Christian, more divided, "more sublime and grotesque at the same time," as Victor Hugo says) description and understanding of life.

The bourgeoisie is terrified of surfaces and appearances and thus shares with Aristotelian nature the *horror vacui:* horror of places without their objects, of events without a plot, of means without ends, of objects with no function. The profusion of objects in the petit-bourgeois home shows this horror of shelves that display no books or figurines, of the corner without its clock, or the wall without its painting.

Nietzsche

This bourgeois stress can be seen in a more elaborate, though not more relaxed, form in Nietzsche. Nietzsche proposes an art which will not carry us deeper, to the foundations, but *beyond*, into life itself, to new experiences and excitements. But if courtly art could enable us to *slip* beyond, the art of his own period (and his own art as well) was only able to advance by poising on and *digging* its heels into the depths of experience. The exemplary failure of this Nietzschean ambition and of its Schillerian precedent shows us that profound experience is more than the *intention* of bourgeois art: it is its *destiny.*

Der Musik als Suplement der Sprache, music as a supplement of language.[31] Nietzsche often speaks about art as the enabling of the faculties, or the refinement of the senses. Even more so when he investigates the "prehistory" of the artist ("the inner craving for a role and mask, for *appearance*") Nietzsche does not look to the sage, the priest, or the magician—to the possessor of some transcendent wisdom which he soon would have learned to translate formally—but rather to the buffoon, the story-teller, the clown, Gil Blas; to plebeians whose circumstances have forced them to become *artist-actors:* "always adapting themselves again to new circumstances . . . until they learned gradually to turn their coat with *every* wind and thus virtually to *become* a coat."[32]

In his interpretation of Greek tragedy this antipuritan approach is reinforced: from *The Birth of Tragedy* (1871) to *The Gay Science*

(1881) and Part Four of *Thus Spake Zarathustra* (1886). Tragedy, like all true art, does not seek "truth" at all, but rather is the expansion of life itself; of the life which lies in appearance, art, illusion, and error.[33] Against the Platonic critique of tragedy on sociopolitical grounds and against its "psychological" legitimization in Aristotle, Nietzsche defends tragedy as game and convention. Who said that tragedy reveals the genius of the race or that it helps us to purify our passions? Both are "puritan" legitimizations ("Christian *avant la lettre*" for Nietzsche) which cannot accept the fact that what stimulated diligence, inventive genius, and the rivalry of Greek authors of tragedy was in no way the goal of thrilling the spectators by means of special effects. "The Athenian went to the theater *in order to hear beautiful speeches.*"[34]

As he tells us in his theory of art, tragedy is an example of the "cult of fiction," of art which is a "counterforce against our honesty," "art as the *good* will to appearance."[35] Greek tragedy is not therefore the investigation or probing into a deeper *reality* (historical in Plato, anthropological in Aristotle) but rather the proud and brave affirmation of *another* reality, of another order opposed to the natural one: the order of fiction, of artistry and deceit—in a word, of culture.[36] Nietzsche goes on:

Even of passion . . . they demanded that it should speak well, and they endured the unnaturalness of dramatic verse with rapture. . . . Thanks to the Greeks . . . we are delighted when the tragic hero still finds words, reasons, eloquent gestures, and altogether intellectual brightness, where life approaches abysses and men in reality usually lose their heads and certainly linguistic felicity. This kind of *deviation from nature* is perhaps the most agreeable repast for human pride: for its sake man loves art as the expression of a lofty, heroic unnaturalness and convention. . . . Just as they made the stage as narrow as possible and denied themselves any effects by means of deep backgrounds; just as they made facial expressions and easy movements impossible for the actor and transformed him into a solemn, stiff, masked bogey— they also deprived passion itself of any deep background and dictated to it a law of beautiful speeches. Indeed, they did everything to counteract the elementary effect of images that might arouse fear and pity.[37]

Up to this point Nietzsche's descriptions and definition seemed to keep to the superficial level of conventions and forms, appearances and roles; but only a slight change of emphasis was required in order to change this description of artistic *play* into a description of the profound and transcendent *function* of art. Nietzsche could not help

but pay tribute to the *esprit du serieux* of his period and his class, even while castigating it.

The very texts quoted above permit us to call his theory puritan. Nietzsche sees the legitimacy of art in its function of discriminating between the *natural* and the *cultural*; by the artist's Promethean accomplishment of overcoming the natural.

It is precisely the *effort* to gain agility which reveals the puritan point of departure of Nietzsche's proposal. The "instinct for form" or "taste for appearance" now takes on the responsibility for nothing less than surmounting the "instinct for knowledge" ("a product of the modesty, moderation, diligence, order, and, in the last analysis, of the indigence [*dürftingen Lebens*] of German life"), and for putting this instinct in service of a unity higher than knowledge and life, thought and passion, action and contemplation. And the philosopher-artist thus takes upon himself the task of synthesizing this "instinct for knowledge" with imagination and life in order to regain a unity which was lost since the time when Socrates began to tailor philosophy to the measure of man and his welfare, thus leaving science and knowledge without "transcendent" control.[38]

Nietzsche's attempt to unite knowledge and life is on a par with Kant's *Critique of Pure Reason*, which was supposed to synthesize understanding and morality. Like every transcendent project, and like the Kantian one, it is proposed as a victory requiring great effort. The Nietzschean "man of affirmation" thus becomes the "man of renunciation" who, in his wish to fly higher "throws away much that would encumber his flight, including not a little that he esteems and likes; he sacrifices it to his desire for the heights."[39] Of course, this longing for the heights, as puritan as the longing for the depths of experience, is quite far away from appearances and surfaces.

For Nietzsche, art has still another transcendent virtue. Starting out from his profound intuition that the form in which things appear turns out to be (and is understood as) their very essence—that, as we say in Spain, the habit makes the monk—the function of creating appearances or effects is then understood by Nietzsche as the Creative Force of Reality. "The reputation, name, and appearance, the usual measure and weight of a thing . . . all this grows from generation unto generation, merely because people believe in it, until it gradually grows to be part of the thing and turns into its very body. . . . It

is enough to create new names and estimations and probabilities in order to create in the long run new 'things.' "[40]

The art that pretended to be a symbol of the "easy" life, the happy and unconcerned playing with forms and appearances, keeps taking on unexpected "virtues" and functions which eventually legitimate its pirouettes. We see once more that from a bourgeois perspective, even a Nietzschean one, appearance can only be accepted as a *signifier*— as a "trampoline" or an "instrument"—never as a *sign* with full rights of its own.

But where Nietzsche's puritanism appears most clearly is in his adjectives and the examples he advances, where censorship of the "spirit of weightiness" which is at work in his explicit and conscious statements does not operate. Nietzsche seems to defend a play-art of Schillerian stripe, or an appearance-art in courtly style, an art which would not try to reveal any transcendence at all, but rather stimulate and diversify practical life (as opposed to art as alienated labor, conventional intimacy, passive leisure, or hard-won happiness). "It is the weak characters without power over themselves that *hate* the constraint of style. . . . Such spirits—and they may be of the first rank—are always out to shape and interpret their environment as *free* nature: wild, arbitrary, fantastic, disorderly, and surprising. And they are well advised because it is only in this way that they can given pleasure to themselves."[41] Nietzsche is calling for an art that will transform the world with images "that will make you shudder."

Before the last phrase—"that will make you shudder," *das euch schaudert*—we might still believe that he saw art as a reintegration into everyday life of the airy spirit of the feast, but from there on we see that the pathos which he introduces here is as grave or graver that the everyday-ness which he is trying to overcome; the proposal now sounds more like Brahms or Wagner than like Scarlatti—like the same "German music" Nietzsche rejected.

Too "Christian" in the final analysis, Nietzsche does not value the formal and spectacular delights (thematically Christian but, in reality, much less puritan and inhibited) of baroque and ecclesiastical art. And it is symptomatic that when he looks for ideal places for his "new man" to live in, Nietzsche expressly rejects the areas where in our day we have gone for inspiration. All Nietzsche's puritanism, gravity, and seriousness show in the description he provides of the

"quiet and wide, expansive places for reflection . . . buildings and sites that would altogether give expression to the sublimity of thoughtfulness and of stepping aside." An aseptic, private, grave, almost Calvinist area is opposed squarely to the areas shaped by courtly or ecclesiastical art.

I do not see how we could remain content with such buildings even if they were stripped of their churchly purposes. The language spoken by these buildings is far too rhetorical and unfree. . . . We who are godless could not think *our thoughts* in such surroundings. We wish to see *ourselves* translated into stone and plants, we want to take walks *in ourselves* when we stroll around these buildings and gardens.[42]

Nietzsche is not rejecting pathos here: he is calling for a rejuvenated pathos. He criticizes the old gravity in the name of the new one. Nietzsche justifiably was calling for the buildings and spaces of the progressive bourgeoisie, felt to be an authentic architectural translation of their way of living and thinking.

Supposedly Nietzsche was the defender of wingèd signifiers, a representative of the "accursed" trend which seems diametrically opposed to bourgeois puritanism. But in Nietzsche the inevitable destiny of signifiers—their role as vehicles of "meaning" which always transcend them—appears in all its nakedness. The supposed defender of free signifiers overwhelms us with transcendent signifieds; the defender of art as a delight in disguises and appearances ends up by rejoining the Romantic tradition that speaks about art as cosmic speculation: art as "the earthquake through which some primeval force that had been damned up for ages finally liberated itself."[43]

One way or another, artistic forms are always brought back to their role as reflections of a reality that transcends appearances. Nietzsche's accurate judgement of the German music of his time could probably be applied to his own theory of art: "in all German music we hear a profound bourgeois envy of nobility, especially of *esprit* and *élégance* as expressions of a courtly, knightly, old, self-assured society."[44]

Proust

Proust's entire work seems to turn on the inborn *esprit* and elegance of Swann, St. Loup, or the Guermantes, whose bourgeois mimicry always seems forced and artificial: "Really, it oughtn't to be

allowed, to play Wagner as well as that!" exclaimed Mme. Verdurin, when her young pianist protegé tried to play the prelude to *Tristan.* Her fear of "too violent an impression" made the hostess of the *petit noyau* protest regularly: "Then you want me to have one of my headaches? You know quite well, it's the same every time he plays that. I know what I'm in for. Tomorrow, when I want to get up— nothing doing!"[45]

The "effort" and "message" betray Mme. Verdurin just as they betray the bourgeois writer. Proust himself, on the contrary, doesn't at first seem to bring us any transcendent message, nor to conceive of intellectual or artistic work as labor. At first.

Proust doesn't begin by talking about the times of great deeds or about tradition, about elaboration or inspiration, but rather about *time past (temps perdu*—literally, "lost time"), the time wasted amid outings, flirtations, waiting, and jealousy. For the fact is that truths about *wasted* time cannot spring out of *occupied* time: of time when our volition and intelligence "seek" something.

As Deleuze has seen, only in empty time do the signs which need to be deciphered appear with all their force. In intellectual dialogue and in "philosophical" friendship, signifiers, theses, cultural "commodities" are exchanged—a mediocre person's love is, on the contrary, an arsenal of signs to be interpreted. Only in these "loves" do we manage to have crude *impressions* that go beyond the *convictions* of our cultural discourses; only then do we stop chewing on thoughts and bite down on the things which make us think; only then does our conscience stop savoring its own conceptions and feel the bittersweet taste of still "unprocessed" experiences.

Proust tells us that the work of art has to elaborate something which is not cultural, but unique, banal, ordinary . . . and something that, furthermore, culture has not yet transformed into established Uniqueness, Banality, Everydayness. In his search for a raw material not yet colonized by culture, Proust only finds spas and salons, the world of uncertain love affairs and of petty vanities, of "anomalous" passions.

We only find theses and messages in the mouths of the ridiculous characters (Cottard, Norpois). Proust himself refuses to manipulate sensations to make Experiences of them; he does not seem to want to *come to the point* but rather to *prolong* life itself—time lost.

But at the end also comes the message, the meaning, the "why" of time lost. Then we see what that time lost "was good for": what its purpose was. The signifiers now don't appear as they did at the beginning, as an extension into a new space and in a new discourse of the events of each day, but rather as pregnant with a meaning which at the end must be deciphered. Like all the works of the puritan tradition whose course we have followed, the *Recherche* does not reply to or multiply experience, but rather explains it. The experiences of "time lost" appear, at the end, as the "negative moment" of the synthesis in *Le Temps retrouvé*. A time, thus, not really *lost* but *invested* in the acquisition of raw material, of direct experience. Who has not met some cheap imitation of the artist or novelist on a trip to "gather experience" for his next work?

Reading Proust, and Nietzsche, has been one of the most powerful experiences of my life—and not only of my intellectual life. Therefore, this is not a "critique" of Proust, as it was not a criticism of Nietzsche. I want only to show that Proust does not really break away from the *Weltanschauung* in which he finds himself; that he doesn't overcome the imperatives that the puritan tradition imposes on artistic and literary creation.

And the adherence to those imperatives is finally made explicit in *Le Temps retrouvé*. Wasted time, leisure, and snobism now appear as the privileged experiences out of which laboriously to build a Metaphysics. Let us see what is the effort and the message that betrayed Mme. Verdurin and ends up unmasking the *Recherche* itself.

"Involuntary memory" seems to distinguish itself from deliberate remembering by its lack of effort, its spontaneous nature: "we should never speak of *our* memory," Cortázar has written, "because, if anything, it is not ours; it works on its own account."[46] Man is not the protagonist, but rather the place where these reminiscences occur. In "involuntary memory," as in Plato's remembrance, an object, a perceptible sign, stimulates an image, an atmosphere, a prior experience whose flavor comes back to us with all the force of present things: the paving stones bring Venice back to us, the taste of the madeleine brings Combray back. But this sensuous and immediate joy is neither in Plato nor in Proust the goal but rather the point of departure. The diffuse *joy* that is felt for the vision of the stones, or the taste of the madeleine, is followed by the painstaking *labor of thinking* which will

lead us to find the *meaning* of these sensations or signs: Time or Beauty as the very core of Being.

This "deep meaning" of experience shows us the past in all its force and immediacy; not as something which is "before" the present but as something that coexists with it: *dans le temps.* Art carries us, thus, to the discovery of this Essence of Time the object of which is nothing more than a "sign" and the subject is but the "place." After this experience, Proust isn't afraid to die anymore. After the process of art in *Recherche,* just as after the process of thought in Hegel's *Phenomenology,* the path we were hesitantly following until we reached the essence appears to us in a new light: as stages on the way to knowledge of an absolute reality which was there all the time.

Thus, for Proust, art is a real "Phenomenology of the Spirit." The Proustian game, which seemed to break with the basic commitments of puritanism—effort, instrumentality of signifiers, transcendence of meanings, etc.—finally appears perfectly at one with its tradition.

It will suffice to choose any other representatitive of the rebel, "accursed" tradition to see that, inevitably, it responds to and ratifies this tradition of restraint, commitment, and function. We have seen it when referring to Norman Mailer and to Thomas Mann's Aschenbach. Octavio Paz makes the same point in a discussion of rebel poets and artists of the avant-garde.

Their disobedience merges into the order they are trying to attack and their rebellion is a paradoxical paean to power. . . . To rebel is to resign oneself to being a prisoner of the rules of power; if the rebel really wanted freedom he wouldn't attack the power of the rules but the rules of power, not the tyrant but power itself. . . . The rebel needs and feeds on power: the ambiguity of power justifies his blasphemy. . . . The mutiny of artists, from Baudelaire to Surrealism, is an internal squabble of the bourgeoisie. . . . Baudelaire's rebellion is a sort of circular simulation, a performance. Exaltation of an abased singularity which is the counterpart of a tyrannical god. The poet's rebellion is a comedy in which the ego plays against power without ever daring to defeat it. Baudelaire does not want nor does he dare to be free; if he really dared to he would stop seeing himself as an object. His rebellion is of a piece with his *dandyism.* The poet wants to be seen. Or better, he wants people to see him.[47]

Breton

In Baudelaire's "rebellion" there is still a subversive hymn to sensuality and desire which in Breton is totally wiped away. With Breton

the artistic process is again understood as an approach to the essence through asceticism and repression: "All the faculties of the human soul ought to be subordinate to the imagination which can requisition them at any time."[48]

And this triumph of imagination comes only through strict obedience to the programmatic principles of the Movement: i.e., surrealism. The paradoxes of the avant-garde which Enzensberger summarizes as an "attempt to establish freedom in the arts in a doctrinaire way,"[49] pile up and thus condense in the Surrealist movement.

But these paradoxes are nothing but the result of applying a pragmatic bourgeois outlook—explicit, deliberate, energetic, professional—to the winning of absolute freedom and pleasure.[50] Even sensuality has to go to school: "enjoyment is a science; the exercise of the senses demands a personal initiation and therefore you need art," writes Breton in his ambiguous "Prologue for Bourgeoises." Art is not the prolongation of sensual and immediate experiences but rather their systematic reinforcement, control, and conversion. "We reject as tendentious or reactionary any image that the painter or poet offers us today of a world . . . where small sensuous pleasures might not only be enjoyed, but exalted."[51]

One must pass through an asceticism of the apparent and the sensual (the *small pleasures*) to reach this deep, *subreal* essence. The effort of great art to unite the instinctive and the rational, delirium and perception, is here rejected with one stroke of the pen. External objects are no longer something which stimulate or carry one farther, but simply all those things that painfully limit the artist.

We saw, when speaking about Aschenbach, why modern art had been unable to be a happy exaltation of the senses and their magic. After bourgeois puritanism—after modern "Christianity" as Hegel or Nietzsche would say—the disorderly, volptuous, or foolish appears only as a nihilist or demoniacal cult. The rejection of conventional values is now inevitably impregnated with the dramatics and grandiloquence of what is denied. There is no way to claim the pleasant and agreeable without turning it into a demand for the sublime, the grotesque. As Victor Hugo knew:

The day when Christianity said to man, "You are split, you are composed of two beings, one perishable, the other immortal, one of the body, the other ethereal" . . . that day drama was born. Drama, the perfectly natural combination of two types, the

sublime and the *grotesque*, which cross paths in the drama as they do in life and in creation. Comedy which represents the human animal and tragedy which represents the soul are fused in the drama of this man, "half angel and half devil."

In this chapter we have seen that puritanism has condemned us up to now to a choice between the sublime and the grotesque. In the two chapters that follow, we shall see if the change of "style" and "theme" which takes place in modern art can free us from this schizophrenic dilemma.

FOUR

A CHANGE OF "STYLE":
THE CRISIS IN
FUNCTIONALIST SENSIBILITY

THE PURITAN ATTITUDE, channeled and diversified by the different strategies which we have reviewed, has had a great deal of influence on artistic and literary formalism, architectural functionalism, philosophical existentialism, etc. But this tradition can only help to inspire us if we know how to make use of its analyses and products without becoming attached to its more ideological elements. Or rather: only by acknowledging that we are located in a different formal and ideological field can we understand our works as ones that have been made possible by that tradition, and our crisis as a product of its way of posing the problems—a way we still haven't been able to overcome.

For greater clarity, I will describe separately the two perspectives of the present crisis: the transformation of style or "manner"—which I will trace through the evolution of architectural functionalism—and the transformation of the subject or "theme"—in the specific case of the avant-garde in the plastic arts and the theater. And in both cases we will see that the split with modern orthodoxy occurs on two opposite and complemenatry levels: (1) criticizing the partial nature of its ideals (*hot* split), and (2) trying to transform these ideals into an effective program (*cold* split)—as an effort to *realize* the proposals arising out of the previous perspective and, on the other hand, to *amplify* that perspective.

1. FUNCTIONAL DISCOURSE AND ITS KITSCH COUNTERPOINT

By taking up again the discourse of Alberti, for whom beauty or ornament were adherent rather than inherent virtues of architecture, rationalism tried to reduce the meaning of architecture to its "strict function"—as if the function had ever been strict. This did not mean, of course, a total disdain of the informative, allusive, or symbolic value of architectural forms. But after World War I, and faced with a purely ornamental use of historical styles, functionalism was a deliberate and programmatic attempt to investigate the primary or mechanical ("*existenz-minimum*," accessibility, etc.) functions, putting other, more sophisticated functions to one side for the moment.

Nonetheless, and regardless of what the modern handbooks say, functionalism did not completely dispense with the meaningful or symbolic dimensions of function. "Functionalism was not considered as a mere rationalist process . . . ; we understood that emotional needs are as pressing as any utilitarian need and that they demand satisfaction."[1] Functionalism took beauty to be one more function, and not a mere epiphenomenon of function-utility:[2] it made beauty *dependent* on the elementary mechanical functions, which does not mean reducing beauty to those functions. Genuine functional architecture did not simply *show* its structure but *revealed* it, and in the subtle difference between showing and revealing lay its conception of beauty as a *manifestatio* of an essential, intrinsic perfection. On this level, consciously or unconsciously, its strategy did not differ fundamentally from that used by the Historicism of the previous century to handle the unexpected increment in the demand for architectural spaces which followed the Industrial Revolution. As we saw, "historicism, keeping the problems of formal classification separate from technical problems, and leaving aside the former under the pretext of historical styles, allowed architects to confront piecemeal the problems posed by the new circumstances, thus helping the art of construction progress in every area, according to the analytical methods of contemporary science and culture."[3] In an analogous fashion, functionalism placed the "semantic" dimensions of function on the sidelines so as to be able to handle its specifically "syntactic" and "pragmatic" problems.

But if the Enlightenment responded to the demands of its time by establishing typologies, and Historicism by appealing to the cosmetic effect of past styles, Functionalism posed the problem in a more radical way. It was no longer a matter of "isolating" the problem of style, but of "integrating" it, studying and emphasizing the connection between function and form. From form as a *typology* and form as *performance*, form came to be understood as the direct result of *research* into function.

One should give back to art the meaning and Function it had in the tradition of classical *techne* and of medieval *ars*, thus eliminating the idealist connotations it had acquired since the Renaissance, and the expressionist ones adhered to in Romanticism. But the Bauhaus did not attempt this reunification of art and technique by means of the romantic "return to craftsmanship" proposed by Ruskin or Morris. Modern systems of production made an archaeological and elitist myth out of craftsmanship. The humanist-scientific ideal, the "return to Archimedes" of the humanist tradition of Leonardo, seemed equally unworkable. The only way to reconnect art and reality was to start from modern science, which pointed out the "goals" to be met, and from modern systems of mass production, which offered the "means" to do it.

Comfortably lodged on the path opened by the Bauhaus, we can indulge today in pointing out its limitations: the formalist or expressionist nature of its introductory courses (which G. Di Carlo simplistically blames for the movement's failure); the rudimentary nature of their sources of sociological or technological information; the fact that their solution for problems of "housing" was only partial, since it separated "housing" from the general urban context, etc. We can even see how its postulates soon turned into the conventional and flat *International Style* whose most extreme and extravagant form (and surely, for that very reason, one that attracts us today) is the "Hollywood style." And no one can be surprised that out of the very awareness of these limitations arose, first, architectural organicism, and then the whole range of regionalisms and historicisms which tried to assert the importance of the geographical or cultural milieu in which the building was situated.

The new tone which kitsch takes on in this period shows well the limitations of the rationalist solution (even as a bourgeois paradigm).

Complementary to functionalist mechanicism, which reduces everything organic and personal to function and systems analysis, kitsch tends to colonize the world of man-made *objects* with the wavey forms of natural *things*. The domestic and familiar gods of *gemütlichkeit*, repressed in the period of functional asceticism, reappeared now as kitsch, thus emphasizing the limits of the anthropological revolution which the progressive bourgeoisie had not been able to carry to completion. Repressed, delimited, these gods arose again here and there, waiting for a period like our own in which neocapitalism and neoformalism have issued them new citizenship papers.[4]

2. FUNCTIONALISM AS PURITANISM

Functionalism was an important factor in the awakening of art from its dogmatic and academic sleep. It reopened the very basic question of *what* art was, and not just of *how* art should be made (what Proust or Joyce did in literature, Nietzsche or Marx in philosophy, Mallarmé in poetry, etc.). But it did so within an economic and cultural context very different from our own: a fact which explains both the circumstantial character of much of its work and the permanence of its influence.

Functionalism is one of the purest cases of what we have called *puritanism of content,* opposed *de jure* to the puritanism of form or formalism, and *de facto* to a ludic conception of art as an unconcerned play with appearances and effects. Art should not be a marvelous exception, but the rule; a real solution and not an illusory formal balance; a tackling of objective problems and not mere subjective expression, etc.

In this period of formal Calvinism, "antistyle" declarations proliferated. Loos warns us that a modern man who still needs ornament "has the mentality of a primitive or a criminal." In *The Great Good Place*, Henry James made an austere hymn to an architecture "all beautified with omissions," and Emerson glossed the Augustinian dictum that "the good and the certain become beautiful." We might thus enjoy appearances, but only because of the functional truth they carry.

Theoretically, this puritanism takes the form of what I have called *esthetic Lamarckianism.* Just as for Lamarck, function *created the*

organ in the natural world, so in functionalist dogma function *creates beauty* in the cultural world. As the representatives of the rationalist movement explicitly declare in their polemical writings: "the aptitude for the goal equals beauty" (Gropius); "form is not the *end* sought after, but rather only the *result* of our work" (Mies van der Rohe). Even on a purely linguistic level, we find once and again the terms characteristic of the puritan ethic of effort and austerity, simplicity and authenticity.

My intention is not to introduce a, so to speak, cut and dried 'Modern Style' from Europe, but rather to introduce a method of approach which allows one to tackle a problem according to its peculiar conditions . . . to create true, genuine forms out of the technical, economic and social conditions in which [the architect] finds himself. . . . [The Bauhaus work] was not based on external stylistic features, but rather on the effort to design things simply and truthfully in accordance with their intrinsic laws.[5]

3. THE SOCIOLOGICAL, TECHNOLOGICAL, AND ECONOMIC CONFLICT OF FUNCTIONALISM

It is not advisable to reduce without qualification *what* something is to *why* it is. My falling in love or my neurosis are one thing, and what caused them is another. American rhetorical escalation on ecological themes may respond to the search for an alternative use for huge war investments after the withdrawal from Vietnam, but the progressive deterioration of the environment is a fact. The Darwinian conception of evolution as natural selection and survival of the fittest could be a projection onto the natural world of Darwin's experience in a world of competitive capitalism; but the important point is that it did hit the nail on the head. Seldom if ever do sociological or psychological explanations of the origin of a phenomenon exhaust its meaning and value.

With this preliminary qualification, we can still insist on the fact that the praise of the useful and simple and the instinctive rejection of all ornament (which is assimilated to the artificial and the mannered), is *part and parcel* of the mystical cult of work, effectiveness, efficiency, and simplicity of the bourgeois ethos during its archaic period (the Enlightenment) and its classical period (the first Industrial Revolution). Occam's razor (*entia non sunt multiplicanda praeter*

necessitatem) was for them both an ethical and an esthetic principle.

As Chueca Goitia has shown, the nineteenth-century use of classical colonnades, Gothic needles or baroque cupolas functioned "as an honorable proof of the purity of the blood . . . since that dignity and uprightness which the bourgeois aspires to above all things was provided, in an easily accessible way, by the prestige of the past better than by anything else."[6] But once this legitimizing function was fulfilled it was soon realized that such theatricality was as useless as it was irritating for a Saint-Simonian mentality which understood man as *the planet's guardian*. Just as his Neoclassical grandfathers were irritated by the extravagance and irrelevance of the baroque, he would be bothered by an aritificial style which was more appropriate to courtly mannerliness and formalism than to bourgeois decorum and effectiveness. There was still a long time to wait—until game theory in mathematics (Morgenstern, Von Neuman) and the concept of business as a "game" (Schumpeter)—for the concept of "game" to cease being repugnant to bourgeois sensitivities.[7]

This sensitivity was obviously connected with a stage of economic, social, and technological development which needed its own formal principle. Functionalism was this formal principle. In the first place, it was because of its suitability for problems of mass production and its formal simplicity, which satisfied both the technical and moral demands of this class. The rationalist ideals of "clear internal separation of functions" and of "external simplicity" were an extension of the formal principles inherent in the mechanical technology of the industrial revolution. Only the proliferation of kitsch in this same period reminds us that social contradictions were not really resolved, but rather disguised, by rationalism. The bucolic which still proliferates on elevators, façades or sewing machines bespeaks a devotion to ornament never perfectly restrained by puritan-functional asceticism.

In the second place, functionalism helped also to express this time's infatuation with new materials—iron, glass, reinforced concrete. Such materials were "news" then, and allowed the creation of astonishing spaces: transparent walls or roofs, cantilevered structures, etc. These modern exhibitionists, like the Gothic builders, took enthusiastic pride in showing off the new structural principles they discovered; the same charm with which Dürer triumphantly displayed his mastery of perspective; or the euphoria with which the impres-

sionists told us pictorially about their new discovery that light—the medium—was the message. Now as then, the marvelous character of new techniques and materials made their mere display attractive; a display that also satisfied the taste of the bourgeois consumers for *sincerity*. At last, beauty, so frivolous in recent years, was really going to be the splendor of truth.

If the early bourgeoisie had had to justify beautiful things by making them, in Hegel's terms, *sinnliche Scheinen der Idee* (a sensible manifestation of the Ideal), the new puritanism had found a new transcendence to which to ascribe them: Technique. Beauty was now "the sensible manifestation of Technique." The virtue of these techniques and materials was thus as much metaphysical as pragmatic, or even more so. The transparency of glass, for example, was a guarantee of loyalty, hygiene, and "objectivity," at the same time that it provided the maximum possibilities for the safe display of merchandise.

4. THE CHANGE IN CONTEXT

From the mid-fifties on, the situation is economically and technically different, and so is the sensibility. To begin with, those techniques and materials have ceased to be "news": looking at them no longer produces any effect whatever since they form a part of the urban landscape in which most of us have been born and raised. The functionalist charm for the simple showing of the structure has thus been followed by indifference and even boredom. The enthusiastic *less is more* of that period has today been turned, as Venturi says, into *less is bore*. Functionalism no longer has any ideological appeal and therefore, since it no longer works as a myth or moral symbol, it must make good on its promises. Classical functionalism is then charged with being more rudimentary than scientific, more rhetorical than effective. Man now thinks that only a greater sophistication in gathering and processing information, in devices for forecasting or preparing for future needs, etc., could make of the functionalist *ideology* a truly functional *architecture*.

On the other hand, the sensibility which appreciated functionalism was educated in, and suited to, a capitalism focused on the problems of *production* whose leitmotif was "maximum output at minimum

cost," and not faced with the need to "produce" consumption. Since that time, nonetheless, the emphasis has shifted from physical production to information or know-how; from competition to organization; from production to commercialization; from the *utility* of the product to its *image*. The simplicity of forms has lost its former economic and esthetic appeal, since: (1) the third age of the machine and electronic technology allows us to mass produce more complex forms, and (2) forms have to be fitted to sales rather than to production. More or less obviously, with more or less modesty, today all forms are in some measure *styling*.

Our economic system does not advertise so much the durability and sturdiness of its products as the feelings which their possession will produce in us, the personal success and social status they will give us. With Formica, Frigidaire, or Ferrari, we will be youthful, elite, progressive, etc. What we are offered is an ideal image of ourselves, only obtainable with the purchase of some charismatic product. Only an object, or even less, only the acquisition of an object, now bridges the gap which separates what I am and what I aspire to be.

Strict and discreet forms, useful and exclusive at the same time, simple and elegant, in a word, distinguished forms, answered problems of production and restricted consumption. Mass consumption and the creation of *images* rather than *products* had to revive a taste for the tricky and flashy, for the striking and gratuitous: for the hyperfunctionality of the gadget or the hypofunctionality of styling. And the lubricant of the new system could no longer be the ascetic of savings and investment, but rather a Dichter-style ethics of superfluous consumption which tries to promote to the status of a moral virtue the acquisition, waste, and replacement of goods.

But while in Europe it is easily accepted that these economic factors fostered American styling and glamour, it has not yet been realized that the neoformalism and neohistoricism of European design or architecture are equally responding—and at times less critically—to this same situation.

This change in sensibility can also be understood from the specific perspective of the technological changes which have occurred from rationalism down to today. In fact, it has been argued that electronics technology and the growing utilization of elements manufactured off-

site (air conditioning, telephone, elevator, curtain-walls, etc.) has dismissed architecture from a good many of the functions related to the physical control and creation of a functional framework. Many of the so-called primary functions (shelter, climate control, safety), have been resolved technically, and thus the architect could concentrate on the so-called "secondary" functions: symbolic connotations, information value, and the like.

But the influence of technology on the modes of formalization doesn't stop here. Functionalist composition—clear, internal separation of functions and external simplicity—was responding metaphorically or mimetically, by imitation or contamination, to the demands of mechanical technology. Electronic technology, on the contrary, creates forms which are more an extension of one's own behavior than a compartmentalization of it. Light itself—pure, content-less "information"—"has created museums without walls, spaces without boundaries, and days without night."[8] Since people work with electronic media it is no longer necessary for each function to have a corresponding element or a stable and delimited physical space in accord with a rigid topological organization. Electricity has "decentralized" or "concentrated" tools and implements, making them independent of their traditional, point-by-point correspondence to the human body. It thus permits the *association* of objects based on the common energy that supplies them: the record-player, lamp, and heating; or the *polyvalence* of a space which the telephone and tape recorder permit to function at one and the same time as a den, information center, family room, office, etc. At the extreme, miniaturization and automation of these devices transforms their functions into an almost direct and automatic translation of our desires, without any other intermediary than pushing a button. "Traditional objects," writes Baudrillard, "were rather witnesses of our *presence*, static symbols of our own bodily organs. Technical objects offer a different fascination insofar as they refer to a virtual *energy*, so that they are no longer receptacles of our presence but rather vehicles for our own dynamic image."

In this sense, it is obvious that the need for a clear physical and spatial delimitation of functions disappears: the telephone even transforms prostitution—which needed a common, urban space for the making of contracts—into the subtle, ubiquitous market of call girls.

5. THE ANNOUNCEMENT OF THE CRISIS

We have seen several separate factors that explained both the rise of functionalism and its ensuing crisis. Among these factors were the change in the economic and technological infrastructure, the precariousness of the very rationalist methods used and their natural tendency to turn into internationalist formalism, the loss of the stimulus value of the techniques employed and the erosion of their formal rhetoric—structural clarity, simplicity, austerity, anti-ornamentalism, etc. And we have also seen how this crisis brought to light the limitations of many of functionalism's effective realizations, as well as the permanent value of its great works which transcended the "ideology" from which they sprang.

Had the functionalists recognized the circumstantial nature of these factors they would have been able to predict their crisis. But in many people—in myself, even in 1962, when I wrote *El arte ensimismado*—there was at work the illusion of a sort of fundamental and permanent affinity between simple, spare forms, flat profiles, pure colors, and the sensibility linked to the new systems of production.[9] The Baroque, we all thought, could arise out of the Counter Reformation but not out of the Production Line. And so we confused mass production and homogeneous production, without realizing that the latter was a special case of the former, and that a greater technological sophistication would permit not only greater, but also more diversified, production. It is no coincidence that in a period like our own of an unbridled thirst for diversity, only huge corporations or the small artisan can survive and respond to this demand. Between the one and the other, the medium-sized enterprise perishes, as it lacks both the artisan's ability to produce diversity individually and the corporation's capacity to program it technologically.

Frank Lloyd Wright and Souriau were among the few people who were not taken in by this illusion. Wright did not tell us—as was *de rigeur* at that time—that at last the ornamental period had been surpassed, but just the opposite: that people *weren't yet ready* for ornament. For him, rationalism in architecture did not mean the last gasp of the decorative, but rather its "forty days in the wilderness," which made its epiphany possible on another level. At the same time, Souriau was predicting in France that the charm of functional

forms was due to the "psychological shock" produced by their novel
character, and that they would soon lose this interest when people
became accustomed to them. "It wouldn't surprise me in the least,"
concluded Souriau, "if toward the year 2000 there appeared a new
industrial and architectural baroque."

And we certainly haven't had to wait that long. Since the mid-six-
ties, reactions have begun to appear against "modern architecture";
historicist reactions in Italy, theoretical ones in France, imaginative,
utopian, or neorationalist ones in the Anglo-Saxon countries. From
these different and complementary perspectives, its implicit ideology,
as well as its methodological insufficiency and the limits of its con-
cepts of function began to be questioned.

6. THE TWO DIRECTIONS OF PRESENT-DAY REVISIONISM

We have seen the reasons for the crisis in the ideology and sup-
posedly "universal solutions" of functionalism. Now we must de-
scribe the arguments marshalled, the methods proposed, and the
forms created by subsequent architects. More than the principles of
functionalism themselves (the study of needs and the fit between
forms and needs), what was soon questioned was the interpretation
and actual translation of these principles in the rationalist period.

1. It was pointed out, on the one hand, that there are more de-
mands or needs than the purely "mechanical" ones perceived by the
functionalists. The term *needs* seemed too aseptic or limiting, and it
was replaced by the less repressive term, *wants*. The concept of "need"
with which functionalist architects worked was the paternalistic trans-
lation, on the architect's part, of the effective demand. The most ob-
viously rhetorical dimension of this demand ("noble" materials, "clas-
sical" forms, "domestic" elements) was treated with Olympian disdain by
the architect, who made a virtue out of not giving the symbolic stuff
he was asked for. The new architects, on the contrary, imposed on
themselves a critique of "architectocentrism" (architectural ethnocen-
trism) with the recognition of the value of people's demands and the
self-critical awareness that the "taste" of an architect is a rhetoric and
system of prejudices—and not always more justified than that of the
client.

On the other hand, the functionalist obsession for perfectly fitting the object to its user (fitting the handle to the hand, the hat to the head, etc.) whose affective realization became more visible thanks to ergonomic, proxemic, and other studies, began to be questioned as an absolute axiom in the shaping of objects. Forms excessively molded to their function often turned out to be inadequate due to their very perfection, since the "forseen function" acted as a censor of whatever other uses or manipulations might be made of them. We all know how uncomfortable it is to sit in a chair which adapts itself perfectly to our anatomy, to *one* position of our rear ends which is difficult to maintain after half an hour. The new "formalist" architects think, with Oscar Wilde, that often the (apparently) superfluous is more important than the (supposedly) necessary. Thus, they thought that functionalism was more rigid and theoretical than it was real and flexibly functional.

2. It was emphasized, on the other hand, that the methods or techniques used by the functionalists to fit or adapt forms to needs were insufficient—that their rationalism was more theoretical than practical, and that the very concept of *need* was not only, as we saw, excessively aseptic, but rather too vague and unclear. It turns out to be more useful to speak of *tendencies* (to study them and use rational methods to create physical surroundings which will make their fulfillment possible) than to keep on preaching about a theoretical "function" which is nothing but a partial vision of actual needs (in general, the most easily observable or manipulable: accessibility, reduction of the weight of the structure, etc.). Thus, they thought that rationalism was in the end not rational and systematic enough.

On the other hand, whether because it wasn't functional enough or rational enough, because it was excessively literary or too austere, a reaction emerged in both directions—cold and hot—analogous, as we have seen, to the reaction of Mannerism against the artistic and theoretical idealism of the Renaissance. It was a reaction which in every case attested to the distance that separated the ideals—humanistic in one case, rationalist in the other—from their practical realization: political restorations at that time, economic speculation and academic up-to-date-ness now.

Significantly enough, the most recent developments in these cold and hot attitudes have led to similar conceptions or formulations (the city as a physical product of a melange of subcultures, and the rejec-

tion of all "style"). The two views have a deep affinity with each other, and a mutual opposition to the "humantistic" view of the problem. My impression is that both trends are but two pathways of one critique of the insufficiency of humanist solutions, as is shown by the practical coincidence of two characteristic representatives of the cold and hot splits: Alexander and Venturi (and, we might add, the Five Architects, the latest Rossi, the School of Barcelona, etc.). The "later" Venturi and the "later" Alexander, in fact, coincide in:

1. Understanding the city as the "physical product of a series of subcultures" whose diversity ought not be disguised but rather displayed and fostered.[10]

2. Rejecting the attitude of those architects bent on a *total* design. "We don't like the megastructural, heroic, pseudoprogressive stance of Establishment architecture now," Venturi writes. "We think it has neither validity nor vitality."[11] A progressive architecture, Alexander thinks, must grow gradually and stay in balance with its context, of which it is, at one and the same time, an expression and a "reparation."[12]

3. Fostering a vulgar style-less architecture. "When everything is so extraordinary, being quiet and normal is surely the least usual thing." Consistent with his idea that the building's impact comes from sources other than the architectural (e.g., as in Las Vegas, from the neon signs which dress them), Venturi has built buildings like the Guild House and, even more in this vein, the Mathematics Building at Yale where everything is ordinary, from its construction and its specifications to its appearance.

Alexander, on the other hand, is convinced that architecture designed by the users will have "style," just as all objects and buildings had before capitalist division of labor and the development of merchandising destroyed the style inherent to detail—gestures, words, clothing, housing—making style a specialized or artistic product in opposition to everyday work and action.

7. TECHNICAL REACTION: NEORATIONALISM

I have dealt with the neorationalist reaction and critique elsewhere;[13] here I will limit myself to adding some marginal observations. For the new rationalists, classical functionalism was more ideological than real: it pointed out the need to pose problems rationally,

but it did not—and could not—manage to carry out the job. The functionalists had *interpreted* architecture—now the neorationalists were going to *implement* it.

The intuitions and good will of classical rationalism had been frustrated by the rudimentary nature of its analytical tools and the intuitive nature of its methods. The Ulm school would train its students in the methods and scientific techniques suited to carrying out the ideals of the Bauhaus. Set theory, computers, etc., would permit them to analyze problems of design and organize the pertinent variables in a systematic and efficient way. Thus, at last, they would manage to save architecture from the speculative methods of philosophy (where every philosopher seems to question everything and begin from scratch) and make out of it a science where one begins at the point where others have left off.

Building, the largest industry in almost every country, is administered as if it were a candy store. It has a practically flat apprenticeship curve because it lacks any means of evaluating its performance and few mechanisms for incorporating and publicizing new experiences. Each building is a poorly designed "experiment" whose "hypotheses" are neither explicitly formulated nor checked up on.[14]

The eye of the good liberal architect—like that of the good shopkeeper—is not enough when the scope of the problems and the number of demands which must be met grow to present-day proportions. So, architecture ought to become *really* rational; that is, use available scientific methods and techniques to gather the required information, test this information, translate it into a project, and organize the design process as a whole.

To understand actual needs, chatting with the client and consulting Neufert weren't enough. First, because the client is now the promotion firm, not the *user* himself, architecture must develop the necessary skill to provide services to clients who do not have the economic power to choose who is going to work for them. To serve this client who, as Lefebvre said, "is mentioned and quoted but never consulted"[15] it was no doubt necessary to analyze the actual use of spaces and places—not only their "supposed function." Secondly, because even when the client can express his wishes, these do not necessarily coincide with his needs. People usually base their desires on what they already know: they want something better—in general,

more of the same—but seldom something different. Thus, one must discover, in Sommer's terms "what people would want if, on the one hand, they were aware of the whole range of possibilities and, on the other, they understood all the limitations." In the third place, because Neufert gave us the measurements and the average distances required for sitting or moving about, but seldom took into account the measurements, distances, or positions which might turn out to be *psychologically* most comfortable.

Because of all this, it was necessary to make use of studies in environmental and topological psychology, ergonomics, proxemics, etc., which could tell us: what "spaces" or "territories" the individual needs for each activity; what position relative to others is more or less disturbing; what environmental facilities do not demand any additional adaptive effort, etc. In design, facts as elementary as the following had to be taken into account:

—that movement is perceived more strongly by the eye's peripheral vision than by the fovea or macula, and thus an area which demands attention and concentration is better located *in front of*, rather than *to the side of*, an area of traffic and movement (with an adequate use of this effect we can get people to slow down in certain areas of a turnpike by means of a gradual lessening of the distances between the posts at the side of the road);

—that the continued convergence of the eyes on an object which is less than about 4 feet away produces marked muscle and optic nerve fatigue;

—that two people face-to-face tend to communicate with each other less than if they are seated diagonally (the chairs situated at an angle of 90 degrees, or at the corner of a table, allow "the eyes to escape the other's face easily" when the individual needs to, making possible a more relaxed communication [see figure]); that, the border represented by a little table between two seated people calms and thus fosters interaction;

—that a rectangular room, thanks to the difference between its two axes, is the one which most easily allows for the orientation and organization of its space;

—that the rooms that produce the most anxiety and fatigue are the almost-rectangular, almost-circular, or almost-whatever-shape ones, since the individual makes an unconscious effort to see them as a regular, known shape;

Seating Position at the Table
and Its Effect on Conversation

$FA = 6FB$

$FA = 2CB$

Verbal exchange between the people placed at the corner (FA) is six times greater than that of those located across from each other (FB) and twice that of those seated side by side (CB).

> —that two individuals placed less than 10 inches apart can fight or kiss, but any other less intimate activity is uncomfortable at this distance;
>
> —that in a European cultural setting, looking directly into the other's eyes seems to violate intimacy if the distance is less than 6 feet, etc.

T. de Quenetain has described how, based on a detailed analysis of these spatial and positional needs, a zoo was built in Antwerp where the animals "liked" to be (a possibility which no doubt must have excited the Skinner-style "social engineers"). Also, in the Paul Riviere psychiatric home, by locating the patients' quarters ("the nest") in close, "safe" areas, and placing the dining rooms and recreation rooms ("the hunting ground") at a distant point that was somewhat hard to get to, they got the daily going and coming from one place to another—from One's Own (the House, the Familiar) to the Other's (the Insecure, the World)—to act therapeutically to reconnect symbolically the two poles of life which for many patients had been separated by a chasm.[16]

Knowledge and information about the practical needs which buildings have to meet were not enough. One had also to find methods to arrange this information and translate it into a form that would re-

spond coherently to it. All the methodological proposals which have appeared in recent years—by Archer, Maldonado, Assimov, Alexander, Rittel, etc.—stemmed from the awareness that the *objectives* of functionalism (fit the form to the functions) required not only a deeper study of the functions, but also some more precise and rigorous *methods* to find the form suitable to them.

I will not linger now over those methods, with which I have dealt elsewhere. Suffice it to say here that all of them aim at carrying out practically the functionalist ideal in a new world whose complexity, pace of change, and scale require a global solution like that proposed by operations research and systems analysis. So, architecture should be understood as a system, distinguishing with total precision its *objectives, context, resources, components,* and *direction.*[17] The scale and scope of capitalist enterprise was sufficiently small for it to continue considering its objectives to be the maximization of production: to produce more and better machines, buildings, or whatever. Today, however, we know that the best System is the one that maximizes, not this particular production, but rather the amount of *production* + use of existing materials (*context*) + use of available work force (*resources*). Functionalism's axioms (economy, adaptation of the available materials and techniques, etc.) should thus be carried out with the Systems Approach. Also, the *objectives* that functionalism proposed could now be established with complete rigor and breadth. Systems analysis could even evaluate the alternatives which the different partial systems (architecture, traffic engineering, etc.) each take as their objective and try to solve on their own. Railway schedules tell us the schedules of the trains, but not if it is more economical or comfortable to take a plane or a car for a certain trip; architecture poses the problem of building houses, or windows, or neighborhoods, but seldom does it ask whether the best solution to a given problem was really a house, a window, or a neighborhood. Also, the functionalist principle that the building must be adapted to its context could be broadened by taking into account not only the given context, but also the context which will come about from the introduction of the new element. Just as in particle physics observation affects what we observe, in architecture building transforms the environment in which we build. The environment to which a skyscraper should be adapted is not the present one, but rather the one which

will result from the very presence of the skyscraper. The study of systems, finally, would even help us to "filter out" or "forget" information when necessary. We all know that there is a sort of principle of entropy of information according to which "information hides information." Too much information can paralyse us when we don't have the instruments (from archives to filing cabinets, computers, etc.) available to handle it. The Systems Approach would thus help us to actually achieve the rationalist ideal of a design that takes off from an exhaustive knowledge of the needs which the form must meet, offering us in each case the "maximum of information that we can handle," no more and no less.

In short, for this trend, the rationalist ideal of achieving a "good fit" between form and context, function and form, requires today a systematicity and rigor which historical functionalism lacked.

Now, I have not included in this section about neorationalism what is today known as "neorationalist architecture" in Italy, Spain, and the U.S.A. And the reason, as I explain elsewhere, is that I am referring here to the rationalism of the attitude, not of the resulting form or style. This second neorationalism may grow equally out of a structural approach or an historical approach.

8. WILD REACTION: NEOFORMALISM

The complementary reaction points out that a perfect fit is a bad fit, thus emphasizing the importance of "secondary" or symbolic functions, of "historical" meaning and the "openness" of the forms. It doesn't criticize functionalism for the insufficiency of its method, but rather for its limited and limiting concept of function.

"However far the existence of a pedestal and a capital is due to more than mere need," wrote Hegel about the classical column, "still we are not to regard them as a superfluous ornament."[18] What was this something that lay between, or beyond, the rigid choice between "need" and "ornament"?

The column, Hegel went on, served to create the agile, analytic, and autonomous image of the Greek temple, in opposition to the stanchion which is "planted directly on the ground and ends just as directly where the load is placed on it." The column, thanks to the pedestal and capital, transmits the sensation that "its beginning and

ending . . . [are] implicit in [its] very nature." Even the "propor-
tion" of the columns (their modulus equal to half the radius of the
base) was meant to underline its strict function as a support: "the col-
umn should neither appear compressed nor rise so high and easily
into the air as merely to look as if it were playing with its load." [19]

Between the useful and the ornamental, between the functional
and the meaningful, there doesn't seem to be here the opposition
which the rationalists had too quickly established.

Reacting to this supposed antithesis, architecture in the sixties tried
to regain for the concept of function the richness and ambiguity
which had been forgotten during the preceding period. This broaden-
ing of the concept of function was carried out on a historical basis in
Italy and Catalonia, and on a systematic basis in France. In the
Anglo-Saxon countries it had a more hybrid and complex basis, a
mixture of science and pop culture in the United States, of neoclassic
historicism or vernacular inspiration and futurism in England.

In Italy, inspiration was sought in historical forms as a reaction to
an international "World's Fair Pavilion" architecture (an aseptic,
nearly surgical architecture now devoid of all meaning, even of the
intense puritan message of early rationalism), which "handled" a
church the same way as a garage. Faced with rationalist sincerity and
anti-ornamentalism, architects turned to a new mannerism and de-
tail-ism, to an insistence on profiles, to an "expressive" exaggeration
of elements, to a display of stylistic hallmarks. The Baroque, Man-
nerism, Modern, and then Neoclassicism or Functionalist "style"
served as an inspiration in Milan or Barcelona for recapturing certain
forms and functions which modern architecture had forgotten. Even
in the cases of the most obvious "revival," the use of classical sty-
lemes had then the value of denouncing the deficiencies of the archi-
tectural language in use, which sacrificed the most immediate and
less codified needs for the sake of purely "rational" ones and which
inhibited or caricatured practical *uses* in the name of *functions*. The
reintroduction of historical styles was certainly effective while it
served to denounce this deficiency and to announce the need to
broaden the modern formal repertoire. Very quickly, however, this
denunciation was taken as a "solution," thus initiating a monotonous
repetition of historical forms, as previously there had been the "func-
tionalist" repetition of "free plan" or *pilotis*. The scope and speed of

media has nowadays caused neohistoricism to be followed by its own international style, a dogmatic and conventional one, much sooner than functionalism was followed by its own.

But in the best of cases the new architects did not try to recapture the historical forms themselves so much as the "deep structure" to which they were a response. Alexander has written,

It is vital that we discover the property of old towns which gave them life and get it back into our own artificial cities. But we cannot do this merely by remaking English villages, Italian piazzas, and Grand Central Stations. . . . [As is the case with Jane Jacobs, who] wants the great modern city to be a sort of mixture between Greenwich village and some Italian hill town, full of short blocks and people sitting in the street. . . . Too many designers today seem to be yearning for the physical and plastic characteristics of the past, instead of searching for the abstract ordering principle which the towns of the past happened to have, and which our modern conceptions of the city have not yet found. . . . To combat the glass box future, many valiant protests and designs have been put forward, all hoping to recreate in modern form the various characteristics of the natural city which seem to give it life. But so far these designs have only remade the old. They have not been able to create the new.[20]

As we might expect, people long today for the characteristics that made the medieval cities a much more human reality than the "modern city": they long for the ecological continuum which, despite its walls, or perhaps precisely because of them, existed between city and nature; the irregular and twisting streets that radiate from the highest point out to the walls; its overlapping of domains and integration of functions; the city's distribution into guilds and the relative arbitrariness of its layouts; the so-called "organic" nature of its structure and growth. Everything, in short, which was sacrificed with the rationalist plans of the Renaissance, so perfectly symbolized by the "ideal city" of F. de Girgio in the Ducal Palace at Urbino. And quite coherently, Rossi longed as well for the "monumental" character of Renaissance cities while others dreamt of the "hierarchical," ordered, and meaningful character of the early bourgeois cities. But with the pure formal "revivals" the same thing happened as with the political revivals of medieval "organic" institutions such as the one which has ruled Spain for the last forty years: their *recovery* amounts to no more than their *degradation*.

To sum up, in a tradition of progressive recoveries—the neo-Gothic of the engineers, Berlage's neo-Romanesque, the neo-

Medievalism of Webb—the historicism of recent years has been a logical reaction against a limited conception of function tied to another stage of capitalist development.

In France, the reaction has mainly focused on understanding the meaning-value of objects, commodities, and artifacts. Barthes pointed out, and it was later endlessly repeated, that "every object ends up being a sign of its own use": stairs a sign of "going up," a chair of "sitting down," etc. Baudrillard emphasized that even the "functional" object (chair, home, etc.) operates more as a *sign* (of difference, efficiency, modernity, etc.) than as a pure useful thing. Against the *mechanical* pragmatism of the functional period, a period of consumption, welfare, and status produces a *semantic* pragmatism in which the signifying role always outstrips the functional role. For Moles, the affluent society confronts the austere and ascetic ethics of functionalism, and the synthesis between the residual but still deeply rooted "moral" need of functionality; and the present-day economic demand for diversification, stylization, and exuberance gives rise to *neo-kitsch* products that incorporate a supposed functionality into their symbolic pirouettes. Thus arises the *gadget*—the olive-pitting knife, the six-speed electric toothbrush, the scissors for opening boiled eggs, the lighter-penknife-keyring-flashlight, etc.—in which the designer creates a frenzy of functionality that ends up negating itself and becoming a pure sign.

From the point of view of a culturalist semiology—more flexible than the "behaviorist" one of the traditionally American analysis of these subjects—the symbolic value of the elements that make up the rhetoric of modern bourgeois housing has been under study: wood, marble, fireplace with or without a working flue, suburban "ranch house" decor, etc. And, we might even add, the split-levels, eat-in kitchen, non-picture window, "informal" atmosphere of the house of every architect proud of his name. There is certainly a popular kitsch, but one should not forget that there is also an *intelligentsia* kitsch.

In a country with a strong petit bourgeois tradition, Moles and Baudrillard had a fruitful field for analyzing:

> —the *array* of objects displayed in a house as a manifestation of its balancing of aspirations and resignations, mobility and social inertia;

—the *functional object* as an excuse or moral alibi for the object ("the object should be *good for something*") as against its old aristocratic condition as an undisguised sign of prestige;

—the *gadget*, or ultrafunctional and absolutely useless object, as a symbol of technological modernity as wastefulness masquerading as practicality;

—the *saturation* and *redundancy* in the distribution of furniture and objects as a domestic rhetoric of a class whose fundamental values are inheritance, conservation, protection, and transmission of a domesticity infinitely emphasized by the curtain that covers the peephole or the window, or by the mat that covers the tablecloth, that covers the glass that covers the table, etc.;

—the *antique* as an instrument of social or cultural legitimation, as a token of authenticity;

—*hygiene* or *domestic cleanliness* as a compromise between the ostentatious possession of things and an *ethos* of work and effort which legitimates them as "objects of an ongoing task, of a daily domestic sacrifice."

The effectiveness of these analyses has been indirect but definite. In introducing concepts with which to understand the rhetoric of ownership and arrangement in petit-bourgeois housing, they also called attention to the mystifications on which the present conventional forms of use and consumption are based. But they also served, and this is much more important, to heighten the designer's awareness that this "rhetorical" element is a constant in all formal or architectural consumption; that it can vary in its contents (that it can be a housewife's or an executive's rhetoric) but that it is a constant ingredient of any demand for forms or living spaces.

In the United States, paralleling the pop explosion and as a reaction to a schematic and compartmentalized architecture and urban planning (the residential zone vs. the commercial center; the business area vs. the recreational area; downtown for blacks and poor people vs. the suburbs for the rich, etc.) we also find this return to ambiguous and complex forms. But whereas in Europe the storehouse where architects went for inspiration was history, in the United States it was enough for them to "recapture" many of the elements which actually shaped American life and which, although until then they had been its embarassment, quickly began to be proudly shown off. What in

Europe was achieved by returning to the past, could be realized in the U.S. by reevaluating the confusion and ambiguity of the spaces which grew up around "the Strip": "Me and my big white car are sailing down the Strip and the Boomerang Modern, Palette Curvilinear, Flash Gordon Ming-Alert Spiral. . . ."[21]

Against the snobbery of *rejecting* there arose in the sixties a new snobbery of *acceptance* of the most bastardized and popular forms of urban, commercial, or television folklore. American highbrows began to lose their complexes about not having a Florence, and to defend the subtle esthetic charm of Las Vegas or Disneyland. There was a new poetics of plastic, neon, the hamburger, popcorn, fancy chrome—the new soda-pop culture, a culture whose countercultural *criticism* was nothing but the other side of its pop *exaltation*.

So the American *intelligentsia* rediscovered the charm of plastic birds that sing through little loudspeakers, of Christs sweating artificial blood in the cemetery in Los Angeles, or of the hunting of a fake hippopotamus with blank cartridges in Disneyland. The storehouse of images of the *fair*, images of traditional mythopoeic power, was now restocked. To the world of clowns or carnival tents was now added, with all the force of novelty, the new ingredients of Wonderland: "a country which exists as a mystery and as a sign."[22]

In this context, though not here alone, different reactions to architectural rationalism arose. In their article, "Complexity and Ambiguity in Environmental Design," Kantor and Rapaport asserted the need to return to ambiguous, complex, and allusive forms. Their line of reasoning, if I understand them correctly, is as follows:

1. In the first place, complex forms permit different levels of understanding—we can attend to their relationship, to the connections of the parts to the whole, the contrast between the individuality of its elements and total unity, etc.—while simple and rational forms are too "forthright" to allow more than one level of attention.

2. But it is precisely the possibility of its being *recreated* by the viewer that characterizes the work of art. (It is not by chance that the word "recreation" means both "pleasure" and "reconstruction".) One of the peculiar pleasures that art-works provide us is the possibility of changing or jumping between the various levels: of going from the level of the fable to that of the writing, from text to texture, from texture to sound, and so on.

3. This possibility of recreation, on the other hand, is what *maintains* the attraction the great works have for us; what makes it possible to return to them time and again without "using them up." The forms whose meaning is too evident—rationalist forms or popular songs—" "go down" easily, but we quickly get fed up with them.

The maintenance of psychic balance, on the other hand, requires at least a minimum of sensual impact. It has been pointed out that, below a certain rate of sensual input, we feel a sensory deprivation, a hunger for stimuli, which even has verifiable somatic symptoms when we don't receive a minimum number of strokes—of "contacts" or interactions.[23] As McGill's experiment spectacularly shows, individuals artificially isolated from any sensation by darkness and environmental soundproofing (soft leather gloves that prevent all tactile sensation, an absolutely soft chair, white noise, etc.) quickly begin to suffer hallucinations. We can thus think that an absolutely "functional" world which never "resisted" our actions would certainly deprive us of this important sensation of safety and balance which we only get from confronting a physically resistent and intellectually opaque world.[24] All control over the environment implies certain risks, as it alters the balance we maintain with it. The technological revolution (which turned the levers and handles that *we used to hold in our fists* into simple buttons that we *push,* or even into photoelectric cells that automatically respond to our presence) involved a sublimation of our contact with reality and, in more than one sense, the disappearance of an important factor of control and libidinal satisfaction.[25]

We ourselves are capable of satisfying the majority of our needs, and it is proper that we, and not a "well-designed environment," do respond to them. Psychologically, a good environment is not therefore a "surrounding which satisfies all my needs" (the eating machine in *Modern Times,* or the chair that massages my backside to keep up my circulation while I'm reading), but rather an environment which will permit me and help me to satisfy them myself. Functionalism or dogmatic rationalism—as well as their present-day technological and futurological translations—forgot that the resistance presented by objects and places was an important aspect of their very functionality: "that the daily and hourly process of adaptation is the very process of

life; that a man who no longer takes charge of satisfying his needs himself stops the process of adapting himself; that an organism that is not adapting is no longer alive."[26]

We should add to these psychological needs for *resistance*, which only complex and ambiguous forms can satisfy, the desirability of a certain *perceptual opulence* in forms and environments. Except in peculiar situations, what we least want and need when we turn a corner is to find an exact duplication of what we have just seen on the previous block. Between the *perceptual chaos* of certain environments shaped by commercial competition and the *perceptual poverty* of excessively "functional" and "designed" forms which quickly bore us, there exists an *optimal rate of variety* (the Ramblas in Barcelona, Italian piazzas, Times Square) with certain perceptual landmarks that permit us to orient ourselves without also dominating and shaping our perception totally.

Thus, the variety, novelty, and unpredictability of forms or environments has a value equal to, and complementary with, its clear structuring and "legibility."[27] An easily and totally legible environment also quickly becomes totally unendurable. Thus, it is important to shape an environment—a street, a neighborhood—*in which one can find what one was not expressly looking for;* one in which the random and unforeseen has not been destroyed or has been recreated. An environment with an optimum level of chance elements, of unprogrammed alternatives, of surprising experiences. The orthodox rationalist solutions shaped zones which were perfectly re-si-den-tial and unmistakably com-mer-cial in unendurably de-sign-ed cities where all intercourse and synergy among spheres was excluded on principle. The "intensified neural stimulation" (of the turn-of-the-century *Grosstadt* described by Simmel) is now concentrated in merchandise: in the department store and the shop window. The urban net even loses the stimulating value that the classical bourgeois city had. Perfect background for merchandise, the city becomes a monotonous network whose only function is to emphasize this merchandise and optimize access to it.

Conscious of this limitation, young American sociologists try to explain, criticize, and propose alternatives to the creeping homogenization and isotopy of their environment. For Sennett, the residential urban fabric lacks any quality precisely because it was not born out of

the conflict and negotiation between producers, residents, pedestrians, etc., but rather out of each citizen's search for his "own identity" among his peers. Sennett even proposes, as a means for cities to grow in a meaningful way, *the suppression of external and bureaucratic control.* Only then will people have to accommodate themselves to each other, adapt, struggle, push and be pushed, and the resulting city would again acquire the interest and intensity of primitive cities. In this same line of thinking, Slater has criticized the youthful tendencies toward "communes" where, as their parents in the suburbs, they are also seeking an unequivocal, sheltering environment, surrounded by their peers and without the conflicts inherent in places where groups and functions overlap. The city will not have "quality" so long as safety and other services exist a priori and do not demand to be won, agreed on with a neighbor, or bargained for with the shopkeeper. How can we hope for any life at all in the neighborhoods of an obtuse middle class which entrusted its morality to policemen and its fine arts to impresarios?[28]

On these and many other considerations can be based a defense of a less "rationalist"—and therefore more psychologically adequate—environment where the edges are blurred, the domains overlap, signs multiply, barriers are broken, environments are elusive and the connections not strictly unequivocal.

Bennett's experiment suggests the existence of a biological, and not merely cultural, basis for such needs. The experiment consists of placing two colonies of rats of equal "intelligence" in two environments: one very simple, clear, and regular, and the other very complex and stimulating. He placed them, so to speak, in (1) a "rationalist," functional, symmetrical, and monotonous cage, and (2) a "Baroque" or "decadent" cage, full of labyrinths and passageways, turnings and arabesques. Well, at the end of a month he was able to show that the "decadent" rats had developed their perceptual and motor intelligence much more than the "functionalist" rats. Buytendijck's experiments on the orientation of rats in space, and Yerkes' with earthworms, only add cogency to this thesis.[29]

In the abovementioned context of acceptance and exaltation of the chaos of the American environment one should mention Robert Venturi's now classic *Complexity and Contradiction in Architecture.*[30] According to Venturi, in the shaping of any object, environ-

ment, or building we meet *conflicting demands* on different levels (function / form, inside / outside, "objectuality" / "utility," consumption value / instrumental value, etc.) which architectural rationalism tried to solve *by eliminating* one of the two demands or subordinating it to the other. The early Alexander, trying to broaden and implement the rationalist project, suggested a method for making these conflicting exigencies *compatible*. Venturi proposes exactly the opposite: we shouldn't eliminate contradictory demands, nor try to make them compatible with each other, but rather the conflict should *be made apparent*. It's not a question of solving the internal contradictions of architecture, but of making them evident.

Venturi takes a perverse pleasure in the hybrid and redundant, the complex and articulated, the ambiguous and ornamental. Against the puritan and functionalist passion for alternatives (either . . . or) he enjoys conjunctions (not only . . . but also) and attacks a rationalism which sacrificed *richness* to *clarity*. Venturi reclaims the traditional ambiguity and wealth of meanings of Baroque architecture. The pilasters of Bernini's Palazzo "Propaganda Fide": are they really pilasters (positive) or the simple separation of panels (negative)? Are they figure or background? In the Pius V Chapel in the Vatican, how high does the wall rise and where does the vault begin? Using Kenneth Burke's concepts of "plurality of interpretations" and "planned incongruity," Venturi takes it that the architectural element is and should be perceived both as form *and* as structure *and* as texture *and* as material *and* . . . The heterogeneity should thus be integrated, never broken down or disarticulated into its simple elements. Against rationalism's tendency toward segregation, which assimilated a space to each function and a function to each element, he insists on the value of ambiguity, contradiction, and contrast: Le Corbusier's Ville Savoie (an externally simple and internally complex form); the Mannerist elliptical plane of San Andrea Quirinale, etc.

Here I will limit myself to only one aspect of Venturi's critique: his defense of the formal principles of the Baroque façade and of the inside / outside relationship it brings about. Functionalist orthodoxy required continuity between the inside and the outside, congruence between the interior and the façade. The axioms of transparency, sincerity, etc., made the façade a faithful expression of the interior: an announcement or notice of what would be found within. And one

can't deny the progressive value which this principle had from a
social point of view (in breaking with the inhibited and scenic con-
ception of bourgeois housing) and from a technological one (in ex-
ploring, and therefore being "a sign of," the new media—heating,
glass, separation, etc.—that permitted the façade to be an expression,
and not a weighty disguise for the inside). Nor can one doubt the for-
mal or esthetic value of flowing space, or of the revolutionary façade
of Mies's Barcelona Pavillion, where the parietal surface is in glass
and the partition wall which crosses it perpendicularly is massive and
consistent, thus stressing the continuity of the external and internal
space. The Barcelona Pavillion was by itself an entire formal, techno-
logical, and ideological manifesto, of what new architecture *could*
make and *wanted* to make.

But this clarity, unity, and continuity of external / internal space
often had more programmatic or ideological value than functional
value. Its validity could be questioned even within a functionalist
perspective: the limitations of its solution of the house-street relation;
its lack of understanding of the "expressive" differences between a
monument and a residential building; its refusal to see the city as a
hierarchy of spaces. The rationalist solution had focused the problem
on the very limited context and scale in which the problem was put
to the bourgeoisie of Simmel's *Grosstadt*.

But one could question as well the idea that the relation of "trans-
parency" was the only relevant relation between the inside and the
outside, between an object and its appearance. The façade, Venturi
holds, ought not be only the *expression*, but also the *organization* and
transformation of the interior's complexity (or, to put it more generi-
cally, of a smaller and more qualified space) in a new "gestalt" or
unity which should connect and coordinate it with the different scale
and qualification of external space: the street, the neighborhood, the
city, etc. To the obsession for *unity and continuity* of space, then, he
responds by insisting on its *hierarchy and articulation*. The frontal
Colonnade of Saint Peter's doesn't have the function of externally
"showing" the series of intricate passages, rooms, and anterooms of
its interior, but rather precisely that of camouflaging this labyrinthine
interior and giving it the outward, coherent, and homogeneous
image of a "Single, Catholic, Apostolic, and Roman" Church.

"The concave façade in the Baroque church," writes Venturi (p.

Interior

FAÇADE

Public Space

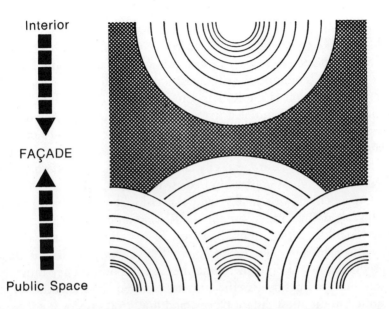

86), "accommodates spatial needs that are specifically different on the inside and the outside. The concave exterior, at odds with the church's essential concave spatial function inside, acknowledges a contrasting exterior need for a pause in the street. At the front of the building outside space is more important. Behind the façade, the church was designed from inside out but in front it was designed from the outside in."

The façade thus appears as the confluence and resultant of two opposed forces—like the meeting of concentric waves in a pool. The façade is not the simple exteriorization of an internal space, nor a brief pause that makes an exterior space before going on to "interiorize itself," but rather it is the product of the collision of two systems of forces and demands with opposite signs.

9. CONCLUSIONS

Image vs. Form: Baroque Spiritualism in Advanced Capitalist Society

No doubt this conception of the façade is much more dynamic and realistic. As a product of the contrast between external and internal forces, the façade ceases to be an *element* and becomes an architec-

tural *event*. But the question is now a new one. What did foster the discovery of this complexity of functions in the Baroque period? And what has helped to rediscover it in our age? Is this demand for façade as an event, common to both ages, a mere coincidence? I doubt it.

The expansion of the Roman Empire, the Baroque Church, or the Modern Capital stimulated new formal and symbolic demands which previous periods, more strictly urban and bourgeois, had not experienced. The eupatridae in Athens, the Florentine patrons, or the intelligentsia of the European city at the beginning of this century, fostered an "in-group" art addressed to their peers. Theirs was a civic art, concerned with quality and the cultural value of its products. The role of the "artists" among the Roman emperors, Baroque popes, or American corporations, however, is very different; their audience is much broader and the problem that arises now is not that of producing but of publicizing the message of power. They must make sure that the message is efficiently transmitted, understood, and consumed in the most distant places, and that it prevails over concurrent messages (Protestant "competition" for the Baroque Church, business "competition" today). The *forms* and *signs* of bourgeois art are transformed into *images* and *symbols*, whose function is to produce a known effect and reinforce its impact on the potential consumers at home or abroad.

We see that a change of territorial scale and a broadening of the audience brings about a change of emphasis (from *production* to *consumption* and *promotion*) and that art responds to it by a change from *form* to *image*. Below I will try to clarify these terms further. For now, it is enough if we have an image (I see myself writing "image": no doubt I feel I am addressing people who do not share many of my codes . . . and whom I want to convince), a schematic image of the process:

Let's begin with Rome. The same territorial expansion that demands the creation of a *jus civilis* and later on its extension with a *jus gentium*, the same expansion that makes the Roman Via Augusta stretch all the way to Barcino in Spain, fosters the unification and illusionist utilization of the Greek formal repertory. The Romans will keep using columns and classical orders, but their new political function will make something very different of them. The needs of unification and of creation of a coherent image can be seen everywhere.

The civil heart of the Greek cities—the *Agora* with its irregular shape, porticoes, and with no public buildings facing it—turns into the unifying political center of the Empire: the *Forum*. The scale and symmetry of the Roman Forum filled with public buildings[31] warns us already that we're not dealing with a town square, a market or meeting place for citizens, but with a symbolic center for patricians' decisions and for the wanderings of the colonials. In theater construction, Greek models continued to be imitated, but now the orchestra and choir have only a decorative function, since the stage centralizes the action, as is appropriate to a spectacle that has turned from participation into mere entertainment (see pp. 180 ff). Greek *Ethics* becomes *Law*; the *Theoria*, or individual vision of the ideal truths of the Athenian democrats, becomes *Religio* (<*religare*, 'to tie')—commitment and the instrument of social cohesion. Therefore, Celsus can with all accuracy accuse the Christians of ir-religiousness in his *Epistle against the Christians*.

In this same sense the idealist, analytical, and discrete architecture of the Greeks is unified by the Roman arch and vault.[32] The Romans thus create a continuous space; they integrate time into the perception of the building—of a building not to be "seen" as a sculpture but "walked around"—and they utilize the Greek orders in a picturesque and dramatic way. The Empire had to unify internal as well as external space with a view to making them harmonize; it had to use the classical orders as an instrument of cultural legitimation. As in the Baroque period or in the second half of this century, forms have

taken over the creation and popularization of a public and coherent "image."[33]

And it is for analogous reasons that the Baroque period transforms Renaissance architectural language along the same lines. The Baroque city is no longer the more or less rationally organized addition of palazzi or singular buildings. The individualistic rationalism of the Renaissance here becomes political styling. In the Quirinale piazza there are no longer any closed, symmetrical, and autonomous elements. The unity that gives the norm is no longer the building, but the city, so the buildings are placed so as to create a conjoint, public effect. The symbolic demands of the Capital (national, ecclesiastical, etc.) dominate here those of the civil bourgeoisie.[34]

Thus, the Baroque implies a new synthesis, and in this regard we should not follow Venturi when he speaks about the "contradiction" and "ambiguity" of the Baroque. In the Baroque there is no contradiction or ambiguity; on the contrary, it represents the elimination of the ambiguous and contradictory character of Mannerist art and architecture. Mannerism, still halfway between merchants and emperors, shows the contradiction between the decorative and the structural, between each stone individualized by means of *rusticatio* and the building as an ensemble (Giulio Romano). The Baroque unification of the elliptical floor or cupola, its elimination of the supporting cornice, and the complete integration of nave and cupola (as in San Ivo alla Sapienza), mean the triumph of a new coherence: the coherence, decisiveness, and force of Santa Susanna as against the blurriness and ambiguity of the Gesù (see figures).

In other words, the form, which degenerates into "manners" during Mannerism, is unified once more under the aegis of the Image and the Visual Effect. "The only judge of proportion," Guarini tells us now, "is the eye of the viewer": a viewer's eye which had already been taken into account in classical art (e.g., in the "deformations" that were introduced into the symmetry of the Parthenon) but which had never polarized Form so long as it did not become Image.

We have seen that this complete dominance of *effectism* over *formalism* responds to the demand for communication and persuasion that appears at certain thresholds of territorial expansion. That is why, as much in the Baroque as in the present day, the emphasis on

The Gesù

creation or production is displaced by the emphasis on sales, advertising, and public relations. Selling the Counter Reformation, or selling washing machines; propaganda for the faith (this is the period when the term *Propaganda Fide* is coined), or propaganda (i.e., advertising)

Carlo Maderno's Santa Susanna

of goods: in both cases the accent is displaced *from the product and its form onto the consumer item and its image*. The "truth" of form is not now in its past or present but in its future: in the image of it that must be created in the prospective consumer. From an "aristocratic"

formal morality (Nietzsche) based on the *provenance* we have thus gone to a "bourgeois" morality that anticipates and is legitimized by its *consequence*.

In a style very much in tune with its object, Rafael Sánchez Ferlosio has accurately described this baroque transformation of spirituality into apologetics; this shift from production to the commercialization of spiritual goods.

The apologetical spirit can be seen in the turn of architecture, especially since Buonarroti, in the . . . otherworldly organization of façades in the Jesuit Baroque, oratorical façades, evasive, vehement, gesticulating, histrionic. Build a better mousetrap and the world beats a path to your door; the period is no longer sure of the treasure it is guarding—like a Roman church, like the mosque in Cordoba, with the sublime, pensive silence of its portals—and it goes out the door to hawk its wares in the street. They are a holy orator's emphatic, dramatic, imposing gestures that point to the loss of faith and its degradation into propaganda: the wings of a divided gable are the arms of a preacher, carnival barker, shrieking, "Come one, come all! Come to the big top, the thrift shop of redemption!" [35]

It would probably be a good exercise in pseudo-etymology to derive "baroque" from carnival "barker"—or vice versa.

This illusionism contrasts with the formal and productive concern of "archaic" periods of the bourgeoisie: the times and places in which this class sets the boundaries of its dominion over the sector it rules, controls, and inhabits. In Athens, Florence, or Amsterdam, the ruling class knows and recognizes itself in a play of forms which are at the same time material production, personal expression, and social manifestation. The great gesture or boast is unnecessary because people don't talk across a great distance; nor is it a question of persuading anyone, but rather of dialoguing within the group formed by a constituent bourgeoisie. The literature and art of these periods wants to praise, as Martial reminds us,

fields not unkindly, an ever blazing hearth; no lawsuit, the toga seldom worn, a quiet mind; a free man's strength, a healthy body; frankness with tact, congenial friends, good-natured guests, a board plainly spread; nights not spent in wine, but freed from cares, a bed not prudish and yet pure; sleep such as makes the darkness brief: be content with what you are, and wish no change; nor dread your last day, nor long for it. [36]

This is the serene exaltation of everyday life, averse to all artifice and ostentation, as befits a class not yet shaped by "nobles proud of

their privileges" nor by "an oppressed agricultural people" but rather, as in Holland during the Reformation, "by inhabitants of cities, hardworking and honest burghers" of whom Hegel could draw a beautiful and accurate portrait:

> This loyal, comfortable, homely bourgeois type: . . . self-respect without pride, . . . piety without the mere enthusiasm of a devotee, but instead concretely pious in mundane affairs and unassuming and content in its wealth. . . . This sensitive and artistically endowed people wishes now in painting too to delight in this existence which is as powerful as just, satisfying, and comfortable; in its pictures it wishes to enjoy once again in every possible situation the neatness of its cities, houses, and furnishings, as well as its domestic peace, its wealth, the respectable dress of wives and children, the brilliance of its civil and political festivals, the boldness of its seamen, the fame of its commerce and the ships that ride the oceans of the world.[37]

"The ships that ride the oceans of the world": In this last phrase, Hegel unconsciously points out the precariousness of this classical bourgeois balance which was everything but homeostatic. As Aristotle had already understood,[38] in the business and economic system of this hardworking class lay the very germ of the imperialism which was to destroy the urban framework of bourgeois classicism: money's only homeland, Marx said, is the universal republic of businessmen. Once the empire and the global market were born, the political or commercial Image became the main object of attention: art thus shifted from production-oriented form to promotion-oriented image.

Modern propaganda is a more secularized but no less spiritualized rhetoric than the Baroque kind. The concern for consumption is chronically idealist, although in a different sense than Hellenic idealism. It is never a question of a formal or verbal hymn to the virtues of a concrete product, but rather a propaganda of the symbol, of the universal, which is embodied in the concrete product. That's why our promotion and advertising sells "essential" youth, vitality, love, or beauty, distilled and reduced to its quintessence. The item offered for sale appears as a mere material *pretext* for the authentic *text* or ideal object consumed—sex appeal, informality, congeniality, distinction. We consume a *pure sign, a sign of ourselves* which we assimilate in an act of genuine symbolic anthropophagy: reified, we consume our love itself in the "lover's emblem," our hope for adventure at the Club Méditerranée, our health in the "enriched" product, or our virility in the automobile, cologne, or "man's drink." *Con-*

sumption, "materialist consumption," thus shows itself as a *totally idealist* practice very much like the edifying rhetoric of the *Propaganda Fide*.

Returning to where we started, it cannot surprise us that today's forms respond in some way to this new neocapitalist idealism, thus confronting the immediately previous styles. The new historicisms, "complexities," "participations," and "open forms," of our art are not so much a reply to as a manifestation of this economic system. Not only are commercial "glamour" and schools of "public relations" a manifestation of this system—also the artistic movements which seem to oppose it turn out to be the symbol or metaphor of the functional terrorism of which they are the latest flower: in a way, its most perfect and sophisticated metaphor. As Marx taught us to see that the liberal and secular state was not the negation but rather the culmination of the primitive confessional state,[39] so we can today understand that the mannered digressions and formal protests of modern art and architecture are the most perfect formalization of the "spirit" of advanced capitalism.

Dialectic of Planning and Realization

The synchrony of the two reactions to architectural rationalism (neorationalism [see, p. 85] and neoformalism [see, p. 90]) suggests to us still another conclusion whose validity is not limited to the facts studied here, but rather can be presented as a general hypothesis.

We saw that the attack came from two opposite fronts: some criticized the scanty rationality of its method, and others the lack of sophistication in its concept of function; for some it was not rational enough, and for others not functional in its layouts. From one point of view its lack of method was blamed; from the other, its lack of a sense of history. But on a second look, a much closer relation between both critiques becomes evident: not only are they *opposite* but also *complementary* and *interdependent*.

1. On one side we saw that the new formalism could be understood as a disillusionment; as a reaction (analogous to the Mannerist one) against the most illusory aspect of rationalist ideology. In the final analysis, the optimistic predictions of the modern movement had been

systematically disconfirmed: the world has not changed since then through its influence, nor are the cities planned according to the principles of the "Athens Letter" any better than traditional ones. This explanation of the crisis of the modern movement may be accurate, but it is certainly not sufficient. The reaction of our day has occurred because of what Functionalism did not do, but also as a result of what it *did* do.

2. The new formalism is also an expression of *the loss of ideological interest which necessarily follows the technical fulfillment of a proposal or ideal*: it is the new strategy which the ideological avant-garde adopts when the most reasonable part of the functionalist ideology is no longer an ideal to intuit or propose but a scientific or practical problem in the hands of the new technocrats. Functionalism doesn't need to be invented any more; it now has to be implemented. How were we not to expect that creative minds and sensibilities would become dissatisfied with this mechanical labor of what has already come to be the "normal architecture"?

In the same way that welfare-state neocapitalism "robbed" the European Left of the ideal of welfare, leaving it to seek new more or less "leftist" ideals (participation, de-bureaucratization, etc.), the more or less technical and automatic processes of creating functional forms robbed the avant-garde ideology of its ideal of functionalism. Complementary to this technification there springs thus an ideology of the intuitive, hypothetical, daring, and not codifiable: the ideology of ambiguity and complexity, or historical recuperation and individual participation. We shouldn't be surprised, then, either by:

1. the fact that the fulfillment, technification, and generalization of rationalist proposals of the "modern movement" could only occur later (with scientific, technical, and economic means which they didn't possess);

2. or that, when this actual implementation became a technical problem, those proposals (structural clarity, accessibility, etc.) ceased operating as ideals for the most experimental branch of architecture.

Both phenomena respond to a principle I will formulate in what follows. *Technical implementation:* (1) *comes after ideological proposals;* (2) *ends up with their appeal* and (3) *transforms them into for-*

mal proposals ready to be recuperated at the stylistic level. (It is precisely because of the outmoded, oldfashioned, démodé, nature of the rationalist ideology that Eisman-Rossi becomes interested in a formal rationalist revival. The mechanics of this process is described in the next chapter, pages 120–21).

When the ideological principles of the new architects have been processed by "fourth generation" computers (computers able to process chance variables and indeterminacy factors) we will no doubt witness a crisis in these ideals (and the consequent "stylistic" appreciation of their products). It is clear, though, that the "actualization" of rationalist ideals as well as of new ones has taken place and will continue to take place within the restricted sphere of housing and interior design; within the reduced milieu in which the formal and spatial imagination can still operate. For modern, or even Renaissance, ideals to be "actualized" in our city and environment, it is necessary for many other things to be "actualized" first.

And why not end as we should: with a moral? The most important and useful lesson I think we can extract from it all is that the critiques and mutual accusations, which so often occur among supposed "technocrats" and supposed "avant-gardists" of art and architecture, amount to nonsense. Really, it's not so much a question of two opposed positions as of a choice between two functions or roles. Only a simplistic approach can forget that generalization and automation of the forms in accordance with traditional axioms is as necessary today as predicting and enunciating new principles. Only the crudest professional distortions can make the technocrats forget the fact that they are already working with now conventional hypotheses, and the "avant-gardists" forget that their guesswork is in the realm of research or hypothesis; that the majority of their realizations (as is the rule in all experimentation) will be nothing more—but also nothing less—than "experiments."

FIVE

A CHANGE OF SUBJECT: THE CRISIS IN AVANT-GARDE SENSIBILITY

1. THE "POSITION" OF ART

I HAVE ALREADY indicated that in a sufficiently lax reading of art history, one with loose periodization, the first thing that became evident was not a mere change in the *styles* used but a radical transformation of the very objects made (construction of pyramids or cathedrals, symbolization of gods or representation of domestic subjects, triumphal marches, ecclesiastical polyphony or an intimate sonata). The word "art," under which we group such products, cannot allude to an "intemporal essence" which runs through all of them but rather, at most, a certain "common family trait" which, as Wittgenstein said, unites the different formal games as it does different linguistic games.

The relation of the different arts in different periods is subject (as are all family relations) to broadening, aging, desertion, etc. Some classical "arts" have been absorbed by science or by technique; others have grown old and then have recovered their prestige, like rhetoric, etc. But these changes in position do not only come from the outside—the state of society, the sciences, etc., which absorb, value, or devalue certain arts. Each new generation, each new art, material, or communicative technique also internally "classifies" the preceding one in the double sense of the word. That is:

—it turns it into a "classic," and
—it serves as a criterion from which to "classify" previous art forms.[1]

Even in the short lifespan of the arts or in techniques whose expansion we have personally witnessed we can see how the emergence of a new medium caused the preceding one to be classified as "artistic." The appearance of the cinema transformed the live theater into "culture," taking for itself the function of mere entertainment, and TV "classified" the cinema in the same way. The invention of plastic turned wood into a "noble" material, just as reinforced concrete charged brick and stone with "classical" connotations. This principle is at work equally in the world of clothing and language. The obsolete suit of another era survives as a habit or tag loaded with symbolic connotations. The language that is no longer in use—Latin, for example—acquires a symbolic value especially suited to rituals, oaths, and ceremonies. The phenomenon, furthermore, is not of recent vintage: Apuleius tells us that in Rome the ceremony of launching a ship, *ploiafesia*, had to be performed with the "noble" ritual and language of the Greeks.[2]

In the world of objects it also happens that the dichotomy between biographical-appropriatable objects (the traditional pipe, arm chair, etc.) and technical-impersonal objects (refrigerator, record player, etc.) is also historical and governed by the law of "classification" established by the latest product.[3] The manual coffee grinder could be appreciated as a technical-impersonal object when it replaced the stone mill but today, after electric coffee grinders, it appears to us as a familiar-intimate-appropriatable object, and is even placed on a shelf as a symbol of rusticity or domesticity. The same thing happened with the stove, which the water heater and air conditioning have transformed into a "natural, intimate" object, or with the bicycle since the introduction of the motor scooter. The distinction between objects with which we can identify (which are beautified through use, acquire a patina and are a mark of our own biographies), and objects which are neither personalized nor take on a patina but simply get dirty and deteriorate, this difference is also governed by the law of "classification" based on the last technique—old "technique" always becomes "value." As in the social world, it is always in relation to the "parvenu" that we define what is noble—in relation to the last artifice that we define nature.

So it turns out that not only is style historical, conventional, and variable, but so is the object or activity which in each period is taken

to be artistic; and so is the relation which this activity socially recognized as artistic maintains with other families of activities: religious, festive, ludic, sexual, ritual, sports, exploratory, display, consumer, magic, or political activities. Art is in each period a certain constellation of these activities; a system in which various of them crystallize. Aztec art could be luxury-magic, Baroque art could be political or religious consumption, and so on. The definition of art depends, above all, on the historical position it occupies within the general system of the *satisfaction of needs and the exercise of abilities*. It is precisely on this level where the most significant *displacement* has recently occurred. If we are convinced that the meaning of art, like that of any social practice, is defined by its position in the system of activities, needs, and faculties in operation, it is evident that a change in this position must imply a profound transformation of what art is and what it does.

2. MESSAGES COLD AND HOT:
ART AS A "TEMPERATE" MESSAGE

We have seen that a romantic-Puritan tenet demanded that the *medium* be different from the *message*: that the latter (the meaning) is never exhausted in the pure formal play of the medium (visual, acoustic, etc.) which served it as a vehicle. The signifiers had always to be laden with meanings, thus frustrating the media's temptation to liberate themselves by painting the voluptuous portrait of freedom itself.

Another postulate, as unconscious as it is deeply-rooted, was that art was a practice with its own categories, categories clearly and definitively distinguished as much from (a) those which governed the mere satisfaction of needs, as from (b) the indiscriminate exercise of the primary sensual faculties. Moreover: not only were its categories different, but also they were defined precisely by their position-opposition with respect to the categories of usage and of those of the primary impulses of life.[4]

Between the "cold" manipulations of objects of daily use and the "hot" interest in the objects to which we feel ourselves vitally related, we find the sphere of art, the "temperate" sphere of "disinterested interest," of the Kantian *interesseloses Wohlgefallen*. All art infected by

excessively "utilitarian" categories (popular art), "pious" ones (ecclesi-astical art) or "pleasing" ones (courtly art) went under that guillotine from which only pure or formal values, without any blemish of *en-gagement* at all, escaped and survived. The rest of the excessively "embodied" and "organic" virtues or beauties were beheaded by a class allergic to all corporative, ecclesiastical, or courtly implications.

The contradictory nature of the formulas that crop up in Kantian and Hegelian esthetics is an unmistakable indicator of this attempt to define the artistic "sphere" between the cold and the hot, between life and use: art ought to remain equidistant from the sensual and the trivial, just as the classical Sun (Phoebus Apollo) had to keep his cart an equal distance from Earth and Heaven.[5] Beauty is "the object of disinterested satisfaction; it is the aim of an object which is perceived without the representation of its aim."[6] Beauty is "a love without pas-sion, indeed . . . love devoid of longing and desire."[7]

> "Disinterested . . . interest"
> "Aimless . . . aim"
> "Love . . . without desire"

It is obvious that these definitions protect art from its extremes; they do not let it get *cold* enough to be pure instrumental use, nor let it get too *hot*, to the point where real "natural" interest or desire would enter into its creation or appreciation.[8]

Between the interest with which I adore an image or desire a woman and the disinterest with which I use a spoon or polish it, between pure withdrawal and pure entertainment, there is this supreme disinter-ested interest, namely art. Thus, until very recently, *cold-use, warm-art,* and *hot-life* made three clearly differentiated spheres. Beauty, we were told in the twenties, *"c'est le désirable lorsqu'il cesse d'être désiré pour être, avec quelque recul, contemplé."*[9]

But if what Kant and Hegel say interests us from a sociological point of view it is because *they were right:* because their *theories* were a faithful reflection of a puritan *practice* and *consumption* of art which they bothered to define and categorize. In this period, in fact, art can be attributed only to certain themes and places, and it can give rise only to certain "cultural" responses.

1. On the one hand, art appreciation must break away from "all the *practical* ramifications, which otherwise connect us with the things of

the world, and [bring] them to us in an entirely *contemplative* way." [10]

2. But on the other hand, in regard to the objects of our desires or passions, art "brings these present objects nearer to us as ends in themselves in their own particular liveliness." [11]

In either case, art is to liberate us from the "natural" bonds which tie us to things: whether they are the "cold" bonds of everyday *use*, or the "hot" bonds of *desire*. Neither the "distracted reading" which I make of an object in the course of using it, nor the "emphatic reading" which excites my desire, have any naturalization papers in the universe of "esthetic" experience. According to this, the object that vitally interested us was cast out of the area of art in the name of the "disinterested attention" that true art should excite. And the object which interested us "pragmatically" was equally forbidden to the extent that the esthetic object could not, and should not, interest us for any specific reason, but only, and solely, "in and for itself."

Now then, if anything shows up clearly in these theories of art it is the crisis in the social meaning of the art forms whose appreciation they try to categorize. When an art is in a period of ascendancy, its *appreciation* is hardly different from its *enjoyment:* appreciation has not yet become "the critical meaning" nor enjoyment "escapist consumption" or "cultural practice." As Walter Benjamin observed:

The reactionary attitude toward a Picasso painting changes into the progressive reaction toward a Chaplin movie. The progressive reaction is characterized by the direct, intimate fusion of visual and emotional enjoyment with the orientation of the expert. Such fusion is of great social significance. The greater the decrease in the social significance of an art form, the sharper the distinction between criticism and enjoyment by the public. The conventional is uncritically enjoyed, and the truly new is criticized with aversion. With regard to the screen, the critical and receptive attitudes of the public coincide. [12]

The distinction which our estheticians felt obliged to make between pleasure and esthetic appreciation is but an index of the fact that they were theorizing about an art whose social meaning had become degraded.

I do not want to discuss the value of the theoretical definitions and the practical delimitation of art during the avant-garde period. All of us appreciate its paintings or sculptures as art, and we can even translate into our own jargon a goodly amount of its definitions.

Thus, we say, with Jakobson, that the appreciation of a message is "esthetic" when the primordial attention is not centered in the *sender* (expressive function), in the *receiver* (communicative function), or in the *referent* (representational function), but rather in the *message itself*. We all agree that, when a work is what we call artistic, the meaningful forms themselves seem to take on a weight, autonomy, and importance that make us forget what they are "for" or "about." The entire third book of my *Teoría de la sensibilitat* is given over to an explanation of this unexpected fact which, of course, is not mere speculation or a product of puritan "reductionism."

If avant-garde art responded to a reality, then what deficiency do its works and definitions have today? Their limitation is none other than the material translation that they made of this "principle of immanence" and their understanding of it as *the conquest of a field proper to art*, instead of seeing it as what it really is: *the opening of a new dimension in any field*. They thus understood this formal autonomy or pregnancy as the property of certain human works, experiences, or activities, and not as the inherent possibility of any experience, activity, or work. Their mistake lay in labelling as *esthetic* the activities and objects to which it was thought "legitimate" in their period to apply imagination, and in calling *nonesthetic* those for which their period did not claim or permit this imaginative elaboration—the merely trivial, banal, passionate, instrumental. In fact they confused the artistic *function* with the *themes* that embodied it.

But only a slight displacement in the nature of the themes that art deals with, or in the faculties that are exercised in it, was enough for it to become evident that those themes and definitions responded to *one* possible function, but not to *all* functions of art. And it is symptomatic that, without feeling any restriction whatever, the bulk of so-called avant-garde art since Impressionism found itself perfectly at home in this narrow precinct that confined art to certain themes or objects, and defined its effect as "disinterested interest." [13] But it is no less symptomatic that the artistic forms and experiences that have emerged since the sixties have defined themselves precisely in opposition to these restrictions.

3. CONTOUR AND OUTLINE

The very posing of the problem had changed dramatically. While in the puritan tradition it was assumed that "you never know what is sufficient as long as you don't know what's *essential*," now people began to think (to paraphrase Blake) that you never know what is enough until you know what is more than enough,[14] i.e.: what is *superfluous*. Thenceforth the task of art was no longer seen as the elaboration within the perimeter (*contour* [*dintorno*]) of these "essential" esthetic spheres, but as the forcing of their possibilities and experimenting to the limit (its *outline* [*contorno*]) to find out to what point this esthetic exercise is extendable outside of that temperate zone delimited by the cold usage of tools and the hot, sensual experience of life. It was necessary to test the mettle of this imagination, until now protected in temperate latitudes, which would now run the risk of freezing or melting in other, more extreme latitudes: from design to religion, from political behavior to fashion, from social to sexual relations.

Pop was a perfect example of trying to force the conventional *sociological* limits by working out an art with the (technological, commercial, etc.) elements which earlier had been understood as the very "shadow" of art—as the reality in contradistinction to which art defined itself. *Pop* also forced the *psychological* limits when it disconnected certain qualities of objects from the sense normally in charge of detecting them. And if transgressing the sociological limits seemed artistically *subversive,* this breaking of the psychological bounds seemed eminently *perverse.*

The fact is that we have a *visual* experience of hard and smooth objects, but with soft objects this experience is above all *tactile.* (It's a well-known game to ask someone what 'sticky' means, and then watch the movements of their hands that inevitably accompany their attempt to define it.) Well then, Oldenburg tried to force us to reverse our reading, i.e. to have a visual experience of soft objects and a tactile one of hard objects. Enlarging a hamburger disproportionately, he managed to give us an optical and plastic impression of an object whose acquaintance we make primarily "with our hand," as a tactile experience (as a soft mass that oozes ketchup when we sink our teeth into it); and conversely, making hard objects (machines)

Oldenburg's Typewriter

with soft materials, Oldenburg led us to a tactile awareness of objects that were primarily visual (see figure). Puritanism was concerned with classifying and establishing "clear and separate" compartments; today's interest has switched to the *displacements* and *extensions* of usages, habits, and experiences.

People began to feel that the relative position or ratio of the different faculties, senses, and social roles was something much more historical and contingent than had customarily been thought; and art couldn't help but intervene in this promising project of prolonging, displacing, mixing, or inverting the established sensual "order"; in forcing, above all, the imagination and the reason to the point where both break with intuition and good sense.

As Nietzsche pointed out, the way in which we see and judge

things is only a reflection of the way in which they have been seen and understood in the past (see p. 66). And if this is true, if generalized truth or ordinary evidence are nothing more than the precipitate of past usage, now codified and canonized, it is obvious that a different use demolishes not only *how* things appear but also what they actually *are*. That is why, as Goya was already aware, uninhibited rational or imaginative exploration "creates monsters": anomalous organizations of the data of experiences, new *experiences* that go against "experience."

But this generation of monsters, this radical use of reason and imagination, is not a mere "diversion" today; nor is it an exclusively artistic "duty" either. Healthy common sense is a precipitate of experience in normal, delimited, and relatively stable situations: "jack of all trades and master of none," "time and tide wait for no man," "the leopard cannot change his spots," etc. All its axioms function perfectly while things maintain their relative stability and inertia (which is why proverbs "work" better in traditional agrarian societies than in our cities). But when a violent social change or a general strike occurs, it's no longer certain that the "jack of all trades [is] master of none." (We have already seen that only by mastering everything, only by eliminating the strikebreaker, can the cohesion and energy in the strike maintain itself). As Trotsky had pointed out, only "in a stable social milieu is good sense enough to do business, care for the sick, write articles, head a union, vote in parliament, start a family, grow, and multiply."[15] Today, on the contrary, not only artists but even businessmen feel obliged both "to rationalize" and "fantasize" their solutions.

To produce and sell, the traditional entrepreneur only needed to exploit his work force, modernize his capital goods, and study the market in line with his common sense. Today, the problems have reached a scale and complexity which obliges him (a) to study economics, organization theory, marketing, consumer motivation, etc., on a level of formalization far beyond the good classical industrialist's calculation "by eye"; and (b) to introduce into his business schools courses with titles as picturesque as "Theory of Creativity," "Techniques of Invention," etc.[16]

A rational as well as an imaginative propaedeutics are then required; more scientific or technical knowledge in order to *produce,*

and more imagination in order to *sell*. The tendency to play for keeps and without holding back in both dimensions is not a whim of our era, but a necessity that everyone feels, both in the East and the West, from businessmen to artists, from philosophers to scientists.

4. THAW

But playing for keeps on both levels meant a loss of respect for the areas within which art had been restricted while reason and imagination were kept under the control of intuition or common sense. And so one reached an *impasse: Technological, intellectual, and social development seemed to demand the liberation of reason and imagination, but once they were liberated, they questioned the very system of ends and means they were supposed to "collaborate" with.* How to hope, for instance, that a rigorous *architectural methodology* would prosper without placing in crisis the traditional profession of the "architect"? How to organize a rigorous method or an imaginative approach of "limited responsibility?" This was and still is the only contradiction not resolved by a society that needs innovation but wants at the same time to foresee and control risk. It is also the only contradiction which can still give account of its cultural and social dynamics.

Since the taboos that controlled the free use of reason or imagination had crumbled, a change had to occur in what was understood as artistic or cultural or even productive activity. And, contrary to what is always said regarding the consuming sensibility's lagging behind creative sensibility, it was changes in demand that forced artists, architects, couturiers, or designers to transform the very nature—not just the style—of their products. Among the traits of this new formal demand which forced this change in artistic supply we can mention:

1. Synchronic *diversification* (proliferation of subgroups or subcultures) and diachronic *lability* (rapid changes and exhaustions of styles) of a demand which only imagination allied with technology could supply.

2. *The increasing demand for objects with which participation was possible*: of houses, clothing, works of art, etc., which did not predetermine a specific use (see p. 10). Then art—as, on another level, the

political left—tries to provide what political power can offer less and less of: active consumption, participation. "Quality" and quantity are already set by the technological and political system. To compete on this plane was therefore misguided. Quality and abundance, nonetheless, are the other side of monopoly capitalism which dramatically reduces participation in discussion and decision-making, and it is this active participation that the arts and cultural movements now claim (see p. 27). Today, it turns out to be a measure of a play's artistic nobility if the spectators storm the stage. To say that an art exhibit is good is to say not that people "admired" it, but rather than they "(man)handled" it. Even in literature, people strive to make the texts manipulable, "*scriptible*" as Roland Barthes says. "So that the reader is no longer a mere 'consumer of the text,' he is invited to 'produce' the text himself, out of its scriptability, the opposite of its consumable legibility," as Klossowsky suggests.[17]

Now then, it is obvious that in order to respond to this demand for active consumption, a visionary imagination and a knowledge of the deep structure and means of possible appropriation of these discourses is required which greatly surpasses the requirements for the creation of the traditional "well-made work."

3. *The disinhibition of the demand for signs.* Until recently, the demand for personal, social, or subcultural signs had to be camouflaged or dignified by demand for "usefulness," "beauty," "culture," or similar attributes. Mink "signified" social class, but above all it kept one warm. According to this morality, "the object had the duty of 'serving,' of 'functioning,' and for this reason, of excusing itself, so to speak, for its time-honored aristocratic condition as a pure sign of prestige."[18] Today, gadgets, personal ornaments and belongings, dare to reveal themselves as pure signs, without the need of functional camouflage or cultural styling. Young people are again dressing, as they did before the Industrial Revolution, not in the clothing of their work but in that of their "role." No one tries to camouflage with functionality or naturalness the beads they cover their body with or the dye they use to color their hair.

4. The resulting importance acquired by *hybrid channels*—design, fashion, cosmetics, cinema. Since there is no longer any demand for traditional classifications or "genres," supply has to become increasingly "interdisciplinary."

5. The trend toward *retrieving past styles*; a retrieval, nevertheless, clearly different from preceding historicisms. Classical historicisms tended to seek in classical styles a cultural legitimation: through clas-

sical "forms" they tried to recapture the classical "prestige." Character-
istic of the neo-historicism of the sixties, on the contrary, was its inter-
est in retrieving the pure forms independently of the socio-cultural
background they had responded to. Even more, I think that what gave
a new value to, say, the fashion of the twenties or to the art-deco style
was precisely the "collective forgetting" of the social background and
(technological, political, etc.) circumstances from which those forms
arose. Only out of this obliviousness did they appear as pure formal
superstructures to a period such as ours, affluent in so many ways, but
with a chronic scarcity of the gratuitous. And it is for this reason that,
when well-meaning sociologists come around to tell us what that style
of the forties or fifties which catches our interest was "responding to,"
what they're actually doing is breaking its spell over us, killing the
goose that laid the golden eggs.

The popularity also of the "gymnastic" use of yoga, and of the "sed-
ative" use of the mass in California, is based on this very same forget-
fulness or ignorance which, years ago, had laid the basis for the use of
the exotic object in a bourgeois domestic milieu. The only problem
with nostalgically retrieving the past is that, with the acceleration of
change, periods closer and closer to the present become archaic, "ob-
solete," and, for that very reason, interesting and retrievable. Soon we
will nostalgically retrieve the hippy style, the style of May 1968, and
we will end up by retrieving the year or month before last. Then we'll
have to change the game.

It is obvious, to take just one example, that the formal tradition
which runs from the Renaissance to the classical avant-garde reduced
formal expression to certain specialized sectors—painting, drama,
symphony, sculpture—to the detriment of its indiscriminate manifes-
tation in clothing or urban design, in festivals or religious ceremo-
nies. The formal and expressive "intensity" of Renaissance works
results from the concentration of forms and symbols of actual life and
their specialized treatment. In place of the ritualization of social
practices, art appears as a social practice in itself; moreover, as a new
Cult. In contrast to what happens in the Middle Ages or in
non-Western civilizations, formalization now becomes specialized
and leaves social life free of formal connotations. The insipid domain
of social "informality" is then the counterpoint to the *"formalism"* of
pure art works. A grey, flat, and informal world is now the comple-
ment of a work which concentrates all grace and daring in itself. Ac-

cording to the puritan bourgeois dictum, order and routine should rule common space or activities, just as the exceptional or perverse should be the rule in art or literature. In Japan, drinking tea is still somewhat like having a snack, attending an art exhibition, and going to mass all at once. Among us these practical, significant, and symbolic functions are already perfectly separated.

The concentration and intensity which formal and imaginary experiences acquired in the precinct of the *oeuvre* were thus the other side of that asepsis and bourgeois frigidity (*bürgerliche Kälte*) that Adorno spoke of. Only in the *work of art* was a sensual and imaginative explosion permissible; *clothing* or *façade* would continue to be governed by the criteria of convention and good name, of respectability and rank. *L'esprit du serieux* dominated all the physical or psychic extentions of man: his *"second nature"* (habits or customs) as well as his *"third"* (manners and courtesy); from his *"second skin"* (clothing) to his *"third"* (the home's façade). Habits and courtesy, clothing and buildings, were governed by principles which in no case could authorize formal experimentalism. The artist—like the tailor—could and should collaborate in the elaboration of the image which the good citizen had of himself—never question or try to reinvent this image. As the prudish Spanish proverb has it: "Everything in its place, and God in every place."

5. FLOOD

When the concepts of "game" or "indeterminacy" come to be understood as a fundamental ingredient of existence—even of efficiency—it is not by chance that the areas where bourgeois puritanism froze and tamed the imagination appear to us increasingly conventional and narrow. Keeping the fantasy in that temperate zone that we used to call "art" is harder and harder when new science and technology constantly call forth interrelations between imagination, reason, and practical life; when the artistic "messages" increasingly depend on the technical "media." McLuhan writes in *Counter-Blast*,

In a *non-literate* society, there is *no art* in our sense, but the whole *environment* is experienced as *unitary*. Neolithic specialism ended that. The Balinese say: "We have *no art*. We do everything *as well as possible*"; that is, they *program* the *environment* instead of [as our artists do] its *content*. What we call *art* would seem to be *specialist*

artifacts for the enhancing of human *perception*. *Since* the *Renaissance*, the *arts* have become privileged means of *perception for the few*, rather than means of *participation* in a common life or *environment*. This phase now seems to be ending, except that we are extending the *privileged artifact* principally to the *environment* itself.[19]

Or even more accurately: "today, culture is the referential frame proposed to the individual by the social system; and under the heading of culture one must now accept not only the traditional contents (books, the press, radio, television, art, music), but also and on an equal footing with them, objects of everyday use, the shell in which we live, the models of employment of time and transportation, philosophical and ethical values,"[20] that is to say, all that makes up our *context* in the dynamic sense which Von Uexküll defined as *Wirkwelt*, i.e., the field of functional possibilities which, according to Lewin, also include the world of dreams and fantasy.[21]

But the demand that imagination inform our scientific research and our physical garments, our public behavior and our handling of objects, comes from two different—and, to a certain extent, opposite—sources. It is required, on the one hand, by the forms of experience and action induced by new technologies that break down the traditional barriers between action and contemplation, knowledge and imagination (what McLuhan calls the "electronic implosion"); and, on the other hand, by the new forms of political and economic organization fostered by this same technology, which tend to block any intervention of the people in the spheres of political and civic decisions.

And this second aspect of the question, neglected by McLuhan, is the one that makes of this incursion of the imagination in our daily life not solely a "technical" but also an "ethical" need.[22] I mean the need to maintain a certain flexibility and ambiguity within a political and economic system which doesn't gag us, but rather buys us off, trading welfare and passive consumption for our liberty: a system that tried to lead the lower classes into this consumption with a view to maintaining for the ruling classes the privileges of political and economic power and responsibility, of action and manipulation of men and signs; a system that thus recreated a *slave* morality (enjoyment, irresponsibility) opposed to a *master's* morality (responsibility, prestige, power). Toynbee writes:

In the age of automation and computers, only a minority will find work which in this way will become a genuine privilege. For this minority it will not only be the key to wealth and power, but it will also procure for them the pleasure of having their ability and competence vouched for. . . . The privilege will be that of these "happy few" who will monopolize work the whole world over. The penalty will consist in benefitting from—of putting up with—enforced leisure . . . which will increase social tension to a tremendous degree. How to dissolve then this tension of a new "leisure majority" for whom an unearned salary, excellent though it may be, will not be able to relieve the sensation of being socially useless, nor enable them to forget that they are at the mercy of an all-powerful minority which decides everything? [23]

Toynbee's answer is blunt: Religion—and quite precisely understood as a new version of Marx's "opiate of the masses."

How to fill up this boredom and uneasiness? Exhorting the masses to idealism. Artistic and intellectual potentials are probably rare. We thus cannot hope that the majority can satisfy itself through artistic or scientific means. The faculty that lies latent in all men is the religious faculty, and so future education ought to apply itself to awakening this faculty. Religion is suited to filling up the spiritual vacuum which the continual progress of technology threatens to create in people's souls. We must hope for a resurrection of religion, and we can predict its new Advent.

Now then, if Toynbee's "prophecy" is not to be fulfilled, our art must denounce and try to break the boundaries within which the exercise of imagination has been enclosed. And this, (a) in order to become adapted to the new technical and social cosmos, and (b) in order to denounce the forms of one-dimensionality to which this same cosmos will limit us, with a velvet glove, in the Church, the Supermarket, or the Museum. It must be understood that the limits within which art since the nineteenth century found itself contained are not its natural and voluntary limits but, rather, the reservation on which it had been confined and from which it had to operate as a camouflage or complement of bourgeois efficiency and desacralization of the world. The artistic avant-garde of the twentieth century broke many molds, but always *within* these bounds—and without recognizing them as such. Without recognizing them, obviously, because one only discovers a boundary when one tries to cross it, and the classical avant-garde tended more toward a search for origins or essences (painting-in-itself, music-in-itself, etc.) than toward a testing

of limits and a breaking of boundaries. Refusing to "wander afield," enclosed within its sphere, it was able to achieve everything.

But an old proverb says that "he who understands everything is badly informed." And in analogous fashion, *he who feels that he can do everything has never set foot outside his own house:* only he who tries to step over the threshold of his front door discovers that a resistant world awaits him outside.

This attempt to break out of its reserve has been the lot—and failure—of the artistic imagination in recent years. Within its reserve, the classical avant-garde only harvested successes. Trying to leave it, trying to colonize habits or institutions, the modern avant-garde only accumulates failures—exactly as befits every experimental attitude or practice.

Luckily, today things are more poorly defined and delimited. People are beginning not to know any more not only *how* to make art, a revolution, etc., but even *what* art or revolution might be. The "clear and distinct" definitions that distinguished art, life, technology, message, sender, spectator, etc., are becoming more diffuse and blurry. Artistic imagination tries to actually involve itself—though with uneven success—in all the areas of theorectical or practical activity. And as we saw before in regard to style (see p. 73ff.), we will see now that this reaction tries to fill two different gaps: the one separating art and utility (cold gap) and the one separating art from life (hot gap).

SIX

THE TECHNICAL SCHISM

"WORKS OF ART" have often functioned as beautiful eccentricities dotting an ordered and utilitarian landscape.[1] Today we feel the need (and also the difficulty) of involving the artistic imagination in the very manufacture of objects and situations; the need not merely to add an artistic "note" or "detail" to the finished product, but rather to have formal imagination intervene from its inception in the product's very elaboration.

This is very clear and it is needless to stress it. What is often forgotten, nonetheless, is that the concept and role of art has become more "functional" or "practical" to the same extent that practical action has become more "artistic." The primary concept of functionality as a *mechanical* adjustment has gradually been replaced by the idea of *psychological* adjustment, which also needs the gratuitous and the ornamental, the ambiguous and the meaningful. The idea that a street, a neighborhood, or an iron "should serve some purpose" is a function of many psychological factors of legibility, sense of identity, degree of environmental complexity, etc., which increasingly make the concept of *function* resemble that of esthetic quality.

But modern art is also changing its position and relationship with respect to science and technology. Thirty years ago, in the full flush of avant-garde euphoria, Focillon declared: "Isn't it wonderful to see this artist, this haggard survivor of the age of handicrafts, still alive, still among us in the mechanical age."[2] Even in 1910, Jean Cassou understood that the role of the artist in our scientific and technological society was to bear witness to creativity, innocence, and imagination—"the eternal human values"—against a world dominated by the scientific view of its dimensions and the technical standardization of

its products. The artist becomes in this way "the tragic hero who, confronting industrial labor, will persist in his eccentricity . . . the man who clings to this obstinate, irreducible, and exceptional character of artistic work, subsisting side-by-side with mechanical production."[3]

But the best artistic and philosophical tradition gives us a very different picture of the relationship that art or philosophy maintained with science or technology. Here it is not a question of "defending" or "protecting" from science the sacred precincts of intuition or imagination, but of using science as a jumping-off point for intuiting, imagining, inventing, or dreaming. Out of this attitude Aristotle began counting the legs of crabs, Plato prohibited entry into his Academy to anyone who did not know some science, and Leibniz proposed both the infinitesimal calculus and his philosophical monadology. Piero della Francesca and Ucello were passionately interested in geometry; Leonardo studied physics, and Michelangelo dissected cadavers. As I have written elsewhere,[4] only out of a certain pseudo-romantic culturalism did people hit on the idea that "humanism"— or intuition, or the eternal values of Western culture, or whatever— was something that had to be defended *against* the sciences. Out of that attitude the profundity and ineffability of *Geistwissenschaften* (sciences of the spirit) began to be seen as opposed to the superficiality of *Naturwissenschaften* (natural sciences) and, in art, the profound reality of the "characteristic" or "picturesque" Romantic descriptions as opposed to the triviality of the naturalistic. Out of this same attitude, professors and academicians of every period have felt themselves obliged to denounce the "danger" for intuition, creativity, and liberty that the advances of science and technology have represented. As "writing" was for Plato and the French Revolution for Rivarol, so television, design, or symbolic logic were the great evils for our professors or liberal artists to exorcise.

1. MASS PRODUCTION AND HOMOGENEITY: SOLUTIONS AND MEANS

But against the most conventional rhetoric of the avant-garde, the new artists are discovering that the antitechnological obsession was both an *illusion* and a case of *myopia*.

1. A case of *myopia* because it assumed that homogeneous production was the permanent destiny of mass production, without realizing that the equation "mass product = standardized product" was only the outcome of our relatively primitive stage of mass production. The *degree of finish, un-perfection, individuality* and the *allowance for chance* which even today distinguish handmade from industrial products will be increasingly regained by industrial production. It is certainly easier to mass produce a thousand identical objects than a thousand different ones, and thus at first the industrial revolution developed at the expense of the individual quality of its products. But thanks to more sophisticated electronic technology, we are glimpsing today the possibility of individualized and diversified mass production. With the problems of quantity production practically solved, technological research is now centered on quality production. It will try to program the differences or "errors" (like the ones made by those sewing-machines that sew in a deliberately imperfect way so that they will give the garment a hand-sewn "quality") or even to program the machine with feed-back from the last article produced, so that the next one turned out will be different.

2. This antitechnological obsession, this fear of becoming involved in the technological process, was also a genuine *illusion* of the past that prevented us from seeing the possibilities which scientific or technological research, and they alone, offered to art. There exists, as I pointed out earlier, a profound affinity between the forms that artistic demand adopts and the possibilities provided by science and technology.

In fact, the increasing demand is more for *means* than for *finished products*; means for making one's own clothing, one's own house, or one's own education. With traditional technical means—architecture, dressmaking, easel painting—it was impossible to dissociate the means from the *solution*. Architects solved the technical problems of housing, but they also predetermined the spaces we were to live in. They didn't build *our* houses but *theirs* or, in the best of cases, the houses they "knew" we needed: what Alexander has called the architect's "emotional theft."

In order to reach a stage where everyone can organize his own environment using a few materials and carrying out a series of elementary activities with no technical training whatever (digging, clamping,

tying, etc.), a sophisticated study is required to reduce all the necessary operations to just a few. It is certainly more difficult to supply an architectural language based on a reduced *lexicon* of materials and an elementary *syntax* of operations with which each individual or group might build up its own environment, than to supply a language with a wide lexicon and a complicated syntax which, for this very reason, cannot be directly used nor personally appropriated by the consumer. And this is one of the difficulties to which it is worthwhile to devote all our energies today; one of the utopias Alexander has been calculating and speculating about for more than five years. In fact, if the city of the future is to consist of a series of "subcultural foci" where each one can participate and express himself, it will not be due so much to the traditional architects as to these "technocrats" who are studying materials and construction methods with a view to turning them into personally manipulable means.

2. NEW VERSION OF FORMALISM: STYLE, TECHNIQUE, AND ENVIRONMENT; CREATION OF ARTIFACTS AND MODIFICATION OF SITUATIONS

The study of technical means for the diffusion and channeling of messages now appears as the destiny and condition of all future experimentalism. Avant-garde formalism rightly insisted on the fact that the function of the artist was to work out the artistic language itself; that rather than an elaboration of meanings—words, figures—his was an elaboration of the signifiers themselves—colors, sounds, phonemes, etc. In contrast to the specialists in discovering the *whats*—truth, meaning—they were the specialists in the *hows:* in the *modes, appearances, channels* through which man expressed himself.

Today the systems or channels which carry the highest percentage of information are technologically hybrid and complex media. The pure "forms" which avant-garde artists investigated have today turned into sophisticated "media" which determine the message which is transmitted through them. A "medium" such as the superhighway visually translates and homogenizes the landscape in a very different way from the road, which was both a spectacle of and penetration into the landscape. Proust already had detected this change in the

"message" produced by the change from medium-carriage to medium-automobile. An argument affects us very differently according to whether it is expressed verbally or in writing; carried by a "cool" medium like TV or a "hot" medium which induces the spectator's passivity.

It follows that today more than ever the artist ought to become a specialist in the *hows*, ought to become acquainted with the media, and their complex mechanisms. Thus, in line with the formalist tradition, and at a time when "forms" have become more sophisticated technological "processes," we must stress that the artist is not so much a *creator* as a *mediator*; an experimenter with the specific potential of the media he uses: with mechanical media in kinetic art, cybernetic media in programmed art, television media in the Arts Lab's closed circuit experiments with "brusch," optical media in the "centers of visual research." The artist, though, does not limit himself to "using" this media: he is the one who tries to force and experiment to the limits of what can be uttered or suggested with them.

In the text (p. 15) and figures (p. 16 and below), we saw that at the time of the classical avant-garde, the pace of change was such that the artist could no longer take Context₁ ("Artistic Game" or "Stylistic Discourse") for granted: he had instead to define himself by his rejection, acceptance, or critique of this context. But today it is Context₂, a still broader one, that we cannot take for granted. To make a work is now to question the very way of life and production system in which it is involved. This is why each new work implies a confronta-

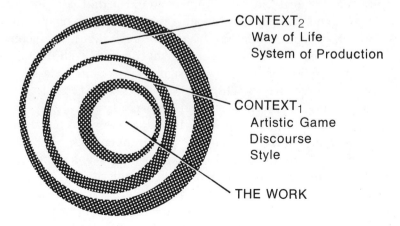

CONTEXT₂
Way of Life
System of Production

CONTEXT₁
Artistic Game
Discourse
Style

THE WORK

tion with this *very mode of production*, whether in its *broad* sense (socio-economic system), in which case the work replies to or makes a pact with this system, or in its *strict* sense (techniques of artistic production), when what defines each artistic project is not its style but rather the technique used: Warhol's serigraphic amplifications, Nauman's sound rooms or Levine's gravityless ones, Vasarely's kinetic contrasts, Christo's wrappings or Barris' coachwork manipulations.

But if the "media" are the instrument and object of present-day art, the "environmedium" is its laboratory and field of action. When our entire environment is a manufactured one, we cannot pretend that the "artificial" activity of the artist can and should remain restricted to the private domestic sphere, as in periods when privacy was synonymous with "culture" and environment with "nature."

Since the everyday environment of the majority of people is man-made, artists must take part in the process of formation of this milieu whose very omnipresence helps to camouflage its impact; a milieu in which we are more vulnerable precisely because we pay no attention to it.

Artists must learn to work with this new raw material of creativity; they must devote themselves to the *modification*, *shaping*, and / or *perturbation* of this milieu which we use (and which uses us) without paying it attention. Surely, radical configurations or perturbations can only be carried out through a political change in the structures that govern this milieu. And it is for this reason that, once the pious hopes were lost that the Establishment would permit (and the "artists" would know how to bring about) an esthetic reshaping of the environment, art and architecture have confronted the sharp dilemma of collaboration or radicalization; either to cooperate with the sort of goals the Establishment imposes (design, city planning, etc.), or to imagine an alternative Establishment; to choose between Integration or Extrapolation, between Death and Utopia.

But no matter how refractory—or how excessively "accomodating" —this environment controlled by the Establishment may be, the proposals of art cannot but look on it as its field of action. And this is true for possible as well as for impossible projects, for realistic as much as for utopian ones. Even the new artists who are working within the tradition of "painting" can no longer present their works as

something separate from this milieu but as a *decoration* (Vasarely), as a *game* (Le Parc, Soto), as an *environmental experiment* (Rauschenberg's "soundings"), as a parodic *monumentalization of its myths* (Oldenburg), or directly, as an *urban perturbation* (in the style of Schöffer's car-sculptures with their revolving mirrors and projectors "making a sculpture that goes toward the spectators instead of the spectators going toward it").

In sum, and whatever importance the technological "media" or the physical "milieu" may have, it is clear that the *goal* or function of art can no longer be understood only as the formal elaboration of specific objects or messages directed to a deliberate, formal consumption. The task is not one of opposing to leisure and mass culture "the defense of traditional and aristocratic models, but of organizing an opposite 'politics' which will focus the dissolution of previous cultural forms in a different direction."[5] The hope for an artistic and cultural politics that will guide consumers' leisure toward a critical and creative leisure may be a mere illusion, but what is definitely illusory is to counter this desublimated environmental and leisure culture with the artistic products of a period in which art was the product of forms of repression different from our own.

Furthermore, we cannot overlook the change of "stance" which in scientific research itself has involved the utilization of increasingly sophisticated technological media. Contrary to what some had forseen, the use of computers has not brought about a greater control over the scientific imagination but, rather, has liberated it in a certain sense. As the establishing and testing of relations became practically automatic, scientific activity has been able to launch a greater number of hypotheses whose testing is no longer a difficult problem. Instead of the laborious inductive process that methodically proceeded from the particular to the general, today we often take off from general "guesses" about relationships between facts whose statistical probability, relevance, or significance is given us by the computer in a few seconds.

A traditional economist, for example, had to carefully check to see whether some relationship existed between the interest rate and inflation, leaving any other variables aside for the moment. Once this hypothetical relationship was established, he could add a new factor and test the effect it had on the model, and so on. By contrast, modern

economists who work with factor analysis and input / output tables tend to propose "frivolously" complicated hypotheses about the relationships between, for example, income level, rate of growth, type of interest, unemployment rate, and degree of inflation. They can afford to suggest multiple hypotheses at random, since the computer will automatically take care of rejecting those which are not valid or relevant.[6]

But the exaggerations, illusions, and even mistakes brought about by this attitude are but another indication of the change which the existence of computers has meant in the scientist's *modus operandi*, a change which, very understandably, has come to bewitch some, but which for the majority has meant a real transformation of their work habits. Popper and Kuhn's critique of the "inductivist" conception of the task of science, and their insistence on its "hypothetical"—guessing, premonitory, idealistic—aspect, thus seemed to be confirmed by the use of modern electronic technology.

And it is not by chance that the same thing has occurred in the world of art. The artistic activity of the avant-garde—contemporary with the scientific activity which we have called inductive—applied itself to a systematic analysis of forms. Their analyses (e.g., Impressionism) and syntheses (e.g., Cubism) distorted natural forms until, at the extreme, so-called abstract art could now devote itself without distractions to the decomposition and recomposition of the forms. But the new artistic trends no longer seem so interested in analyzing and recomposing the forms as in experimenting with the immense (visual, acoustic, symbolic) wealth of the virtual images which the new Babylon emits.

More than looking for artistic infrastructures the tendency today is to juxtapose, dissociate, or extrapolate the superstructures themselves. Against the Modern Movement's "purism" which sought out formal essences, today artists are trying *horizontal* (synchronic) *hybridizations* in which semantic fields and discourses from different areas intermingle, thus the ideal of delimiting "clear and distinct" forms has been followed by that of confounding and overlapping them. And against the avant-garde's "modernity," *vertical* (diachronic) *hybridizations* are now being experimented with in which styles from other periods are mixed and recycled. Relationships seem now to be more interesting than essences—the multiplication of *coups* more than

making the "right *coup*." Since art no longer erupts into the market as an absolute work or visionary hypothesis—whose refutation, in any case, the art critic takes upon himself—but rather as a proposal of activity or a working hypothesis, the very problem of making the coup stick makes less and less sense. "It's not so much a question," Jodorowsky writes, "of finding a solution as of suggesting the greatest possible number of solutions." "Perfection," Arrabal concludes, "seems to me the height of inhumanity. All that is human is confused *par excellence*." [7]

Many are the factors that have fostered the appearance of this more hypothetical and imaginative activity of the "mediologists" and "provocateurs": technical facilities, de-emphasis of the concept of the "artist role," diversification of the levels of consumption. One might think that this is but a trivialization of art, an abdication of its eternal mission, even a petulant manifestation of its present impotence to formalize *en profondeur*. But we will return to this later on.

SEVEN

THE WILD SCHISM

COMPLEMENTARY WITH and allied to this progressive *technification* of the media and *trivialization* of the objects to which imagination is applied, there exists the increasing claim for *individual and immediate exercise* of this imagination. As Touraine pointed out:

Today, science and individuality ally themselves against integration into large organizations and against the standardization of ways of life. . . . The liberation of the individual, political activity, and scientific creativity certainly do not associate without crisis and tension; but it is only and precisely this coalition which opposes the hegemony of the large organizations and of stratified consumption.[1]

The traditional "warm" art, as we have defined it, had to keep aloof and equidistant from scientific or pragmatic goals as well as from immediate experience. "Between the intellectual and the visceral sign, [bourgeois art] hypocritically inserted a hybrid [sign]"[2] which the current cold reaction takes to be *a complement to the banality of everyday objects* and the hot reaction understands as *a complement to the conventionality of usages and habits.* The artistic products of traditional warm art ought not to be tied to an instrumental usage nor to a sensuous experience. Sensuousness and utility were one thing, and artistic sensitivity another very different thing. Therefore, warm art's mission was to idealize or categorize the immediate: *make the tangible intangible.*

The mission of art today (in a capitalist society *no longer* strictly bourgeois, just as in societies *not yet* bourgeois) seems exactly the reverse: *to make tangible the intangible.* Not to *idealize* a reality which is too crude, but to *somatize* the ideals which are too illusory.[3] All intellectual generalization is then mistrusted ("our rebellion is of an

intensely sensuous sort . . . with the body, with sound, with lights,"
says the director of the Open Theater); all "diction" that is not "ex-
pression" is rejected ("we use only our bodies to express it all," con-
cludes J. Chaikin), since, as Artaud had pointed out, art is not to use
ideas but gestures—those "cartilaginous transformations of ideas."[4]
In the new art ideas surely will continue to operate, but they are
"ideas as sensory stimulants which will function as décor, props, sen-
suous material."[5] Artaud wrote that

> If music affects snakes, it is not on account of the spiritual notions it offers them, but
> because snakes are long and coil their length upon the earth, because their bodies
> touch the earth at almost every point; and because the musical vibrations which are
> communicated to the earth affect them like a very subtle, very long massage; and I
> propose to treat the spectators like the snakecharmer's subjects and conduct them *by
> means of their organisms* to an apprehension of the subtlest notions.[6]

Modern kinesic experiments have confirmed this hybrid
character—at once audible and visible, verbal and gestural—of all
direct communication. From this point of view, what would distin-
guish the communication of schizophrenics from that of normal peo-
ple is not the use of a different verbal-gestural code, but the use of
the same common code in unpredictable ways, in terms of unusual
durations, loadings, and intensities. Thus, according to Gregory
Bateson, the difference between schizophrenic and artistic com-
munication is reduced to the fact that "the artist can do purposefully
that over which the schizophrenic has but partial control."[7]

Even on a purely verbal level it has been observed that many of the
sentences of schizophrenics use the phonetic and semantic material
in a quasi-physical, condensed, noninterpretive fashion, thus produc-
ing maximally the effects of polysemy, economical use of signifiers,
wealth of meanings, and other devices by which the work of art has
been characterized. Examine, for example, the sentence which, in
an amusing, almost enthusiastic tone, a schizophrenic says to the
psychiatrist as soon as she comes into the room:

My mother had to marry and now I'm here.

The psychiatrist managed, after a few weeks, to disentangle this sen-
tence's wealth of meanings which, in an "artistic" context, and with-
out analytically breaking the sentence down, constituted the factors of
its esthetic effect. The sentence, in essence, meant:

1. I am the product of an illegitimate pregnancy.

2. This fact has in some way caused my disorder.

3. "Had to marry" means that social pressure had forced my mother to get married, and that she had regretted this decision just as she had my own birth.

4. "Here" means the psychiatrist's office as well as my existence on earth, this second meaning implying the ambiguity of my reaction toward a mother whom I hated and who has driven me insane, but to whom I owe infinite gratitude for her having sinned and suffered to bring me into the world.[8]

It is hard to find a greater wealth and ambiguity of meanings in a single sentence: meanings, moveover, which appear in the crude— "incantatory" (Artaud)—state, in the very "body" of the expression, susceptible to complete or partial detection by someone who is not hunting for symptoms but allows himself to be carried along by the strength of the words and the direction of the gestures.

But if art was to be again a "refined means of understanding and practicing life" (Artaud); if, more than a message, it was to be—as Artaud had said before McLuhan—a massage; if, more than a description or criticism of life, it was to be an extension of its sensory richness; if this was to be the case, it is evident that the "genres" and traditional spheres of art were too narrow to fulfill this function.[9] We could describe or criticize in a book or an isolated work, but to facilitate and stimulate changes, something had to be done live, on the spot. That is why the new art could not be a physical merchandise, but rather something which, as began to occur with the happening, was consumed on the spot. The separation between art and an individual's practical life—as that between politics and life from the viewpoint of the "new Left"—became increasingly questionable. And not just because the art of the galleries or conventional party politics were in fact distanced from the individual and practical exercise of the imagination or freedom which they promoted theoretically. It was also, and mainly, because the kind of "imagination" or "freedom" which grew in those precincts was indebted to the very structure which produced them. *The philosophy and program of a system reflects, above all, its very own organization.* As Sartre said, *"On pense comme on est structuré."*

Hence one was inclined to reject those institutions that claimed freedom or imagination in our name but which—as Simmel was the

first to point out—ended up constituting themselves into a charismatic Art, Church, or Party, which blocked the direct taking-up of this freedom by individuals. It is possible that for a long time the dream of liberty and imagination could only survive in those areas which on the one hand limited immediate enjoyment, but on the other preserved them from annihilation. It is possible that the attempt at a rapprochement between art and life—between the possible and the real, between what one can imagine and what exists—may have certain strategic, unbridgeable limits. But the impulse of the new art is no longer resignedly to accept this gap but rather to try to reduce it.

The progress of art in this direction soon develops into a confrontation. The displacement and broadening of the sphere of influence of art into less "ideal," more "political" and practical domains, confronts a movement in precisely the opposite direction on the part of the political establishment which keeps extending its influence into increasingly more subjective spheres—manipulation of consciences, supplier of individual welfare, spokesman of the "silent minority," etc. Traditionally intimate and imaginative activities tend to get politicized while the traditionally public services tend toward an ever greater (real or fictitious) personalization. And a collision seems inevitable between the two contingents hurtling head-on down the same track in opposite directions, each in search of the place the other started out from. Only a transcendent and impartial switchman might prevent the collision.

1. THE SCHISM OFF STAGE

Among genres themselves we can notice this split in the established norms and compartments. In Vargas Llosa, the personal pronouns lose their fixed, conventional values:[10] the first person no longer plays the lyrical role (I love), the second person the dramatic role (thou accuseth), and the third the epic role (he conquers).[11] The boundaries that separated major and minor, elite and popular genres, seem to collapse when Ken Russell, taking up a tradition forgotten since the theater of Shakespeare and Lope de Vega, comes to mix tragedy, vaudeville, and melodrama.

Victorian and Neoclassical prudery told us it was acceptable to watch tragedy or vaudeville, but the sublime and the trivial could not

mix, nor the grandiose and the grotesque. We were prepared to accept shows that transmit the sensations caused by the events narrated, but not to accept having the brutality, arbitrariness, and "bad taste" of their actual occurrence forced on us. "The uneasy passion being . . . raised alone, unaccompanied with any spirit, genius, or eloquence, conveys a pure uneasiness, and is attended with nothing that can soften it into pleasure." [12] These were the norms or expectations which works as different as Chabrol's *Rien* or the "operas" of Kathy Barberian tend to violate.

Modern artists seem to take a perverse pleasure in works that cannot be confined within the limits of the traditional arts. Like the camouflage painted on a tank which deliberately avoids following the outlines of the tank's shape, the new works of art seem to enjoy not respecting the system of the arts. They create a deliberate disjunction between the themes and the treatment which was traditional to them. The works of La Monte Young or Silvano Bussoti have broken every boundary between theater and concert. The pictorial works become acoustical with Len Lye, and Béjart's theater comes down off the stage and goes into the streets of Avignon. One no longer dances to music, but to silence, or to the silences between John Cage's blows on the piano (blows to the wood, not to the keys) which Merce Cunningham undertakes to "interpret."

The theater tried to embrace both the public and the pictorial arts with happenings and environmental or conceptual art. With Venturi, architecture became nothing but parking lots and advertising. With Burroughs, literature wanted to incorporate from practical life "the effects of simultaneity, acceleration, slowing-down, echoes, etc." [13] There arose a tendency toward absorbing all genres into the theater—into the "Great Spectacle of the World" that Calderón spoke of. Artists began looking for a *multichannel approach* which, like the Catholic liturgy, may be at one and the same time a visual, olfactory, acoustic, rhythmic, mimetic, and symbolic experience: an effect in which everything would have a place, from gesture to architecture, from music to illumination. The possession of the work of art had to be followed by the participation in fleeting events which could not be held onto and which often, when they were carried out with solid materials, programmed their own destruction. Together with the happening, and following in the footsteps of Tinguely's "self-destruc-

tibles," there proliferated the *disappearings*, machines full of gears and rods whose charm lay in falling spectacularly to pieces after working for a while, giving rise to a celebration.

A Cool Medium for a Hot Situation

The traditional "clear and distinct" differentiation between artistic creation and artistic consumption thus became as problematical as the distinction between art objects and objects of other kinds. Warm art was assaulted by extreme temperatures. And every day the atmosphere got increasingly rarified and problematical.

A redistribution of this scope could not but profoundly affect the function and meaning that art and the artist had. Today we know that the values of the components in a field are dependent, above all, on their relative position in the field. The transformations which the concepts of "function of the artist" and "authenticity of the work" undergo in this emerging system will show us that we are not dealing here with any exception to the above rule.

We saw that the "cold split" had brought about a change from the artist as creator to the artist as *mediator* (pp. 69–72), and that the "hot split" made a *provocateur* out of him. The artist appeared then, in retrospect, as the manipulator of media (words, TV images, styles, discourses, classical or anesthetic stylemes) in which he uncovered possibilities beyond their normal and normalized use; and, in prospect, as a stimulator of responses not yet standardized or codified, as a detector of realities whose very omnipresence acts as a camouflage, realities concealed by the fact that we all decipher our environment with the categories arising out of the preceding environment. As McLuhan says, "We see the Emperor's *old* clothes. Only children and artists are antisocial enough to see the new ones." [14]

From this second perspective—the one I'm referring to now—the artist began to appear as an *encourager*, a *promoter*, a *clown*, or a *master of ceremonies*, who puts the rest of us into a state of experiencing our bodies, touching our surroundings, detecting sounds, breaking our associative habits, tearing down our defenses against the unexpected, freeing up our feelings, tranquilizing our passions or making them euphoric, liberating our narcissism, etc.

The Platonic conception of the artist is not far from this point of

view. Plato's criticisms of representational art ($\mu\iota\mu\eta\tau\iota\kappa\acute{\eta}$) and emotive art ($\eta\delta\acute{\upsilon}\varsigma$) were a function of his more global critique of any product which did not facilitate responses but instead chloroformed the spectator,[15] which did not *stimulate* but rather, like bread and circuses, *satisfied*. In an Athens in crisis after its defeat by Sparta, in the Athens of the rhapsodists and of Europides' "psychological" tragedies, the reactionary Plato already foresaw the "consumeristic" tendencies of the art of his time and preached the impossibility of a return to a collective—at the same time mythical and pedagogical—art.

But, in order to provoke this "artistic situation" that Plato saw behind him and we glimpse in the future, the artist must act in a way very different from that which characterized his activity during the long period in which he was creating works that would be consumed passively. Naturalist as well as abstract painting filled us with a peremptory and overbearing message. Purely naturalistic art was *onomatopoeic* and abstract art was *interjective*—the former "repeated" natural landscapes, the latter psychical ones—and together they defined the range of artistic forms that could interest or satisfy, please or disgust, but not necessarily excite, awaken, provoke, and initiate into the game—into this "other" game that is art.

McLuhan's term, "cool work,"—whatever one may think about his speculations—seems apropos for describing this quality that artistic products began to acquire in recent years. (For McLuhan, a message in particular or a medium of communication in general is cold when it has a low definition: when it doesn't fill up and permeate our senses, but offers them only a key, a pathway, a hint of its meaning.) Now, if there is one case where it is clear that the information transmitted must involve something more than the mere transmission of certain bits of information, this case is art. In esthetic dialogue two systems collect and exchange information for the purpose of changing the states of each one of them continually. And for that to be true, for communication to turn out to be a creative process also on the receiver's part, the message has to be relatively cold. The artist *proposes*—controlled silences (Cage-Cunningham), gilded cushions (Levine-Warhol), etc.—and the spectator *disposes*.

And it is significant that the first, cool series—Speech, Fiesta, Television, and the Comics—is where people search for inspiration these days. These media are seen as more suitable for transmitting

the cold message of the new art forms: the message that must be a *stimulus for a reaction* in the receiver and not a mere *report on the sender's intentions.* The artistic practice which responds to this reorganization of the artistic field does not aim any longer to send *hot, impressive messages* but rather *cool, pertinent* messages.

The coolness of the message is today a necessary but not sufficient condition of its effect—thus the term "pertinent." A work can induce me to participate in it without this activity resulting in a widening of my perceptual field. Just as getting excited is not enough for developing one's muscles, so merely participating in something is not enough to loosen up our senses. It is also necessary that our participation be led toward a place where sensations exist to be discovered, faculties to be exercised, an inhibited past to be overcome, or possibilities to be recovered. And this is what seldom happens in the new mod art (call it conceptual, behavioral, or whatever) that promises more than it delivers and whose transcendence of the classical avant-garde is often more verbal than real.

From the Authenticity of the Object to the Authenticity of the Attitude

As Walter Benjamin observed, the idea of the *authenticity* or *originality* of the work of art is nothing but a secularization of "aura," of the unique and transcendent character that images and fetishes had. But ever since the *sacred* value of the image became its *cultural* value, people have tended to substitute the absolute uniqueness of the image for the empirical uniqueness of the artist or of his creative activity [16] (e.g., it is "a" Matisse).

The fetishism of the original work, of the author's "signature," thus replaced the absolute uniqueness of the fetish. And when this uniqueness seemed threatened by the possibility of making technically perfect copies, the art market made sure to reinforce the myth that the only valid work is the original, thus bringing back the "scarcity" that speculators need. The art market continues in this way to stress the "authenticity" of the works, but the present-day sensibility seems more alien to this concern, when indeed it is not positively interested in "falsification." A perverse pleasure in equivocalness and metalanguages makes us sympathetic to the perfect "interpretations"

of Matisse or Picasso which are made—and sold to the museums—by professional forgers like David Stein and Elmyr de Hory, the "hero" of a recent film by Orson Welles.

The "original" of a record, a film, a new car, or a conceptual art work is a *model* or *plan* and the museum is then nothing but a warehouse of plans, a gallery of models. In a series of proofs of a photograph, which one is authentic? What is the original of a "conceptual" work that traces on a map the route someone travelled: the map or the trip? In the end we are led to think that the most original work is no longer that which is most faithful to a hypothetical matrix but that which is closest to *our* experience. As Moles remarked,

Authenticity is no longer connected to the object [of art] but to the relation established between the individual receiver and the object. . . . There are authentic art situations and inauthentic situations: the postcard will be authentic for the soldier who looks at it with love and the original work of art will be inauthentic for the victim of touristic alienation who looks at it because it is on the itinerary of his visit to the city. *The authenticity of the situation* (that replaces the authenticity of the object) is then the special attitude of a person in front of an object, an attitude characterized by the absence of cultural alienation.[17]

The authenticity of the *situation* overrides the fetishistic concern for the "origin" of the object, the cultural concern over its "originality," the commercial concern for its "authenticity," the avant-garde concern for its "novelty," the snob's concern for its "exclusivity." And a new valuation can emerge of kitsch (Moles), camp (Sontag), pop architecture (Venturi), and even the Sacred Hearts and plaster crowns of funerary sculpture in cemeteries—authentic outdoor peoples' museums.[18] All of them are "styles" more distinguished by their consumption or popularity than by their "authenticity." None works with new ideas, but neither do they put you down or overwhelm you like those artistic or cultural forms that people feel obliged to experience or to understand.

Actually, art and culture have often worked as generators of guilt feelings or impotence; their segregating or excluding function has been as great or greater than their ludic function. That is precisely the reason for this tendency to claim a *pain-less* art, an agreeable and marketable art that, more than breaking with the codes, confirms and exalts them, and perhaps transcends social or cultural alienation with its very exaltation: making pop out of Times Square, camp out of

Jayne Mansfield, Kitsch out of the Tyrolean calendar, and *Pattern Painting* out of Abstract Expressionism.

As existentialists have already remarked, the concern for authenticity shifts from the object to the subject: from the thing to the act, from the instrument to how it is used. Thus Kierkegaard's defense of the minor genres, of *Farce* in particular, against more important theatrical genres. In farce, Kierkegaard writes, "one can't rely on one's neighbor or on the newspaper review to know if one had fun. It is up to the individual to decide, since criticism has not yet gotten around to putting a handbook together for the use of cultivated amateurs of theater who deign to attend a farce; there is, in this respect, *no possible good taste.*"[19]

The pictorial styles retrieved since 1968 also have this character of being more "agreeable" than "important," styles whose consumption has not yet been ritualized by *good taste.* The nineteenth century seems to be the inexhaustible storehouse of such reevaluations: the *symbolist* painters discovered in the 1969 "Mostra," the English *pre-Rafaelites*, the American *realists* of the turn of the century, etc.

The new rallying cry proclaims that there are no cultural *goods*, only cultural *acts*. "Acts" which only turn into "goods" at the point where the "collector" arrives who amasses the relics of these acts. According to this operational definition, the work of art is the result of a process of accumulating the leftovers from certain cultural activities and separating them from the context out of which they arose, an operation that, together with the "works" it gave birth to, originated in Rome, especially with Hadrian[20] when he began to classify and exhibit the archaic ("typical") works of peoples from the four corners of the Empire.

In the new urban and civilized context, the products of those acts lost their ancient "aura," but they generated a new cultural fetishism which existentialism repeatedly denounced a few years ago. It is the *museum*, according to Merleau-Ponty, that "adds a strange prestige to the authentic value of the works, separating them from the contingencies of the environment in which they were born and making us think that the artists' hands were directed by fate." It is the *library*, along whose shelves are ranged, according to Sartre, "the works, once the troublesome authors have ceased to exist and there is no more left

of them but small tombs which are placed on slabs along the walls, like urns in a mausoleum; then—for the critic—the book is no longer an object, nor an act, nor even a thought: written by a dead man on dead subjects, it no longer has any place in this world and comes to belong to a nonmaterial world where human feelings, which no longer move us, have passed into the category of exemplary feelings and, make no mistake, of *values.*" Therefore, the critic, jealous watchman of the graveyard, "is happy when contemporary authors have the good grace to die: their books, too crude, alive, and compelling, cross from the other side, affect people less and less, and become more and more beautiful; and, after a brief stay in purgatory, they go on to populate the intelligible heaven of new values."[21]

This line of reasoning was taken up again by the leftist critique of Western bourgeois culture when it denounced "the disruption of balance between *received culture* and *lived culture*; between what the contemporary world imposes on the individual and what he is capable of finding in the depths of himself." The authentic culture should then be understood as a search for the lost unity of what Simmel called "objective" culture and "subjective" culture. "And in this search for unity, culture as a separate sphere must refute itself."[22] "Rather than works of art, what people need today are situations that will permit them to express themselves."[23] Culture or art—just as education for Ivan Illich—are not, nor should they be, a *domain*—a compartment, a subject, an assignment, a specialization—but an attitude.

For Cohn-Bendit, transubstantiation of every creative act into a *spectacular* commodity was the work of the Establishment, which "extends its domain to every area of daily life." Every imaginative action is turned into an Image and a Product to be consumed, judged, and appreciated according to the criteria of "good taste," "avant-gardism," or "up-to-date-ness" which the critics of the moment promote. And this tendency (feared by Plato before anyone else) toward the transformation of culture-action into culture-spectacle, is only countered by the will to live the creative activity before it precipitates into a consumable object or spectacle.

It would be too easy to emphasize the innocent idealism or political naiveté of these alternatives. Let us keep in mind, for the moment, that they understood cultural authenticity to be

1. the imaginative exercise of daily activities
2. which is not a private but rather a public or "scandalous" one
3. and which tends to put its solutions into practice immediately so that they don't "harden" into an ideological program, an artistic trend, or a social fashion.

Below we shall see the symptomatic value of all this. For now, I am only interested in emphasizing that, together with the concept of *artist-creator-of-an-authentic-object*, the concept *authentic-object-created-by-an-artist* has also entered the crisis stage.

2. THE SCHISM ON THE STAGE

The breakdown of the barriers that separated art from the conventional notion of reality is perhaps nowhere more evident than in theater. There has been a tendency toward performances with a minimal or nonexistent boundary between actor and spectator capable of creating "social" situations in which we ourselves are a performance for others. A certain spatial, lighting, and acoustic organization may help to create a setting which dissolves the inhibitions that hem in our behavior, making possible "spectacular" forms of social intercourse and participation; something which has more to do with ecclesiastical or courtly rituals or even with primitive agricultural festivals than with urban, bourgeois performance.

For at least two interdependent reasons, the theatrical show, in fact, is possible only in the city. In the first place, only in the city do actions and relationships lose their ritual dimension, their stimulating or dangerous character, and become banal customs to which art then tries to restore interest by means of theatrical "stylization." A city that has rationalized all relationships finds itself threatened by the specter of understimulation, and seeks compensation in *dramatization*, in what Morris called the *extremism of the stimulus*. Even in the most "naturalistic" schools of art, literature, or theater this stylization is at work in eliminating what is irrelevant, thus producing an indirect sort of exaggeration.[24]

In the second place, it seems clear that a theatrical performance is impossible without the separation between *stage* and *spectators*, a separation that only appears in the *polis*, that is, after the wall has of-

fered a model for the separation between nature and culture, *physis* and *nomos*. Theater, on the other hand, arises quite precisely as the affirmation and revenge of the new walled, civic world created by man in the face of the gods who had dominated and harrassed the tribe and who are finally domesticated by it. As Duvignaud writes:

The city convokes the ancient gods, those who had tortured the rural world and still torture numerous spirits: the city represents them, carries them to the scaffold of the stage, with that dark pleasure that people collectively experience when they torture and annihilate that to which they are still profoundly connected. Tragedy and the theater thus begin, perhaps, by placing the rural gods on an urban stage. . . . From then on, the gods find themselves imprisoned behind tightly sealed walls, and on the theatrical stage they will turn into characters among many others. Man takes possession of that which surpasses him, or rather, he slowly digests that which for so long had been beyond his reach and he tries to recover its lost existence in heaven. He tries hard! We know that in the Greek city, things weren't that simple: freedom could only make its way in the theater. The Greek actually liberates himself on the stage more than in real life.[25]

The connection Walter Benjamin discovered between the imaginary life and the industrial city as the ideal habitat of dream and poetry can thus be carried farther backward, to the very birth of the bourgeois *polis* as the natural place of fiction and spectacle. But two questions arise on this level of our description.

First: before beginning to study the cause of this tendency toward *blending* theater and life, reality and artificiality, ordinary and extraordinary life, one must ask, as we have already begun to do, about the origin of its *segregation*.

Second: no doubt Artaud's proposal was justified: "To link the theater to the expressive possibilities of forms, to everything in the domain of gestures, noises, colors, movements, etc., is to restore it to its original direction, to reinstate it in its religious and metaphysical aspect, is to reconcile it with the universe."[26] For our purposes, however, this appeal to "everything that the theater should never have ceased to be" is as naive as it is insufficient. We can deplore the intellectualist psychologism of our spectacles which have lost all the ceremony's deep meaning in a proliferation of feelings and ideas; we can long for the recovery of a sensibility in which gesture was inseparable from idea, intonation from content, poem from the dance, but we cannot forget that this desacralization and cultural compart-

mentalization is both the price and the product of an intellectual, social, and technological development which would have been impossible without the breakdown of that hypothetical "primitive unity."

How and why did festivals and ceremonies break down to the point of becoming "double entry" spectacles, where some now went to *see* and others to *act*—but none went to *participate?* How did those *events* become *performances?* First, I will try to answer this question. Later, we will see how the tendency toward the recovery of a "lost unity" between art and life responds to the present crisis of the bourgeois cosmos that caused the split in the first place. Then we will analyze the middle-of-the-road projects of Artaud, the theater of the absurd, Vilar, etc., and follow this with a description of some of the new theater works, with a sociological interpretation of them. I will end this section by considering the "assimilation" of these spectacles by the culture industry, noting the gain which, in spite of some pessimistic interpretations, has already been made. In the last section, I will try to follow this trend outside of the space institutionalized as "theater."

Ritual and Celebration

According to Huizinga, ancient poetic art was a single unity consisting simultaneously of worship, festival, social game, handicraft, test, enigma, lesson, belief, prediction, prophecy, and competition.[27] In archaic agrarian festivals, as in the agonal competitions of the aristocratic societies which follow them, no one "expresses" or "simulates" anything: there is no fiction, but only the bodying forth of roles or attitudes. Interior life is not expressed nor is exterior life represented; rather one enters into collective contact with the forces that transcend and direct this life. As Plato said, man achieves there his supreme experience "in festive company with the gods."

In these religious celebrations, rhythm, verse, music, and dance are not merely ludic, representational, or expressive devices. They are not solely *ludic* since, in Nietzsche's words (see above, pp. 12–13), they try to produce a practical effect, although, contrary to what Nietzsche thought, this search for the effect is not as single-

minded in the celebration as it is in magic. Nor are they mere *representations*, since the primitive Greek or the present-day Huichol do not "represent" myths about the origin of the world; rather they repeat, "remember," or embody this origin. It is not *subjective expression*, finally, since men are then communing with an objective and transcendent process in which the individual submerges himself. Classical Greek, furthermore, is a poor expressive instrument: one could not intone or gesture freely in it since every word carries a fixed tone[28] (as in the Totzil spoken today in southeastern Mexico, a change of "tone" implies a change of "word"), just as in Greek dance each sound carries a fixed movement and each role its mask.[29]

These religious celebrations precede the spectacle organized by a few specialists to "represent" a reality, "express" their feelings, and "amuse" the community. "If life itself," writes K. Kereny, "is integrated into tradition, with a complete surrender of itself and in grand ceremonial forms (in worship or in war—since the latter is also ceremonial in archaic peoples) we are in the presence of mythology and of heroic legends. If the grand ceremonies have shrunk to the point of consisting merely in telling and listening, and finally, only in reading, we are faced with a narration, a sort of novel."[30]

But in Greece itself, and notably since the fourth century B.C., philosophers and poets gradually replace bards and rhapsodists. The poet is no more an anonymous celebrant of ancestral glory; his expression ceases to be choral and becomes, with Archilochus and Sappho, a personal song about his intimate feelings. At the end of the fifth century, the *dithyramb* appears which begins the breakdown of the original unity between writing and composing, between poetry and music. The words of the dithyramb are adaptable to the expressive verve of the poet who can freely choose the scales that best display his feeling. Thus begins the crisis in mythical stereotypes: with the eruption of subjectivity, intimate feelings, individual expression, and the correlative of all this—the passive consumer of such products.

A new art springs up which, as Grassi puts it, "cancels out the seriousness of the myth since it no longer reveals reality, but merely what is possible or what is experienced. . . . And, precisely because it shows the multiple possibilities of human existence, art now is sat-

isfied with pure observation, without making the individual reach a final and dangerous decision. In this way, it offers him a flight into the plausible, leads him to escape from a commitment to life."[31]

All the arts of this period show the same tendency. Lysippus says he doesn't paint men as they are but as they "appear"; Praxitelean sculpture gradually turns into a "gallant mythology," more formalist than religious. In tragedy, the chorus goes on losing importance, while the individual protagonist emerges as such, and the religiosity and traditionalism of the work of Aeschylus dissipates under the proliferation of the "emotions" and "ideas" which stand out in the work of Euripides.[32]

But when ritual and ceremony become spectacle they not only lose the "gravity, danger, and immediate efficacy"[33] which characterize them, they also lose the integrating or levelling social function present as well in pre-Colombian festivals where, as Fray Toribio de Benavente tells us, there existed a rotating priesthood among men who "had worked two or three years and acquired everything possible to honor the demon on his holiday. In this festival they not only spent what they had, but they also contracted debts for two or three years." "By liquidating the surplus," these rituals "made everyone rich in religious experience but poor in material goods. Since they levelled out differences in wealth, they prevented the development of wealthy classes . . . since the expenditure on religious worship restored the distribution of wealth to a state of equilibrium."[34]

Only among more or less "primitive" peoples do these *events* still endure in which people participate vitally, socially, and economically, in contrast to Western *spectacles* that people merely attend. After the execution *of* Christians in the Roman Circus and the execution *by* Christians of witches and heretics at the stake, collective events tend to disappear in the West.[35]. Only in the Middle Ages, within a courtly or ecclesiastical atmosphere, does there persist in some guise this "art" which is more event than aseptic spectacle:

> 1. In the *courtly festivals* with their "living tableaux" and their tournaments; in the "entremets" which Philip Borgia and John the Bold held, where the dining tables were laden with immense Easter cakes in the shape of ships or castles (a twenty-eight piece orchestra

would emerge from inside a gigantic cake, while a flock of birds came out of the jaws of an immense papier-mâché dragon).

2. In the *great cathedrals*, with their complex, simultaneous series of events. In them, Hegel writes, "the whole community of a city and its neighborhood is to assemble . . . all the various interests of life which touch religion in any way have their place alongside one another. The wide space is not divided and narrowed by series of rows of pews; everyone goes and comes unhindered, hires or takes a chair for his present use, kneels down, offers his prayer, and departs again . . . the most varied things go on simultaneously without inconvenience. Here there is a sermon: there a sick man is brought in. Between the two a procession drags slowly on. Here there is baptism, there a bier. At another point again a priest reads mass or blesses a couple's marriage. . . . But this variety of occupations and their separate individuality with their continual alteration disappears all the same in face of the width and size of the building; nothing fills it entirely, everything passes quickly; individuals and their doings are lost and dispersed like points in this grandiose structure." [36]

3. In the *religious events*, such as pilgrimages and the preachings of St. Vincent Ferrer, which caused a furor and disturbances in every city he visited; or in the *social events*, such as the public executions of a young man in Brussels or of Mansart du Bois. The former, Chastellain tells us, urged the spectators to avoid his example and spoke so movingly that "everyone burst into tears and his death was commended as the finest that was ever seen." The latter, Messire Mansart, forgave the executioner and even asked him to kiss him, with which, of course "nearly all wept hot tears." [37]

The Origins of Tragedy

Against the "spectacular" tendencies of his period, Plato stands for that collective tragedy that still keeps alive the sense of its etymology (*tragoedia* or 'goat song'), recalling the satyrs of the sixth century covered with goatskins, dancing before the altar of Dionysos in the festivals that give rise to the theater. The orchestra and altar of the later classical theater are still vestiges of the place where the *thiasos* ("group of rebels") gave itself up to dithyrambic dances around a jovial god. These dances "were the expression of their rejection of the social and political order," [38] but the Athenian Establishment, far from

suppressing them, assimilated the *thiasos*, turning it into the *chorus* of the tragedy, which thus synthesized the "crazy" divine forces and their control by the civil power. Certainly, the bourgeoisie's ability to integrate contradictory elements and make a Spectacle of them is not new.

Plato understood this transformation of the Ceremony into a consumable Spectacle as symptomatic of the naturalist, hedonist, or sentimental tendencies of the art of his age. The character of contest and emulation that tragedy had at the annual festivals of Dionysos and Lenaea disappeared together with the sacrifices, processions, and offerings that accompanied them. Even so, the classical tragedy that Plato excoriates still maintains clear vestiges of the primitive ritual: it does not consist of an ordering of what the actors are going to do, but rather of the event as a whole, spectators included: it is not pure *Spectacle* but rather *Metaspectacle.* I will explain.

The chorus which spies on, approves, questions, sympathizes with, or excites the extraordinary actions of the protagonist possessed by *hubris* is a residue of the "magical conclave" that surrounds the shaman, of the community which participates in the exalted passion of one of its members: an "actor" who is not yet a professional "protagonist."[39] The intimate relationship which exists in the Festival or propitiatory Ceremony between *action* (A) and *participating community* (C), expressed here as

$$(A\ C)$$

is now, in Tragedy, seen from the outside as a whole. Now the *Actor* professionally plays the part of the possessed man, and the *Chorus* plays the role of the Participating Community. Thus, the *Spectators* (S) are attending, although perhaps in an increasingly stereotyped way, the primitive *Event* (A C), the relationship created between the Actor and the Chorus which eggs him on. Thus, it is not a Spectacle but a *Metaspectacle,* whose object is an archaic Happening or Event:

$$S \rightarrow (A\ C)$$

But from the mid-fifth century on, the actor stops being a mere counterpoint to the chorus and becomes the authentic Protagonist.

The chorus, which had maintained a dialectical relationship with the action taking place on the stage, is absorbed totally in the play and becomes merely a group of extras. The Action-Response of the chorus, which the classical spectator still witnessed as true action, then becomes part of the Performance itself, (A C) = P. Thus:

$$S \rightarrow P$$

In later tragedy, the memory of the primitive Event, a memory which Aeschylus' chorus still maintained, disappears totally. The dialectical Relationship (A C) is no longer experienced by the spectators who are now passively assisting an already "modern" Performance (P).[40]

Now then, if primitive Greek tragedy was effectively a metaspectacle, this also means that there was no place in it for subjective or objective illusionism; that it was as impossible to feel that one was witnessing a real event as it was to identify oneself with the protagonist's feelings. The chorus "recalls" the festival, and therefore "distances" us from the fable or series of events represented in it. In the archaic tragedy the spectators cannot feel they are witnessing and living through the protagonist's anguish precisely because the chorus assumes this function: it is the chorus that is surprised, horrified, moved, and submits to the action. The chorus in the tragedy thus fulfills an "epic" role analogous to that of the posters, figures, or quotations with which Brecht tries to remind us that everything we are witnessing is a fiction to which we must react, and not a reality for us to identify with. The Brechtian theater is therefore anti-Aristotelian, not anticlassical. As Nietzsche saw very well: "Giving all honor—and the highest honors—to Aristotle, he certainly did not hit the nail, much less on the head, when he discussed the ultimate end of Greek tragedy . . . [which was] certainly not the attempt to overwhelm the spectator with sentiments. The Athenian went to the theater *in order to hear beautiful speeches.*"[41] The hoped for purification, release, or catharsis was not that of men but of the gods themselves. Beneath his Aristotelian translation and reduction to psychological terms, Brecht seems thus to connect with the actual tradition of Greek tragedy.

From Tragedy to Theater:
Thematic Plausibility and Scenic Segregation

The road from the primitive Event or Festival to classical Tragedy, and from this to Spectacle, is a process of secularization characterized

1. *topologically* by a progressive separation between Spectacle and Spectator; and
2. *topically* by plots or fables that are increasingly more polished, plausible, or, as we would say today, "hot."

But we have still not answered the question we posed on page 152: how and why did the community formed by the members of the tribe in their festivals break down to the point of becoming a "double entry" spectacle, where some go to *see* and others to *act*, some to *feel* and others to *perform?*

Aristotle—more progressive although less intuitive than Plato—speaks already about the art-spectacle as art *tout-court.* He is the first to raise the question of the communication between the artist and society, between producer and consumer of imagination. In the *Poetics* he speaks of the word, melody, and action as media of imitation and communication. Tragedy is not understood as exaltation or participation, but as a spectacle which has to suit the demands of the passive and distant spectator: "Just as bodies and animals ought to have magnitude, this being what is easily seen all together, so plot ought to have length, this being what is easily remembered."[42] He studies the consumption of cultural products whose effect he describes in psychological terms (catharsis or "purging"). The collective or pedagogical function of tragedy is now displaced by its function of giving pleasure and adapting itself to the spectator's point of view. The problem of truth yields to that of plausibility: "If the poet has produced an impossibility, then he has made a mistake."[43]

Despite his "historical" introduction to the topic, Aristotle does not appear to have realized the interdependence of the *physical arrangement* (an independent stage) and the reasonable and plausible *speech* which naturally arise out of it: between the theatrical *space* and theatrical *discourse.* Aristotle limits himself to describing and classifying the situation of poetry and tragedy in his time, a situation which the more discerning Plato sees in all its historical and structural implica-

tions, thus giving us a key to understanding the later evolution of theater, from Seneca to the Open Theater. In other words, it was Plato who saw that only a plausible plot and a physical separation between actors and spectators could give the theater the status of a "work of art" or, in our terms, a *warm spectacle*.

Actually, only a sequence of plausible events presented on a separate stage can pacify the spectators' tendencies to participate. Only when what occurs "there" is a coherent whole, complete and finished, does any activity of the spectator that might go beyond the strict contemplation of what is occurring become impossible and irrelevant. (To have told stories to a child is to know that only the repetition and predictability of the story keep the child passively enchanted—or, from the parent's point of view, enchantingly passive.)

This autonomy, and intangibility of the spectacle turn the spectators into passive consumers of a sequence of events which only asks for their attention. And the *typical* nature of the characters that Aristotle himself recommends, and which impregnates all Western theater and cinema (the young lad and lass, the servant-confidant, the little old man who sees everything, etc.), offers a reasonable generality that avoids the extremes which might enrapture the spectator: the radical individuality of the hero or the absolute universality of the situation. Myth is thus completely secularized and becomes fable or fiction. The rigid, symbolic, and religious nature of classical masks is thus replaced by new, maskless masks: by psychological "characters."

Plausibility and *typicality* were the expedients already proposed by Thespis of Icaria, in Pisistratus' time, to force the transformation of the archaic celebration into the modern Spectacle.[44] And it is odd to see how these devices—which seem the most natural thing to us—appeared to the classical Greeks as "tricks" or "lies." The ancient feast encouraged or provoked identification with the religious events of the magical reality: it didn't represent anything, but rather embodied it, repeated it, or reminded us of it. The plausible and naturalistic spectacle was performed, on the contrary, as a virtual reality with its own subject matter and conclusion; as the creation of an *als ob* of reality. Thus, one thing was "the poetry which celebrates the praises of the gods and of good men" that Plato was willing to accept in his ideal State, and another was "fiction"—which Plato equates with

"lie"—which "will usurp the sovereignty of law and of the principles always recognized by common consent as the best."[45]

Perhaps the best testimony that has come down to us of how people saw theatrical naturalism in opposition to the still collective and pedagogical nature of tragedy is the commentary of Solon, collected by Plutarch, on a work of Thespis himself:

Thespis, at this time, beginning to act tragedies, and the thing, because it was new, taking very much with the multitude, though it was not yet made a matter of competition, Solon, being by nature fond of hearing and learning something new . . . went to see Thespis himself, as the ancient custom was, act: and after the play was done, he addressed him, and asked him if he was not ashamed to tell so many lies before such a number of people; and Thespis [replied] that is was no harm to say or do so in play.[46]

Plausibility and Naturalism, Entertainment and Amusement thus were the categories and conditions of the autonomous—"untruthful"—spectacle which was developing; the first front of the segregation between spectator and spectacle.

Ceremonial space and time are qualitative; the ceremony is conducted in a "holy" space, on "appointed" days.[47] But the progressive secularization of the topics had to be complemented by that of the places and times of the performance. The stage and scheduling had to be set in a merely quantitative or Cartesian space and time. The places of pilgrimage or the calendar of major festivals could be retained as relics, but the urban spectacle needed a more rational and functional structuring which would no longer depend on those contingencies. Sure, the times or places convenient to leisure can today be sanctified *a posteriori* (as Christmas or Easter are today), but they cannot be made to depend really on the mythic nature of certain moments or locales.

Everybody speaks today about recovering these qualitative times and spaces: hence the rejection of the aseptic stage located "in front" of the spectators, and the new little-theater groups' search for performing places charged with all sorts of connotations: garages, chapels, wharves, cellars, etc. And likewise, there is a search for the collective ritual *pathos* of the Feast by means of the consumption of stimulants or hallucinogens which accompanied religious ceremonies: alcohol in Dionysian festivals, the "philtre" of Eleusis, peyote in the Huichols' pilgrimage to Viricota, etc. Thus the effect to recover

both the inner and the communal experience—experiences that take place at frequencies higher or lower than those of the warm, spectacular work of art.

Nonetheless, in the rational programming of this collective communion ("we must give back to the spectacle its function as a collective religious experience," Peter Brook preaches) and, above all, in the acquisition and direct consumption of mystical experiences under the aegis of drugs, there seems to be at work a puritan, rationalist, and functional principle that has little to do with an authentic recovery of primitive stages. It connects, on the contrary, with the principle our economy is based on: there is always a material product—drugs or cars, it doesn't make much difference—to satisfy a need. And it also connects with the mercantile ideal of avoiding intermediaries: ecstasy without belief, participation by injection, the private recovery of Ritual by means of stimulants, the unmediated, risk-free Direct Vision. These costs and risks, nonetheless, are basic ingredients of any radical experience. "A sunset is beautiful," Artaud said, "because of all it makes us lose." To recover a greatness which had been withheld from us, "to acquire the eyes, ears, senses of the gods," does not mean "an *improvement* of what we are,"[48] but rather a radical transformation of ourselves. To attempt to broaden awareness or experience without running the risk of defeat only helps to banalize the very thing which, so laboriously and deliberately, one is attempting to achieve.

But these observations should not make us forget the reduction of the experience that modern conventional spectacles involved, and the justified rejection of those plays "which one goes to as to a restaurant—to sit down, be served, and consume, during a pause from the routine of life."[49] "What good is all the art of our works of art," Nietzsche asked, "if we lose that higher art, the art of festivals? Formerly, all works of art adorned the great festival road of humanity, to commemorate high and happy moments. Now, one uses works of art to lure aside from the great *via dolorosa* of humanity those who are wretched, exhausted, and sick, to offer them a brief lustful moment—a little intoxication and madness."[50]

The best indication, perhaps, that "participation" is not something that can easily be programmed, but rather that it demands a background of common beliefs or projects, is the fact that in our century,

this participation was achieved not so much by those who talked about it as by those who tried to return to the drama a pedagogical or political function, analogous to that of primitive tragedy. Piscator and Brecht, in fact, understood drama much as Aeschylus had—no matter how concerned they were to show that the problem was not so much a Metaphysical Destiny as a Social Situation.

A Short History of Stage Space

The collective Feast occurs in a locale, in a *topos* or Holy Place "preserved" by men, so that gods, and men along with them, can inhabit it.[51] This festive space is not structured beforehand: it becomes polarized anew on each occasion, around the "inspired one" in whom the forces of the place are embodied, and who transmits these forces to the others. And as long as the professional caste of inspired ones—priests, actors,—has not yet appeared, this role of polarizer of the event is taken on by different *thiasos* or participants. The "center"

Feast

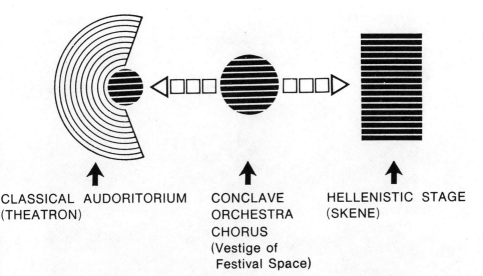

CLASSICAL AUDORITORIUM
(THEATRON)

CONCLAVE
ORCHESTRA
CHORUS
(Vestige of
Festival Space)

HELLENISTIC STAGE
(SKENE)

is then the place or individual in which the forces take shape, not a geometrically defined space.

As a direct outgrowth of the Feast, no elevated seats surround the archaic Greek tragedy: only the circular orchestra or magical conclave. The wise citizens who are not participating in the enchantment of the feast and who, as we saw, instead of "prohibiting" their excesses, decide now to "witness" them, can sit or stand in the space that surrounds this orchestra. The orchestra is therefore the generating nucleus out of which develops, on the one hand (in the classical period) the *Auditorium* or *Theatron,* and on the other (in the Hellenistic period) the *Stage.*[52]

The unity of the conclave and chorus where everyone acts is thus split in order to provide increasingly differentiated and specialized spaces. The auditorium doesn't become raised until the fourth century, and the stage not until the third.

But even in the classical and Hellenistic theaters, the separation between these spaces is not sharp. The *theatron* or auditorium in Epidaurus' theater is still the very hillside forming an ellipse that almost completely surrounds the orchestra. The spectators can see each other and, over the top of the stage, can see the sea and Aegina in the distance. The spectator therefore does not feel separated from the

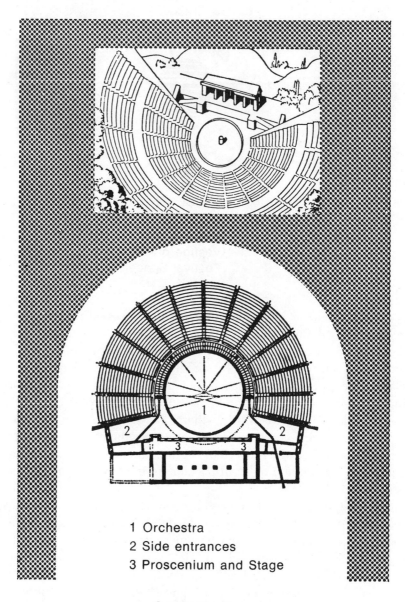

1 Orchestra
2 Side entrances
3 Proscenium and Stage

Greek Theater

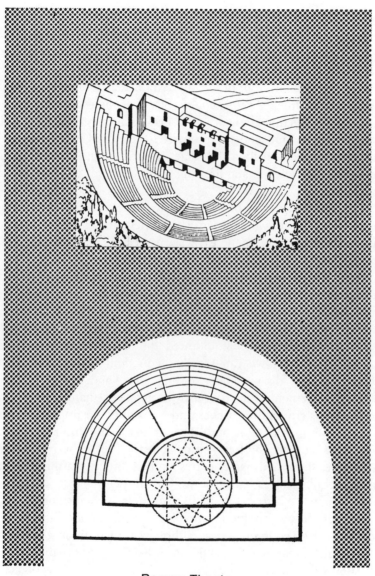

Roman Theater

other participants nor from the geographical *topos* where everyone is experiencing the event. The circular *orchestra* at the foot of the seats concentrates the chorus: the place where the inspired few cry and dance, and where we can still see, as in Epidaurus, the basis of the Dionysian altar. In front of the orchestra is the colonnade of the Proscenium and, finally, the *Skene* or Stage. In its evolution, nonetheless, the connecting elements—the Dionysian altar and the chorus—were losing ground and the properly scenic ones were gaining: first the proscenium and then the stage, which had at first been nothing more than a backdrop and dressing area (*Skene* means 'tent' or 'dressing room').

The semicircular floor plan of the Greek theater thus shows a breaking of the festive circle in which, nevertheless, the chorus continues to be circular, as the excavations of Epidaurus, Eretria, Megalopolis, and Delphi show without exception.

In Rome, the series is already polarized on both sides: steps-orchestra / proscenium-stage. The *Theatron* (seating for the spectators-consumers) and the *Skene* (stage for the actors-professionals) become prominent, dissolving the sacred collective space (orchestra, altar). Even in the theaters that followed the Greek model—like *Leptis Magna* in Libya—we can see the reduction of the orchestra to a semicircle, the disappearance of the altar, and the corresponding forward movement of the Stage which acquires, thanks to the Roman building system with its arches and the vaults, an impressive consistency and importance. A built stage or "set" which no longer permits people to see over the top of it or across it, but rather which totally dominates the visual space, corresponds to the increasing plausibility and psychological character of the Roman plays.

In Rome we also begin to find theaters with rectangular floors, which reflect spatially the less involved attitude of the Roman spectator. Less involved in one sense, although more so in another: here we must make a clarification. When in a Roman performance someone must be killed on stage, they bring in a slave or prisoner who actually dies, so that his screams as well as his blood are real. And this unbridled *naturalism* in their performances is the perfect counterpoint to the *intellectualism* and *moralism* of their plays. And it is clear that these two extremes (radical naturalism and subjectivism) can no longer be absorbed into the classical model, no matter how

much its space and themes change. Thus the link which Greek classicism had established between passion and intellect, sensibility and sensuality, is broken forever, and with it, the quality of the spaces which reflected, expressed, and were the right frame for Greek balance.

Oddly enough, the circular shape, symbolic of festive participation, is actually kept in Rome, but now only in the buildings devoted to sports and violence. It is clear that in Rome, sensitivity and sensuality are already very different things—and in the very floor plans of their buildings we can read this split.

While the products of sensitivity, the "cultural" products, continue to be displayed in theaters which "distance" the spectator more and more, sports events or politics are carried on in circular and closed settings like the *Coliseum* or the *Circus Maximus*, where chariots careen, prisoners fight with animals, and gladiators struggle with each other. Here, topologically as well as topically, we find the origins of our football stadiums and bull rings, on the one hand, in which we *participate* and, on the other, the origins of the theaters which, after dressing up properly, we *attend*. From Rome on, the split between places for "passionate" *events* and places for "cultured" *spectacles*, between sensitivity and sensibility, is consummated.

The concentric and circular form is good for passion and blood (isn't it surprising how suitable the circus at Arles turns out to be today for the bullfight, without any modifications at all?); but for sensibility and "taste," increasingly lateral and distant stages are required. The classical *Skene* reinforces its nature as Dressing Room in cruel spectacles or sporting events, while it turns into a distant and oratorical Stage in cultural events.

After following the course of this late split in Rome between *cruelty* and *artistic "taste"* we should be able to avoid Artaud's confusion between cruelty and metaphysical idealism. Artaud thought that cruelty is the only primitive dimension that could free us from the trivial psychologism of our time. But, contrary to what he thought, there is nothing of the "primeval" about cruelty; cruelty is a "specialization" of a metaphysical *factum* that is beyond the petit-bourgeois psychology, certainly, but also beyond bloody enthusiasm. It is only after the Roman "split"—or before the Greek "synthesis"—that cruelty appears as the only vehicle of real metaphysical and cosmological experiences

At the Stadium in the Afternoon

At the Theater at Night

as opposed to soft spiritualism of inspired intellectualism. What Artaud does not see is that cruelty is not a state that precedes moralism and intellectualism, but rather the other side of the coin, its very twin.

Mindful of the Balinese theater or the Medieval plague, Artaud

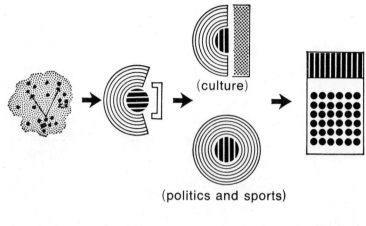

(culture)

(politics and sports)

| Archaic Festivity | Classical Greece | Rome | Nineteenth Century |

overlooked the Hellenic experience. Only there could he have dis-covered—even "physically" as he wanted to, in its very buildings and spaces—that cruelty was not "the poetic state, a transcendent experi-ence of life," that he had been seeking.[53] Only there would he have seen that "cosmic themes . . . and the total man who transcends the social man" do not manifest themselves only in Mexican cosmology, Hindu mythology, or the medieval plague: that not only the most *beautiful* but also the most *radical* manifestation of these "cosmic themes" is not found in the spectator's "taste for crime, his erotic ob-sessions, his savagery, his chimeras, his utopian sense of life and mat-ter, even his cannibalism,"[54] but instead, beyond cruelty, beyond good and evil, in Apollonian idealism and Dionysian orgy: *in vino veritas.* A more radical, less melodramatic origin—and no doubt, a more amusing one than Artaud's cruelty.

Up to this point we have seen an evolution of the spatial frame of the performance and its parallel evolution with the performed action or play. But what happens after Rome? The evolution seems to fol-low the same trend of progressive segregation of spaces which culmi-nate in the eighteenth and nineteenth centuries, in Neoclassical the-aters, and above all, in the Romantic and Rococo theaters, where the stage no longer appears distinct but rather deliberately distant and picturesque, ethereal and allusive, almost unreal, producing a sub-

lime distortion in the spectator. The physical and psychological separation is now so great that the spectator begins to seek in suggestion a new mode, the "modern" mode, of connecting with the plot. The intermediate spaces of the primitive theater still survive, but no longer to connect the spectators; they consist now of a no-man's-land of proscenia and empty orchestras, which distance the spectator from the stage where the story is unfolding—as if they foresaw the appearance of the cinema, which demands a certain distance between the first row of seats and the screen.

The Renaissance Continuation and the Medieval Alternative

But a linear concept of this evolution is too simplified. From Roman times on, we have to recognize and distinguish at least two different traditions.

> 1. The Renaissance tradition, which introduces linear perspective into the stage, thus confirming, reinforcing, and stabilizing the segregation between the stage and loge.
> 2. The tradition that evolves from the Medieval Festivals and Mysteries and merges with the classical tradition in Elizabethan and Spanish Golden Age theater.

Now I will discuss these two traditions in more detail:

1. Only the plausibility and discursive nature of the plot could thematically fit "double entry" spectacles, and only scenic perspective machinery could fit them spatially. The Roman theater had accentuated verisimilitude and had physically distanced the stage from the loge, but there was not a real break between these two spaces: the "quality" of stage and loge space was still the same. They were juxtaposed but not distinct. Thus, in order to achieve a final separation of the spectacle from the spectators, one had to find a new spatial organization for the stage. And this was what the Renaissance contributed.

The Renaissance organization of the stage is the first to endow it with real autonomy. Just as plausibility gave autonomy to the plot,

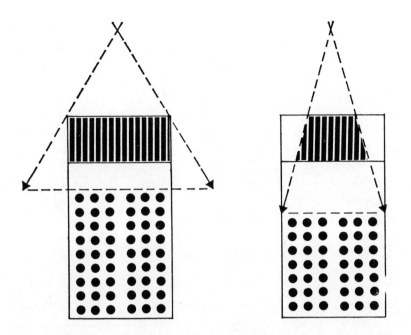

the perspective stage bestowed this autonomy on its frame, making it a fully *different* place where the actor could move with complete naturalness as if he were in his home.[55] Here, the analogy with painting could not be more clear. The linear perspective of Piero della Francesca or Ucello makes of the retable or mural—that is, of the painting belonging to the place—an absolute, autonomous representation, which the frame quickly segregates as an external sign of its qualitative difference from any context in which it might be placed. And it is, likewise, perspective organization which gives this independence to scenic space.

The creators of this new dramatic space are Servius and Sabbattini (*Pratica di fabbricare scene e machine nei teatri*, 1759), who introduce into the theater the perspective techniques which had allowed painting to become both a "deceptive appearance" and a product independent of its context. The stage of the Olympic theater in Vicenza is already set in a triangle whose base rests on the first row of seats, and where objects keep diminishing in size until they reach beyond the set to a distant and imaginary focal point.[56] In the Rococo

and Romantic theater, the base will keep getting smaller and the focal point more distant, until an unreal and picturesque effect is achieved. Here people can consume even more sublimated plots, even more effective images.

It is against this situation that the modern theater reacted and defined itself, from Piscator to Brook and the *Teatro del Sole*. It was a theater which, for that very reason, could not be just a rejection of certain *themes* or plots, but also and above all, of the *space* which those themes had marked out as their natural frame, and of the *ratio* between the senses which it established. Therefore, the revolution in the new theater has not been merely theatrical, but also literally spatial and cultural. In the next section we shall see that the greatest limitation of what until the sixties was called avant-garde theater was its ignorance of this wider framework out of which a theatrical renewal had to begin.

2. But before this modern classical tradition, and more akin to the magic origins of Greek tragedy, there is another tradition beginning with the medieval mystery plays and extending to the Elizabethan and Spanish theater of the sixteenth century. It is a tradition that escapes from homogeneous space or time, and that newly inspires the theater of today. To begin with, the religious *mysteries* and courtly *entremets* ("entertainments") of the Middle Ages are not based on the rationalist fiction of a succession of plausible actions in a unitary space, nor do they suppose that the actor is a character separate from events whose course has been fixed once and for all. They consist, on the contrary, of a succession of *living frescoes*, of farces and mimes played by some actors-animators (Fraridet, Berenger de Pasarol) who, like the members of some modern troupes or like the Greek tragedians before Thespis, feel the need to encourage the audience to participate for the spectacle to be complete.[57] The themes are popular ones (farces, satirical monologues, off-color jokes) or religious ones: naturalistic *Mysteries* whose topics are the Passion, the Life of Mary, etc., and *allegories* (*Morality Plays* whose characters are Virtue, Sin, etc., and which will later give rise to the *Autos Sacramentales*).[58] The Dances of Death represent the first synthesis of both traditions. In medieval Spain (as in ancient Greece) this religious character determines the *thematic* polarization of the performances, as well as their connection to a liturgical *calendar*: the Christmas or Passion

cycles are as temporally and thematically fixed as the Dionysian and Lanaean ones in Greece.

The *place* of the performance is at first the altar itself, and then begins a slow process of secularization: from the altar to the atrium, from the atrium to the door of the Church (where on Holy Saturday the fire is still blessed) and from there to the public plaza. Later, from the end of the sixteenth century, the process of interiorization will begin as the play passes from the plaza to the *corrals*, which already foreshadow the private bourgeois theater. The medieval *stage space* is made up of a wide platform (*tablado*) on which different scenes or "places"—Golgotha, Caifas' house, etc.—are juxtaposed so that the actors go from one "scene" to another as in a retable, to perform the next part of the drama. And it is this tradition of the medieval scenic retable which first collides with the "Italian stage" and ends up merging with it in the stage of the corrals.

In this way the theater in more traditional and backward countries like England or Spain maintains (even after Renaissance rationalism) a sense of the spectacle as a succession or juxtaposition of different events which the spectators watch without feeling themselves hypnotized by the unifying perspective that shapes the active space of the Italian stage. As Victor Hugo emphasized, on a Shakespearean stage the audience could at the same time see King Richard returning hurriedly from Ireland while his rival, Bolingbroke, in furious combat, takes possession of the cities in the country of Wales, and the Queen laments in her garden. And in the same way, "Calderón de la Barca could *juxtapose* the elements of real life and fiction in *Life is a Dream* because he was using the stage of tableaux and a dramatic field composed of diverse platforms."[59]

The illusory naturalism (the "lie," according to Solon) of the Italian stages brought about, on the contrary, the "unities" of space, time, and action which the Neoclassicists explicitly formulated. The public was to be absorbed by the total image, by the unique illusion of the stage: a virtual forest or palace, a living, breathing Caesar or Cinna. The discourse itself, as Duvignaud points out, was caught in this scenic context in which action or violence could only be "explained" by the *Subject*: the bourgeois subject that possesses and organizes the world around himself. In fact, it is not by chance that when the time came to look for precedents, Brecht referred to the

Spanish or Elizabethan theaters as historical examples of the "achievement of artistic effects by means of distancing."[60]

We have seen how the open stage of the Elizabethan or Spanish Golden Age theater permitted more complex *Plots*. And we can see as well how it fostered much more open *Characters* and theatrical *Genres*. Compared to the more or less subtle and profound but in any case *unified* characters of French Neoclassicism, Shakespeare's characters are heterogeneous, complex, and contradictory. Shakespeare's Cromwell is a "tyrant over Europe and the toy of his family, sober, frugal, and sensitive to questions of etiquette; a coarse soldier, a subtle politician, a boring, obscure orator, but with a fluent use of language when he wants to persuade; believer in the astrologers and banishing them, always threatening, almost never bloodthirsty. Or a Rochester, ridiculous and spiritual, bad poet and good gentleman, sinful and ingenuous, risking his head, but little concerned for winning the game once it amuses him; astute and quick, crazy and calculating, infamous and generous."[61]

Also the rules and strict divisions between genres lose meaning in this milieu, which is still not unified by the Italian stage. As I pointed out above (p. 31), the scandal provoked by Ken Russell's *The Devils* was only due to the fact that it was a movie at once intellectual and banal, cruel and sentimental, serious and superficial, brutal and devious—that it was picking up again a tradition of the Elizabethan theater which, thank God, still did not know that certain things are for tragedy and others for comedy, that one thing is suitable for drama and another for vaudeville. The very list of terms used in nineteenth-century Paris to criticize the works of Shakespeare literally matches the ones used by the new customs-agents of culture to criticize the most radical works of the new cinema or theater. Shakespeare's theater, in fact, was accused of "implausibility, extravagance, absurdity, obscenity, puerility, disproportion, exaggeration, . . . immorality, pandering to the market, taking pleasure in the horrible, wordiness, vulgarity, pathos, stylistic obscurity."[62]

In Spain, the Golden Age theater begins the desacralization of themes and the interiorization and homogenization of space, but it still keeps alive many elements of the medieval tradition. In his *Arte nuevo de hacer comedias* [*New Rules for Writing Plays*] Lope de Vega "advises":

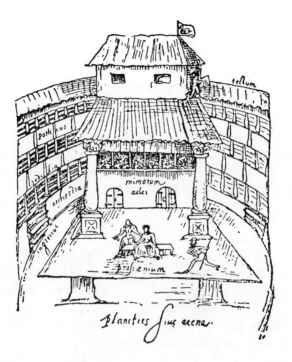

In the first act, put the situation,
In the second, link up the events,
So that, by the middle of the third,
Hardly anyone can tell what's happening.

But these principles only apply to the principal "play." The spectacle as a whole is a complex event still linked to the community it is performed for. It begins with a hymn of praise (*loa*) to the city followed by the three acts of the main work. Between the first and second acts a farce (*entremés*) is put on, and between the second and third, a musical interlude (*jácara*). Everything ends with dancing. The stages in the corrals, furthermore, are still not a private interior space like the bourgeois theater, but a patio between buildings; the staging—any place at all with doors—does not create a unitary and illusionist space, but is rather so scanty and elemental that frequently the characters themselves have to explain what the "place" is when the action starts: "What a beautiful garden this is!" or "I wonder where the innkeeper is?" or "Who broke the sacred silence of these cloistered walls?"

Aside from other cultural or social reasons we shall examine later, there is at least one technical factor that explains the present-day return to (and inspiration in) preclassical ceremonial theater. This factor is electricity. (I am aware, of course, that the influence of this factor need not necessarily be a lasting one: "electronic poetics" will follow the same process of becoming prosaic that "mechanical poetics" did.) Electrical lighting and sound certainly help to "recover" the simultaneity and the coexistence of times and spaces that we find in the original scenic discourse of Shakespeare or Lope. Electricity "breaks down the fixed unity of the cubic stage, multiplying points of view, modifying the places, accentuating with greater or lesser intensity landscapes and scenes, modulating the moments of intrigue,"[63] and making possible the most spectacular effects of succession and simultaneity. Cinematic resources and technical effects (close-up, slow-motion, flashback, etc.) even allow for the return to a direct expression of action and violence, without its discursive processing as in classical theater.[64] "The movies," Merleau-Ponty has written, "do not give us the *thoughts* of a man, but his *behavior* . . . for the movies, as for modern psychology, vertigo, pleasure, love, pain, or hatred are just *behaviors.*"[65]

So, we should not be surprised when the new theater rejects the discursive and autonomous nature of the traditional spectacle; when it wants to change theater into pure bodily expression on the part of the actors and into a stimulant for the spectators; when even *provocation* begins to seem too deliberate and theater turns towards pure *exaltation*.

But before dealing with the so-called new theater, we must briefly analyze the pros and cons of the modern attempts to give a new meaning to the art of the stage, represented in Piscator, Brecht, Ionesco, Grotowski, Artaud, etc.

Modern Compromises

Although they may have rejected one or more of the factors that made theater a separate and autonomous reality ready for cultural consumption, modern playwrights were not able to create a spectacle that actually transcended such a situation. As a matter of fact, they

wanted to dispense with the conventions on which that theater was based without actually disrupting its frame and scope.

In the last section I pointed out two necessary and sufficient conditions of the "double entry" theater, one of which affects its message and the other its medium:

 1. the *plausibility* of the plot, which keeps the spectators quietly following the course of the tale, and
 2. the *segregated and unitary stage*, a condition of the passivity of the spectators seated in "their" seats.

The autonomy of the theatrical work, based on plausible plot and the segregation of the stage, in turn caused:

 1. the "professional" status of the actors, who now are distinguished from the collective of primitive celebrations, and
 2. their "discursive" rather than active attitude.

Now then, our authors either (1) tried to dispense with the "causes" of the self-sufficient character of this autonomous theater—dispense with plausibility (Ionesco or Beckett), or with stage decoration (Vilar)—without breaking with its structure, or (2) they aspired to break with its structure but did not want to dispense with the related consequences: with the actor-person (Grotowski) or with the direct stimulation of the spectators (Artaud). Let's take a closer look.

THEATER OF THE ABSURD

Beckett, Ionesco, and Adamov tried to get out of the impasse by eliminating thematic plausibility. The character waits for no one knows what, is pursued by no one knows whom. The dialogues don't connect the characters with each other but isolate them, each one "within" a language which is exchanged with his fellows, without ever connecting them. ("Are you coming from home?" "No, I haven't told anyone." "Ah! I thought you had bought it for Paul" . . .) These are self-sufficient, absolute characters and languages, and therefore "absurd."

In its heyday, 1950 to 1960 approximately, this theater was effec-

tive in its stress on the "solitary" nature of situations commonly thought to be collective and the circular and vicious nature of most verbal interaction.

Nonetheless, as much in its most lyrical version (Beckett) as in its most sarcastic (Ionesco) or imaginative (Adamov), it appears now to us more related to existentialist ideology (*Angst, Nausée,* Dereliction) and to the search for a properly theatrical language that would survive the competition of the cinema, than to the more recent questioning of the very framework of dramatic art. Just as painting became abstract with the development of photography, which represented an "unfair competition" in the field of representational art, so theater became "absurd" when it was already evident that it could not compete in "plausibility" with the movies. It is thus a defensive reaction and involution, when the traditional pathways for expansion are blocked. With art, as with nations, a blockade always causes an attempt to recover the essences—national, theatrical, pictorial essences. Only exceptional nations, philosophers, or artists—Picasso or Piscator, for example—are capable in these competitive situations of giving an open, "catholic" response, instead of following the puritan line; that is, instead of trying to hide their truths in the depths of a "demythified" essence (abstract painting, Heideggerian philosophy, theater of the absurd, etc.) where they hope that the new techniques or sciences will not be operative. In this sense, a good deal of avant-garde painting, theater, and philosophy seem more like professional defensive reactions than culturally viable alternatives.

On the other hand, the theater of the absurd tried to dispense with traditional linear and naturalistic plots on the same stage, without realizing that "plausibility" and "stage" are only aspects of one and the same system: that they are two interdependent realities which arise one with the other and one for the other. This self-defeating aspiration was certainly analogous to abstract art's attempt to eliminate pictorial "representation" on the very "easel painting" that had appeared precisely with and for this representation.

A further step was needed—or one less step. The theater of the absurd certainly had its effect, but today the still puritan and prudent nature of its break with tradition is all too evident. As the "pánicos" have recently reminded us, playwrights of the theater of the absurd

had a ready-made "message" (usually formulated in negative terms) before they started writing. They kept on "imitating" characters and "representing" situations, instead of "embodying" the character and "committing" the acts. No doubt this judgment is harsh and lacks the historical perspective from which one can appreciate the theater of the absurd's contribution; but Ionesco's denunciations of recent theater—"which preaches liberation of desires but in reality has no other desire than to destroy"—are equally biased and lacking in historical insight.[66]

JEAN VILAR

From the point of view of my argument, Vilar's contribution to the theater is complementary to that of the theater of the absurd. If the theater of the absurd tried to eliminate plausibility in the plot, Vilar hoped to eliminate *scenic* plausibility. In both cases it was a question of purifying or weeding out, not in order to go beyond conventional theater, but rather to keep it alive. As in the previous case, Vilar did not see the profound connection between scenic organization and plot. It was also a matter of "surrendering" the special effects to the movies and "returning" to scanty staging in the theater—an optimum staging for highly symbolic and intellectualized spactacles. Only a gray curtain could compete with Cecil B. DeMille, as only the absurd theater could compete with *Gone With the Wind*.

Vilar's proposal, unlike later theater, was not aimed at the *dissolution* of classical stage space, but rather at its *simplification*. It didn't *eliminate* the stage but only the *sets*, especially the *naturalistic sets*. The stage continues to exist, but as a "normal" space, not qualified or emphasized: a gray backdrop, two spots, perhaps a table. In any case, if this space could still be distinguished from the soft, decorated loge, it was because of its simplicity and poverty.

Jean Vilar's *aggiornamento* of theater is comparable to what happened in the Church. When the Church decided to become more secular and eliminate the liturgical pomp, it turned out that people started to join even more ritualized, charismatic, and cosmic religions; they missed the traditional mass, which then appeared as "the last great audiovisual spectacle in the West." Similarly, after Vilar had purified the stage, the new theater became interested in strongly

characterized spaces, loaded with connotations. For the new theater, a garage, a church, or a warehouse were always better than a "poor" and purified stage space.

Garages or churches as opposed to Vilar's spare stages: this sums up the whole contrast between the avant-grade *simplifying* tradition of the fifties, and the new *accumulating* tradition of the sixties. Even the French wanted now to break with their cherished tradition: in his *Mass for the Present Day* in Avignon in 1967, Béjart designed a spectacle of cultural animation which, using the whole town as a stage, tried "to foster the expression of violent, dangerous, and uncontrolled desires." Planchon and the new T.N.P. tried to broaden the scenic frame by taking part in workers' "meetings," organizing "parties," and offering "babysitting" services.

Vilar himself stated that he wanted "to eliminate all means of expression foreign to the pure and Spartan laws of the stage." "He tried," as Bernard Dort wrote, "to bring together individual dreams and social reality, the freedom of the actor and the tyranny of the text, rejecting any mediation which did not stem from the naked walls of the stage. This was his merit and his limitation."[67]

GROTOWSKI

Grotowski was the great master of bodily expressivity, and it's no accident that the new theater groups, more mistrustful of ideas and words than of gestures, sought him for inspiration. The body, he wrote in *Toward a Poor Theater*, is the first resonator and vibrator of intimate experiences; more than attempting to express these experiences verbally, one must transform the body itself into their perfect viaticum. With that, Grotowski squared off against the tradition of the literary and ideological bourgeois theater, as well as against any idea of returning for inspiration to classical Greek theater. The *mousike* of the Greek theater was based on a high degree of conventionalization and ritualization of tones, gestures, and expressions: each speech carried along with it a given and fixed tone, just as a stereotyped mask corresponded to each person or emotional state. In modern performances, however, diction is no longer conventional but rather expressive, and the persona-mask is replaced by the persona-subject. This persona-subject or "ego" that now polarizes the plot was a product of the fixed stage and plausible plot of modern

drama. Only within the subjective arguments of the bourgeois drama should the actors have a personal expression that corresponds to their "internal" feelings. Only within the space of a fixed stage will an "ego" become necessary to inform the "context" of each scene and the sequence of events which occurs between one scene and the next. This ego was the pivot of the entire aura of events which could not be produced on the stage and which were thus communicated or "processed" through a protagonist who told them to the spectator—or to whom they were told for general knowledge. It was through him that the spectators knew about the synchronic context of the event as well as about the diachronic linking between one scene and the following one (e.g., the beginning of the second act, "Ah, how much has happened, dear Louis, since we saw each other yesterday in this same inn. My wife and your faithful servant . . ." etc.) Schematically:

Nowhere as in the conventional drama is it so clear that words, as I. A. Richards defined them, "are the meeting points at which regions of experience which can never combine in sensation or intuition, come together."[68] When the theater tends to become a series of immediate expressions without logical connection, or when the surroundings and the continuity of the events can be presented directly, as in the movies, the function of this Ego and of its words as "meeting points" tends to disappear. As I have written elsewhere, "the images and sequences of the movies are not 'reticent'; they *say*

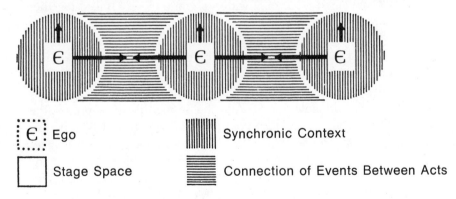

Ɛ Ego

Stage Space

‖‖ Synchronic Context

≡ Connection of Events Between Acts

Ɛ represents on the stage the scenic surroundings as well as the events occurring between one act and the following one that maintain the continuity of the plot.

by *showing*. What surprises us when we see the movie version of a play is its unnecessarily lengthy narrations of the past, and its detailed descriptions of the emotions of the protagonist in his monologues. The movies would ordinarily show us that past in a flashback, the emotion in a gesture (a trembling hand, or the movement of an eyeball).[69]

In the movies or the new theater, the protagonist can again be the Event, the Violence itself, without the mediation of an Ego or a Discourse that represents them. The Grotowskian techniques for the bodily translation of this Ego, then, cease to have the meaning their creator gave them. Grotowski was not surpassing but rather, like Ionesco or Vilar, purifying the conventional teater. And if his techniques are still used in the new theater, I'm convinced that it is only at the cost of changing their meaning: ceasing to be instruments of the Ego's expression and becoming techniques of pure gesticulation in the direction of kinesic experiences. Grotowski's techniques will no doubt survive, but in the service of a theater very different from his own.

ARTAUD

Throughout these pages we have dealt more than once with Artaud's ideas and influence. Here, I only want to question the viability of his proposals and the supposed modernity of his conceptions.

Artaud saw clearly that only within a group closely linked together by the same passion of fear was it possible to liberate behavior from customary gestures and social attitudes—to recover the dramatic, metaphysical, and cosmic meaning of existence. For Artaud, this "dramatization" meant the recovery of "authenticity." Under the effects of the Plague, people pursue the wealth which they know very well they won't be able to use. And that's when theater appears: the theater, that is, the immediate gratuitousness which impels to useless and fruitless acts, gratuitous outrages and murder. Like the Plague, "the theater also takes gestures and pushes them as far as they will go" (Artaud, p. 27). "Like the plague[theater] is the revelation, the bringing forth, the exteriorization of a depth of latent cruelty by means of which all the perverse possibilities of the mind, whether of an individual or a people, are localized" (*ibid.*, p. 30). "The theater, like the plague . . . releases conflicts, disengages powers, liberates possibil-

ities, and if these possibilities and these powers are dark, it is the fault not of the plague nor of the theater but of life" (p. 31).

The "gratuitous" conduct which the Plague unleashes is, for Artaud, more "profound" and "authentic" than everyday conventionality. "For, impelling men to see themselves as they are, [the Plague] causes the mask to fall, reveals the lie, the slackness, baseness, and hypocrisy of our world" (p. 31). Nothing like a masquerade, then, in Artaud; his innovations—and his limitations—are of a different sort.

Much has been said about his innovations. Artaud understands that theater ought to connect with life itself. He foresees that to renew the theater one need not criticize drama, but rather look in places where the modern drama is not; in all that which the theater is *not*. The attempt to reconnect Art and Life, overcoming the stereotype which the drama (or art in general) gave us of this connection, has been, in fact, the common denominator of art from the sixties on.

Not so much has been said about his limitations, and that is why I will insist on at least three of them: one purely theoretical (already noted on pp. 167–70), and two others which are practical.

1. From a theoretical point of view, the belief that this recovery of the connective tissue which unites one's own personal life with the cosmos is possible only in times of the Plague or in situations of cruelty is, simply, a mistake. Surely, Artaud speaks of Cruelty and the Plague in a very general sense, which comes to be the synonym of Life. ("I have said, thus, *cruelty* as I might have said *life*."[70]) But it is no accident that Artaud takes the Plague as an objective "model" of Life, and Cruelty as his subjective model. There we have both the perspicacity and the theoretical limitation of his proposal.

In Orphism, in Rome, in medieval Christianity, or in pre-Columbian culture, transcendent life actually means a split, purification, and therefore, often *cruelty*. So the association Artaud makes between Cruelty, Life, and Spectacle is not a gratuitous one (we can recall the symbolic cruelty of the Holy Sacrifice of the Mass, or the real cruelty of the sacrifice applied *to* Christians in the amphitheater and practiced *by* Christians who in their turn purified heretics at the stake). Nonetheless, in other less "split" societies, we discover events and celebrations (Kula in Borneo, Panathenaea and Dionysian in

Greece, etc.) where the festive or estraordinary experience does not necessarily have cruel manifestations.

Artaud rightly saw that only in a closely defined cultural area in which all participate in the same *pathos,* only in the identity of beliefs and expectations of a group in the strongest sense of *Gemeinschaft,* is an authentic spectacle-participation possible; a performance without separation between roles and functions, between actors and spectators. Only there can one find this communication-contamination which does not require the establishment of a conventional thematic or spatial frame of reference. That is why spectacle-participations have been connected in recent years with "communes" and small-group communities which allow for non-conventionalized forms of behavior and interaction. Nevertheless, this means a *displacement,* not an *elimination* of the fixed frame: either the cultural frame is rigid, or the frame of the spectacle itself is; either there is a deeply shared code of reference (myths, ideals, plans), or what is fixed in the performing space, and the conventions of the spectacle. *The rigidity of the stage has only been dispensable when and where this necessary rigidity took root or survived in the community at large.*

What Artaud didn't see, moreover, was that these fixed frames have existed and may arise today without any mediation by the plague or cruelty. Just to take a few examples, they can exist based on:

> —A *common project:* the common project of an extreme revolutionary situation (the Bastile; May 1937 in Barcelona) can create a cohesiveness that permits immediate, nondiscursive communication. Much of Sartre's *Critique of Dialectical Reason* is given over to the description of this existential-revolutionary spectacle in which the group manufactures its own principles of intelligibility, creating and recreating its code in the course of the action. Today, after Cuba and Chile, the spatial and, above all, temporal limitations of such situations are more obvious than ever.
>
> —A *shared faith or belief:* the complicity existing between members of a faith, or even between the churchman and the heretic, have set the stage for great events and spectacles. Between the man who condemns a heretic to burn at the stake to defend the doctrine that the Son is *omousios* (the same as the Father) and the man who, following Tertullian or Arrianus, is burned because he says he is *omoiousios*

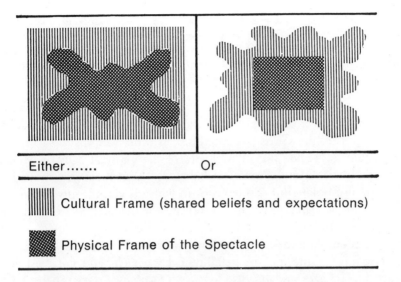

Either....... Or

Cultural Frame (shared beliefs and expectations)

Physical Frame of the Spectacle

(analogous to the Father) there is a profound complicity which is the key to the exceptional dramatism of the stake, so different from the simply "humanitarian" or cruel characters of an ordinary execution.

—*Familiarity with the environment*: ethologists have discovered that in animals there exist two different principles that both lead to exploratory activity. Under normal conditions, the animal sticks to known patterns of behavior. Only *panic* or *extreme confidence* push an animal to use a strange cave or explore some unknown territory. Not only fear, but also the optimum disposition of the environment fosters the experimental instinct, since it offers a fixed framework within which it is possible to challenge the patterns of conventional behavior without serious risks. Also among men, the feeling of safety generates as much or more innovating behavior than does panic, which tends to provoke quite fixed and standard reactions. To oppose conventional behavior to collective panic, means therefore to ignore equally the conventional nature of behavior in extreme situations and the innovating possibilities of non-anxiety-producing environments. As Simmel wrote:

The more restricted our social group becomes, the more we loose our personal freedom. The group itself will become more personalized, however, if it is able clearly to differentiate itself from all other groups by virtue of its smallness. Inversely, when the group to which we belong, in which our interests are invested, expands, our capacity for personal growth within the group also expands. . . . In other words, the members of the differentiated group are undifferentiated, while the members of the undifferentiated group are differentiated. . . . Both terms of this formula are

quite clearly evident in the organizational types of the American North and South, especially in the period prior to the Secession. . . . The independent individuals of the South had an abstract, generally colorless government, whereas the tightly regulated individuals of the North tended to create small-scale civil insititutions which as a whole possessed a very distinctive individual color.[71]

2. The second of Artaud's mistakes, more serious than the previous one, is of a practical sort. Artaud knew very well that modern man—split by the Christian emphasis on time over space—had not been able to create "the mythologies of the classical ages in which man participated and found his balance" (Klossowski); mythologies that did not isolate but connected him with his community. Modern man is only capable of producing private mythologies that enclose or segregate him: schizophrenia, deviance, Bohemianism, protest.

Now then, Artaud knew that this mythology, which could operate as a code or frame for his metaphysical spectacle, did not exist any more in our age, and he decided . . . to change ages (as the king being told that people did not agree with his government ordered his men to change the people). If there is not a mythical collective consciousness, we must create it by loosing the Plague on the world: propagate the Terror so that the conditions favoring the new spectacle will occur. It is better to sacrifice Reality to Art than the reverse: *Fiat ars, pereat mundus.*

Artaud's worship of the Plague or Cruelty—just as Marinetti's of War—were variants of the fascist poetics of violence. "All efforts to render politics esthetic," wrote Benjamin in 1936, "culminate in one thing: war. War and only war can set a goal for mass movements on the largest scale while respecting the traditional property system."[72] Artaud and Marinetti[73] saw very clearly that the contemporary esthetic phenomenon could not thrive on the sidelines of the development of industrial productivity and technological progress. The beauty of one epoch could only be the "spectacular" use of its technological and human potential: the explosion of its bombs, the powerful drive of its tanks, the take-offs of its squadrons of aircraft, the movement of the masses. Contemporary esthetics could not disdain the possibilities offered by the "mobilization" of technical forces and the exuberant exploitation of its resources.

As W. Benjamin wrote,

If the natural utilization of productive forces is impeded by the property system, the increase in technical devices, in speed, and in the sources of energy will press for an unnatural utilization, and this is found in war. The destructiveness of war furnishes proof that society has not been mature enough to incorporate technology as its organ. . . . Instead of draining rivers, society directs a human stream into a bed of trenches; instead of dropping seeds from airplanes, it drops incendiary bombs over cities."[74]

Thus, social potential could only "express" itself now in war. War, genocide, cruelty alone were the perfect actualization of art for art's sake. Today, though, the progressively technological or "cold" nature of this "art" of destruction is making increasingly problematical the erotic and esthetic gratification which it was able to procure—thus fostering the escalation of violence.

3. Artaud's proposal is not only questionable sociologically: from a psychological point of view there are also mistakes whose negative effects have strongly affected the work of his followers. When Artaud proposes to *somatize the messages* and *return to words their incantatory meaning,* he almost always refers to a return to body language—gesture, tone, the music of the words. *"La musique de la parole parle directement à l'inconscient . . . à l'esprit."* For Artaud, while verbal language is abstract, distorting, and mendacious, the language of gesture and tone are immediate, spontaneous, truthful: a blush or the dilation of the pupils unmask the words with which we try to hide our emotions.

But the fact is that tone and gesture are also conventional (the American's stock of gestures is obviously different from the Italian's) and susceptible to social control or subjective manipulation.

"So then," Cranly went on musingly, "you were born in the lap of luxury."
He used the phrase broadly and loudly as he often used technical expressions as if he wished his hearer to understand that they were used by him without conviction.[75]

When I am speaking, and I hear myself uttering a grandiloquent or sententious phrase, I also tend to introduce an excessive verbal or gestural emphasis in order to distance myself—like putting the phrase in quotation marks—and suggest its skeptical or oblique use.

So in body language (just as in verbal language, with which it forms a *continuum*) it is Language or the Ego that speaks, not, as Artaud thought, a supposed authentic and transparent unconscious.

opposite of empathetic and cathartic illusion. He aims not at a theater which transmits sensations that become satisfactory in themselves, but rather one "which has to show us the very nature of things." It is not a matter of being transfixed by the process that is developing on stage, but of involving ourselves and "taking sides"—just the opposite of identifying with it and being purified by its grace. That's why Brecht proposes a theater-trial and Piscator a theater-parliament, which do not offer a moving and finished product capable only of being consumed, but rather a "reality so that the individual will participate."

"The alienation effect and the happening effect," writes Peter Brook, "are similar and opposite—the happening shock is there to smash through all the barriers set up by our reason, alienation is to shock us into bringing the best of our reason into play."[76] Brecht used various techniques to achieve the effect of alienation or distancing—and the audience's ensuing reaction. "I am continually obliged to work out models," he wrote in 1938; "someone seeing me at this work would think that I'm only interested in formal questions."[77] Aware that forms are not natural vehicles, but rather that their inertia or innovating nature impregnate whatever is said with them, Brecht did not stop investigating scenic resources and effects. His goal, just as the technique we associate with Brecht today, has been accurately described by Brook:

A girl, raped, walks on to a stage in tears—and if her acting touches us sufficiently, we automatically accept the implied conclusion that she is a victim and an unfortunate one. But suppose a clown were to follow her, mimicking her tears, and suppose by his talent he succeeds in making us laugh. His mockery destroys our first response. Then where do our sympathies go? The truth of her character, the validity of her position, are both put into question by the clown, and at the same time our own easy sentimentality is exposed. If carried far enough, such a series of events can suddenly make us confront our shifting views of right and wrong. All this stems from a strict sense of purpose. Brecht believed that, in making an audience take stock of the elements in a situation, the theatre was serving the purpose of leading its audience to a juster understanding of the society in which it lived, and so to learning in what ways that society was capable of change.[78]

This "strict sense of purpose" outside of and prior to the spectacle, is what most clearly distinguishes Brecht's work from that of Artaud. Artaud wants and proposes a Plague that will transform, unify, and

To attain a creative bodily expression therefore involves a difficult apprenticeship and overcoming of kinesic clichés. Faced with the current theater groups that seem to believe in the Artaudian myth that bodily spontaneity directly expresses the unconscious depth of the actor and connects in an equally direct and deep way with the spectator, we should recall the rigorous techniques of Grotowski or, in another sense, of Wilhelm Reich, for whom this spontaneity was not a point of departure but rather the product of a difficult sensual and expressive pedagogy. The limitations of almost all the small off-off-Broadway theater groups comes precisely from having adopted the most ideological and superficial of the proposals of Artaud and Grotowski, without catching on to the fact that only a critical and combined use of both traditions can overcome the vicious circle within which each one of them individually was moving.

BRECHT AND PISCATOR

The theater of Brecht and Piscator seems in principle very distant from, and even the opposite, of the participatory rhetoric now in use. Didn't Brecht himself coin the term "distancing" as opposed to emotive participation in the play? And nevertheless, isn't it possible that, when he opposed the classical form of participation described by Aristotle ("catharsis" or purging), Brecht was searching for another form of participation at once more primal and more contemporary?

According to Nietzsche, classical tragedy was a stylistic convention that excited esthetic participation rather than projection, compassion, and purification. Participation did not mean, in the origins of the theater, "belief in, or illusory identification with, what was happening on the stage." Greek "participation" assumed the fictitious nature of the theatrical performance. The spectator was attending a dialectical game between actor and chorus, not the embodiment of an illusory reality. It was only after psychological plausibility gained sway that events on stage began to take on the appearance of "real life," with which it was proper to identify oneself. At the same time, the feeling of attending a game disappeared—a game which, like poetry itself, had a social and pedagogical function.

Now then, these two dimensions—awareness of fiction and pedagogical function—are the ones Brecht tries to recapture for the modern theater, setting up the bases for a *participation* that is the exact

polarize conventional social relations, making epic forms of interaction out of them. Brecht and Piscator do not need this activator because their political intention and historical materialism already polarize a context within which, naturally, a new epic theater can— now we should say *could*—occur. The rapprochement of art and life, the breakdown of residual genres, can only be carried out from a meta-artistic—in this case, extratheatrical—idea, vision, or intention. It is out of this "distance" with respect to dramatic language that Brecht organizes the staging following the actors' needs as they emerge in rehearsal (Neher's principle) and creates a work which is both cabaret revue, melodrama, popular song, and revolutionary discourse.

The example of Brecht thus confirms my impression that the decisive formal or qualitative transformations of art—as H. Kuhn has shown for the sciences—seldom come from the professionals of formal innovation who deliberately look for them. These specialists in formal revolutions take off from a contingent idea of their sphere of activity (painting, movies, theater), and seldom look at problems other than those they feel capable of resolving. The professionals at "breaking conventions" are always perfectly prepared to surpass the style which has already been surpassed, just as the generals are always prepared to win the last battle they lost; they are the security police of the artistic avant-garde, capable only of mopping up defeated enemies or consolidating dominion over conquered territory.

Against these customs agents of formal revolutions, eternal keepers of the temperate flame of the avant-garde, the formal revolutions—from Baudelaire to Rimbaud, from Neitzsche to Proust, from Joyce to Brecht—come from individuals who lived and faced real problems that forced them to develop new formal solutions to describe and confront them. Conventional arts and genres confine us in that warm area where the emotions are already coded, reasoning is already scholastic, and the resources already inventoried. Only those who, dispensing with the temperate logic of the established arts and genres, approach the sources of their own experience, are able to find a new register from which to see, name, or feel things. As we shall see now, it is out of a specifically *political* intention that Piscator introduces the most significant *formal* innovations of the modern theater.

In the twenties and thirties, Erwin Piscator proposes a spectacle that anticipates today's theater and even suggests the specific techniques necessary for realizing it. In contrast to the puritan, avantgarde search for a "specifically theatrical" language, Piscator, as early as 1926, proposes a spectacle which "will join the techniques of the circus, variety shows, and pantomine to the political theater." Here I will briefly list some of the innovations he introduces.

1. We saw that the "unitary stage" was the space naturally arising out of, and for, a plausible plot allied to Italian staging techniques. In *Rasputin*, Piscator tries to break this unity by turning the stage into a series of "places" as it had been in the Medieval theater. The stage consists of a semisphere with opening and closing sections, thus permitting numerous changes of setting, effects of simultaneity, overlapping, and interference between two or more sequences of events.

And Piscator can break the *scenic* unity because the *actual* unity of his works is assured (to its believers) by the laws of historical materialism (symbolized by the semisphere) that explain the connection between the different series of events: a "sector" of the semisphere opens and we see Krupp with his lawyer, considering the desirability of a new armed conflict in order to increase the production of weapons; this sector closes and another opens to show the same lawyer talking from a political platform of the need to defend Christian civilization, etc.

2. Piscator also breaks with the myth of the actor as an "interpreter" of a character: the very character himself in flesh and blood, or a rag doll with his attributes, can replace the actor to advantage. Like Grotowski, Piscator understands that actions should be committed directly on the stage—thus embodying, rather than representing, situations.

When the Kaiser brought Piscator to trial because of the way he had represented him on the stage, Piscator hastened to offer him a contract; "let him come play himself," he remarked, "no one will do it better than he." But if the Kaiser or Krupp cannot come in person, certainly a doll or a marionette will play these stereotyped personages better than an actor.

3. But it is not just the character himself or his marionette who come to complete the actors' action. The cinema can also collaborate in this hybrid spectacle Piscator proposes. Unlike the avant-garde,

which sought what was properly theatrical (aspirations that last until Vilar, the "panic" theater of Jodorowsky, and a good part of today's "intentional accidents"), Piscator, like Picasso, was not as concerned for purifying or saving essences as for taking advantage of resources at hand, such as cinema.

"Where theater wastes its time in explanations and dialogues, the film clarifies the situation with a few images."[79] Thus, he uses naturalistic cinema projected on the backdrop to create "atmospheres," the documentary to recreate the historical milieu, and even animated cartoons by Grosz, in which the secret agent of imperialism is shown as a man attached to an oversized ear. But his most innovative technique is that of film images with superimposed commentaries: commentaries which spell out facts, accuse, propagandize, and function as a pathetic or satirical contrast to the events portrayed. For example:

> a) Superimposition on the stage of the masses' assault during the Spring campaign: "Losses: half a million dead; Gains: 300 sq. meters."
>
> b) Superimposition on a battlefield covered with the mutilated bodies of Czarist soldiers: "My life at the head of my army seems to me healthy, sporting, and vivifying" (fragment of a letter from the Czar to the Czarina).

Diebold compared these filmic devices used by Piscator to the chorus of the Greek tragedy; a *chorus filmicus* which, like the classical one, represents a realistic, collective counterpoint to the stylized, individual actors. This use of the cinema and posters amounts to the introduction of a metalanguage—a language no longer *of* the play, but rather one that takes the very representation as its object— offering the possibility of enjoyment and distancing that characterized the classical tragedy.

4. The very logic of the plots and situations led Piscator to transform the stage into a moving sidewalk, in the adaptation of Hasek's *The Good Soldier Schweik* by Brecht, Lania, and Piscator. In this play we see the other side of the war through the eyes of the young Schweick who finds himself transported from front to front and from prison to prison, learning quickly to get along with that fine sense the oppressed have for detecting survival needs, adapting to the wishes of the powerful, and exploiting their vices. Now the only way of ex-

pressing on stage the story of this person who doesn't "make" war, but to whom the war "happens," and who ends up "making his peace with it," was by organizing the events not around his "thoughts or desires" but rather around his physical movements, his pacing. For that, Piscator introduced the *tapis roulant* or endless belt, thanks to which, marching in the opposite direction to that of the belt, he could keep the protagonist on stage while he went on walking and walking. It was his walking itself, not his awareness or perception, which served now as the connecting thread of the events. A classical performance would have had to invent a hypothetical "ego" for the young Schweick. By means of this device, Piscator avoided dissolving the epic character of the work into a psychology of the character.

Piscator dispensed with classical conventions as well as with avant-garde ones: the definition of the actor, the role of the performance, the limits of drama as genre, the ideas of the unity of setting and action. As K. Kersen saw at the time, "Piscator suppressed once and for all the classical unities of time, place, and action, returning to the theater its magical character, thanks to his brilliant mastery of technical procedures."

Recovery of the "magical character" of theater thanks to the "mastery of technical procedures": the "hot" or magical break thus appears (as we have seen) deeply connected to the "cold" or technical one; the recovery of a bygone theater connected to a future social ideal. Thus, no matter how paradoxical it may seem, it was their ideological convictions and their realist aspirations that gave Brecht or Piscator the perspective and the "metalanguage" out of which to renovate modern drama. And with this statement, I'm not so much trying to justify their concept of realism (to the criticism of which I have devoted a chapter of an earlier book),[80] as to emphasize the vein of formal inspiration which it represents. To appreciate realism because of the formal devices it gives birth to might seem a paradox and a sort of heresy from the standpoint of any realist orthodoxy whatever. And, nonetheless, I'm convinced that all realisms—socialist, ethnological, stream of consciousness, or whatever—are a sort of subterfuge by means of which new art renews its formal repertory and breaks from its academic routine.

"Truth can be silenced in many ways, and it should therefore be

told in many ways." It's not a question, Brecht went on, of finding the form or method suited to a revolutionary theater:

A Method? We didn't believe in this. We knew that we needed many methods to reach our goal . . . ; that we would have to make use of all the possible means, old and new, tried and untried, originating in art and originating from wherever, so that we could offer men a reality that could be controlled.

And now, Brecht concludes, referring to his collaboration with Piscator:

Piscator's great theater experiments, and my own, where we were continually smashing the conventional forms to bits, found the collaboration and enthusiastic support of the most progressive segments of the working class. The workers judged everything according to its truth content, approved every sort of innovation which was necessary for the representation of truth, of the real social mechanism. . . . Their arguments were never literary, nor about theatrical esthetics. Sentences like "you can't mix theater with movies" were never heard there. At most, when the cinema hadn't been blended in well, you heard: the film was unnecessary, it distracts. . . . [81]

Artaud's dream of producing new myths thanks to the theater was beautiful but contradictory: the myth is not *that which is created* in an individual work but the communal background *out of which one creates*. We have seen that Brecht and Piscator avoided the contradiction because they made use of what is already a myth, i.e. a revolutionary ideology. Next we will look at the question: Out of what myth did the new forms of avant-garde theater create?

3. THE SCHISM BEYOND THE STAGE— NEW THEATER

As we have seen for the other arts, there is also, in the new theater a polarization of solutions: the "cold" one of the documentary theater of Frisch or Weiss, and the "hot" one of the groups that followed the tradition of the Living Theater. In this second series one must speak more about groups than about authors or actors: Living Theater, Open, Magic, Impossible, Ridiculous, La Mamma, Zaj, Els Joglars, Bread and Puppet, Theater of the Sun, Mime, Teatro Campesino, New Troupe, etc. Often they were or are groups analogous to the classical choruses of *thiasos* which appeared at the origin of Greek tragedy (see pp. 155 and 162), forming anomalous communities

which reinforce their cohesion and imagination with stimulants. Since the mid-sixties, these groups have tried to develop an essentially *non-discursive, participatory* and *original* theater. In what follows, I will try to (a) explain the relative success with which they have carried out the first aim, (b) explain the poverty of their conquests on the level of participation, and (c) criticize their aspiration to create still another "irreducible" genre; I will conclude by trying to (d) evaluate their actual contribution, (e) point out its limits, and (f) reject the customary criticisms that have been made about them.

Brakes Off in the Garage

These groups plunged into the *commission* of an immediate theater, often drawing inspiration from Vilar, Grotowski, Artaud, etc., but eliminating their timidities and their contradictions. The new works broke with the cultural "punctuation" which determines the limits of theatrical pertinence, and tried to make the work, at one and the same time, Festival, Meeting, Party, Lesson, Ritual, Psychodrama, Demonstration, Advertising Campaign, Gymnastics, etc.

The coarseness or impieties which the members of the Open Theater shouted in *America Hurra* while they destroyed a motel had an obvious provocative intent, which gave us back the flavor of that Greek comedy which, in the heat of a war of national defense, made nothing but a pacifist apologia. But the Open Theater's subjects always turned on a few stereotyped situations, as repetitive as the classical topics or even more so: Adoration, Ecstasy, Violence, Propitiation, Destruction, Consecration, Provocation, Violation, etc. In these situations, Spontaneity was opposed to Convention, or Love to Egoism, in the same simplistic, evasive, way as that of the worst works in which the Good Guys confront the Bad Guys. Thus transgression became an institution, and rhetorical excess obligatory. And, just as Burroughs' systematic sexual engineering or positional topology makes me nostalgic for the erotic possibilities of Romanticism and Classical repression, so this monotonous and repetitive exhibition of pure and wild emotions awakened in me the nostalgia for a more hybrid esthetics and psychology, which certainly opens up more possibilities than the spontaneists' repetitiveness: I felt nostalgia for irony instead of prophecy, for precarious balance instead of easy

transgression. Many of these works did no more than remind me to what extent "madness is insipid and disorder dull."[82]

Intuitively guessing the deep connectedness between discursive argument and the "Italian" stage space, the new works looked for more hybrid places loaded with connotations foreign to the bourgeois spectacle. The most significant works of the new theater in New York were performed outside conventional theaters (in a warehouse, on the waterfront, in a church, in a garage); Planchon and the new T.N.P. tried to widen his audience, giving "parties" instead of performances and joining in with workers' meetings; every year Avignon witnesses the efforts of the French to take their theater into the street.

The spectator of these works was no longer safe in a theater box: when they entered the hall where Tavel and Carmines had organized their *Gorilla Queen* (a 1940s-style tale about a homosexual King Kong), the audience was assaulted by a girl covered with suction cups, only to be trampled later by naked girls followed by nuns who were in turn pursued by the perverse gorilla.[83] Just inside the hall where Ariane Minouchkine's *1793* was being performed, a girl dressed as a servant mingled with the spectators and came up to whisper in my ear, repeatedly and louder and louder, that they had taken the Bastille.

"You Should Participate"

Too often the "message" of these actors who came up to us and whispered, caressed us, or looked intently into our eyes, was, as Kaplan said, "miserably clear," as if a greater physical contact by itself would produce a greater participation.

But contrary to common belief, any *invited* and not really *provoked* participation has an inhibitory effect on the audience—the same effect as when we are asked to be "spontaneous," or when a woman tells her son "not to be so dependent," or her husband "to be more assertive" with her. In this way, anxiety or shame prevented the spectators of many of these works from effectively participating in them.

The stereotyped repertory of extreme situations (ecstasy, copulation, adoration, etc.) also had an inhibitory effect on the spectator who, with no previous warm-up, proceeded to watch a few individuals in ecstatic states—somewhat like when we are sober and drop in

at a party where everyone is already high. The way to transport the spectator out of his everyday prosaic life into a poetic participation is not by exhibiting emotions, but rather by inducing "transgression" or a slippage of meaning in his very own world. Against the forced and deliberate nature of the new theater's aims, the Japanese garden or the tea ceremony are examples of how participation is obtained not by asking for it or calling attention to it, but rather by introducing it surreptitiously into the visitor's mind. To take Japanese tea is to feel oneself initiated into a symbolic community, where the sensations one used to have while having a snack, visiting a museum, and attending mass are mingled and transfigured. So long as our authors and directors fail to inject this symbolic and extraordinary dimension into ordinary events—into our snacks or our outings—their appeals for participation will just be pious wishes and declarations of principles, as discursive and theoretical as those of the theater they are trying to transcend.

The Immediate and Ephemeral as "Properly" Theatrical

A good deal of the new theater followed the puritan tradition of the classics of the avant-garde in their hope to create and define an irreducible theater. Only underlying its ephemeral character, Jodorowsky wrote, will the theater find what distinguishes it from the other arts and, thence, its essence. Other arts leave written pages, painted canvasses, etc.; theater, instead, disappears.[84] Making a virtue of necessity, trying to exploit precisely those resources with which the cinema cannot compete, the theater should be *ephemeral, not repeatable, immediate*, etc.

Just as the movies have had to change in order to survive after TV, the theater had to do the same with the rise of the movies, which stole a good part of its audience. "I believe that the theater, like ballet and grand opera, is already an anachronism," Orson Welles said in an interview.[85] "It isn't an institution that belongs to our times, and it cannot expect a long future. It's not true that we've always had the theater. That's a dream. We've had it for only a few periods in history, no matter what its partisans say to the contrary. And the theater as we know it is now in its last stages."

We said at the outset that the appearance of a new style, art, genre or technique helps us to take a new look at or give a new "reading" to the previous stylistic processes. From the new perspective acquired with the automatic media and cinematic reproduction techniques, the "theater" seems to us to have less of a past than we had thought— and also, therefore, perhaps more of a future. And I am sure that many of the new "revolutionary" proposals which have tried to shake up the theater were in fact nothing but efforts to find a new function and new role for it. In a world of rapid change, the most intelligent conservatives are often revolutionary. And I do not think that most works of the new theater were much more than this—intelligent, conservative strategies, dedicated to working out and magnifying that which *only* the theater could provide: presence, the commission of an act, contact, immediacy, etc.

Promiscuity as an Antisymbolic Device

The new theater had a definite horror of the vacuum—just as the theater of the absurd had a certain affinity with it. In the theater of the absurd, a lone and eccentric character or object was turned into a symbol of the human condition: an empty chair became a symbol of loneliness, repose, domesticity, absence (of the person who is not sitting in it), of seriality (next to other chairs of the same shape), etc. But it is surely this symbolic power of empty and isolated objects that the new theater rejected when it accumulated, in rapid succession, objects, actions, gestures, situations, without leaving time or space for each one to grow into a symbol. If the chair ("absence?") is followed by a rainstorm of plastic chips ("pop meteorology?"), and this by an acrobat ("a Fellini-esque childhood memory?") and a bear painted purple ("an ecological warning?") that lets loose the "terrible" topics of Norman Mailer, and that a naked adolescent then pets and mimics with his gestures—if all this occurs in rapid succession, it is obvious that the *symbolic power of each gag or situation in particular is neutralized by the one that accompanies or follows it.* In such a wild accumulation, meanings and messages neutralize each other, and we find ourselves faced with a series of events that lack any discursive or plausible connection, but which are not governed by the

"metaphysical" meaning which so easily swallowed up such decon-
textualized events in the works of art of the fifties. "I don't believe in
symbols," wrote the New York director, A. Mekas—"a glass is a glass
and it shouldn't signify anything else. I detest the atmosphere in An-
tonioni's or Bergman's movies. Not Eisenstein's. Eisenstein is dif-
ferent."

The new directors reacted to the fact that the *commercial* as well as
the *cultural* world was being increasingly made up of universal "sym-
bols." Commercial advertising does not sell merchandise so much as
ideals: Happiness, Success, Comfort, Well-being. And the products
of the cultural market are equally plagued with symbols—usually
ones opposite to, but just as ethereal as, the previous ones: Absence
of Communication, Alienation, etc.

If one wants to recover a concrete reality that can be touched,
savored, mulled over, one must begin by eliminating its stylizations,
the commercial as well as the cultural ones. Pop had provided the
formula: literally take and reproduce these generators of images in
their very promiscuity and brutality. And pop's tactics had an imme-
diate effect even among the European avant-garde. In 1970, Robbe-
Grillet wrote:

Advertising and the mass-media are a little bit like society's collective unconscious,
that is, both the image that wants to give of itself and the reflection of the anxieties
that enclose it. . . . There are two possible attitudes toward these modern myths: ei-
ther condemn them in the name of the current values (e.g., condemn pornography
in the name of a genuine, profound and feeling eroticism), but that moral condem-
nation is nothing but an evasion that takes refuge in the past; or, take on these myths
respecting their obsolescence and vulgarity; recognize that such images are all around
me, that is, in me, and that instead of closing my eyes to them, I have the chance to
play with them. Deliberately labelled as stereotypes, these images will no longer
function as tricks from the very moment when they will be taken up again by a living
discourse, which is still the only space for my freedom.

For the new theater, all places and myths, all ideals and symbols,
were equally useful, since only out of their promiscuity and profusion
could a euphoria be generated that transcended them all. The best
directors did not allow themselves to be seduced by the mythologies
they made use of and never lost sight of their instrumental character.
"It is all very well," Peter Brook writes, "to use crumbs of Zen to as-

sert the principle that existence is existence, that every manifestation contains within it all of everything, and that a slap on the face, a tweak of the nose or a custard pie are all equally Buddha."[86]

Only the ecumenical piling up of mythologies could allow this mutual stimulation of the emotive value of each one of them, as well as the sterilization of their respective metaphysical value. The operation of the new theater has been, in this sense, irreplaceable and perfectly achieved.

The desire to recover the immediate, still unprocessed contact is, of course, a characteristic reaction to a world where it is increasingly difficult to get in touch with things that have not first been stylized, processed as "news," sweetened for acquisition or enriched for consumption. Just as the Romantic myth of Virgin Nature constituted a response to the beginnings of industrialization, and the ideology of ecology and the energy crisis were related to the latest great migration to the cities, this unusual thirst for contact and immediate communication is a reaction to the increasing impersonality of relations between people and, as Richard Sennett notes, anticipated new forms of social control: destructive *Gemeinschaft*.[87]

But as I suggested when dealing with Brecht and Artaud, this immediate, prediscursive communication, in which the gesture or the hint "grab" the audience without any need for rhetoric at all; this discourse which—like the fakir to his serpent—speaks to people through their skin or their spinal cord, is only possible within a stable group whose members share a series of conventions, convictions, ideas, traditions, and prejudices. "To the monarchist tendencies of time," wrote L. Feuerbach, "nature always opposes the liberalism of space." Klossowski adds:

> The ages which preceded us were able to create familiar mythologies which contributed to their equilibrium—the modern world has only known how to create individual mythologies, that is, dementias headed for the asylums. . . . The eminently spatial conditions of the mythical world have thus been lost—lost are the specific situating of a sacred and terrible event, and the plastic and spectacular expression of worship.[88]

Only a fixed frame of collective myths and memorials makes possible a direct, contagious communication. But more than trying to lengthen the lifespan of these memorials, which today only exist as an official rhetoric, the art of our age must create parodies of monu-

ments—or anti-monuments like Oldenburg's windshield wipers on an immense crystal ball. Since our art is in any case alien to a collective memory, let it also be foreign to the system of expectations with which people are always prepared to understand everything as an "instance" of something they already know.

The Small Group as a Laboratory

The figure on p. 185 shows the fixed "frame" which conditions all nondiscursive, contagious communication. It is in the remains of a peasant culture still made up of gestures, habits, and work songs that Dario Fo looks for inspiration for his animations in occupied factories or labor strikes in progress. Many modern "animators" believe, with Sartre, that these extreme situations themselves can create the conditions for a communication which no longer needs any established code, since it generates its own. A common project or "fixed frame" of this sort was, for certain groups in the United States, the fight against organized genocide or institutionalized racism. But once the act is committed, or the resistance organized, the tension diminishes, the thaumaturgic virtues of the "group" dissolve, and we must communicate once again in a conventional and discursive language. The Tower of Babel is a wonderful symbol of the crisis of this immediate communication which only a live and collective tradition can maintain.

It is not by chance that most new theater lived and survived in communes whose internal freedom—*Kleine Freiheit*—and prolonged adolescence made it possible to keep on experimenting and playing. It is no accident that Julian Beck and Judith Malina's Living Theater was not just a new company but a nomadic community in which some thirty men and women lived, worked, discussed, and performed physical and spiritual exercises together.

In the commune, theatrical or not, some exceptional traits can be maintained: spontaneity in relations, hedonism, candor, sense of play, nonpragmatic use of the senses, etc. The problem arises, however, of how to communicate these ways of life and interaction to others. The mere exhibition of them (see p. 196) has more of an inhibiting than a contagious effect: it marks off the "others" as the still conventional, not spontaneous ones. The attempts to overcome

this situation have not gone beyond compromises and eclecticism—
that is why I agree with Brook's opinion of the Living Theater, a
judgment which is applicable by extension to the best examples of
modern theater groups:

In fact, the Living Theater, exemplary in so many ways, has still not yet come to
grips with its own essential dilemma. Searching for holiness without tradition, with-
out source, it is compelled to turn to many traditions, many sources—yoga, Zen,
psychoanalysis, books, hearsay, discovery, inspiration—a rich but dangerous eclec-
ticism. For the method that leads to what they are seeking cannot be an additive one.
To subtract, to strip away can only be effected in the light of some constant. They
are still in search of this constant.[89]

The gratuitous celebration into which these groups wanted to turn
the spectacle was not psychological or sociological viable in a pro-
duct-oriented and rationalized world. What were they aiming at,
then, when they proposed a spectacular superstructure which did not
respond to the social reality of our time? At first glance, their attempt
might look like a straightforward idealism, but we soon realize that it
is this very impossibility of a festive spectacle which was announced
and denounced in the uncertain products of the new experimental
theater. With them we became aware of the fact that the celebration
is something very different from the "programmed leisure" which the
affluent society provides for us in our free time. The new theater
groups thus denounced conventional leisure and spectacle as the *psy-
chological* counterpoint to a productivist world . . . but might not
they themselves, in their turn, be its *sociological* counterpoint?

I have stressed the theoretical and practical limitations of the new
theater: its naive belief that the mere exhibition of an unrepressed
way of life is necessarily contagious; its conviction that it was enough
to come down into the audience or to stare directly into the specta-
tor's eyes to manage to get his participation; their continued search
for the "specifically theatrical" in a defensive tradition of avant-garde
theater; its limited and repeated repertory of extreme situations; and,
finally, the still puritan nature of its very ideals of authenticity. As
S. Cavell has written, "to act without performing, to permit only ac-
tion and its specific traits, this has been the explicit ideal for human
action since Kierkegaard and Nietzsche carried out the supreme syn-
thesis of Protestantism, since Stanislavsky introduced it into the thea-
ter."[90] It is also clear that in many ways this theater, more than ques-

tioning the social establishment, responded to it; that it was soon reabsorbed as the Greek *thiasos* were, and soon came the systematic production of such works by the entertainment industry, bestowing on us any number of plays like *Hair, Oh Calcutta, Godspell,* etc.

I have stressed these and other limitations, but it seems exaggerated to me to conclude that these theater groups were nothing but a "biological surplus, an historical survival of the Romantic-Manchesterian spirit financed by the affluent society,"[91] by a repressive but coopting establishment whose miraculous metabolism permitted it to assimilate and even wax fat on the most radical critiques. At any rate, the very effort made by the establishment to assimilate a new movement politically, or exploit it economically, is a proof of the innovative and subversive potential it held.

4. FROM FORMALISM TO DANDYISM

The authentic avant-garde of a given period can dispense neither with considering critically the very "place" assigned to art by an established social punctuation, nor with trying to transgress the boundaries which rigidly separate it from other social practices. To make art, then, means above all to redefine its relation with these practices. And each redefinition involves art in domains that were considered external or improper; it means taking art off the stage or off the canvas, out of the church or the gallery, out of the sphere of performance or of illusion . . . and introducing it, perhaps, into the realm of entertainment or political action, cosmetics or sports, religion or gymnastics.

Between "Happenings" and "Concepts"

The happening and conceptual art were two formulas which tried to set themselves apart from the conventional art domain by mixing with traditionally an-esthetic behaviors. In conceptual art as well as in earth art, body art, etc., we find significant examples of this attempt. The art of the Italian *behaviorists* like Dominicis or Pisano consisted of making marks, walking around, or drawing on the skin. For Muntadas, the work was the smells of the street itself, and for Schult the tracks of his own itinerary; for Annatt it was his virtual

burial, for Hutchinson, photographs from his past, and for Hacker, the statistics of his own show (see above, pp. 33–34). Instead of "works," maps, lists, programs, graphics, user's manuals, and patterns proliferated in the galleries. These documents were not to take on any substantive value, but worked instead as mere records of an action (or thought) that had taken place. Inverting the traditional relationship, it turned out that the museum or gallery was not a warehouse of "copies" of the works; works whose "original"—the artist's journey, his childhood, or his ankle—was always somewhere else. The intention was not to be caught up in the game of the market and artistic consumption, which transforms every meaningful or subversive act into a sterile (and profitable) item of cultural merchandise, nor in the machinery of Galleries which makes a sterile "Work of Art" out of any work. Above all, the act of Production should not be swallowed up by the resulting Product.

But this direct and naive attempt to break out of art's scenario and to liberate artistic behavior did not have much more success than the attempts to break out of the theatrical stage. The new artists were unable to replace the old machinery, and they even reinforced it, since, paradoxically, the new "conceptual" works needed the galleries, magazines, and art books even more than traditional works. The very fact that they could be nothing more than records of gestures or acts without any physical existence beyond their documentation, made them not just dependent, but identical, to their display in the gallery or the catalogue.

In Lucy Lippard's book, *Six Years: The Dematerialization of the Art Object from 1966 to 1972* (New York: Praeger, 1973), one can see the new power which this art had given to texts, books, criticism, and even to the placement of the photographs of works in an anthology. In fact, it's difficult to imagine a more idyllic situation for the critic: the works exist only by the grace of his book, which "saves" them, "recovers" and "evaluates" them. We should not be surprised, then, by the welcome that critics gave to these trends—trends which established them as unique arbiters. But for the artists, the perspective was not so nice: having claimed the freedom of their gestures, having dematerialized their works, they ended up more dependent than ever on galleries and on criticism, which now became their work's only destination—the very locus of its survival.

In another sense, the happening was also a vindication of the "act" over the "work." The happening could occur any place, could last any length of time at all, and its message was the audience itself—it was a matter of getting the people to carry out, for once in their lives, a nonpragmatic, unpredictable act.

In one way or another, these quasi-works or quasi-spectacles worked, to use Althusser's terms, like "an indicative sign": they pointed away from themselves to a possible experimentation with everyday behavior itself. This was their actual performance, as well as their obvious limitation.

Cultural Criticism and the Antiformal Instinct

Our language is not a fixed stock of sentences but it often operates as if it were, impoverishing and trivializing our messages. Hence the vital need for experimenting with language: for forcing its limits and stretching its registers. Our culture, our possible forms of comprehension and behavior, are not a fixed repertory either, but in fact we often operate with a limited number of patterns of understanding and rituals of interaction, to which we have recourse as if to a script. That is why the new artists often feel that a broadening of experience can only arise out of the creation of a *counterculture*—just as their avant-garde grandparents thought that it could only arise out of a *counter-language*.[92]

To experiment with culture, to experiment with behavior, is an esthetic imperative as compelling as it is difficult, as urgent as it is ambiguous. Against our tendency to reduce the range of our experience or possible behavior, to "formalize" our gestures and convictions, the esthetic impulse is, so to speak, *antiformal*: "Keep your distance from forms!" Gombrowicz taught. "Don't ever identify with what you make of yourself."[93] The esthetic sense should thus keep us in the realm of the imprecise and unknown, of the still un-understood visions and the still untested behaviors. And this is so, above all, in the world of "culture."

"We express ourselves," Gombrowicz went on, "in a higher language which doesn't belong to us; everyone hides his imperfections and shows only those aspects of himself that are most polished, and while the whole culture rises up to the heights, we stay down below,

with our nose in the air." In the book or in the public lecture, in the work of art or in cultural conversation, we only use the tested sentence, the already elaborated argument, and we likewise receive the "finished" answers and works which others have previously decided to give out in public. We never risk making of the book or the work an authentic experience, which makes visible everything about it that is tentative and precarious. We do not talk about what we are intuiting or wondering about, but rather of our already thought-out thoughts, the already-formulated intuitions, the experiences already glossed with a commentary. Now then, this game of the "objective" culture likewise involves the circumspect consumers of these well-polished cultural goods, who energetically try to keep up with them. The entire culture is then a system of efforts: on the part of the creator, the effort to "objectivize" his own experiences; on the part of the culture consumer, the effort to connect his own subjective experience with this objective cultural imperative.

But if our works and our words were more experimental, if we gave voice to those of our doubts that are not yet formalized, if we really dared to experiment with our minds and our hands, the result would not appear to others as Cultural Goods to study or learn from, but as an Invitation to Seeing, to Thought, to Sensuality. *Culture would then be seeing or understanding itself—not just an object to be seen or understood.* And that would mean replacing the market of Ideas, Meanings, Concepts, Works, or Theses of our culture with an immediate exchange of signs or gestures, of entities not yet codified. Of course these signs, gestures, or entities would soon be recaptured and codified as "un-codified culture," "counter-coding," or whatever— but this is but one more imperative to prolong the *antiformal discourse* indefinitely.

The Risks of Widespread Experimentalism

I have been pointing out what seems to have been a general trend in the more recent art forms: the meshing and blurring of the boundaries that separate ordinary and extraordinary experience, daily life and celebration, convention and invention. It was no longer a question of experimenting in isolated and *ad hoc* areas, but of doing so instead in everyday life and thought, in personal decisions and in inter-

personal relationships, in the ways of mating and worshipping, in the way one carries his body or organizes his personal space. To experiment not on the stage or on the canvas, but with one's own house, one's own face, one's own mind amounts to an experimentalism which is outside of the safe precincts of art, and introduces the esthetic instinct, the antiformal principle, into the working out of life itself.

But to experiment is easier said than done. In reality, we feel a special horror (I, at least, feel it) when faced with the prospect of experimenting in and with our lives: using our senses in an unaccustomed way, opening ourselves to experiences with unforseeable outcomes, changing our management of space and time. This space and time of our everyday life is not usually our own, but is rather monitored by the dominant minority that decides how and where we live, move about, or amuse ourselves. But it is no less certain that this delegation of power is profoundly addictive, and that when we glimpse the possibility of being the masters of our own fates, we shrink back, horrified, looking for an institution, a duty, or the established order to give us the guidelines.

We should not be surprised by this "fear of freedom," nor by the consequent fact that we have associated experimentalism only with relatively closed domains—"art," "science." To experiment with a gas, a pigment, a belief, or an institution means in effect:

1. making use of them in an unpredictable way with the hope of discovering a new aspect or property, but without any guarantee that it won't be a miserable waste of time; and

2. not knowing if, in the event this new aspect should reveal itself to us (a new continent, a new facet of our personality), we will be able to reabsorb it into our prior (mental, psychical, social) structure or if, on the contrary, it will make us lose our equilibrium, pushing us to a "revolution" in Kuhn's sense; that is, we do not know if, instead of standing for an enrichment of what we are, know or have, it is going to bring on a crisis in that very structure. "Every new acquisition," wrote Piaget, "modifies previous notions and has the risk of introducing contradiction into thinking which had found its equilibrium."[94]

Thus, by definition, to experiment is a failure in the vast majority of cases: almost all works of experimental art are bad, just as almost

all laboratory experiments involve no discovery at all, and almost all efforts to organize one's life experimentally—outside of institutions and customs—assume an utter disillusionment. But if experimental works are often bad, the works that aren't experimental turn out to be insignificant. If one paints like Cézanne, Picasso, or Tàpies, one is surely not making a mistake—but neither is one making anything at all new. At most, one is using, degrading, and wearing out a formal code.

Thus, in its extreme form, the choice lies between experimental *failure* or conventional *insignificance*. But while a failure in art does not involve anything more than spoiling a canvas, an experiment in the forms of being a Christian, or a Marxist, of living or of mating, involves the risk of ruining one's own life—or that of others. That is why those who try to open virgin pathways for perception, sensation, or action, so often end up deteriorated and taking refuge in one conventional form of self-destruction or another: alcohol, political collaborationism, suicide.

The probability of experimental failure is analogous in art and life, but the consequences for each are very different. That is why we tend to experiment and be imaginative in well-defined areas of our existence: in spheres where we can lose the battle but not the war. That is also why the failure which we daily witness among those who have dared to experiment wholeheartedly is not an argument against their experience, but rather a proof of its authenticity. Seeing the commune split up, the traveller to Katmandu come back to ask for a job in a publishing house, or the progressive Catholic end up being neither Catholic nor progressive, the good bourgeois conscience is comforted: "We never had to regret out marriage, our careers, our convictions." But, were they really theirs? The only thing they did when they took up matrimony, a career, or the faith of their fathers, was to use them, that is, to wear them out, take them one step further in their progressive loss of real meaning—like the painters or thinkers who go on repeating and degrading Impressionist or Structuralist topics. Only those who failed on behalf of others, those who attempted forms of art or life still not tested by experience, turned out to be creators of social reality. The others are their users, or their exploiters. As Philip Slater writes:

For the reason a group needs the . . . creative deviant . . . is the same reason it needs to sacrifice him: the failure of the group members to recognize the complexity and diversity and ambivalence within themselves. Since they have oversimplified and rejected parts of themselves, they not only lack certain resources but also are unable to tolerate their naked exposure by others. The deviant is a compensatory mechanism to mitigate this condition. He comes along and tries to provide what is "lacking" in the group (that is, what is present but denied, suppressed). His role is like that of the mutant—most are sacrificed but a few survive to save the group from itself in times of change.[95]

The Suspension of Art and Morality

Giving oneself to this experimentalism in and of daily life involves, no doubt, renouncing "all the subproducts from eternity which have survived as weapons of the world of the rulers" (G. Débord): renouncing "art" and "morality" first off.

Renouncing "art"[96]—i.e., a "dramatic" art that concentrates in itself all the intrigues and intensities incompatible with normal, productive life. This seems to point to a formal activity which will not be any more the exceptional complement and counterpoint of the banal use we make of our bodies, our utensils, or our living spaces. It will consist, on the contrary, in the trans-formation of them. Up to now, the conventional debate about art limited itself to questioning what new painting, sculpture, or theater could do, taking for granted that these arts were the natural and eternal places in whose bosom the imagination should operate. (But, to ask oneself what new kind of painting to do—like how the "dining rooms" in new houses should look—is to take for granted much more than what is questioned, to wit: that the artistic world ought to turn on painting, that the dining room should be a substantive part of the dwelling.) The questions themselves functioned thus as a rigorous delimiting of possible alternatives. "All the questions openly raised in present-day society," we read in *Internationale Situationiste* (8 [1963]), "already imply given answers. No one ever poses problems which presuppose anything but this mandatory sort of answer. The numerous successors of God who organize the present-day Society of the Spectacle know perfectly well up to what point they can raise questions. The normal production of philosophy and the arts likewise adheres to this limit."

This experimentalism also involves renouncing "morality," under-

stood as a typology of sanctioned and proven modes of conduct whose consequences are known or at least forseeable. "You ask me what I would say if I were told that by pulling out a hair I could save all the starving children in the world. Well, I would say that the hair is mine." With these words Nietzsche wasn't trying to scandalize people so much as bring out the miserly economicism and cost-accounting that supported bourgeois humanism. More radical still, Kierkegaard denounced morality's complicity with bourgeois humanism.[97] When, against the "religious" ideal of universal celibacy, it was argued that in such a situation the human race would die out, Kierkegaard's answer was simply, "So what?"[98] Are we speaking about morality or are we speaking about the survival of the species? Or is it that they never were two different things? Wilhelm Reich, finally, understood this morality to be linked to a "characterological structure" produced by the social structure which, beyond ideological differences, impregnated all its members equally. "The biopsychic structure of individuals who are struggling for a new path in social life is fundamentally the same as that of the individuals who are fighting it": i.e., a prudish humanist structure to which one should oppose "the will and joy of living as ordering principles of social life."[99]

The cultural criticism of everyday life has thus come to realize and revitalize Kierkegaard's proposals, just as Marx did for Hegel's. Vital experimentalism would thus be the "practical realization" of Kierkegaard's theoretical proposal: "the translation of its esthetic rebellion, not into the critique of ethics in general, but into that of the particular forms of ethicality: of institutions, usages, customs, criteria, prejudices."[100]

The Avant-Garde as Behavior

An experimental and creative attitude should then permeate the areas of existence which have been kept under the control of a single human faculty, of a convention or an institution. *The despecialization of the imagination* corresponded to *the deschooling of knowledge.* Just as "only education carried out by everyone means education for everyone,"[101] only imagination exercised by everyone means a functioning imagination for everyone.

But this dispersion of imagination in everyday life should be clearly distinguished from a very different option which also aims to bring art closer to ordinary life, but in order to beautify commercial products, or idealize political projects. Faced with this instrumental trivialization of the dramatic, the new experimentalism tends toward a dramatization of the trivial. That the boundaries between art and life are to be blurred does not mean that drama has to become everyday life, but rather that everyday life has to become dramatic. People thus try to live their own race, sex, faith, or revolution dramatically. Churches, Parties, or Institutions, which define and sanction the "orthodox" practices in each of these fields, are soon overrun. Those who do not agree with them do not leave, but try to live in their own way a practice or experience whose monopoly is no longer granted to any institution whatever.

People no longer defend themselves by trying to hide whatever is different or specific about them, but precisely by emphasizing it, showing it off. The revolution is somatized, thus becoming "the affirmation of one's own biology" (Cleaver): women's liberation, gay lib, black power, children's lib. To claim what is peculiar and deviant (a "reactionary" attitude since the bourgeois revolution, whose axioms had not been radically questioned by the proletarian revolution) takes on a new political value since it is precisely peculiarities and differences that the System can least tolerate. The dramatization of individual existence, until recently a snobbish or esthetic luxury, takes on a symbolic value from the moment the new technocratic system finds it necessary to devalue the "representations" of the bourgeois political spectacle which, like the Parliament or Stock Exchange, have become increasingly manipulated and marginal.

Since imagination and individual creativity are asserted in spheres of what had been socially established and sanctioned practices, the very definition of these practices enters a crisis: they cease to be fixed roles and become open possibilities. It is not that people no longer know *how* one is to be a good Christian, a good artist, or a good spouse. What is beginning not to be known is prior to that and much more fundamental: *what* revolution, fashion, art, Catholicism *are*. These practices are no longer understood as a *text* already written down, a *plot* that cannot be changed, but as a *language* in which everyone can have his say.

The Last Refuge: Critique of the Commune

I have noted the tendency toward the desublimation and spread of an art which timidly began in the open air with a few hybrid or intermediate formations: participatory theater, conceptual art, happenings, communes. In the communes, authentic experimental centers of behavior, the first, halting attempts at an esthetics of everyday life were carried out—attempts to exercise a nonsublimated, nonspecialized imagination.

Within the commune people tried to live a different order, establish different priorities, carry out *in vitro* the revolution in usages and mores which they took as a precondition and model of any authentic, thoroughgoing revolution. And, nevertheless, the greatest limitation on the experiences of the communes—as with laboratory experiments—was that they reflected above all their own structure. Their limitation did not lie in their *difference from*, but rather in their excessive *similarity to*, the reality outside.

Settled on the border between city and country, made up of people of like age and social class, the communes often reproduced the system of families that seek out a residential suburb far from the urban chaos where they can meet people "like themselves" in a "natural" environment. But an urban, natural, and rich order can only arise out of the coexistence of the diverse and the contradictory—this is the great lesson of the modern city which those who take refuge in the homogeneous reservations of the suburb or commune try to dodge. Only when people are confronted with this strange and even hostile reality do they learn to find their place, coping with it and making arrangements with others who then become actual "neighbors." Compared with the order that emerges from this process of conflict and adaptation, the order that arises out of that flight from or repression of the conflict only creates a poor and fragile unity, lacking any disruptive innovations. Communes—like families and residential neighborhoods—tend to build *functionally segregated* and *internally coherent* entities whose main concern is to preserve the identity of the group.[102]

We saw that there were good reasons for this search for fixed, homogeneous frameworks that permitted a dispensing with the distinctions (actors vs. spectators, producers vs. consumers, creators vs. ad-

mirers) which inevitably appear in the social maelstrom. But we now see that the communes weren't breaking with the existing social structure, but were a caricature, a stylized reply to it. We can justify their segregation and homogeneity as a *means*—for, say, the renovation of political activity in the Second Commune in Berlin, or of theatrical performance in the commune of the Living Theater—but not as an *end*, and even less as a conquest.

But if you want the commune to be something more than a "laboratory" or a working "tool"—and the new culture's disgust with whatever is merely instrumental is well known—then you must be capable of making its boundaries flexible and introducing into it the complexity of real life. In Slater's words:

What the new culture seeks is wholeness, and obviously it cannot achieve this by exclusion. A community that does not have old people and children, white-collar and blue-collar, eccentric and conventional, and so on, is not a community at all, but the same kind of truncated and deformed monstrosity that most people inhabit today.[103]

Now, according to Pareto's Law, "a social trend reaches its greatest intensity precisely at the point before a general change in its direction."[104] The intensity that psychosocial conventions took on in the microcosmos of the communes could thus be a symptom of an impending change.

When late eighteenth-century intellectuals lost faith in the possibility that Enlightened principles (knowledge, education, happiness) could actually inform and reform Society as a whole, they decided to create their "communes"—microcosms in whose bosoms at least those principles would operate: *revolution* in Fourier's Falansterium, *pleasure* in Sade's Silling Castle, *fraternity* in Mozart's Masonry.[105] In a way, the evolution of social reform expectations from the sixties on is surprisingly similar to the evolution traced by three Mozart operas: from *Don Giovanni*, where there is still a rebel—Don Giovanni himself—who is able to oppose social conventions, to *Così fan tutti*, where there is the impossibility of having true and meaningful relationship—not even "deviant" ones—in a social context whose mechanisms man does not understand any more, and *The Magic Flute*, which represents a last attempt to recover in the small commune—in an oasis of fraternity and rationality—the conditions in which personal relationships can again become true; all this at the

price, of course, of renouncing any attempt to extend this sort of revitalization to society as a whole. The Enlightened ideals thus end up hiding in the commune, just as our ideals of the sixties did.

The Culmination of One Bourgeois Victory and the Crisis of Another: Expressivity and Informality

It is not hard to envision religious, family and political activities as esthetic experiences which can extend into everyday life the demands avant-garde art had made in its own sphere—whether we call these demands "experimentalism," "criticism of codes," "breaking with convention," or "evaluation of the improbable." What changes and gets broader is then the estimation of the subject competent for, and the object pertinent to, these demands. It is not only certain specialized work that should be experimental or creative, but also the daily use of space and time.

Ever since art, around the fourteenth century, became independent of its functional ties and asserted a properly artistic legitimacy, the artist himself became the real theme of the work of art. What mattered was no longer the model but rather his way of dealing with it; his style, his manner. Now then, the recent proliferation of these manners and styles in everyday life was only the democratization of this bourgeois conquest of art as a "personal expression"—with all the efficacy and also all the limitations that this tradition shows when we compare it with the artistic practices of the Orient, where expression appears only as embedded in the subject or argument itself.

In fact, if we have rescued art from gods and monarchs, if we have made it a personal expression (and no longer a manifestation of a transcendent order, representation of a natural order, or service of an established order), how can we hope that the process would stop now and leave this conquest exclusively in the hands of a tiny caste of specialists? How can we accept without objection and as a natural affair "the exclusive concentration of artistic talent in some individuals and its corollary—the repression of this talent in the masses—which results from the division of labor in society?" [106] Evidently, the democratization of this *duty* and *right to express oneself* does not immediately bring about the development of a general competence for creating. But it is also true that this capacity for expression, like de-

mocracy, is learned by exercising it, and not by remaining a consumer of products created by those who imagine—or govern—for others. It is clear, furthermore, that this generalizing of formal competence will not interfere with real artists and creators, but it certainly will interfere with the professions and interest groups that have proliferated on the basis of their monopoly over creation. I mean, for instance, professional groups who defend not architectural quality, but the very specific law that forces every citizen who wants to build a house to pay for the signature of an architect; groups who do not create and who are not interested in painting except for the crass, speculative market of the painting-as-investment or the painting-as-display, on behalf of an art-market, moreover, which has even lost the elegance of the bourgeois market where the economic and ludic interest often coexisted in the *amateur*.

But those behaviors connect with the tradition of avant-garde art in a much more obvious—and superficial—sense, which I will only note here. The ideal of spontaneity or informality had governed the rhetoric of the middle-class liberal. What was valued in it was the "natural" effect, the transmutation of an official act into an apparently personal and direct relation. The rituals with which men since the beginning of time sanctioned decisive acts (marrying, drawing up a will, writing important letters, mating, entering adolescence, judging) kept on losing meaning and becoming mere formalities ("Very truly yours") so that the collective memory that gave meaning to them was being forgotten. And we have certainly not recovered the memory or the beliefs on which those rituals were based, but we feel the need for, and the lack of, their "forms." The puritan middle class could afford to *demythify*, but what we need today is to *remythify*.[107]

When we dispensed with historical or religious conventions, we were left without ceremonies to signal the decisive actions and without memorials to remember the decisive moments. The churches and institutions that were repositories of those beliefs were also the administrators in our world of social dramatization. That is why a deliberate renunciation of the system of beliefs that we inherited forces us also to renounce, without wanting to, all the "forms." Some people might even have hastily thought that today's residual ceremonial forms—the mass, the club, the wedding dress, or the forms of politeness—were precisely what had been destroyed. But what society do

we know of which has not dramatized rites of passage and initiations, marriages and encounters, deaths and conflicts? So, we do not have too many, but too few, ceremonies and etiquettes, languages, and conventional situations. That is why we react against bourgeois "informality" and try again to dramatize everyday life. That is also why it is no longer a question, as in the Living Theater, of exalting personal and exceptional situations—ecstasy, epiphanies, rapture, etc.— but rather of looking precisely for already established forms—Christian or Buddhist, plebeian or aristocratic, folkloric or academic,[108] classical or romantic—to put new markers on a life and on relations which bourgeois asceticism had desiccated.

Whether we like it or not, the fact is that precisely those gestures, rites, languages, or garments which have become less usual have also become more meaningful: medieval clothing became the priest's costume, the wig became the judge's garment. Languages not in daily circulation were retained for sacred rituals: the archaic verses with which Spanish witches spoke their curses, or the Latin in which people still marry or bury us. How could anyone come to think—even in the Catholic Church—that a language which we all understand perfectly could have the slightest power to sanction, inaugurate, consecrate?

The problem and weakness of the new dramatization, thus, is its lack of a stock of conventional gestures and languages; its having to dramatize the present from out of the present itself, from out of a void and informal reality very easy to exaggerate but very difficult to actually dramatize. But if we are not to get stuck in the banal accumulation of shocking situations, which the new theater was bent on, I suppose that the only means open to us is the redesignation and deviant use of classical forms of rituals in a new ceremonial context. It is in that area that the recovery of Mannerism, Surrealism, and Dadaism has been so important today.

5. "MANNERISMS"

Political Manifestos and Manuals of Urbanity

As opposed to the well-defined, classical avant-garde of the forties and fifties (Abstract Expressionism in New York, Informalism in

Paris; the art monitored by Harold Rosenberg and Michel Tapiés) we find in the sixties and seventies an increased blurring and questioning of the very limits of art. The trend of art to become more "worldly" is then complemented by its counterpoint: worldly life-styles and thought-styles becoming more "formal." I call these more formal or imaginative conducts *mannerisms*.

To begin with, I will illustrate this trend with an example, that of the political activism of the new left in the sixties in the United States and Europe, which is already distant enough to be seen with a certain detachment, hence we may distinguish clearly its specific (and mostly obsolete) contents by the direction in which it pointed. At this time, political manifestos became very much like books of fashion, or better still, of *urbanity*. [109] We were seeking in them a theory of revolution and instead we found a guidebook to the gestures we should make, to the ways of running the household, using the media, dressing, fixing our hair, or going out into the street. "Our long hair," Jerry Rubin said, "tells people where we stand on Vietnam, Wallace, campus disruption, dope. We're living TV commercials for revolution. We're walking picket signs." Nakedness, too, is a political statement.

"What the ancients said most vividly," wrote Rousseau, "was not expressed in words but rather with signs; they didn't say it, they showed it." [110] This also seemed to be the program of the moderns. And they had to dramatize their acts according to "an active theory of political theater" (Abbie Hoffmann). The Dutch *provos* were the first to go from the theater of provocation to direct provocation in the streets. In the movements of black, women's, or gay liberation, the first revolutionary act was the display of their bodies, gestures, and language—precisely because their bodies themselves had been colonized and they had to express themselves in a "normal" language in which every sentence stressed their inferiority or marginality.

The revolution turned into exhibitionism and promiscuity: of bodies and peculiarities, of all that was irregular or deviant. The differences which previously had to be hidden or smoothed over for tactical reasons were now dramatized. The revolution, they felt, is not only instrumental: it is also expressive. And since differences were exalted, it was also a question of doing it in a different way. As in avant-garde art, though in a new dimension, there was more insis-

tence now on the manner than on the theme: what mattered was style, which had to break down ordinary conventions—and even revolutionary conventions—as modernist art had had to break down expressive conventions. The end is unimportant: the means are everything. Revolution means abolishing all programs and turning spectators into actors. In the political demonstration—an exemplary theatrical experience, according to Rubin—roles must be found for everyone, even for the police: "When planning a demonstration, always include a role for the cops." More than on ideas or theories the works of Rubin or Hoffman dwell on "manners" and staging: how to prepare a demonstration with a view to its maximum effect on radio and TV ("TV packs all the action into two minutes—a commercial for the Revolution")[111]; how to avoid paying a turnpike toll or, if there were no other way, how to pay also the tolls for the three cars behind you, although the best thing seemed to be to blow up the toll booth. In a similar vein, Teufel managed to turn his trial into a suggestion to the judge that he go get psychoanalyzed but then, once the charges were dismissed, he went to the jail asking to be let in, since he preferred, so he said, "to be inside feeling guiltless rather than free and feeling guilty."

In all these cases the action was aimed at the "degree zero" of ideology: the point where ideas not only influenced conduct but were nothing but conducts, gestures, mannerisms; where ideologies became "conductologies"—"testimonials" as the preceding generation would have called them. I have already suggested the reasons for this desire to produce bodily responses (behaviorist responses, if you like) in which gesture and ideology dramatically become one—instead of continuing to preach conventional strategies on the one hand and ideological messages on the other. Confronted with a more ubiquitous Power which did not only produce *ideological messages* but promoted as well *behavioral patterns*, the proper protest was not just theoretical but also behavioral. With it the counterculture certainly was not pointing to the deep structure of this power, but it was at least very accurately replying to the way this power was being exercised.

Criticism and the Usages of the "Society of the Spectacle"

One can describe this mannerist dandyism as *a host of practices in search of a theory*. But if it is true that its practitioners had no particular theory which accounted for what they were doing, on the other hand they sued the media brilliantly and showed an extraordinary "sense" for the spectacular. Well aware of the press's hunger for *news*, they knew that it would suffice to give the press an outline of a "revolutionary event" (for instance, the pseudo-kidnapping of Hubert Humphrey by students at the Free University of Berlin, in April 1967) for the press to turn it into something much more beautiful, important, and dramatic. In contrast to classical avant-garde ways of formalization, they were able to use much cooler or technical means for much hotter, more personal or sensual, ends, thus summarizing the two shifts we described in chapter 2.

More puritan than their American friends, European leftists often defined their revolt against the "society of the spectacle" as a protest against the idealization of a "political economy of the sign" which transforms everything into a pseudo-event. From conceptual art to counterculture politics, they showed this fear of being coopted and transformed into merchandise—especially into the favorite merchandise of the media, which is new "news": a new "trend," a new "talent," a new "spectacle." Now then, no matter how justified and radical their rejection might have been, what is certain is that *their "critique" of the society of the spectacle* (Débord, Vaneigem, etc.), *was infinitely poorer and more naive than the brilliant "use" they made of the resources it offered.*

The way these mannerisms were tuned in to the media was certainly much clearer than their familiarity with revolutionary theory—and if in one sense they were caught by the ideology of the media they used, in another they rightly pointed out the need for using more secular means to attain more radical ends. Their praxis also had a genuine theoretical influence in reminding the left that to explain the new capitalist society (where even information and consumption had fallen under the laws of exchange value) it wasn't enough to repeat the old litany about the new techniques of communication as instruments of "universal manipulation." For them, this meant an

actual mutation—and not just another "perversion"—in the capitalist system; a mutation of an importance analogous to that of the Industrial Revolution. The struggle for control of the means of production had broadened into one for the control of the means of communication and understanding. The first and most important monopoly was now the monopoly on the code: the design and definition of the repertory of actual needs, meaningful aspirations, and appropriate reactions.[112]

Thus, we should distinguish as clearly as possible the two aspects of this mannerist approach to the media:

1. its positive utilization of media techniques and rhetoric, and
2. the contamination of its ideology by that of the media it was using.

I will elaborate on this distinction below:

1. The new movements quickly understood the immense redundancy on which the information industry is based: the creation or dramatization of the events it seems to "transmit." The corporate enterprise Galbraith has so often described tends to maintain the rhythm of production and to avoid risk. And to do that, it must create or control the demand for its product as well as the supply of its raw materials—which, for the information industry, are "events." The information industries create tautological celebrities according to the principle of the best-seller or hit: books, objects, or people who are known because of how well-known they are. As Boorstin had pointed out many years ago, the media make news out of their own activity of making known, create celebrities based on their notoriety, people famous for their fame.[113] And in contrast with advertising which simplifies experience, what the creation of events does is to dramatize it, amplify it.

Addicted to these standards of elaboration and stylization, people could stand less and less the serious and specious intellectual rhetoric of the traditional left. Aware of the fact that there was no way to compete with the media, the new mannerists tried to learn and utilize to the fullest possible extent its self-confirming, dramatizing, and mythic nature in order to *divert* their power and make a perverse use of it.

2. To fight something—Hegel said—you have to embrace it. It is difficult to fight in the domain of a modern institution without ending up as its guest, coopted by the institution. One must utilize its means without ending up contaminated by its very purposes and ideology. A good deal of the antirhetorical, antiprogrammatic, and exhibitionistic attitude of the mannerists did not so much question the Establishment as actually tailor itself to an attitude that it defined and promoted through the media. I'm referring to the change from a communication based on ideas or concepts to a communication based on images.

No matter how much "all that is thought is necessarily thought in images,"[114] the structure and function of reality does not always appear in the immediate image we have of it. To see this "deep structure" we need the distance which thought and imagination, beyond the perceptual habits of the moment, are able to introduce and which help to organize the senses' data in a way both creative and objective ("Geniality," Schopenhauer said, "is nothing but objectivity.") The images are but the "medium" of thought, as light is the "medium" of vision; therefore, thought bewitched by images is blind, just as vision bedazzled by the light. Both lack *distance* from things as well as *penetration* into them.

The mass media and the counterculture both coincided in defending this iconic, anti-ideological discourse, which is perfectly consonant with images. Hadn't Freud and Nietzsche observed that *ideals* were but mythified *images?* Why then not return thought to its true content, prior to ideological mythification? Thanks to this "demythification," the *aspiration* toward an idea was quickly replaced everywhere by the *identification* with an image. And this is a fundamental difference between ideals and images: the ideal is something we *aspire* to—the image is something by means of which we *aspire;* we can project ourselves into ideals—images project us or project themselves onto us.

I don't mean to suggest that the existence and influence of images is something new, but that the images' passage from nature to culture, their transformation into products expressly manufactured to be "impressed" on people's minds, has not involved so much the demythification of ideologies as it has the planned remythification of a supposed "direct experience." Only thus can we understand that the cult

of the image and the strictest empiricism join together harmoniously without any conflict in American culture. Practical, pragmatic, and profoundly mistrustful of ideologies, Americans were nonetheless not upset when the White House launched "Operation Candor" (as if it were a marketing campaign) whose declared purpose was "to improve the President's *image* after Watergate." Equally "empirical" in their research, the anthropologists at an Ivy League university I visited reject Mauss's or Levi-Strauss's "speculations" and adhere strictly—empirically—to what the Indian Pedro or "Aunt" Maria tell them about their concept of God, or of the world. But the Indian Pedro quickly learns that the longer and more convoluted his story is, the more there is in it for him. So, with dollars, they are making as many myths and traditions proliferate in Mexico as there are doctoral theses to be written in the United States. Theses all of which, obviously, will transcribe with complete precision the observations and interviews carried out in the field. My wife's conclusion after seeing these anthropologists at work was: since they are "empirical" and refuse to invent *theories*, what they invent—or pay to have invented for them—are the *facts* themselves.

Thus, what American scholars as well as the counterculture people very often opposed to theories or ideologies were not concrete facts, but rather the manufactured images and manufactured facts which confirmed their crassest love of spontaneity or pragmatism. The cult of instant results, the faith in "information," the distrust of any "theory," the rejection of all ideology in the name of a revolutionary iconology not so different from advertising iconology—all this deeply relates the American mannerists with the "positivist" ideology of the cultural system they were attempting to overcome.

In Europe, in contrast to the United States, this appeal to manners and the rejection of the "Society of the Spectacle" had no such anti-intellectualist bias. People tried, on the contrary, to find a new global theory which would not remain as a separated and segregated activity, but would rather stick to everyday life and its transformation. And it was in the name of this totalizing aspiration that they rejected spectacular neocapitalist society as well as orthodox communist ideology. The society of the spectacle was "the social organization of appearance . . . the dramatic presentation of pseudo-events that have not

been experienced by those who are told about them . . . at the same time that what is lived of daily life remains without a language, without a concept, un-understood and forgotten on behalf of the false, spectacular memory." Faced with this situation, the so-called revolutionary "ideology" of the East was nothing more than "the coherence of the separated . . . , which has not even transformed the world economically as capitalism did reaching the stage of affluence, but rather has limited itself to transforming its political perception." [115]

Consequently, they rejected *en masse* the old specialized politics and ideology since "ideology, no matter how revolutionary it is, is always in the service of the bosses . . . ; 'theoretical' tendencies and deviations should be turned into questions of organization, and judged only from that basis." [116]

Thus, the revolution was presented as a qualitative and nonspecialized action aiming at the symbolic shaping of life and social relations which had been distorted by the abstract shaping of political economy. But it was not only in politics where compartmentalization was attacked and a global attitude claimed. In Art and Religion, more than anywhere else, a possibility was glimpsed of overcoming "ideology" and recovering an integrated attitude in which gesture and thought, action and contemplation would merge in the lifestyle and ritual of a new urbanity.

The Meeting of Style and Culture—Worship

Naturally, the model of art before the fourteenth century, that is, before art had emerged as an autonomous domain, exercised a strong attraction and influence on those recently in search of a unified creative practice. Looking back at this tradition, people looked for signs of an artistic activity not sublimated but focused instead on the elaboration of everyday life.

Faced with a bourgeois culture which had given us estheticism instead of art, the French leftists thought that a new praxis could be recovered in which style and culture would be one. "The creativity liberated in constructing all the moments and events of daily life," the situationists wrote, "is the only poetry we can acknowledge." "The art of the future," they stressed elsewhere, "will not be able to be eval-

uated as merchandise, since we see it as completely dependent on our use of space, feelings, and time."[117]

They aspired to a "diffuse" stylistic praxis; to a culture where, as in "cold societies" described by Lévi-Strauss, culture is not a specific product of care and attention locked up in "books" or "works," but a ritual method of sewing or cooking, of marrying or trading: a formal inflection of all behaviors rather than a differentiated behavior. Clearly, this idyllic culture-action was based on the existence of an implicit common code—of a culture in the strongest sense of the term—where everything was preordained or foreseen, and where hardly any innovations were possible: one had to build one's house facing east, with certain materials and not others, etc. The existence of a common code which will allow a nonspecialized art thus depends on a rigid social formalization which few of us would willingly accept. Our mannerists, however, did not seem very aware of the other side—a profoundly totalitarian side—of this community of the code. In opposition to modern, schismatic art, writes Débord, "a common language must be rediscovered in the praxis which unites direct activity and its language. We must effectively *possess* the community of dialogue and play that later on has only been *represented* by the poetic-artistic work." It is a question now, in Marcuse's terms, of recovering "the esthetic dimension not only in its cultural and sublimated form—art—but also in its political and existential form."

But there is still another activity which has served as a model for this mannerist integration of activity and language, of praxis and form. I am referring to religion.

Religions have always been mannerist—total systems of behavior rather than mere systems of belief. Religion is both worship and prayer, ritual and morality, liturgy and sacrament. The acts of officiating or consecrating give a new dimension to what is ordinary— to a place, food, birth, or death. The community of the faithful actually participates in the ceremonies whose "script" they know beforehand; ceremonies where, as in the "total spectacle" being sought today, the effect of special costumes and smells merges with that of the music, gestures, and words.

The prototype of the religious man is not the *theologian* but the *disciple*; not the one who *knows* but the one who *follows*, repeats, or

embodies the message (that is why radical and anti-institutional Christianity today often takes the form of *Jesusism*). The accusations against new and radical forms of religiosity—Celsus against the Christians, the Confucianists against Tao, Ossorius against Priscillian, the Inquisition against the illuminati—are always directed at their scandalous behavior, their immoral practices and perverse ceremonies. Already in the Rome of the second century, Celsus sees very clearly that the Christians are directly attacking the Roman way of life, and like a good liberal he asks them to believe whatever they want, think and worship whatever they like, but just mind the social conventions (e.g., the worship of the Emperor, as formal as today's allegiance to the Queen of England) which are nothing more, but nothing less either, than rules for living together.[118]

Rationalist idealism understood that religion, linked to symbols and images, had to be surpassed by philosophy, by pure conceptual thought; that figurative religion (*myth*) was a "prior stage" of the cult of reason (*logos*). But there is growing evidence that nonreligious ideologies are incapable of bridging the gap between practice and ideology, as religious systems do. The men of the Enlightenment and Reformation believed that man was "mature" enough to dispense with figurative religions; to stop reading religious comic books and come to grips with the Book, the *verbum* naked and unadorned. But in this way the genius of religion got lost among the Protestants, who had made of it a pure ideology or inner experience, just as it did among those who, by reaction, made of it a pure practice in the style of Jesuit casuistry. And it was lost, as Harvey Cox has pointed out, even among those who, keener and more aware of the integrating value of religion, tried to manufacture new religions or adapt the old ones to new social necessities: the cult of the Emperor of Rome, to the goddess of Reason in Revolutionary France, or the Catholic religion in integrationist France.

But reformed and manufactured religions break down, Catholic *aggiornamenti* or secularizations fail, and old, non-"functional" religions spring up with renewed force. The religious future—"the future of an illusion"—now seems to us less simple than the way Freud saw it. What seems in crisis is not so much the Grand Illusion in capital letters, but rather the sensible and humanistic small change Western culture and society had made out of that illusion.[119] Re-

ligion, which Helvetius and Diderot took to be a *falsehood* fabricated by priests, and which Marx saw as a true-to-life *reflection* of a situation—"inverted conception of this world, its encyclopedic compendium, its logic in popular form"[120]—now begins to be understood no longer as a coercion or a reflection, but rather as a denunciation and a protest: *a coded protest against the senselessness of the real.*[121]

An Attempt at Interpretation: Unified and Polyvalent Control

No doubt, many of the examples adduced to illustrate this "hot split" in the boundaries between art and life have been ephemeral—and so was the naive belief that these mannerisms would be able to dismantle the structure of conventional culture or politics. But in more diffuse and less mythified forms, this tendency keeps coloring in a certain way our convictions and sensibility. We do not believe any more that the commune can be the alternative to the traditional family, or that the spectacular dramatization of life can overcome the contradictions of conventional politics or culture; but no one who has his wits about him can believe in the viability of the nuclear family, in the coarse "economicism" of established leftist ideology, in Daniel Bell's *Crisis of Ideology* or in the revolutionary effectiveness of a new style in the plastic arts. But what is the social and political situation that explains the mannerists' reaction as well as the fact that we, even without their millenarian hopes, will have to keep working within the field they opened if we are to avoid pure cynicism or pure conformity?

For the post-structuralist French philosophers of the sixties and seventies (Deleuze, Foucault, Lyotard, etc.), the ultimate truth, the authentic infrastructure, the real motivating force will no longer be either Marx's relations of production or Freud's Oedipal relations, but will consist in a single, unique truth: Desire, Language, Discourse. And, against these: Order, Power, Institutionalized Disciplines, Socialization in the Family, Scientific Languages, etc., which clearly repress what they claim to represent.

"There is nothing but desire and the social—and that's all," say Deleuze and Guattari.[122] For them, all the supposed channels of expression or structuring—familial, productive, sexual—of this pure

flux of impersonal and polymorphous desire which man consists of, are nothing but instruments for repressing that desire. When the psychoanalysts traced the genealogy and ultimate model of desire to the Oedipal relationship, what they were in fact doing was taking for the basic archetype of desire what actually was the first form of social control and restraint.[123] In Foucault's classical works we find the same schema, only now this foundation is not pure Desire but Discourse: a discontinuous discourse-event that the Establishment will try to tame with the various expedients of ordering and socialization: disciplinary languages, professional groups, rituals of the word, taboo words, etc. According to Foucault, in this system of prohibitions and exclusions a profound social logophobia comes to light:

A kind of mute fear of these events, of this mass of pronouncements, of the proliferation of statements, against all they may contain that is violent, discontinuous, equivocal, and dangerous; against this incessant and disorderly ebullience of discourse.

At first glance the discourse may seem insignificant, but the prohibitions that come into play against it quickly show its connection with desire and power. Discourse is not only what manifests (or hides) desire; it is also the object of desire . . . ; it is not simply what translates struggles or systems of domination but rather what one fights for, the power that people try to control.[124]

Regardless of how linear and schematic this approach may seem,[125] it was at least a warning that the control and reproduction of the *relations of production* are today overrun and overdetermined by *relations of power*. On the one hand, what is controlled is much more primary or basic: desire, language. On the other, this control appears as something much more radical and ubiquitous: not only the *means of production*, but also of the *means of expression*. The appropriation is not merely of economic, but also of somatic and libidinal production. Thus we see both the polymorphous nature of what is repressed and the polyvalent nature of the means of repression; the richness of what is controlled and the sophistication of the means of control and appropriation.

The direct exploitation of the labor force in the pursuit of profit was a concrete reality which the classical English moralists described and even tried to quantify when they became economists. Today, though, power is something more generalized and elusive. "At the present time," Foucault wrote in 1972, "we know more or less who

exploits, where the profits go, whose hands they pass through and where they are reinvested, while power. . . . We would have to know definitely up to what point power is exercised, by means of what mechanisms and in what instances: as *hierarchy, control, supervision, taboos, pressures.* Wherever it exists, Power is exercised. No one is, properly speaking, its owner; and nonetheless, it is always exercised in a certain direction, with some on one side and others on the other; one doesn't know exactly who has it, but one knows who does not have it." Deleuze concluded: "One knows who exploits, who gets the advantage, who governs; but power is somewhat more diffuse. . . . How else can we explain the fact that people who have no share in it identify with and faithfully serve power? . . . Because profit isn't the last word: there are investments of Desire.[126]

Time and time again—as more than one non-Marxist sociologist had seen[127]—we are reduced to the Desire-Power alternative. And this power begins by controlling and colonizing the very language of desire, making of it a specific "need," an economic "claim," a "personal problem." Controlling the code and language of desire, power sees to it that no other questions or demands are raised than those that suit it and it wants to satisfy. That is why we are concerned as much over the control of the *means of communication* as over the control of the *means of production.* These means of communication produce and distribute a code according to which people will have to express their desires to others and, finally, understand them themselves. Power designs the danger or the enemy as something external to the system, as something which threatens oppressors and oppressed equally. Symbolic needs and the ideals of justice are translated into terms of technological development and progress. Formal education in the universities offers the initiation and model of this recodification of all needs into consumerist terms. As Illich saw, once young people have accepted the idea that their imaginations or intellectual interests are formed by curricular instruction, measured and documented by grades, certified by titles which connect them with positions in the work market, they already find themselves in a position to accept institutional planning in any later aspect of their lives.[128] They have already been initiated into the great axiom of the consumer society: whatever desire, dream, or aspiration one has, there is

always an institution that channels it and an object that satisfies it. Thus we reach the supreme stage of a system which, as Marx saw, not only produces an object for the subject but ends up producing a subject for the object: an instinct and talent for consuming which synchronizes the system of one's desires with the system of production.

Traditional capitalism at one time had another domain, an ambient reality which it served or exploited, but which remained "external," or "natural." Alongside production, effort, work, there existed another reality still not controlled by the productive system: desire, delight, waste, leisure. But today this second series is likewise controlled and fitted to the needs of the establishment. Modern capitalism has become perversely ecumenical and humanist: nothing human is alien to it. No aspect of our most intimate lives fails to interest it and be an object of its planning. We are its object when it taylorizes our work and we are its object when it codifies our consumption. The increase in well-being and reduction of work schedules have been paid for by the renunciation of control over the use of free time. To live in a capitalist system has become, more than ever before, a full-time job.

The ubiquity and polyvalence of the new systems of control explain the fact that imaginative resistance to them also takes many forms. In a world of programmed behavior, it is only natural to adopt irregular behaviors not yet colonized or integrated into the system: haphazard subsistence vs. planned "consumption" and the logic of "status"; camping or back-packing vs. "tourism"; a "laid-back" stance vs. "personalization"; the adoption of "perennial" philosophies vs. the commercial stimulation of trends or fashions; unisex and androgynous forms vs. commercially exalted secondary sex characteristics, etc.

Only experimentalism on all levels of life seemed an adequate response to a world of total control: only the involvement of the imagination in daily life could perhaps reply practically to a system which had been able to appropriate—and even make profitable—all the catchwords of traditional art or critical theory. Manners, then, more than ideals; tactics, more than programs; gestures, more than

plans; cultural rather than specifically economic protest, etc. And we saw that, naive or uncritical as these forms of protest might be, they were very well adjusted to the present forms of domination.

When we understand that educational or cultural superstructures not only passively *manifest* the social forms of domination, but also *reproduce* them; when even the process of legitimation has been inverted to an extent where it becomes the infrastructure (the economic process) which works as a subterfuge to legitimize superstructural forms of repression and segregation on the political, social, and cultural levels;[129] when there is not only a general economic exploitation based on private ownership of the means of production, but also a specific repression and segregation aimed directly at individual women, homosexuals, citizens, professionals, then nothing is more appropriate than to redouble economic claims with cultural demands and to assert that aspect of each person which is individual, irregular, anomalous. As I pointed out in an earlier work,[130] the modern techno-structure can still grant the freedom of ideological expression in middle frequencies, those (like the Party or Congress) already "punctuated" by the Establishment, but not in the private, creative, and imaginative employment of people's so-called free time. Freedom is the only objective that has acquired a prohibitive price tag, as Wallich and Skinner acknowledge in their books significantly titled *The Cost of Freedom*, and *Beyond Freedom and Dignity*. And it is precisely this prohibitive cost of freedom which demands an "art" consisting of "methodical experimentation with the possibilities of man and human organization"[131]—an art understood as the symbolic rejection of a system of control that, since it no longer prohibits *anything* in particular but the *particular* itself, cannot be attacked by means of specific products—books or art works—which it will automatically assimilate and consume, but rather by means of the irregularity which may be introduced into everyday activities. As long as power promoted philosophical or moral ideals, it could be protested against in a "work"; when it distributes ideals of existence or status, it has to be confronted "on the spot," in the everyday way of running one's own life.

We have seen some of the external causes of this mannerist reaction, and we might think that if many intellectuals, artists, and young

professionals converted to it, it was because they were the ones who first detected this situation. And surely there is some truth in that. But it is no less true that there were also "internal" reasons in the guild of professionals of culture which pushed them in that direction.

At work in their "radical" critique of the Establishment was also the nostalgia for a traditional bourgeois society, which they had served not so long ago by means of the prestigious mechanics of the commission, consultation, lecture, etc. Today, on the contrary, they saw themselves as a mere labor force within the bureaucratic university, research center, construction firm, or publishing house.

As Foucault observed, until the forties the intellectuals could be at once "socialists" and "accursed": "Those who told the truth to those who didn't see it yet, in the name of those who couldn't say it: at once conscience and eloquence." But from the forties on, this critical consciousness and this eloquence began to lose their political exchange value. Orwell's comment to Koestler that "history stopped in 1936,"[132] is a characteristic complaint of this intellectual who feels himself a depository of a "critical consciousness" which power no longer utilizes—let alone pays any attention to. Although it may more or less retain its democratic forms, the functioning of political power in the period of monopoly and corporate capitalism is already very different from when it represented the interests of the middle classes, whose private needs the professional satisfied in his office, and whose public interests he defended in the Parliament with his eloquent and critical discourse. Critical Sensibility or Consciousness are thus condemned either to renounce all criticism and directly collaborate with power, or radically to oppose it: middle-of-the-road issues do not work any more.

This is the end of my book. I have tried to describe an "art" that had no choice but to step out of bounds, mingling with "religion," "social usages," "politics," and other activities which an established social convention had defined as separate and unrelated. Art, like the sciences or philosophy, lives by its crises: by the questioning of its very questions, and not just by its solutions; by the criticism of its role, and not only of its productivity; by the exploration or transgression of its boundaries, and not only by the consolidation of its territory. This identity crisis of modern art and the consequent need to

redefine its position is what I have summarily described as the polar split of the avant-garde tradition. Furthermore, I have not tried to guess or anticipate anything, since I am convinced (with Hegel, Neurath, and the "conformist sociologists") that only phenomena that have occurred already can be analyzed.

I began by trying to justify the reasons for the "hot" shift in art which blurred its boundaries with practical life, as well as the "cold" shift which tended to dissolve the boundaries between art, science, and technology. But throughout these pages, and in particular when referring to the involvement of esthetics in social and political life, I have tried to analyze the concrete forms which these reactions have taken, as well as to describe my reasons for welcoming them.

Actually, I believe that we should always end our works by acknowledging the system of motivations, prejudices, and *partis pris* from which those works arose. Only by trying to incorporate an awareness of our position into our theses will we still be able to defend, if not always effectively then at least without shame, our role as critical consciousness.

NOTES

One. A Model

1. A few examples: within the Mediterranean world, calculations based on the hypothesis that the sun revolves around the earth permitted men to manage navigation and predict eclipses with a reasonable margin of error from 240 B.C. to A.D. 1543. But with the Age of Exploration, the margin of error was now too great—and the heliocentric theory permitted its elimination. Thus, it was the escalation in navigation that ultimately forced a change in the scientific hypothesis (See V. G. Childe, *Society and Knowledge* [London: G. Allen and Unwin, 1956]).

Nor is it the "internal dynamics" of economic theory which accounts for changes in explanatory models. Classical economics is a system which arose out of—and was operative in—a specific era (Europe in 1800) or place (Kenya in 1972) where a capitalist mode of production coexists with a subsistence economy (handicrafts and traditional agriculture). In this situation, the least developed sector provides an inexhaustible supply of labor for the capitalist system—and salaries are kept at a subsistence level which does not permit their being spent on anything but immediate consumption. Thus, the rate of growth or volume of accumulation is here governed only by profits. Nonetheless, when the whole process follows capitalist lines, the economic theorists are obliged to go from the "classical" scheme, which focuses on the study of *factors* and *production*, to the "neoclassical" model of *demand*, since, on the one hand, the problem of unemployment arises and, on the other, growth is then also a function of the consumption of the salaried masses who have now become responsible for both producing and consuming. And when this capitalist process reaches a further development, economic theory has to change once again and become "Keynesian," that is, to study the dynamics of these needs (demand) and intervene in the dynamics by means of the channeling of money and public investment.

2. A little over ten years ago (in *El arte ensimismado* [Barcelona: Ariel, 1963]), I thought that the parallel formalistic tendencies which appeared in painting, film, poetry, etc., could be understood from the standpoint of a theory of *self-absorption*: each art was searching for its identity and trying to invent its own set of rules, avoiding anything that might make its message relative. Painting had to talk about painting and not become a means for representation, decoration, education, etc.

In 1967 (*Teoría de la sensibilitat* [Barcelona: Ed. 62, 1968]), it seemed to me that self-absorption was nothing but a special case of *realism*. The naturalist ideal of the

Renaissance culminated in an avant-garde whose works were not trying to *resemble reality* more closely, but rather to *be real*. Nonfigurative or nontonal art tried to teach people to perceive as reality or as object—as colors, words, or sounds in and for themselves—what before had been taken as signs of external meanings or of subjective emotions. But if conventional Figuration did eliminate the fundamental ambiguity of the art work—*physical existence / reference*—reducing it to the latter, avant-garde art had done the same in identifying art with the former: to physical existence. (In other respects, the bulk of the avant-garde crowd continued asking itself *"What is art?"* when everything already seemed to point to the fact that the pertinent question was not *"What is art?"* but *"When is art?"* That is, when and under what conditions does a stone, a pipe, a torn canvas, or an advertisement carry both appearance and suggestion, presence and reference.)

Now, since 1970, this explanation of bourgeois artistic practice has seemed to me, in its turn, only partial. *Realism* is a special case of an even more general phenomenon and one which explains it in all its forms: *puritanism*.

3. I believe, with Freud, that there is no specific impulse which leads us to a "strategy for realizing our dreams." Thus, I do not think that a nonpuritan, nonsublimated art is attainable. We should remember this when we survey the crisis of the specific forms—"utility," "transcendence," etc.—which this artistic puritanism took in its bourgeois period. Puritanisms are not created or destroyed, they are only transformed: from the obligation that art be "representative" to the obligation that it be "popular," or "ludic," etc.

4. Pierre Boulez, *Boulez on Music Today*, tr. Susan Bradshaw and Richard Rodney Bennett (Cambridge: Harvard University Press, 1971).

5. Recently, Peter Brooks has analyzed and defended the "melodramatic mode" with its stock of disguised, secret societies and slow-acting poisons; with feelings which are always overmotivated and adjectivized ("the irony of vengeance," "the anticipation of pleasure," "the intoxication of the soul and the rage of frustration.") For Brooks, this literary space of "the emotional hyperbole, the extravagant expression, and moral polarization" represents the great victory against repression and censorship by the principle of social reality. Melodrama would thus be the only tragedy possible in a secularized world; the only communal poetics possible in an individualistic age ("The Melodramatic Imagination," *Partisan Review*, No. 2 [1972], p. 197).

6. The classical Platonic-Kantian distinction between the artist and the cook, between the "sensibility" which appreciates works of art and the "sensuality" which is content with meat and potatoes, is one which is still alive among modern critics and in avant-garde reviews. See, for example, John Calendo's interview with Parker Tyler, "The Game of Movie Going," in *Andy Warhol's Interview*, 30 (March 1973), pp. 35 and 44.

7. See Xavier Rubert de Ventós, *Utopías de la sensualidad y métodos del sentido* (Barcelona: Anagrama, 1973), Introduction, p. 16.

8. See Altizer, *et al.*, *La teología de la muerte de Dios* (Barcelona: Ariel, 1966); J. M. Benoist, *Marx est mort* (Paris: Gallimard, 1970); M. Foucault, *Les mots et les choses* (Paris: Gallimard, 1969), where he speaks of "the death of man," and D. Cooper, *The Death of the Family* (New York: Vintage Books, 1971).

9. The only possible meaning of the "death of art" which does not fall within this rhetoric is the one used by E. M. Cioran in *The Temptation to Exist*, tr. Richard Howard, intro. Susan Sontag (New York: Quandrangle, 1968). According to him, given the present-day proliferation in the availability of formal devices and of esthetic manoeuvres, man ought to have the "good taste" to call a halt to his artistic activities "at least for a few generations," and spend some time learning again to be surprised, and to need works of art before going back to producing and consuming them on a mass scale.

10. Nietzsche, *The Gay Science*, trans. by Walter Kaufman (New York: Vintage, 1974), pp. 138–40.

11. See Xavier Rubert de Ventós, "Fare ed Ornare," in *La Scienza e l'Arte* (Milano: Mazzola, 1972), p. 202.

12. G. Simmel, *Soziologie, Untersuchungen über die Formen der Vergesellschaftung* (Leipzig: Duncker und Humblot, 1923), 3rd ed., p. 323.

TWO. APPLICATION OF THE MODEL

1. For a theoretical discussion of this subject, see C. Lévi-Strauss, *Race et histoire* (Paris: Gonthier, 1961), and Chapter 9 of *La Pensée sauvage* (Paris: Plon, 1962), pp. 324–57 (English trans.: *The Savage Mind* [London: Weidenfeld and Nicolson, 1966]).

2. See Arnold Toynbee, *Cities on the Move* (New York: Oxford University Press, 1970), p. 195.

3. See G. Simmel, *Philosophie des Geldes* (Munich: Duncker und Humblot, 1900), and the famous article, "The Metropolis and Intellectual Life," English trans. by Kurt H. Wolff in *The Sociology of Georg Simmel* (New York: Free Press–Macmillan, 1950), pp. 409–24. See also G. Thibon, *Diagnostics: Essai de physiologie sociale* (Paris: Librairie de Medicis, 1946) (English trans. by Willard Hill: *What Ails Mankind?* [New York: Sheed and Ward, 1947]), and above all, Max Weber, *Wirtschaftgeschichte* (Munich: Duncker and Humblot, 1933).

4. *The Sociology of Georg Simmel*, p. 422.

5. Harold Rosenberg, *The Anxious Object, Art Today and Its Audience* (New York: New American Library, 1966), p. 57. The subject is developed in my *Teoría de la sensibilitat*, pp. 70–77 and 443–68.

6. See Roland Barthes, *Système de la Mode* (Paris: Seuil, 1967) and the section on "Style and Fashion" in my *Teoría de la sensibilitat*, pp. 106–24.

7. Tom Wolfe, *The New Journalism* (New York: Harper & Row, 1973), pp. 15 and 18.

8. See Fromm's criticism of the "sociological" interpretation in the magnificent epilogue to *Eros and Civilization*. The Sartrian critique mentioned here belongs to his *Critique de la Raison dialectique*.

9. We could add to the list of the disciplines which are "out of tune" today: the *cold* break Jacques Lacan introduced in *Psychoanalysis* (see his *Ecrits* [Paris: Seuil,

1966], pp. 234ff.); the *hot* one begun by Karl Polanyi in *Economics* (see his *Primitive, Archaic and Modern Economics* [Boston; Beacon Press, 1971], pp. 116ff.).

10. This change can also be understood as a crisis, both internal and external, in the avant-garde's devotion to change, to new departures, to progress. As I suggested in my *Teoría de la sensibilitat*, and as Octavio Paz has further elaborated, the accelerated proliferation of revolutionary trends or styles paradoxically threw its very "tradition of the new" into a crisis. Thus occurred "the fragmentation of the avant-garde into hundreds of identical movements: the anthill [where] all differences are abolished." (O. Paz, "El ocaso de la vanguardia," in *Plural*, 1 [1974], p. 23). Hundreds of perfectly and uniformly "progressive" movements appeared for which the present was no more than the juncture from which to criticize the past and invent the future. The present-day conflicts were merely residues from the past which would be resolved in an epiphany of the new Art, the new Culture, the new State, or the new Whatever.

But it is symptomatic that the past does not appear to us any more as something to overcome, but rather as something to be recovered, and that, as Paz writes, the "vision of the 'now' as a convergence center of time, originally a vision of poets, has turned into a belief underlying the attitudes and ideas of the majority of our contemporaries" (*Ibid.*, p. 22).

The symptoms and reasons for this crisis of "modernity"—of chronic avant-gardism—should not be sought only in the world of art. The term "new," which in the United States had a charismatic value, is being displaced by its opposites: "used, recovered, recycled." *Recycled* has replaced *new* as a prestige adjective people use in selling products. The future no longer appears as the place of all perfection, but rather of degradation or catastrophe. This had not helped, though, to change the direction or pace of economic development: Robert L. Heilbroner has shown the impotence of the two great, dominant socioeconomic blocks for the reconversion to a nonproductive posture—the only posture that might prevent disaster ("The Human Prospect," *The New York Review of Books*, 20, 21 [1974], pp. 21–34).

Finally, the Future now appears to us as a secularized variety of Eternity. For the Religion of the Future, Salvation was not Beyond, but merely Up Ahead: its image, however, served as a promise in whose name one had to postpone pleasure and accept the present's injustices. The present-day revolt of the body and the imagination are no longer directed against Eternity but against its new civilized form—against the Future. Both body and imagination "deny linear time: their values are those of the present." The structuralists no longer try to interpret the course of history but try to understand a moment or slice of it; the new artists no longer see themselves as the "vanguard" of an army bent on the conquest of the future, but rather as people who awaken our sensibility for the present—their enemy, therefore, is no longer the residue of the past, but rather the social and cultural norms that condition the use of the senses. And also politics loses its avant-garde look: "politics today is no longer the construction of the future; its mission is to make the present livable" (O. Paz, "El ocaso," p. 22). In the last chapter we will have occasion to see the general framework (pp. 216ff.) in which this new synchrony, this post-avant-garde ideology finds its place.

11. Claude Lévi-Strauss, *La Pensée sauvage* (Paris: Plon, 1962), p. 43.

12. G. Deleuze, *Proust et les signes* (Paris: Presses Universitaires de France, 1964) (English trans. by Richard Howard: *Proust and Signs* [New York: Braziller, 1972]).

THREE. PURITANISM IN MODERN CULTURE

1. Philip Slater, *The Pursuit of Loneliness* (Boston: Beacon Press, 1976), p. 115.

2. George Santayana, *The Sense of Beauty* [1896] (New York: Dover, 1955), p. 47.

3. Herbert Marcuse, "Art as a Form of Reality," p. 128.

4. See, on this subject, J. Pieper, *Leisure, The Basis of Culture* (New York: New American Library, 1963).

5. In W. Sombart, *Der Bürger* (Berlin, 1917), p. 19.

6. Benjamin Franklin, *Advice to a Young Tradesman* (1748) and *Necessary hints to those who would be rich* (1736), in *The Works of Benjamin Franklin*, ed. Jared Sparks (Chicago, 1882), II, pp. 80–81, 87–88.

7. "On the one hand the labouring classes accepted from ignorance or powerlessness, or were compelled, persuaded, or cajoled by custom, convention, authority, and the well-established order of Society into accepting, a situation in which they could call their own very little of the cake, that they and Nature and the capitalists were co-operating to produce. And on the other hand the capitalist classes were allowed to call the best part of the cake theirs and were theoretically free to consume it, on the tacit underlying condition that they consumed very little of it in practice. The duty of 'saving' became nine-tenths of virtue and the growth of the cake the object of true religion. There grew round the non-consumption of the cake all those instincts of puritanism which in other ages has withdrawn itself from the world and has neglected the arts of production as well as those of enjoyment. And so the cake increased; but to what end was not clearly contemplated. Individuals would be exhorted not so much to abstain as to defer, and to cultivate the pleasures of security and anticipation. Saving was for old age or for your children, but this was only in theory—the virtue of the cake was that it was never to be consumed, neither by you nor by your children after you." J. M. Keynes, *Economic Consequences of the Peace* (London: Macmillan, 1919), pp. 16–7. Quoted in J. Robinson: *Economics: An Awkward Corner* (London: Allen & Unwin, 1966), p. 4.

8. We pay what it has cost to produce a pair of shoes, but "when we buy an illustrated magazine we pay only a small part of its real price, and radio or television programs, being tremendously more expensive, do not cost anything or hardly anything; that is, it is they who ask us to accept them free of charge." Surely if we do not pay money it is because we pay in kind, or better, *in corpore*: we are allowing these generous channels to speak for us, inform us, advertise to us and, finally, control us. Our awareness has a supreme exchange value, and people pay in alienation what they would never allow themselves to pay in money; and this value increases, Enzensberger concludes, when "the accumulation of political power exceeds the accumulation of economic wealth"; when "what is accumulated is not the force of

labor but the capacity to choose." H. M. Enzensberger, *Detalles* (Barcelona: Ana-grama, 1969), pp. 13. and 14. [The German original: *Einzelheiten* (Frankfurt: Suhr-kamp Verlag, 1962)].

9. See Georges Bataille, *La Part maudite* (Paris: Minuit, 1967), p. 43, and also the interpretation of this thesis of Bataille's by Jacques Derrida in *L'Écriture et la dif-férance* (Paris: Seuil, 1967) pp. 369–407. Reality, of course, is very different: in the present stage of capitalist development, the reduction of everything to its commercial value has spread into areas which even early capitalism had not taken into account: education, leisure, sex, etc. Thus, we are not witnessing a "spiritualization" of politi-cal economy, but rather the totalitarian inclusion in political economy of everything spiritual.

10. The incipient bourgeoisie of the Greek eupatridae not only produced the best works of art of all times, but also the norm for all the later puritan discourses on bourgeois art. The first great bourgeois thinker and systematizer, Aristotle, assigns art a *pedagogical* and *heuristic* function, and attributes to it the task of expressing the *type* which is in every thing: three characteristically puritan legitimizations of art. And Plato had already suggested the three great main pathways through which for-mal puritanism would thenceforth try to justify the form from outside the form itself and its ludic effects. When he speaks about art as a "reflection" of the archetypes, Plato is proposing the model of all *puritanisms of content*. When in the *Symposium* he speaks of Beauty as viaticum and an "aphrodisiac in search of truth," and when, finally, he proposes as a function of art the "ensuring of politico-social cohesion," Plato establishes the basis for all the *functional puritanisms*. *Puritan discourse has been moving ever since between both alternatives: art forms legitimated by what they "reflect," or by what they "serve."*

11. For a development of the history of esthetic ideas abridged in this paragraph, see my *Teoría de la sensibilitat*, pp. 86–87 and 424–29.

12. Thomas Mann, *Death in Venice*, trans. by Kenneth Burke (New York: Knopf, 1925), pp. 28 and 30.

13. See Julio Cortázar, *La vuelta al día en ochenta mundos* [1967] (Madrid: S[iglo] XXI, 1970), 5th ed., pp. 32–38.

14. This means the crisis of any possible "reconciliation" between these two worlds: the crisis of the Greek or classical worlds for which, in Nietzsche's words, "ugliness, in itself an objection, is . . . almost a refutation" (Nietzsche, *Crepúsculo de los ídolos* [Madrid: Alianza, 1971], p. 39. (English trans. by Walter Kaufman: *Twilight of the Idols*, in *The Portable Nietzsche* [New York: Viking, 1954], p. 474.) It is a crisis also of the Hegelian effort to make it understood that there is no other tran-scendence than the particular phenomenon seen in all its dimensions ("the spiritual is the phenomenon as phenomenon"), and that the mind gets to experience itself only through its object. Hegel, *Fenomenología del espíritu*, pp. 124 and 73–74 (En-glish trans. by J. B. Baillie: *The Phenomenology of Mind* [New York: Macmillan, 1910], vol. 1).

15. N. Schöffer, *La Ville cybernetique* (Paris: Tchou, 1969), p. 18.

16. Nietzsche, *Más allá del bien y del mal* (Madrid: Alianza, 1972), p. 158. (En-glish trans. by Walter Kaufman: *Beyond Good and Evil* [New York: Vintage, 1966].)

17. Hermann Broch, *Kitsch, vanguardia y arte por el arte* (Barcelona: Tusquets, 1970), p. 23. (German original: *Einige Bemerkungen zum Problem des Kitsches*, in *Dichten und Erkennen* [Zurich, Rhein-Verlag 1955], I, p. 302.)

18. Goethe, "Weimarisches Hoftheater," in *Sammtliche Werke*, 36 (Berlin, 1927), p. 249.

19. G. W. F. Hegel, *Aesthetics: Lectures on Fine Art*, trans. T. M. Knox (Oxford: Oxford University Press, 1975), vol. 2, pp. 901–2.

20. Hermann Broch, *Kitsch*, p. 23.

21. L. Benevolo, *Introducción a la arquitectura* (Buenos Aires: Teckne, 1967), p. 115.

22. "Naturalism" is a real *option* since, as Sartre, Panofsky, and Gombrich have shown, neither literary Naturalism nor pictorial perspective are neutral or natural in any sense at all; the bare description of what is perceived presupposes a choice and needs an elaboration as does any other style.

23. A. Herzen, *Cartas sobre el estudio de la naturaleza* (Madrid: Ciencia Nueva, 1962), p. 194. (English title: *Letters on the Study of Nature*, in *Selected Philosophical Works* [Moscow: Foreign Language Publishing House, 1956], pp. 97–305.)

24. Kant, *Crítica del juicio* (Buenos Aires: Losada, 1961), p. 66. (English trans. by James Creed Meredith: *The Critique of Judgment* [Oxford: Clarendon Press, 1964]).

25. *Ibid.*, p. 68.

26. On the opposition between this *puritan or realist formalism* of the avant-garde and *courtly or sumptuous formalism*, see my *Teoría de la sensibilitat*, pp. 83–87; on formalism as a "deep realism," *ibid.*, pp. 218–36.

27. Xavier Rubert de Ventós, *Utopías de la sensualidad y métodos del sentido* (Barcelona: Anagrama, 1973), pp. 99–122.

28. Claude Lévi-Strauss, *L'Homme nu* (Paris: Plon, 1971), last section, and H. Gardner, "Some notes . . . ," in *The Human Context*, V, I (1973), 222.

29. Roland Barthes, *Sade, Fourier, Loyola* (Paris: Seuil, 1971). (English trans. by Richard Miller: *Sade, Fourier, Loyola* [New York: Hill and Wang, 1976].)

30. "Oh, marvellous necessity; you, with your supreme reason, cause all effects to be a direct result of their causes . . . ," etc.

31. Nietzsche, *Das Philosophenbuch. Theoretischen Studien* ([n.p.]): Kroner-Aubier, 1969), p. 111.

32. Nietzsche, *The Gay Science*, trans. by Walter Kaufman (New York: Vintage, 1974), sect. 25, p. 316.

33. Nietzsche, "Essay of Self-Criticism," *Thus Spake Zarathustra*, Part 4; and *Crepúsculo de los idolos* (Madrid: Alianza, 1973), p. 102 (*Twilight of the Idols*, p. 562).

34. *The Gay Science*, sect. 113; p. 135.

35. *Ibid.*, sect. 107, p. 163.

36. Tragedy is, in fact, temporally and structurally related to urban culture. (a) *Temporally*, since it does not arise in Homer's patriarchal and tribal society but rather is contemporaneous with the city, where laws and destiny are in man's hands and the boundary is drawn between *nature* and *culture*: between the given and the

created, the assumed and the constructed, the seen and the invented. (b) *Structurally*, since the proscenium in the theater also functions as a "boundary" between the natural and the artificial, between spectator and spectacle.

37. *Ibid.*, p. 134. As we see, Nietzsche, just as Plato and Aristotle, makes an "essential" element of tragedy out of a certain moment of its evolution. Plato's theory is thus the one which gives a better account of the tragedy of Aeschylus, Nietzsche's of Sophocles, and Aristotle's of Euripides.

38. Nietzsche, *Das Philosophenbuch—Betrachtungen über den Kampf von Kunst und Erkenntnis*, Sects. 25 & 35.

39. Nietzsche, *The Gay Science*, Sect. 27, p. 100. In *Más allá del bien y del mal* (*Beyond Good and Evil*) the plea for asceticism appears again and again: one must be reserved, be detached from one's thoughts, distance oneself heroically from the "rapture of his own senses" and from the virtues like generosity and spontaneity to which one naturally tends (Sects. 41 & 44, pp. 66 and 70). In *Crepúsculo de los ídolos* (*Twilight of the Idols*), the superior man is also characterized by his capacity to "keep himself at a distance" (p. 127), to "resist stimuli" (p. 83), to "not *let himself go* even when alone" (p. 124).

40. Nietzsche, *The Gay Science*, Sec. 58, p. 121. In *Crepúsculo* [*Twilight* . . .] art is even endowed with the "function" of struggling against the degeneration of the species (p. 99), and guaranteeing its propagation (p. 113).

41. *The Gay Science*, Sect. 290, pp. 232–33.

42. *Ibid.*, sect. 280, p. 22T.

43. *Ibid.*, sect. 370, p. 327.

44. *Ibid.*, sect. 103, p. 158.

45. Marcel Proust, *Un Amour de Swann* (Paris: Gallimard, 1954), pp. 188 and 189. (English trans. by C. K. Scott Moncrieff: *Remembrance of Things Past* [New York: Random House, 1934], vol. 1, pp. 144 and 145.)

46. Julio Cortázar, *La vuelta al día en ochenta mundos*, p. 96.

47. O. Paz, "El ocaso de la vanguardia," in *Plural*, 1 (1974).

48. On this subject, see my *Self-Defeated Man*, trans. Christine Denmead (New York: Harper & Row, 1975), pp. 1–3.

49. Hans Magnus Enzensberger, *Detalles*, p. 161.

50. Along the same lines, see M. Blanchot, *Lautréamont et Sade* (Paris: Minuit, 1963), pp. 29–30, and Georges Bataille, *L'Erotisme* (Paris: Minuit, 1957) (English trans. by Mary Dalwood: *Eroticism* [London: John Calder, 1962]). A critique of this hedonism or applied experimentalism may be found in my *Self-Defeated Man*, pp. 48–52.

51. André Breton, *Prestige d'André Masson* (Paris, 1939).

FOUR. A CHANGE OF "STYLE": THE CRISIS IN FUNCTIONALIST SENSIBILITY

1. Walter Gropius, *The Scope of Total Architecture* (New York: Harper 1955).

2. Along these lines, see my *El arte ensimismado* (Barcelona: Ariel, 1963), pp. 98 and 53.

3. Benevolo, *Introducción a la arquitectura*, p. 115.

4. On Kitsch and classical bourgeois society, see Hermann Broch, *Kitsch, vanguardia y arte por el arte*. On Kitsch and neocapitalist society, see A. Moles, *Psychologie du Kitsch. L'Art du Bonheur* (Paris: Mame, 1971), especially pp. 133–221, and L. Giesz, *Fenomenología del kitsch* (Barcelona: Tusquets, 1973) [in the German Original: *Phänomenologie des Kitsches. Ein Beitrag zur anthropologischen Aesthetik* (Heidelberg: W. Rothe 1960)], in addition to the well-known studies of Dorfles and Eco. On Kitsch and vulgarity, see my *Teoría de la sensibilitat*, pp. 203–16.

5. Walter Gropius, *Scope*, pp. 3 and 17–18.

6. F. Chueca Goitia, *Breve historia del urbanismo* (Madrid: Alianza Editorial, 1968), p. 183.

7. See A. Moles, *Psychologie*, p. 173.

8. Marshall McLuhan, *Understanding Media* (New York: McGraw-Hill, 1964), p. 117.

9. Some analysts as discerning as Baudrillard must be aware of this fact even today. This author held, as late as 1969, that against the lower classes' devotion to the artificial, the overdone, and the flashy, there had arisen a tendency in the upper classes and the avant-garde toward "the values of frankness, toward 'naturalness': the rough-hewn, dark, and neglected." I agree, of course, with Baudrillard's thesis that creators or formal innovators, despite their pious litanies ("we should educate the public's taste," etc.), are in the service of cultural discrimination: that they aim to create forms not immediately recoverable by the masses. What seems incorrect is the concrete example with which he illustrates his thesis, i.e., the artificial / natural opposition which he uses to describe this dialectic in the present. I think, on the contrary, that the order of the opposition is the reverse (*natural / artificial*), since the petit bourgeoisie discovered the formal and ethical values of functional asceticism under the guise of a picture-window or a piece of mass-produced Scandinavian furniture.

10. See R. Venturi and D. S. Brown, "Significance for A & P Parking Lots, or Learning from Las Vegas," *The Architectural Forum*, (March 1968), and Ch[ristopher] Alexander, *Cells for Subcultures*, unpublished ms.

11. J. W. Cook and H. Klotz, "Ugly is Beautiful. The Main Street School of Architecture," an interview with Robert Venturi and Denise Scott Brown, *The Atlantic* (May 1973), p. 35.

12. Ch[ristopher] Alexander, "The Timeless Way of Building," unpublished ms. In his Center for Environmental Structure in Berkeley, Alexander and his team have been working in a "pattern language" which aims to allow everybody to carry out this process of design and reparation of his living space for himself. "The Oregon Experiment" (published in 1976 in France and Spain) gives an example of how it could work.

13. See my *Teoría de la sensibilitat*, pp. 541–60, and *Utopías de la sensualidad y métodos del sentido*, 57–82.

14. M. Brill, *Architecture for Human Behavior* (Philadelphia, 1971), p. 86.

15. H. Lefebvre, *La Révolution urbaine* (Paris: Gallimard, 1970).

16. See T. de Quénétain, "Comment l'espace conditionne nos humeurs," *Realité*

(March 1968). There is a copious bibliography on the subject; notable are the early studies of Edward T. Hall (*The Silent Language* and *The Hidden Dimension*), C. Perrin's *With Man in Mind*, R. Sommer's *Personal Space*, and the studies of R. Prochansky and others collected in the volume, *Environmental Psychology—Man and His Physical Setting* (New York: Holt, Rinehart, Winston, 1970).

17. For the technical meaning of these terms in systems analysis, the reader is referred to the excellent and readable work of C. W. Churchman, *The Systems Approach* (New York: Delta Books, 1968).

18. Hegel, *Aesthetics*, vol. II, p. 668.

19. *Ibid.*, p. 666.

20. Ch[ristopher] Alexander, *La ciudad es un árbol* (Buenos Aires, 1968), pp. 20, 29. ("A City is Not a Tree," *The Architectural Forum* [April 1965], p. 58).

21. Tom Wolfe, *The Kandy-Kolored Tangerine-Flake Streamline Baby* (New York: Pocket Books, 1970), p. 23.

22. Alan Watts, *Does It Matter? Essays on Man's Relation to Materiality* (New York: Pantheon, 1970).

23. Eric Berne, *Games People Play: The Psychology of Human Relationships* [1964] ([New York]: Castle Books, 1971), pp. 13–20.

24. On a theoretical level, the philosophers of so-called "volitional realism" (Maine de Biran, Dilthey and, to a certain extent, Köhler and Scheler) even held that "things resist our wills and desires, and only thanks to this resistance do we experience reality. Objects appear to us as real only because they make themselves felt as adverse factors to our volitional life" (H. Hessen, *Teoría del conocimiento* [Mexico, 1956], p. 78).

25. That is how Marcuse sees it with respect to technological warfare where aggression is, so to speak, transferred from the subject to the object (guided missiles, etc.). "Delegating destructiveness to an object, or a group or system of more or less automated objects, produces an 'interruption' in the instinctual satisfaction of the aggressor; this satisfaction is lessened, frustrated, 'oversublimated.' And such a frustration leads to repetition and escalation. . . . The more efficient and 'technological' aggression becomes, the less it helps to satisfy and placate the primary impulses, and the more it tends to repeat and escalate itself . . . since it sets free a mental dynamic which aggravates the destructive, antierotic tendencies of the puritan complex." Herbert Marcuse, *La agresividad en la sociedad industrial avanzada* (Madrid, 1971), pp. 120, 122. (English title: *Aggressiveness in Advanced Industrial Society* [Boston, 1968].)

26. B. Poyner and Ch[ristopher] Alexander, *The Atoms of Environmental Structure* (1967).

27. The term is Kevin Lynch's (*The Image of the City* [Cambridge, Mass.: Technology Press, 1960]), who, despite his insistence on the clarity of "Paths, Edges, Districts, and Landmarks," recognizes after all that an environment that is ordered in a detailed and final form can hinder the emergence of new models of behavior.

28. See James Joyce, "A Painful Case," *Dubliners* (New York: Viking, 1958), p. 138. The preceding argument can be found in Richard Sennett, *The Uses of Disorder* (New York: Vintage, 1970).

29. F. Buytendijck, *Psychologie des Animaux*, French trans. by Dr. H. R. Brédo (Paris: Payot, 1928), pp. 86–87. M. Merleau-Ponty, *La Structure du Comportement* (Paris: Presses Universitaires de France, 1960), pp. 120–21 (English trans. by Alden L. Fisher: *The Structure of Behavior* [Boston: Beacon Press, 1963]). R. M. Yerkes, "The Intelligence of Earthworms," *Journal of Animal Behavior*, 2 (1972); M. Polanyi, *Personal Knowledge* (New York, 1964), pp. 122 and 317.

30. The Museum of Modern Art Papers on Architecture (New York, 1966).

31. See Simmel, *Brücke und Tür* (Stuttgart: K. F. Koehler, 1957), where the connection between spatial symmetry and totalitarianism is stressed.

32. See, in this connection, A. Riegl's argument against Hildebrand and Riedler in *La industria artística tardorromana* (Florence, 1953).

33. See my *Utopías de la sensualidad y métodos del sentido*, pp. 124–26 and 136–37.

34. Venturi has seen this analogy between Rome and the modern commercial or entertainment city. In Rome as well as in Las Vegas "we find elements from a supranational scale vividly superimposed on top of local construction: churches in the religious capital, casinos with their signs and billboards in the entertainment capital," in "Learning from Las Vegas," p. 38.

35. Rafael Sánchez Ferlosio, *Las semanas del jardín* (Madrid: Nostrodomo, 1972).

36. Martial, *Epigrams*, trans. by Walter C. A. Ker (Cambridge: Harvard University Press, 1968), vol. 2, pp. 189–91.

37. Hegel, *Aesthetics*, vol. II, p. 886.

38. See Aristotle, *Politics*, 1257, and *Nichomachaen Ethics*, 1133. The subject is developed by K. Polanyi, in "Aristotle Discovers the Economy," *Primitive, Archaic, and Modern Economies* (Boston: Beacon Press, 1968), pp. 95–115.

39. Karl Marx, *La Question juive* (Paris: Ed. Costes, 1946), pp. 163ff.

FIVE. A CHANGE OF SUBJECT: THE CRISIS IN AVANT-GARDE SENSIBILITY

1. This phenomenon was intuited by Walter Benjamin in his work on the technical reproducibility of modern art, and has been rediscovered and abundantly illustrated by Marshall McLuhan.

2. Apuleius, *The Golden Ass*, Book XI.

3. Violette Morin overlooked this in her work "L'Object biographique," (*Communications*, #13 [1969], pp. 131–39), which I follow in the next ten lines.

4. This concern for delimiting the sphere of art, unknown to primitives, is obviously a characteristic of bourgeois art. "In certain primitive as well as in some culturally highly developed societies, literature is integrated into other social manifestations and is not clearly differentiated as an independent entity apart from ceremonials of cult and religion. . . . In contradistinction, literature in the middle-class world leads an existence clearly separated from other cultural activities, with many functional differentiations." Leo Lowenthal, *Literature, Popular Culture, and Society* (Englewood Cliffs, N.J.: Prentice Hall, 1961), pp. 141–42.

5. Ovid, *Metamorphoses* II, 11. 134–37: "Sky and earth both need / Equal degrees of heat: too low, you burn / The one, too high the other. The middle is safest"; trans. Rolphe Humphries (Bloomington, 1957), p. 32.

6. Kant, *Crítica del juicio* (Buenos Aires: Losada, 1961), p. 86. (English title: *The Critique of Judgment.*)

7. Hegel, *Aesthetics*, vol. II, p. 817.

8. This detachment from the natural in order to conquer the cultural or conventional might be—as Nietzsche said of the classics—"the most agreeable repast for human pride" (*The Gay Science*, Sect. 80), but also, and more modestly, in bourgeois society, the sustenance of its moral and intellectual prudery.

9. Charles Baudouin, *Psychoanalyse de l'art* (Paris: F. Alcan, 1929), p. 86.

10. Hegel, *Aesthetics*, vol. II, p. 835.

11. *Ibid.*

12. Walter Benjamin, "The Work of Art in the Age of Mechanical Reproduction," *Illuminations*, trans. by Harry Zohn (New York: Schocken Books, 1978), p. 234. The text dates from 1936. Today this statement would not be quite so accurate, because the cineclubs and specialized magazines have "culturalized" the cinema, now increasingly more "artistic" in its cinematheques, art clubs, and preview houses. In consequence, also in the cinema the process of separation between ludic behavior and critical behavior has begun.

13. Hence, in my *Teoría de la sensibilitat* I thought it justified to situate within the Renaissance *episteme* this trend that runs from impressionism to informalism—to see it as the culmination of that tradition's tendency toward autonomy and self-sufficiency.

14. We could add many other statements that point to a similar attitude: "Poètes . . . extravaguez" (Victor Hugo); "L'extremisme est le phenomène même de l'élan poétique" (Gaston Bachelard); "Only exceptions are true" (Norman O. Brown).

15. Leon Trotsky, *Leur morale et la nôtre* (Paris: J. J. Pauvert, 1966), p. 43. (English trans.: *Their Morals and Ours* [New York: Pioneer, 1942].)

16. In this sense, the new manager stands out as much from the old model of the bureaucrat as from the aggressive and self-assured, self-made man who shaped the model of the capitalist entrepreneur. The new manager, write Bennis and Slater, must make himself and his organization "vulnerable and receptive to external sources and to new, unexpected, and even unwanted information." But the new pace of change and growing complexity of businesses does not only invalidate the model bureaucrat, but the classical entrepreneurial model as well. "The great man," Bennis and Slater continue, "was usually a man with a single idea, or a constellation of related ideas, which he developed brilliantly. . . . His aggressiveness now begins to turn in on his own organization, and the absolutism of his position begins to be a liability, a dead hand, an iron shackle upon the flexibility and growth of the company." See "Beyond Bureaucracy," and "Democracy is Inevitable," in Warren G. Bennis and Philip Slater, *The Temporary Society* (New York: Harper & Row, 1968), pp. 60 and 10.

17. P. Klossowski, "Protase et Apodose," in *L'Arc*, p. 43.

18. J. Baudrillard, *Pour une Critique de l'économie politique du signe* (Paris: Gallimard, 1972), Chapter 1.

19. Marshall McLuhan, *Counter-Blast* (New York: Harcourt, Brace, & World, 1969), pp. 31–32.

20. A. Moles, "Sociodynamique et politique d'équipement culturel dans la societé urbaine," *Communications*, #14 (1969), p. 148.

21. Kurt Lewin, A *Dynamic Theory of Personality* (New York: McGraw Hill, 1935), p. 76.

22. See my *Self-Defeated Man: Personal Identity and Beyond*, tr. Christine Denmead (New York: Harper and Row, 1975), pp. 20–22 and 68–69.

23. Arnold Toynbee, "Sommes-nous condamnés auz 'loisirs à perpetuité?' " *Le Figaro* (March 4, 1971). See also, F. Basaglia, *Psiquiatría o ideología de la locura?* (Barcelona: Anagrama, 1972), p. 87.

SIX. THE TECHNICAL SCHISM

1. For as broad a statement of the cold split on the "thematic" as well as on the "stylistic" level, I refer the reader to the last part of my *Teoría de la sensibilitat*, pp. 463–566.

2. H. Focillon, *La Vie des formes* (Paris, Librairie Ernest Heroux, 1934), p. 87. (English trans. by B. Hogan and G. Kubler: *The Life Forms in Art* [New Haven: Yale University Press, 1942].)

3. J. Cassou, *Situation de l'art moderne* (Paris, 1950), p. 63.

4. Prologue to J. Margarit and C. Buxade, *Introducción a una teoría del conocimiento del diseño y de la arquitectura* (Barcelona: Blume, 1969), p. 10.

5. A. Touraine, *La sociedad post-industrial* (Barcelona: Ariel, 1970), p. 229. (*The Post-Industrial Society* [New York: Random House, 1971].)

6. From a theoretical point of view, the exaggerations of this procedure have brought on a supposed "crisis of theory"; and in practical terms, they have led to economic models like that of Phillips about the relationship between rate of inflation and level of unemployment which, after briefly entrancing British economists, was shown by Milton Friedman to be a tautology pure and simple. The variables taken into consideration were not independent variables, and their correlation was just a self-fulfilling prophecy. It was, so to speak, as if a model showed us that there exists a close correlation between "interest rate" and "the neuroses of individuals seeking to obtain credit." Up to now Anglo-Saxon empiricists were fond of translating banal facts into figures; now they begin to translate also banal fantasies into figures.

7. Arrabal and Jodorowsky, in *Le Panique* (Paris: 10 / 18, 1973), pp. 58, and 42.

SEVEN. THE WILD SCHISM

1. Touraine, *La sociedad*, pp. 224 and 230.

2. Roland Barthes, *Mythologies* [1957], selected and trans. by Annette Lavers (New York: Hill and Wang, 1972), p. 28.

3. See Paul Valéry, *L'Idée fixe* (Paris: Gallimard, 1934).

4. Antonin Artaud, "Letters on Language," in *The Theater and Its Double,* trans. Mary Caroline Richards (New York: Grove Press, 1958), p. 109.

5. Susan Sontag, *Against Interpretation* (New York: Farrar, Straus & Giroux, 1969), p. 176.

6. Antonin Artaud, "No More Masterpieces," p. 81.

7. See Ray L. Birdwhistell, *Kinesics and Context: Essays on Body Motion Communication* (New York: Ballantine Books, 1972), p. 30.

8. See P. Watzlawick et al., *Teoría de la comunicación humana* (Buenos Aires: Tiempo Contemporáneo, 1971), p. 74. English original: *Pragmatics of Human Communication: A Study of Interactional Patterns, Pathologies, and Paradoxes* (New York: Norton, 1967).

9. The conviction that art should collaborate in the broadening of experience goes back to Plato, Goethe, Schiller, Matthew Arnold, and Tolstoi. It is an idea, furthermore, not less but even more "puritan" than the ones we analyzed under that heading.

10. Recall the beginning of *Los cachorros:* "They were still wearing short pants, although we still weren't smoking, they preferred soccer to all other sports and we were learning to ride surfboards" (Barcelona: Lumen, 1967). Or the beginning of *Julia* by Ana Maria Moix: "Mother told me I have to buy clothes because now it's time for you to dress like girls your age."

11. Traditionally, the first-person pronoun, the interjection, and lyric poetry were associated with the "expressive" function (which Bühler called *Kundgabe*); the second-person pronoun, commands, and dramatic poetry corresponded to the "directive" function (*Auslösung*); and the third person, like epic poetry, to the "referential" function (*Darstellung*).

12. David Hume, "Of Tragedy," in *Essential Works of David Hume,* ed. Ralph Cohen (New York, 1965), p. 448.

13. Interview with William Burroughs by D. Odier in *Le Travail* (Paris: Ed. P. Belfond, 1970).

14. Marshall McLuhan, *Counter-Blast* (New York: Harcourt, Brace and World, 1969), p. 33.

15. Plato, *Republic,* especially sects. 392–394, 460, and 595.

16. "The Work of Art in the Age of Mechanical Reproduction," in *Illuminations* (New York: Schocken Books, 1978).

17. A. Moles, "Sur les bases d'une socio-esthétique dans le système de l'affluence," in *Opus International.*

18. M. Rheims, *La Sculpture funéraire au XIXᵉ siecle* (Paris: Arts et Metiers, 1972).

19. Soren Kierkegaard, *La Répétition* (Paris, 1933), p. 79. (English trans. by Walter Lowrie: *Repetition* [Princeton: Princeton University Press, 1941].)

20. See, in this connection, C. N. Shulz, *Intentions in Architecture* (Oslo: Universitetsforlaget, 1963), p. 63, and Arnold Toynbee, *Estudio de la historia* (Buenos Aires: Emecé, 1952), p. 506 (English Original: *A Study of History* [New York & London: Oxford University Press, 1947–57], abridgment of vols. 1–10 by D. C. Somervell).

21. Maurice Merleau-Ponty, "Le Langage indirect," *Les Temps Modernes* (June

1952), p. 623, and Jean-Paul Sartre, *Qué es la literatura?* (Buenos Aires: Losada, n.d.), pp. 56 and 57 (English title: *What Is Literature?*).

22. G. Debord, *La Société du spectacle* (Paris: Champ Libre, 1971), p. 121. English trans.: *Society of the Spectacle* (Detroit: Black and Red, 1970).

23. M. Metter, "Approche d'une politique culturelle en France," *Communications*, 24, p. 140.

24. See Desmond Morris, *El zoo humano* (Barcelona, 1969), p. 243. (English original: *The Human Zoo* [New York: McGraw-Hill, 1969].) Here, although probably unaware of it, Morris is following in the line of the studies of Simmel and Thibon.

25. J. Duvignaud, *Espectáculo y sociedad*, p. 106. (French original: *Spectacle et société* [Paris: Denoël, Gonthier, 1970].)

26. Antonin Artaud, *The Theater and its Double*, p. 70.

27. J[ohan] Huizinga, *Homo Ludens* (Boston: Beacon Press), 1955, pp. 119ff.

28. In this sense the difference between our languages and Classical Greek is perhaps analogous to the difference between the *piano* and the *harpsichord*. The keys of the harpsichord are, so to speak, digital: I can play or not play a note, but never modulate it. The piano, on the contrary, permits "expressive" intensities and modulations in the use of its keys.

29. "The terms the Greeks used to name their rhythms show us that they were felt in a bodily way: *foot, thesis, arsis*. The foot is a set combination of long and short syllables recognizable by their regular recurrence. *Thesis* means to put your foot down, *arsis*, to pick it up. . . . The Greek has expressed the unity of all the features of language in the word '*mousike*,' a term that has a much broader meaning than our word 'music'. . . . But seldom has anyone studied the cause and meaning of the fact that classic Greek words had a life independent of the will of the person speaking. The fact that poetry, music, and dance do not originally appear as individual arts and that they aren't given over to the free individual, helps us to see that their ultimate origin was the sacred order. And we see the same thing when we observe the role of the Greek theatrical *mask*: it represents the identical, not the subjective, while it hides the merely idiosyncratic. The individual disappears behind it to revisit the archetypal and eternal. But when the original unity broke down, poetry, music, and dance became detached from their connection with the totality." E. Grassi, *Arte y mito* (Buenos Aires: Nueva Visión, 1968), pp. 110–21. Original title: *Kunst und Mythos* (Hamburg, 1966). See also, in this connection, J. J. Rousseau, *El origen de las lenguas* (Buenos Aires: Calden, 1970), pp. 88–100. English trans. by J. H. Moran and A. Gode: *On the Origin of Language* (New York: F. Ungar, 1967).

30. K. Kereny, *Die Antike Religion* (Düsseldorf / Köln, 1952.

31. E. Grassi, *Arte*, p. 124.

32. See my article, "Trivialización del arte y vanguardia," in *Convivium* [Barcelona] (1967), pp. 30–33.

33. Cf. Artaud, *The Theater and Its Double*, p. 11.

34. Fray Toribio de Paredes, *Historia de las Indias de la Nueva España*, (Washington Academy of American Franciscan History); E. Wolf, *Sons of the Shaking Earth* (Chicago: University of Chicago Press, 1959), pp. 216 and 285.

35. Observe, furthermore, that these latter events are founded now exclusively on

a very partial aspect of the ritual: mere cruelty. Contrary to Artaud, I understand cruelty as already a step in the direction of trivialization, secularization and "specialization" of the mythic texture.

36. Hegel, *Aesthetics*, III, vol. II, 692.

37. J[ohan] Huizinga, *The Waning of the Middle Ages* (Garden City: Doubleday Anchor, 1954), pp. 11, 12.

38. A Proucopiou, *Atenas, ciudad de dioses* (Barcelona, 1965), p. 206.

39. It is revealing in this sense that until the fourth century, the prize for tragedies is given to the author and the chorus jointly, never to the "actor."

40. A vestige of that second stage of tragedy (in which one sees both the event and the reaction that it produces in the chorus) is present in television movies with canned laughter, in which we are spectators of a comic situation and, at the same time, of the laughter which it has produced in the invisible spectators who show us what to laugh at. How did McLuhan miss this "magical" dimension of television?

41. Nietzsche, *The Gay Science*, Sect. 80, p. 135.

42. Aristotle, *Poetics*, 1451a, trans. Kenneth A. Telford (Chicago: H. Regnery, 1961), p. 15.

43. *Ibid.*, 1460b, p. 50.

44. Until his time, the symbolic and conventional had been maintained, with hardly any concessions to naturalism or subjectivism. The masks of joy or sorrow were conventional, as was the meaning of the doors which opened onto the stage: the right-hand door led to the countryside, the left-hand one to the city.

45. Plato, *Republic*, 605, tr. Francis Macdonald Cornford (New York and London: Oxford University Press, 1945), p. 339. Plausibility as "lie" is still present in Eugenio D'Ors's intelligent witticism: "The authentic photograph is the posed photograph—not the snapshot." The pose would show what we really *are* and want to be—not "just" the way we look.

46. Plutarch, *Lives of the Noble Greeks*, trans. E. Fuller (New York: Dell, 1959), p. 105.

47. These "appointed" days and subjects endured until classical Greece: Dionysiac festival, in March, for tragedies; Lanaean festival, in January, for comedies.

48. F. Benítez, *En la tierra mágica del peyote* (Mexico: Biblioteca Era, 1968), p. 83.

49. J. C. Lambert, "Le Théâtre hors Théâtre," in *Opus International*.

50. Nietzsche, *The Gay Science*, Sect. 89, p. 144.

51. See Martin Heidegger, *Sein und Zeit*, Chapter III, Sect. 22.

52. See M. Bieber, *The History of the Greek and Roman Theater* (Princeton: Princeton University Press 1939), and R. E. Wycherly, *How the Greeks Built Cities* (Garden City: Doubleday Anchor, 1969).

53. Antonin Artaud, "The Theater of Cruelty (Second Manifesto)," in *The Theater and Its Double*, p. 122.

54. Artaud, "The Theater of Cruelty (First Manifesto)," *ibid.*, p. 92.

55. See J. Duvignaud, *Espectáculo*, p. 117.

56. *Ibid.*, pp. 84–112.

57. If the audience is impatient, Peter Brook reminds us again, it is more impor-

tant to improvise a gag than to try to maintain the stylistic unity of the work. *The Empty Space* (New York: Atheneum, 1968).

58. See Guillermo Díaz Plaja, *Historia de la literatura española a través de la crítica y de los textos* (Barcelona: La Espiga, 1943), pp. 98 and 55.

59. See Victor Hugo, *Introduction to Cromwell* [1827], and J. Duvignaud, *Espectáculo*, pp. 60 and 66.

60. Berthold Brecht, "Sobre el teatro experimental," in *Escritos sobre el teatro* (Buenos Aires: Nueva Vision, 1970), p. 156.

61. Victor Hugo, *Cromwell*, pp. 79 and 83.

62. *Ibid.*, p. 98.

63. Duvignaud, *Espectáculo*, pp. 112–13.

64. Cf. my *Teoría de la sensibilitat*, pp. 535–36.

65. Maurice Merleau-Ponty, *Sens et Non Sens* (Paris: Nagel, 1948), p. 105. English trans. by H. L. Dreyfus and P. A. Dreyfus: *Sense and Non-sense* (Evanston: Northwestern University Press, 1964).

66. Eugene Ionesco, "La Chasse de l'homme," *Le Figaro* (May 6, 1972).

67. See M. Kustow, "The New TNF," *Performance* (September 1, 1972), p. 90.

68. I. A. Richards, *The Philosophy of Rhetoric* [1936] (New York: Oxford University Press, 1971), p. 131.

69. *Teoría de la sensibilitat*, pp. 535, 536. The use of the term "reticent" in this context is Tierno Galván's.

70. See the interpretation, very superficial despite its cryptic language, that Derrida makes of this sentence in *Le Théâtre de la cruauté et la clôture de la représentation* (Paris, 1967).

71. G. Simmel, *Soziologie* (Leipzig: Duncker und Humblot, 1923), pp. 531–33.

72. Walter Benjamin, "The Work of Art in the Age of Mechanical Reproduction," *Illuminations*, trans. Harry Zohn (New York: Schocken Books, 1978), p. 242.

73. Already in 1913, Marinetti had gone further than Artaud when he suggested an "out" for the theater, not through metaphysics but through its hybridization with less noble spectacles: "The authors, actors, technicians," he writes in his "The Variety Theater" [1913], "have only one reason for existing and triumphing: incessantly to invent new elements of astonishment. . . . The Variety Theater is alone in seeking the audience's collaboration. It doesn't remain static like a stupid voyeur, but joins noisily in the action. . . . The Variety Theater uses cigars and cigarettes to join the atmosphere of the theater to that of the stage. . . . While the conventional theater exalts the inner life, professorial meditation, libraries, museums, the monotonous crises of conscience, stupid analyses of feelings, in other words (dirty thing and dirty word), *psychology*, whereas, on the other hand, the Variety Theater exalts action, heroism, life in the open air, dexterity, the authority of instinct and intuition." (In R. W. Flint, ed., *Marinetti: Selected Writings*, trans. by R. W. Flint and Arthur A. Coppotelli [New York: Farrar, Straus, and Giroux, 1972], pp. 116–22 *passim*.)

74. Benjamin, "The Work of Art," p. 242.

75. James Joyce, *A Portrait of the Artist as a Young Man* (New York: Viking-Compass, 1956), p. 241. (All of Proust's work is dotted with these gestural expressions by means of which he tries to give a nuance to what is said or to what denotes

some profession or social situation, as Cottard or Norpois reveal.) Joyce himself had made a perfect description of Jesuitical gesturing: "The preacher began to speak in a quiet friendly tone. His face was kind and he joined gently the fingers of each hand, forming a frail cage by the union of their tips" (p. 127). "The priest rose and turning towards the altar knelt upon the step before the tabernacle in the fallen gloom. He waited til all in the chapel had knelt and every least noise was still. Then, raising his head, he repeated the act of contrition, phrase by phrase, with fervour" (p. 135).

76. Peter Brook, *The Empty Space*, p. 72.

77. It is not a matter of proposing classical models of realism since, as Brecht himself argued, "trust in Balzac" is, in the best of cases, "like advising someone: trust in the sea," and in the worst, "to want to keep old conventional forms of 'realism' which, in the face of a social milieu that changes continually, is nothing but formalism." Bertold Brecht, *Formalisme i Realisme* (Barcelona, Ed. 62, 1971), pp. 19 and 14. German original: *Über den Realismus*, in *Schriften zur Literatur und Kunst* (Frankfurt, 1967).

78. *The Empty Space*, pp. 72–73.

79. Erwin Piscator, *Le Théâtre politique* (Paris: Ed. l'Arche, 1962), p. 181. German original: *Das Politische Theater* (Berlin: A. Schultz, cop. 1929).

80. For Brecht in 1938, realist means "discovering the causal, social complex . . . writing the point of view of the class that has the best solutions for the most urgent problems of humanity, unmasking the dominant points of view as points of view of the oppressors, accentuating the momentum of evolution, being concrete and making abstraction possible," and, above all, "representing exactly the authentic driving forces which are operating in society under the surface of that which is apparent at first sight." In 1940, he still accepted the axiom that the realistic work should have the three elements: "realist detail," "a certain perceptible momentum," and "the presence of a still unelaborated raw material" (See *Formalisme i Realisme*, p. 332). My critique of this realism which claims to discover the "profound tendencies" of reality as if the process of its description were not part and parcel of it, can be found in my *Teoría de la sensibilitat*, pp. 219–23. Withal, we must recognize that Brecht was well aware of this contradiction in "realism." Recall his criticism along these lines of Lukács' *Assault on Reason* in the abovementioned book: "It's a shame that a man as active in the class struggle as Lukács almost completely excludes the class struggle from his literary history and sees, in the decadence of bourgeois literature and in the rise of the proletariat's, two absolutely unconnected phenomena."

The defense of "formalist" devices of his period (interior monologues, montage, "Joycean" changes of style) is made explicit in numerous passages where Brecht says time and again that "if formalism means to look always for new forms for an unchangeable content, to preserve old forms for a new content also means formalism" (*Formalisme i Realisme*, p. 128).

81. *Ibid.*, pp. 61 and 62.

82. Eugenio D'Ors, *Jardín botánico* (Madrid: La Rosa de Piedra, 1940), pp. 13–14.

83. See A. Arbasino, *Off-off* (Milano: Feltrinelli, 1968), p. 182.

84. Alejandro Jodorowsky, in *Le Panique*, p. 75.

85. *Playboy* (March 1967), p. 60.

86. *The Empty Space*, p. 56.

87. See Richard Sennett, "Destructive Gemeinschaft," *Parisan Review*, 43, no. 3 (1976), pp. 341–61, and the recent *The Fall of Public Man* (New York: Knopf, 1977).

88. L. Feuerbach, *Contribution to the Critique to Hegel's Philosophy* (Hallische Jahrbucher, 1839). P. Klossowski, preface to the trans. of Kierkegaard's *Antigone* (Paris: Les Lettres Nouvelles, 1938), and *Origines culturelles et mythiques d'un certain comportement des dames romaines* (Montpellier: Fata Morgana, 1968).

89. *The Empty Space*, p. 63.

90. S. Cavell, *The World Viewed: Essays on the Ontology of Film* (New York: Viking, 1971), p. 153.

91. M. Vázquez Montalbán, "San U. Eco, ni virgen ni mártir," *Triunfo*, #495.

92. In the figure on p. 16 we see the two contexts in which the work is inscribed and whence it acquires its meaning. The classical avant-garde was aware of the first (linguistic or stylistic) context, and therefore focused its attention on the "language" of art. Today, we are aware as well of the second context: the life-style within which art styles and languages work.

93. W. Gombrowicz, *Autobiografia sucinta, textos y entrevistas* (Barcelona: Anagrama, 1972), pp. 28, 32.

94. Jean Piaget, *La psychologie de l'intelligence* (Paris: A. Colin, 1967), p. 46. English trans. by M. Piercy and D. E. Berlyne: *The Psychology of Intelligence* (New York: Harcourt Brace, 1950).

95. Philip E. Slater, *The Pursuit of Loneliness*, pp. 27–28.

96. Renunciation of "art," and not "death" of Art which, as we saw (p. 21), is nothing but a rhetorical affirmation. Renouncing art means here doing without its established role and place—that is why the term *art* is in quotation marks and not capitalized.

97. Bourgeois ideology is made up of the pair of terms: economicism / humanism; of the exaltation of both "productivity" and "freedom" (see L. Althusser, *Réponse à John Lewis*, pp. 87–92, and *Pour Marx* [Paris: F. Maspero, 1973], pp. 225ff. Orig. pub. in English in *Marxism Today* [Oct.–Nov. 1972]). But what happens when the two ideals conflict with each other? Bourgeois ideology then decides to give priority to Production on the middle, real, and practical levels, while giving preeminence to Man on private or universal levels. Exploitation of classes and colonies, but humanitarian aid to the *private* individual and, of course, exaltation of the supreme value of Man *in general*.

98. A more radical reply than that of St. Jerome, for whom, in the last analysis, "marriage couldn't be bad, since only by means of marriage could new virgins be born."

99. Wilhelm Reich, *La Révolution sexuelle* (Paris: Plon 1968), pp. 74 and 78. English trans. by Theodore P. Wolfe: *The Sexual Revolution* ((New York: Orgone Institute Press, 1945).

100. T. Perlini, *Kierkegaard* (Rome: Ubaldini 1968), p. 108.

101. Ivan Illich, *Deschooling Society* (New York: Harper & Row, 1971), p. 32.

102. Christopher Alexander, Philip Slater, and Richard Sennet have pointed out this phenomenon, each from a different perspective.

103. Philip Slater, *The Pursuit of Loneliness*, p. 143.

104. Vilfredo Pareto, *Les Systèmes socialistes* (Paris: V. Giard and E. Brière, 1902), p. 22.

105. J. Queoglas, *El espacio en Mozart y Sade* (Unpublished ms., School of Architecture, University of Barcelona).

106. Karl Marx and Friedrich Engels, *Uber Künst und Literatur*, vol. II (Frankfurt, 1968), p. 351.

107. After writing this book I read Richard Sennett's works (*The Hidden Injuries of Class, The Uses of Disorder* and *The Fall of Public Man*) where, especially in the latter, this subject is brilliantly elaborated. While reading his books I actually felt a strange personal affinity with Sennett which later, when I met him, I could both understand and enjoy.

108. "We can use academic forms," writes Igor Stravinsky in his *Musical Poetics*, without running the risk of becoming academical . . . I use them as purposefully as I [would] use folklore. Both are raw materials of my work."

109. The very titles of these books or magazines indicate that they are treatises on manner or urbanity—or counterurbanity if one prefers: *Treatise of How to Live for the Use of the New Generations, Do It, On the Misery of Students Considered in its Economic, Political, Psychological, Sexual, and Above All Intellectual Aspects and On Some Means of Remedying It, We Are Everywhere, Dare to Struggle* (Maoist magazine), *The Collected Works Against Us* (a publication of the K Commune in Berlin). By far the most characteristic in this sense is the *Little Red Book of Schoolchildren and High Schoolers*, a genuine catechism of counterbehaviors which retains even the catechism's structure of questions and answers: "What is heckling?" (p. 26). "How do you make critical use of your homework?" (p. 30). "What does taking a 'trip' mean?" (p. 134). See B. D. Andersen, S. Hansen, and J. Jensen, *Le Petit Livre rouge des écoliers et lycéens* (Lausanne: Cedips, 1970).

110. J. J. Rousseau, *Ensayo sobre el origen de las lenguas* (Buenos Aires: Caldeu, 1970), p. 43. English trans. of French original by J. H. Moran and A. Gode: *On the Origin of Language* (New York: F. Ungar, 1967).

111. Jerry Rubin, *Do It* (New York: Simon and Schuster, 1970), pp. 95, 106, and 127.

112. See J. Baudrillard, *Le Miroir de la production* (Paris: Casterman, 1973), pp. 100–4. As Octavio Paz emphasizes, we face here two different modes of dehumanization: "Capitalism treated men like machines; the postindustrial society treats them as signs" ("El ocaso de la vanguardia," *Plural*, 1 [1974]).

113. See D. J. Boorstin, *The Image* (New York: Atheneum, 1962), Chapters 1 and 2.

114. Aristotle, *De Anima*, III, 7, 432a.

115. G. Débord, *La Société du spectacle* (Paris: Champ-Libre, 1971), pp. 68, 105, and 142.

116. "De la misère en milieu étudiant," *21–27 Étudiants de France* [Strasbourg], 16 (1966), p. 24.

117. See "La Domination de la nature," *ibid.*, p. 70.

118. Celsus, *Contre les Chrétiens* (Paris: J. J. Pauvert, 1970).

119. See my *Utopías de la sensualidad y métodos del sentido*, pp. 134 and 135, note.

120. Karl Marx, *Introducción a la crítica de la filosofía del derecho de Hegel* [*Introduction to Hegel's Critique of the Philosophy of Law*], *Sobre la cuestión judía*, (Paris: Costes, 1946), *ibid.*, p. 96.

121. See C. Roy, *L'Histoire en histoires*, p. 48.

122. G. Deleuze and F. Guattari, *Capitalisme et schizofrenie: L'Anti-Oedipe* (Paris: Minuit, 1972), p. 36.

123. "Isn't Oedipus perhaps a demand or a consequence of social reproduction through which the latter tries to domesticate a genealogical material and form which everywhere elude it?" *ibid.*, p. 20. And Foucault followed the discourse in a more poetic and ironic vein: "Do not cry, my children, if you are orphans and you lived within yourselves the mother-object or the mighty sign of the father. Do not cry, do not cry at all: because it is through them that you will accede to desire."

124. Michel Foucault, *L'Ordre du discours* (Paris: Gallimard, 1972), pp. 52 and 12. The association of Discourse with Desire (and its Expression / Repression) appear also in Julia Kristeva (*Sēmiōtikē: Recherche pour une semanalyse* [Paris: Ed. du Seuil, 1979], and *La Révolution du langage poétique* [Paris: Ed. du Seuil, 1974]) and in Roland Barthes (*Le Plaisir du texte* [Paris: Seuil, 1973], as well as his *Fragments d'un discours Amoureux*).

125. Personally, I understand that this reduction or definition of "what is fundamental" as pure desire, wild discourse, *"entretien infini"* (Blanchot), etc., is formally identical to classical reductionisms—philosophical, political, and economic. My thesis seems to be confirmed now in 1977 with Foucault's criticism—in a way, self-criticism—of the "philosophy of desire." Desire, he now writes, is not "the only thing that opposes bourgeois power"; it is part and parcel of this very power (*Histoire de la sexualité*, I, *La Volonté de Savoir* [Paris: Gallimard, 1977]). See also the works of the *nouvelle philosophie*, especially A. Glucksmann's *Les Maîtres penseurs* (Paris: Grasset, 1977).

126. G. Deleuze and M. Foucault, "Les Intellectuels et le Pouvir," interview in *Le Nouvel Observateur* (May 1972). Certainly, diffuse systems of social control (and not merely political or police control) are nothing new, and as Simmel saw, they are more rigid in small agrarian, primitive, cohesive, and organic communities, from whose "ties" the *Freie Luft* of the bourgeois city did at last free people (see *Soziologie*, p. 528, and *Metropolis and Spiritual Life*, p. 419). In my *Utopías de la sensualidad* (pp. 132–34), I have tried to draw an analogy between two diametrically opposed situations— the primitive tribe and the modern megalopolis—that would explain, among other things, the importance this system of implicit or diffuse sanctions assumes in both. Before Adorno, Horkheimer, or Marcuse, and also before Foucault or Deleuze, Tönnies and Radcliffe-Brown had already developed a typology of the immanent forms of social sanction. Tönnies distinguished between habit, custom, and usage—individual, collective, and traditional, respectively—as increasingly diffuse forms of repression, which become less institutional and more social; see F.

Tönnies, *Die Sitte* (English translation, *The Custom* [Chicago, 1961], pp. 57, 84ff.). Radcliffe-Brown distinguished in turn the terms that express a diffuse social reproach: behavior that is discourteous, shameful, libelous, gross, ridiculous, etc., and the socially prescribed procedures by which impurity, sin, or other institutionalized forms of transgression (e.g., sacrifice, penance, cleanliness, reparation, repentence, etc.) could be neutralized. See *Estructura y función en la sociedad primitiva* (Barcelona: Península, 1972), pp. 234 and 235 (English original: *Structure and Function in Primitive Society* [London: Routledge and Kegan Paul, 1969]).

127. To understand what is happening today, a "rightist" sociological tradition which has been silenced during recent years should be reclaimed: Scheler, Sombart or Simmel, Tönnies, Pareto or Mosca. When speaking of the sociology of the city, it is incomprehensible that in Europe only the studies of Walter Benjamin are cited, and those of Simmel are ignored; and that Poulantzas is allowed to "invent" concepts relating to the dominant class which were worked out by Pareto more than thirty years ago.

128. Ivan Illich, *Deschooling Society*, p. 56.

129. "If capitalism has for centuries used all the superstructural ideologies to camouflage contradictions on the economic plane, the strategy has now been turned upside down: the establishment appeals to economics (welfare, consumption, working conditions, salary, productivity, growth) as a defense against the most dangerous subversion, which threatens it in the symbolic order. It is the economic sphere, with its partial contradictions, which operates today as an ideological factor for integration" (J. Baudrillard, *Le Miroir*, pp. 118, 119).

130. X. Rubert de Ventós, *Self-Defeated Man: Personal Identity and Beyond*, pp. 66–67.

131. Herbert Marcuse, *Die Gesellschaft als Kunstwerk* (Vienna: Neues Forum, 1967), p. 863.

132. George Orwell, "Looking Back on the Spanish War," in *A Collection of Essays* (Garden City: Doubleday, 1954), p. 202.

INDEX